GREAT ENGLISH INTERIORS

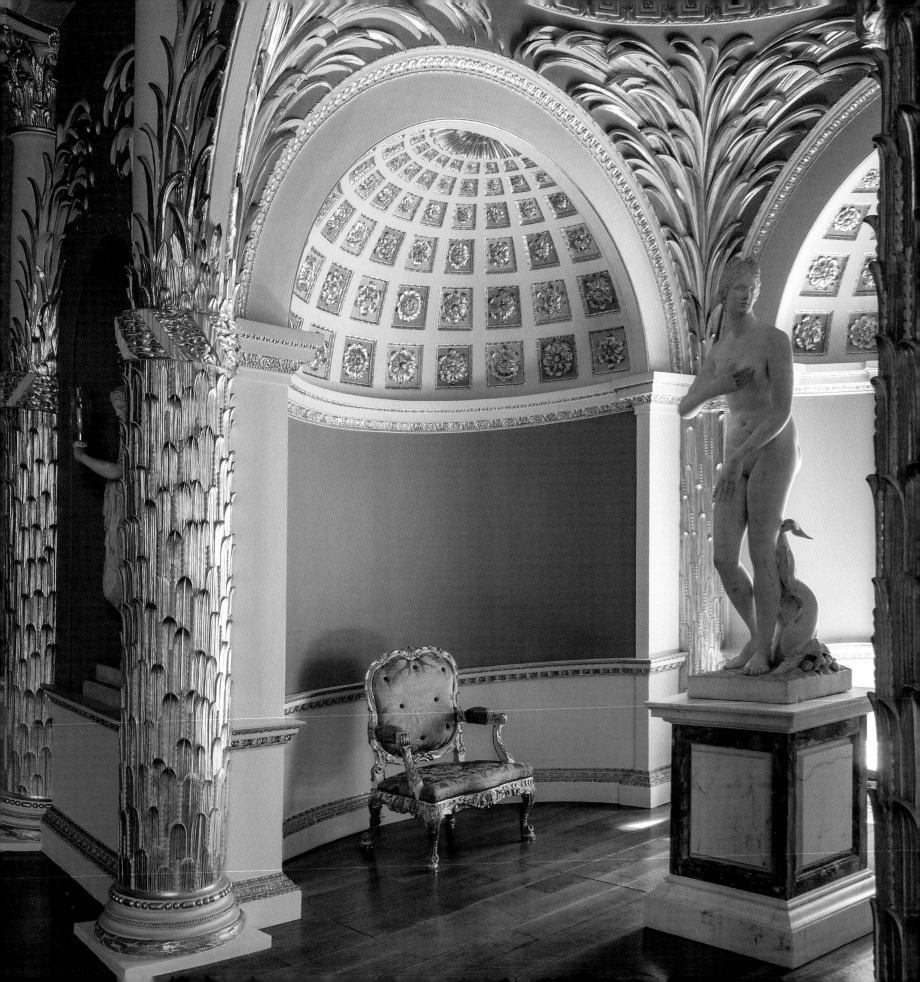

GREAT ENGLISH INTERIORS

DAVID MLINARIC AND DERRY MOORE

With a foreword by Emily Tobin

PRESTEL

MUNICH · LONDON · NEW YORK

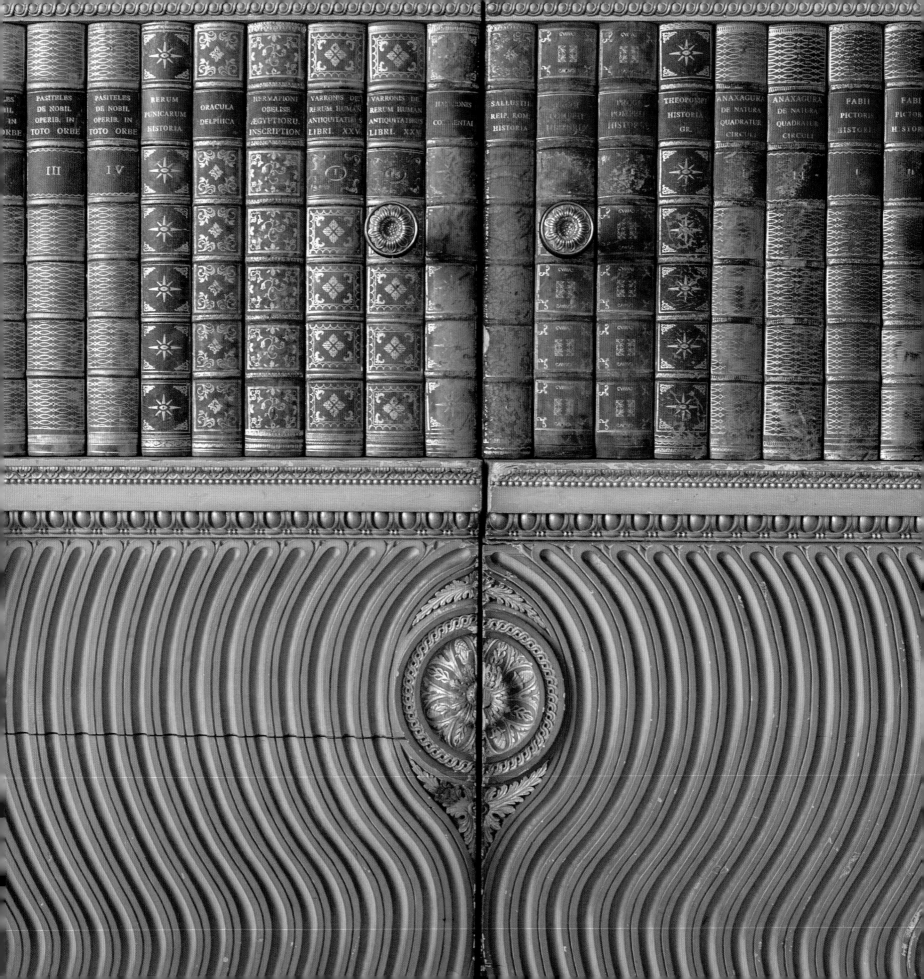

CONTENTS

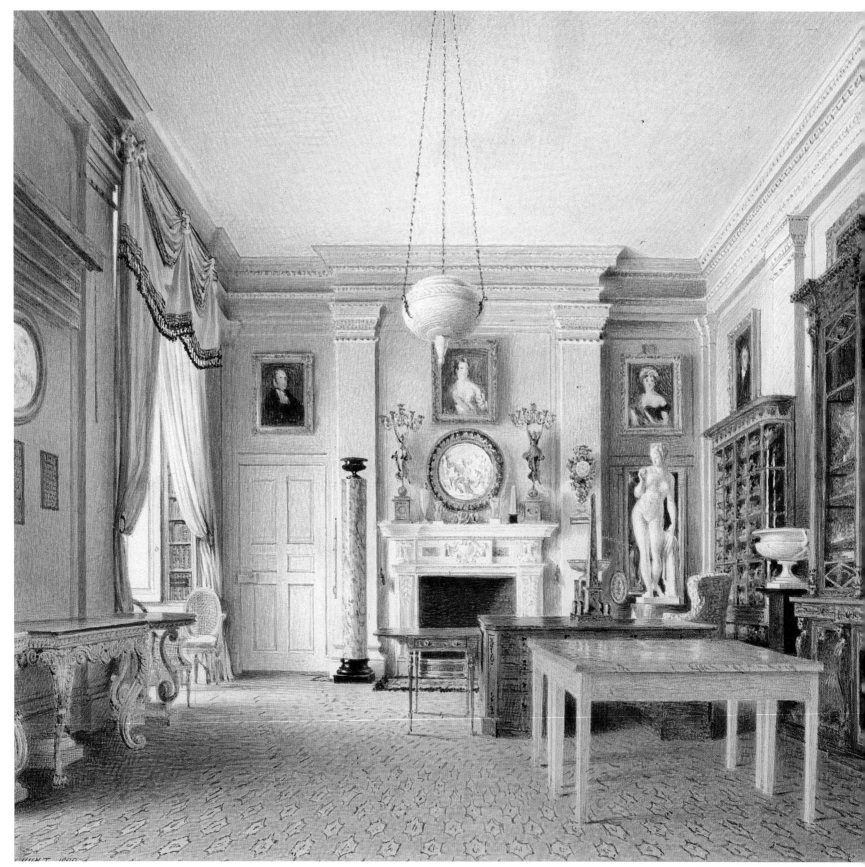

A contemporary watercolour of the Lower Library at Chatsworth (pages 59–71), showing the Regency scheme before the room's redecoration in the 19th century by John Gregory Crace.

INTRODUCTION

—

The White Rabbit put on his spectacles. 'Where shall I begin, please your Majesty?' he asked.
'Begin at the beginning,' The King said gravely, 'and go on till you come to the end: then stop.'
— LEWIS CARROLL, ALICE'S ADVENTURES IN WONDERLAND, 1865

LIKE ALL THE BEST tales, the story of interior design and decoration in England is long and winding. It has many chapters and a cast of riveting characters, and demands a canny narrator. David Mlinaric is just that person. He has been creating beautiful rooms in historic interiors for more than half a century, and, like the king in *Alice's Adventures in Wonderland,* has been asked by plenty of White Rabbits, 'Where shall I begin?' This book is his answer. While these buildings and the rooms within them may be lavish, vast and of another era, they are also ingenious, timeless and packed with inspiration. Moreover, they are repositories for terrific stories.

Derry Moore's photographs showcase the glorious potential of architecture and decoration across the centuries, because for as long as David has been conjuring magnificent rooms, Derry has been capturing them on camera. They are a formidable pair who share a well-honed sense of what looks good where; David's somewhat ascetic tastes counter Derry's penchant for more luscious things. They have curated this book accordingly and recorded these places before the inevitable day when they change beyond recognition. David and Derry both possess an artist's eye, boundless curiosity and a deep-rooted historical knowledge. These are skills that have served them well throughout long careers, but perhaps most important of all is a shared ability to grasp the character of a building and immediately understand its previous life and its potential. As David says, 'A journey into the past can help make sense of the present.'

David was born to an English mother and a Slovenian father, and his exacting approach to design, decoration and architecture is that of a self-confessed outsider. As the architectural historian John Cornforth wrote, 'He has always looked at the English tradition with the appreciation of detachment.' In the 1950s David attended Downside, the Roman Catholic boarding school in Somerset. He and a handful of friends were allowed to skip games lessons in favour of art, and would cycle through the surrounding countryside in search of beautiful places. Family holidays were spent by the sea where he shunned buckets, spades and sandcastles in favour of studying the houses that lined the shore. Despite his headmaster's insistence that 'interior decoration' was not 'a real profession', and that there was room for only about three people to do it in London, he advised him to attend an architectural school. So, off David went to The Bartlett School of Architecture, part of University College London, and in doing so he became one of the few practitioners of his generation to be formally trained. 'I gave the impression of having a frivolous attitude because I didn't want to be brought down by responsibility, but really, underneath it all, I was deadly serious,' he says. 'Good jobs and interesting people tumbled into my orbit from day one, and I felt encouraged by that.'

One particularly interesting person who tumbled into David's orbit and – as this book will attest – never tumbled back out of it was Derry. In the late 1960s Derry was commissioned by *Vogue* to photograph David's dining room in Tite Street, and so began more than 50 years of collaboration, with Derry photographing countless projects by David, including all his own houses. Derry studied painting at Oskar Kokoschka's School of Seeing in Salzburg (Die Schule des Sehens), which, he says, 'opened my eyes', but it was while working with David that he 'learned how rooms should look'. In the years since beginning his career as a professional photographer, he has documented some of the most extraordinary buildings on the planet – a few of which feature in this book.

Just as Lewis Carroll's king suggests, *Great English Interiors* begins at the beginning – or, at least, at the beginning of the end of fortification: the fifteenth century. Firstly, the reader comes to Haddon Hall, home in the sixteenth century of Dorothy Vernon, who, trussed up in her ballgown, escaped into the night to elope with her lover. Skip forward a little and we find Knole, sensitively renovated by Thomas Sackville and later described by the architectural conservationist James Lees-Milne as 'having a perennially romantic history and seeming to be immortal'. Hatfield House was home to the man who had thwarted the Gunpowder Plot. There was Sir Robert Walpole, who built Houghton Hall, his vast Palladian masterpiece – for how else could he demonstrate his wealth and power? And, later still, the 'Bachelor' 6th Duke of Devonshire, so enamoured by his inheritance, Chatsworth, that he added and added to it with increasingly grandiose schemes; the house and its estate became his life's work. Later, Baron Ferdinand de Rothschild had the confidence, verging on audacity, to create a French chateau in Buckinghamshire; he named it Waddesdon Manor and held fabulously extravagant house parties there. Less than a century later, Nancy Lancaster fastidiously oversaw the mixing of the perfect glaze by John Fowler for her Yellow Drawing Room in Mayfair; it remains one of London's best-known interiors of its date. Meanwhile, the Bloomsbury Group were liberally daubing their distinctive brand of bohemia on the walls of Charleston, their Sussex home.

THIS IS BY NO MEANS an exhaustive list of the best rooms in England, or indeed of the best architects and decorators, and I suspect the selection process was a painful one for both David and Derry. However, every interior featured in this book has influenced the pair in some capacity, and by default will have had an impact on those of us who have looked to David and Derry for inspiration over the last half-century. Put simply, there are some things that work and some things that do not, and these interiors are fine examples of the former. It is a rarity for someone to create a room that is entirely different from those that came before; in fact, it is almost impossible. But in the scarce instances where this does happen and the room in question is beautifully designed, they tend to stand the test of time.

While David is the first to concede that his children's birthdays and the names of close acquaintances slip his mind with frustrating ease, his memory for architectural detail is impeccable. Who else would think to compare the fan vaulting at Heveningham Hall with the sculpted columns at the Apollo Victoria Theatre? As Neil MacGregor, former director of the National Gallery, astutely observed, 'Everyone comes to the gallery to look at the pictures. Everyone except David – he's looking at the cornices.' And really, that's what it all boils down to. Just as a writer takes notes and an artist draws, David and Derry look and look and look again.

Great English Interiors is their invitation to the reader to do just that: to look at the houses and buildings that have endured over the centuries and shaped a nation's sense of style. Each one is a physical record of not just history and tradition, but also the beliefs and aspirations of the people who designed, commissioned and lived in it. This book is not concerned with decoration trends; as David says, 'They might brighten up a room, but eventually they'll disappear in the quicksand.' These interiors are unified by their extraordinary quality, innate Englishness and, in many cases, staying power.

So, what next? 'More architectural interiors', says David. Larger budgets are enabling architecture to take the lead over decoration, since people aren't simply applying a lick of paint and adding a new bookcase, they are digging down, building out and opening up. They are taking their lead from commercial spaces, such as Norman Foster's Apple Store on Regent Street, John Pawson's Design Museum and Kings Place by Dixon Jones, all in London. In fact, it is wholly conceivable that these architectural heavyweights sought inspiration from the bricks and mortar illustrated in the pages ahead.

The interiors in this book span the gamut of design and decoration, from austere to frivolous, jam-packed to pared-back, ornate to streamlined, but a sense of spirit unifies them. There is plenty here to inspire, for surely there can be no greater pleasure for the curious soul than stepping – if only for a moment – into an unknown room.

Emily Tobin, Arts Editor, **House & Garden** *magazine*

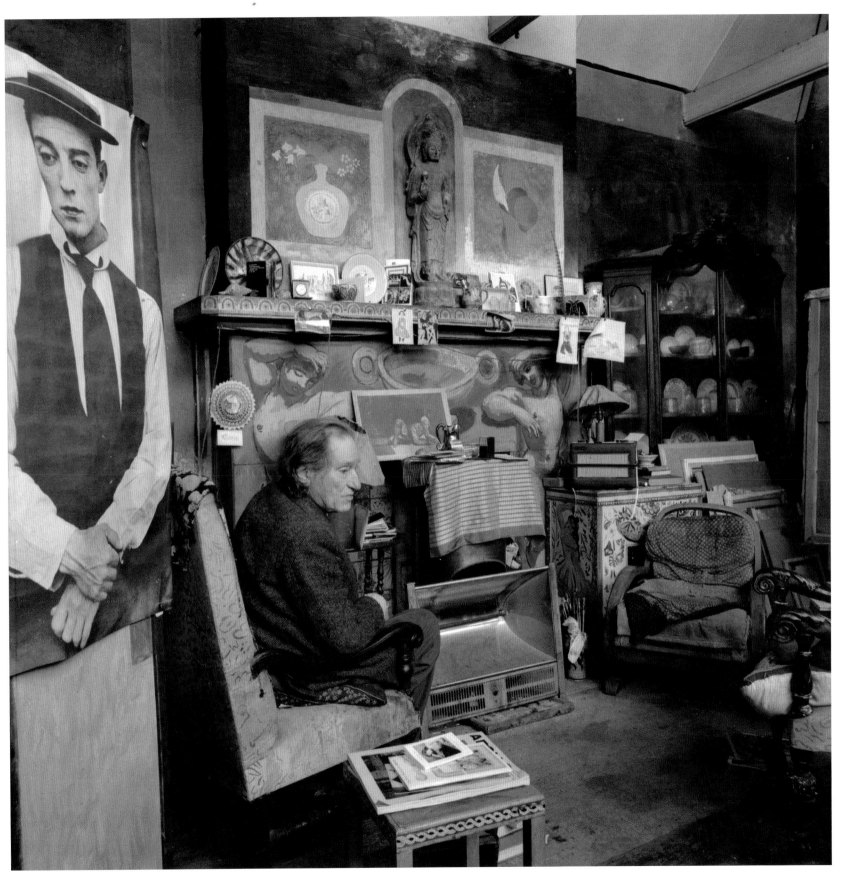

Duncan Grant in the studio at Charleston, Sussex (pages 192–95), in 1971.

FIFTEENTH CENTURY

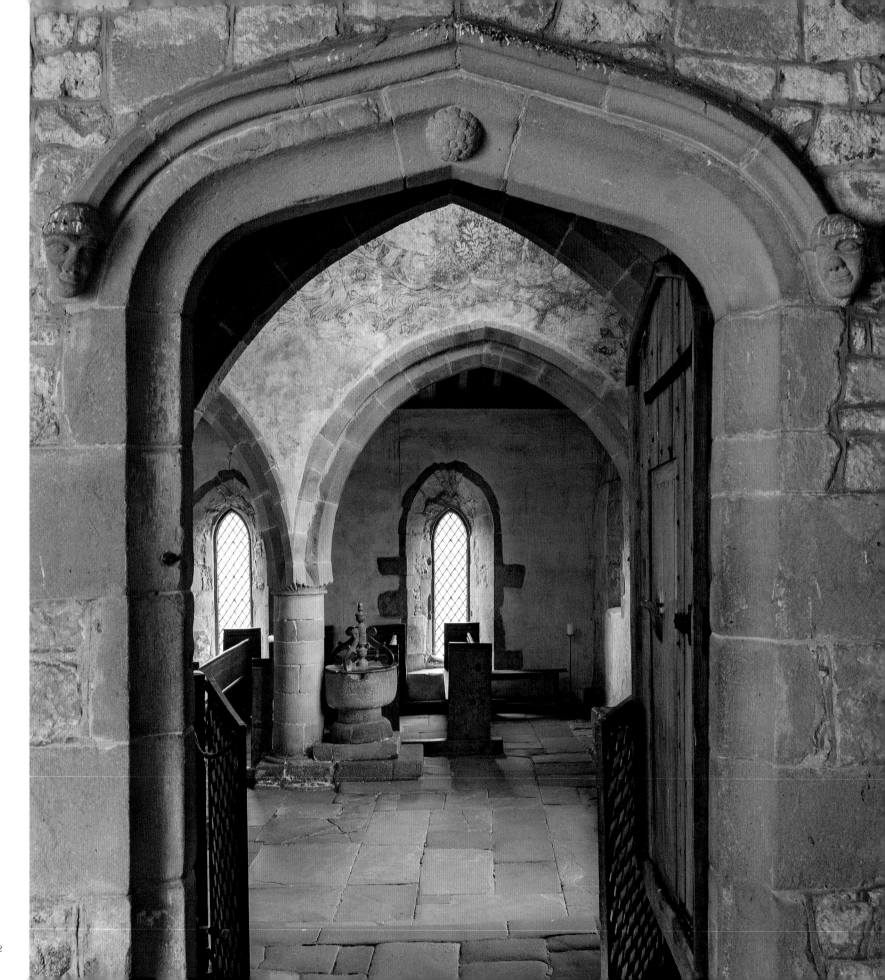

The End of Fortification

———◆———

THE STORY OF DOMESTIC INTERIORS in England starts in the fifteenth century. Until this time houses, as well as castles, were built with the primary purpose of withstanding sieges. The medieval ethos was one of security, not comfort. There were moats, portcullises and crenellations, but with the invention of gunpowder and the cannon such precautions became obsolete and signs of fortification became decorative rather than practical.

Although very few secular and domestic buildings survive from this period, England is unparalleled when it comes to medieval parish churches. These buildings pre-date the division of western Christianity and contain within them an entire social and architectural history. Most are relatively unaltered, and very beautiful. They appeal to our sense of the picturesque, which in England can be more powerful than the academic approach.

Haddon Hall (pages 14–25). The chapel, originally built in the 12th and 13th centuries. The view on entering from the courtyard shows part of the Gothic arcade, a Norman pillar and font, a Jacobean font cover and part of the fresco secco.

HADDON HALL

DERBYSHIRE

—————

Genesis of the Private House in England

Haddon hall is one of few English houses to survive in near original condition from the late Middle Ages. As anyone who lived through the second half of the twentieth century will know, the hand of the destroyer has been as active in times of peace as in times of war. The house owes its survival and its retained character to four key facts. The first is neglect: between 1700 and 1920 no one lived at Haddon; the roof was kept intact and the windows kept firm, but it was without occupants for more than 200 years. Since the house was not the family's primary residence, they could afford to leave it untouched. The second is religion: the chapel at Haddon, which was primarily built in the early fifteenth century (although it incorporates twelfth- and fourteenth-century elements and a Norman font and column), was and still is the consecrated, and therefore sacred, parish church at Nether Haddon (the village has since gone). The third is the fact that the house and estate have never been sold; they have passed from one owner to another by marriage or inheritance since the twelfth century. Finally, Haddon survived because it was classified by John, Earl of Mortayne (later King John I), in the 1180s as a fortified house, not a castle. It was therefore never garrisoned, and avoided destruction during the Wars of the Roses and the Civil War.

The earliest record of a house at Haddon is in 1180, when a marriage settlement brought it to the Vernon family. The last heiress, Dorothy Vernon, married Sir John Manners after (allegedly) eloping with him in 1563. The story goes that Dorothy fled a party celebrating the engagement of her sister Margaret; still wearing her ballgown she slipped into the night and ran through the garden, over a packhorse bridge to where Sir John Manners waited for her. If indeed this tale is true (most suspect it of being a nineteenth-century yarn), the couple were soon reconciled with Dorothy's father, Sir George, because they inherited the estate upon his death. Haddon has remained in the Manners family ever since. Sir John and Dorothy built the Long Gallery and the early Renaissance terraced garden.

The house has been added to as needed, but always in the vernacular style, which means parts of it can be difficult to date. What we see today is a composite building of different dates from the late twelfth century to the early seventeenth, all built around two courtyards with at the centre the Banqueting Hall, where life would have been focused since the early fourteenth century.

The house, its contents, the setting and the garden combine to make Haddon an exceptionally romantic place. The 9th Duke of Rutland, John Manners (1886–1940), spent his life restoring the buildings with great care and sensitivity, while his wife, Kathleen, oversaw the garden.

The view towards the entrance of the Chapel at Haddon Hall. The stone seat on the left was for impoverished parishioners who through bad luck had 'gone to the wall'.

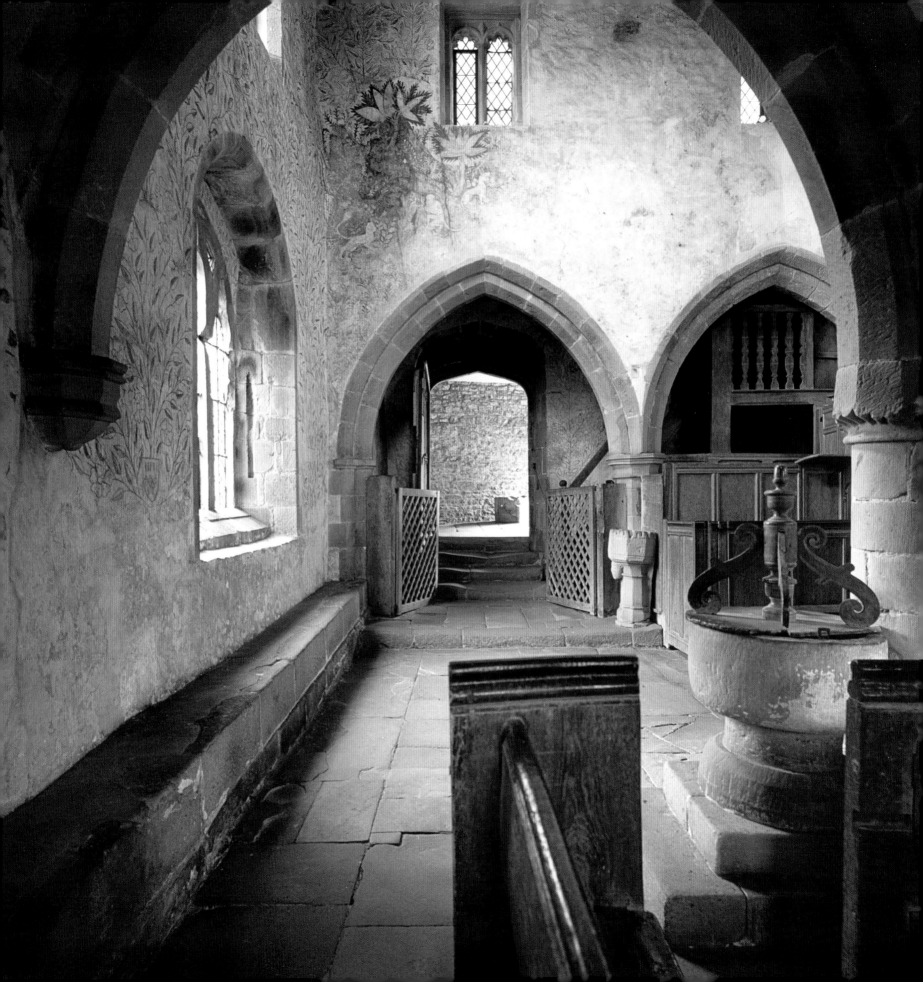

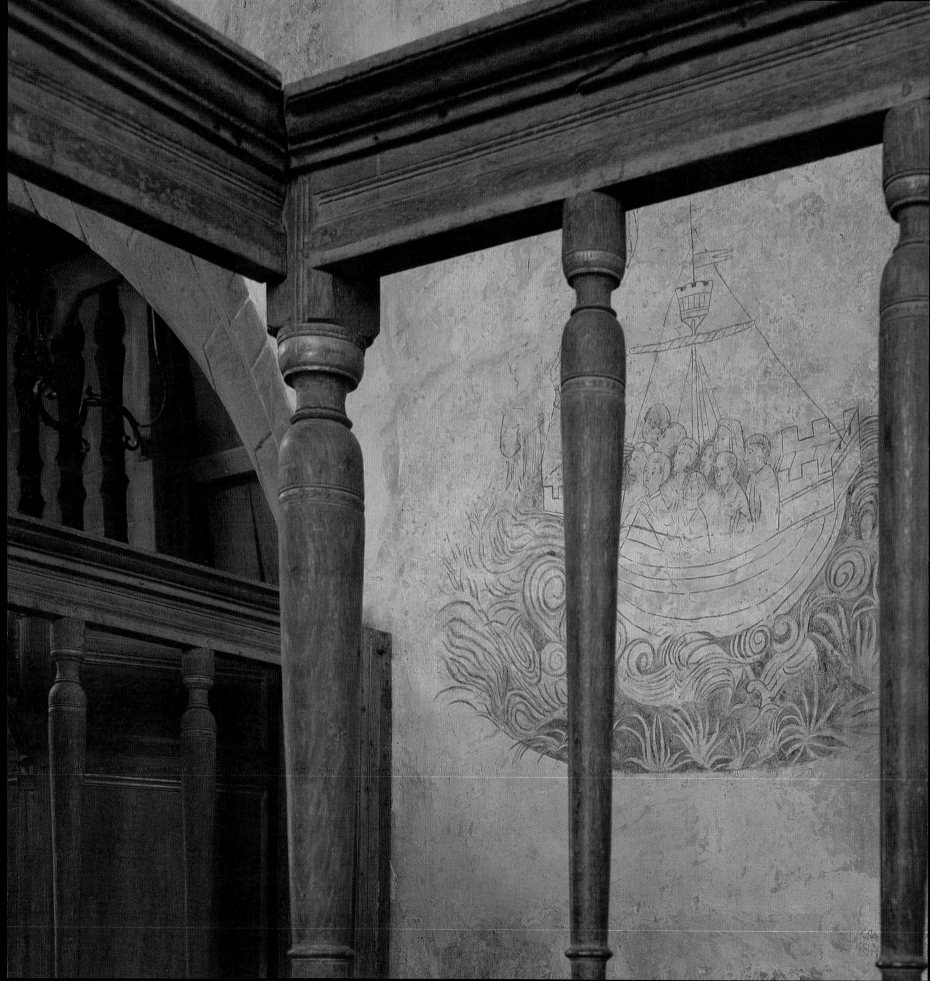

The first chapel at Haddon was built in the Norman period, although the major part of the existing building is medieval, as is the surviving stained glass. The walls of the chapel were painted with fresco secco (dried fresco) in the early fifteenth century, but were plastered over during the Reformation and then rediscovered and restored in the early twentieth century. They would once have been brightly coloured, but, despite their faded hues, they provide a powerful insight into medieval ecclesiastical decoration. The pulpit and pews are Jacobean. There is a marble effigy of Lord Haddon, son of the 8th Duke of Rutland, who died aged nine in 1894. It is a copy of an original sculpted by his mother, Violet, Duchess of Rutland, which is in the chapel at Belvoir Castle, Leicestershire.

The Banqueting Hall and Long Gallery are two of the largest rooms in the house. In the fourteenth century the Banqueting Hall would have been used not only to receive guests, but also for the entire household to sleep and dine in.

The wooden screen, gallery above, stone floor, high table and furniture all share a muted tonal palette, in contrast to the faded blues and yellows in the Mortlake tapestry, which is part of a set of five 'Senses' tapestries commissioned by Charles I and sold to the Manners family after his death. One of these hangs in the minstrels' gallery. Another tapestry, which hangs behind the dais table, depicts the Royal Arms of England and was reputedly given by Henry VIII to George Vernon.

A staircase with a seventeenth-century dog gate at the top of the first flight gives access to the upper-floor rooms, including the Long Gallery. Here the walls are panelled and carved, and again the tonal harmony is noticeably complete. Traditionally, a long gallery in an English house would have been used mainly for exercise in bad weather. When one looks at the elaborate clothes of the period, especially for women, one can see why they might avoid outdoor exertion. The furniture is of different dates, from a fifteenth-century dowry chest to ten Daniel Marot-style seventeenth-century chairs. In 1933 the 9th Duke commissioned Rex Whistler to paint Haddon in its landscape. His painting is set over the fireplace and is a fine example of the English Romanticism so popular between the two world wars. Although this is an idealised rendering of a house with figures in the landscape, Haddon is just as beautiful in reality as it is in Whistler's picture.

This is a house that has always been, and still is, loved by its owners, even in neglect. Although James Lees-Milne reminds us that when Princess Victoria, later Queen Victoria, visited she found that 'it did not please though thought singular'.

Detail of fresco secco of St Nicholas calming the storm in the Chapel at Haddon Hall.

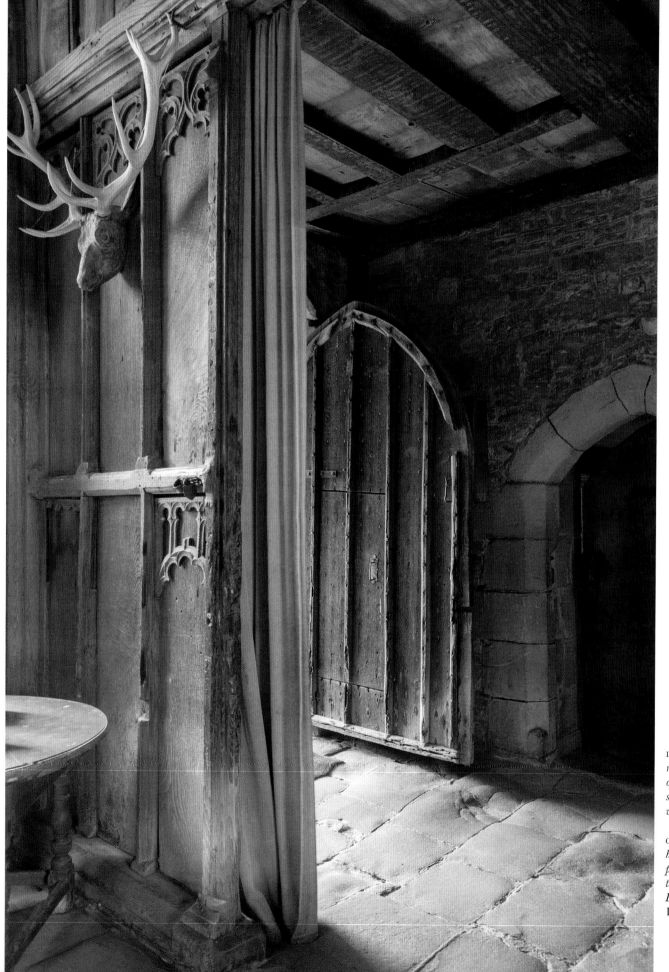

LEFT *A surviving part of the medieval screen and entrance door of the Great Hall. Note the random stonework walls and centuries of wear on the pavement.*

OPPOSITE *In the Great Hall, the high table is on a dais. On the panelled wall behind hangs a French tapestry showing the royal arms of England, probably given to the Vernon family by Henry VIII.*

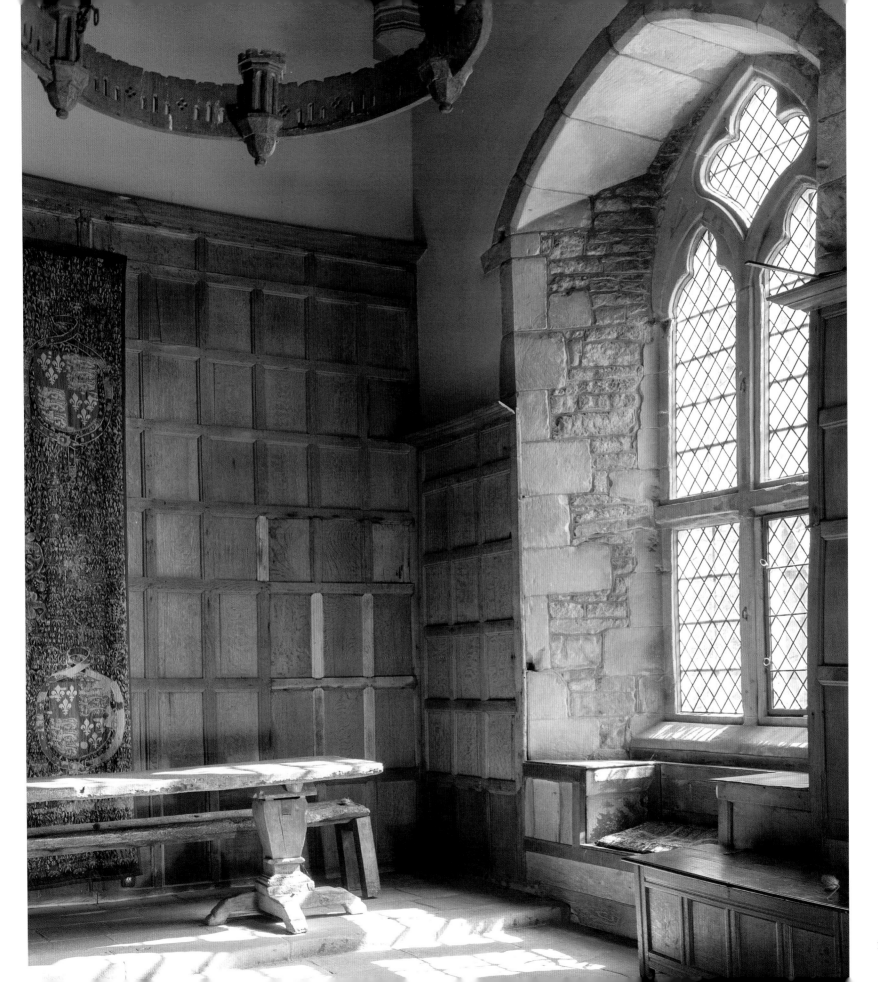

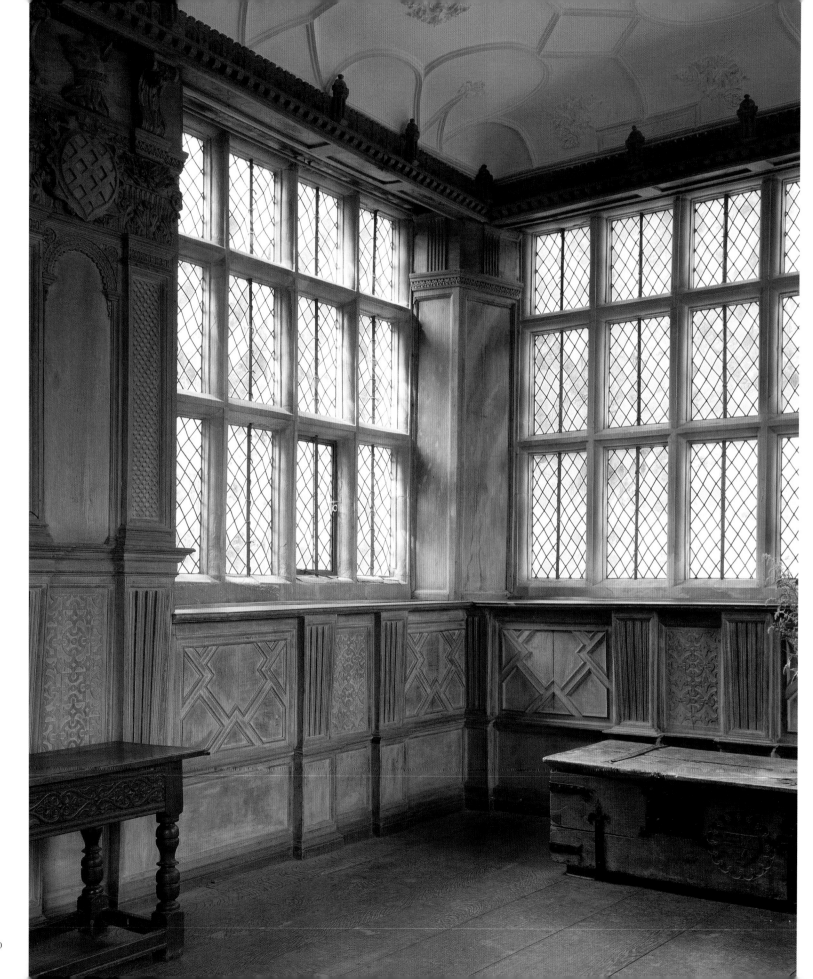

OPPOSITE *The leaded panes of glass in the windows in this corner of the Long Gallery were fitted irregularly, to catch the sunlight and create sparkle.*

RIGHT *The staircase to the Long Gallery, showing half of its dog gate.*

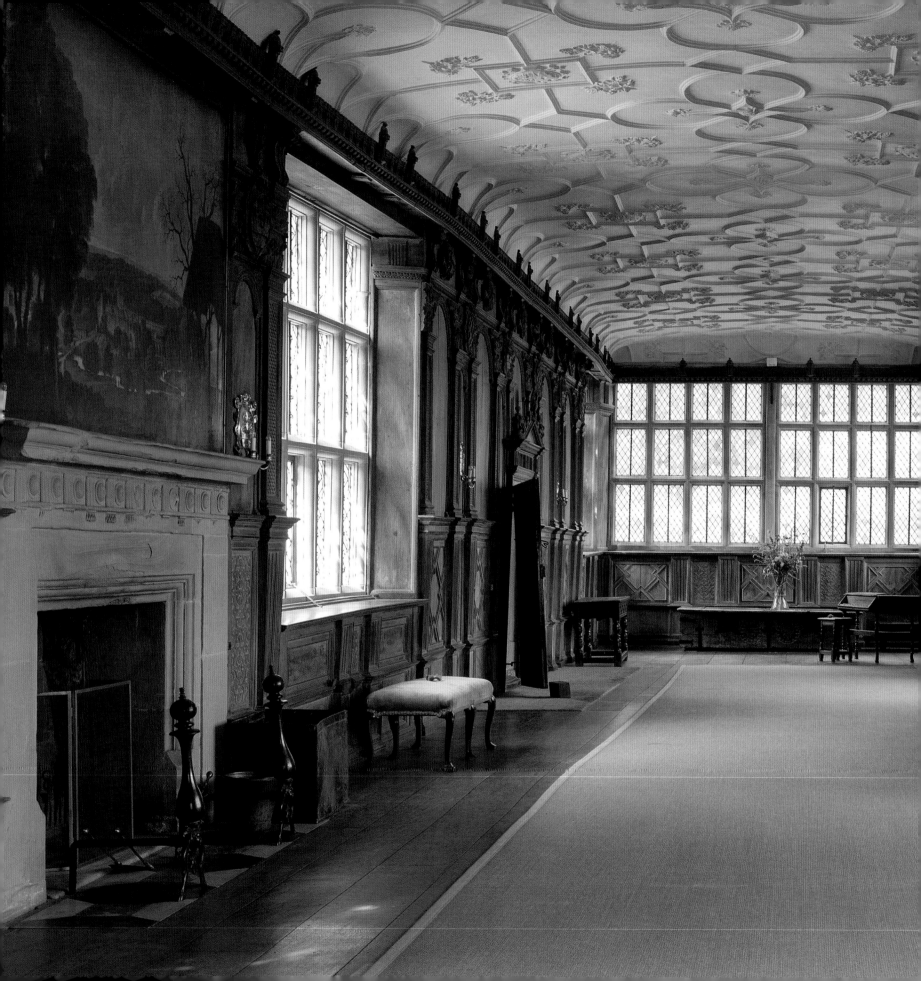

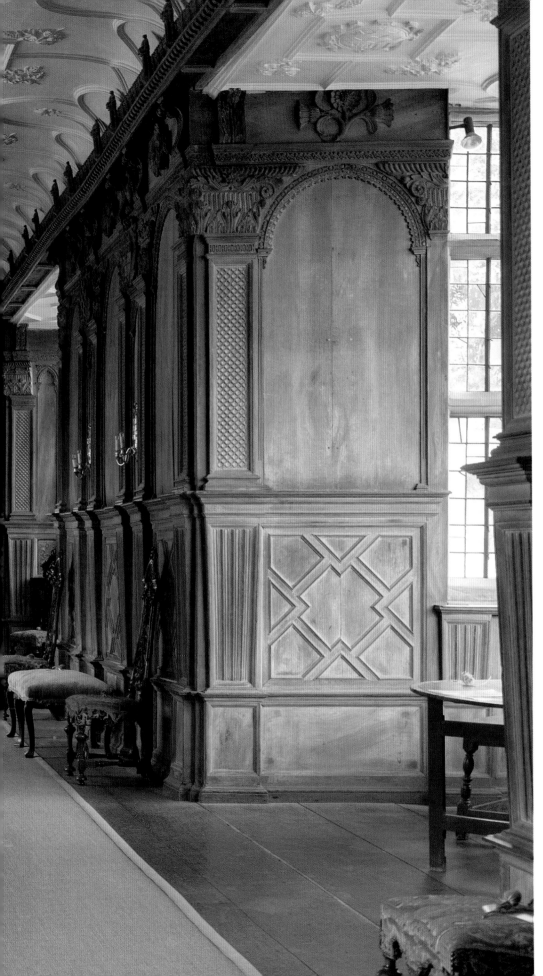

*The Long Gallery displays
a union of natural surfaces: wood,
stone and plaster with no added
colour, creating a dry beauty.
Rex Whistler's painting,
a romantic vision of the house
in its landscape, is on the left
above the fireplace.*

23

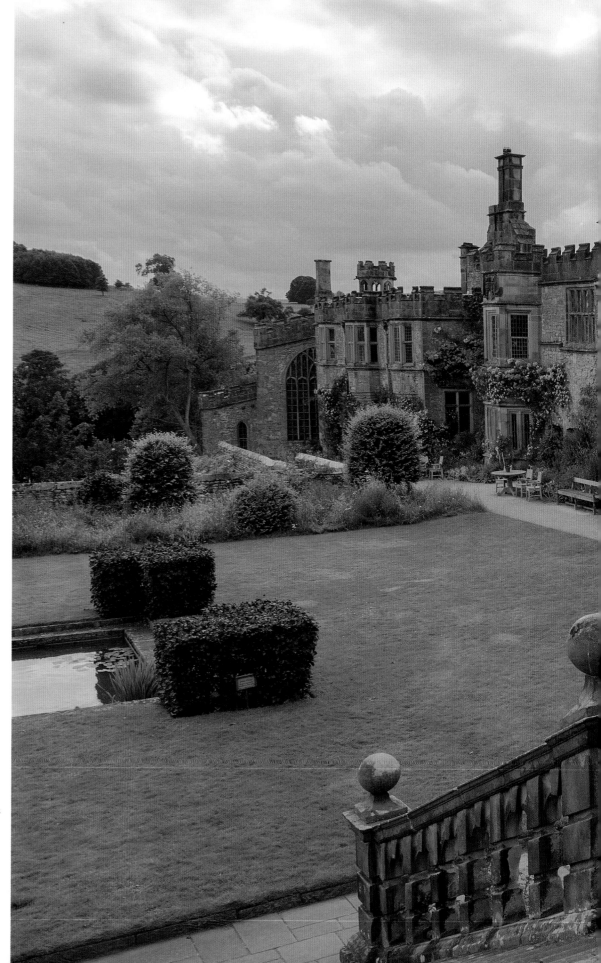

The garden made by Dorothy Vernon
in the 16th century, close to the house.
This is a rare surviving example
of what must have been many such
gardens, swept away by Lancelot
'Capability' Brown's 'improvements'
in the 18th century.

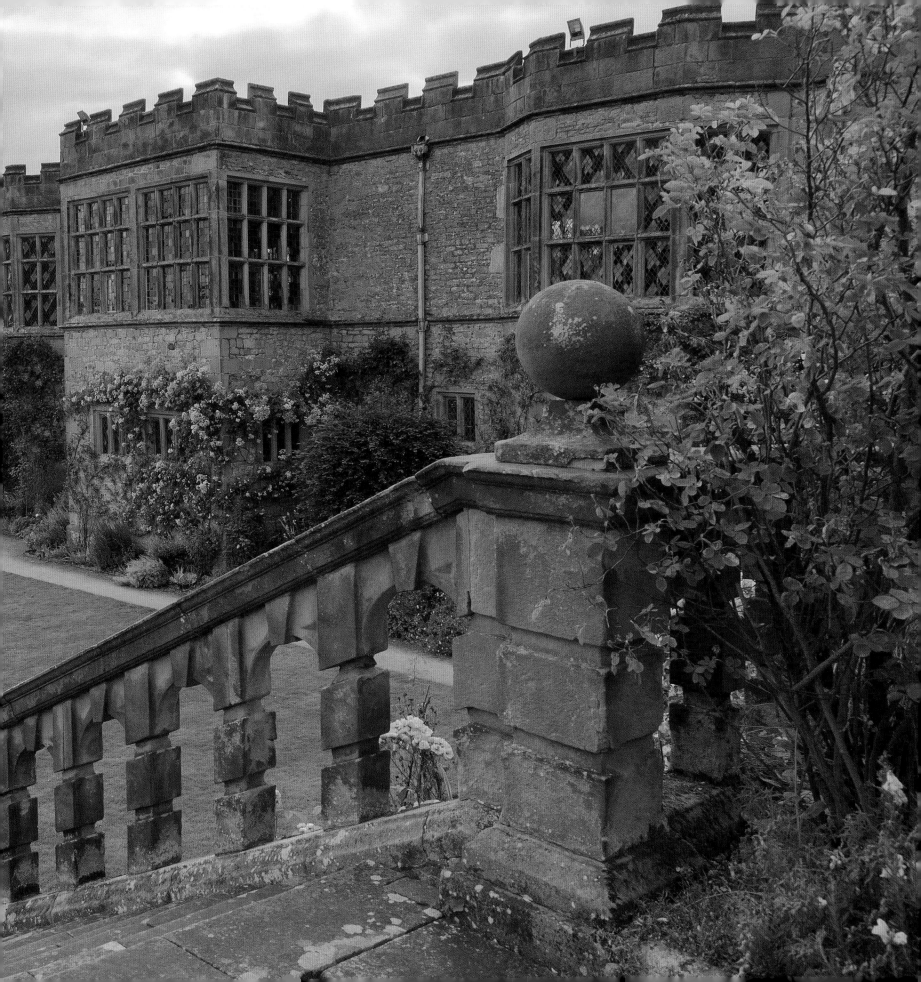

SIXTEENTH & SEVENTEENTH CENTURIES

From Tudor, Elizabethan and Jacobean to Palladian and Baroque

—

In 1501 CATHERINE OF ARAGON made her passage from Spain to Dover, then to London and over the Thames across Old London Bridge, to marry Prince Arthur, the eldest son of King Henry VII. When she arrived in the capital, the Renaissance and Reformation, both of which would change England irrevocably, were still several years away. The sixteenth century would bring significant, albeit gradual changes in the look and character of English domestic architecture, with influences arriving from abroad. Until this point secular architecture was primarily home-grown.

This was the beginning of the age of domestic architecture. The dissolution of the monasteries under Henry VIII impeded the building of churches, and so the increasingly wealthy upper classes instead began to build grand houses. These became a means of displaying status and wealth, as William Harrison noted in his *Description of England* (1577): 'Each one desireth to set his house aloft on the hill, to be seen afar off, and cast forth his beams of stately and curious workmanship into every quarter of the country.'

The first half of the sixteenth century covers the reigns of the first four Tudor monarchs: Henry VII, Henry VIII, Edward IV and Queen Mary. Queen Elizabeth I reigned from 1558 to 1603. During the century, changes in the design and arrangement of houses took place slowly, accelerating and gaining momentum only in future centuries. Most Tudor houses before Queen Elizabeth would have looked a lot like Haddon (pages 14–25), but the Renaissance influences from abroad began at mid-century. The greater feeling of security brought with it a movement away from the medieval arrangement of buildings, which, because of the historic need for defence, had often faced into a series of courtyards. Instead, houses were now built to be outward-looking, with open façades allowing greater ornamentation. The first example is now generally accepted to be the Strand façade of Old Somerset House in London, built in the late 1540s and pulled down in the eighteenth century.

Towards the end of the century, under Queen Elizabeth, more grand houses were started and some then completed in the seventeenth century. Although there was certainly a building boom, the Renaissance was slow to arrive in England. This was largely because of Elizabeth's difficult relationship with Catholic Europe, a circumstance that hindered the free exchange of ideas. As the century marched on, many people altered and improved their houses; as such, interiors of this period often do not reflect the exteriors. Moreover, the stylistic changes between the Elizabethan and Jacobean eras are slight, and buildings of this time can be difficult to date, particularly some smaller houses built during James I's reign.

It was not until Inigo Jones began his work, after about 1600, that any dramatic changes in architecture occurred. His buildings were part of a vast cultural shift that must have seemed extraordinary in such a conservative society, especially after the political and religious upheaval that people had lived through. But during the early part of the seventeenth century Jones was the exception to the rule. His extraordinary knowledge and considered application of classical detail and proportion set him apart from other architects of the time, for whom overblown ornament was still the order of the day.

THE ARCHITECTURE and decorative arts of the seventeenth century in England are not nearly as easily recognised as those of the eighteenth century. It is a period that has since been overshadowed by the Georgian and Regency styles, which were popularised by the golden crescents of Jane Austen's Bath and the rakish Prince Regent, and later romanticised in period dramas in film and on television.

It is often the case that seventeenth-century buildings are mistaken for works of the eighteenth century. During the ten years I worked on the interiors at Chatsworth (pages 59–71), I heard many visitors make this mistake, presuming that the great Baroque house was built a century later than it actually was. William Talman was in fact appointed to remodel the south façade in 1687. A similar error has often been made about some of Sir Christopher Wren's plainer brick houses, with their twelve-pane sash windows. These were such a good formula that they continued in popularity right through the eighteenth century and into the nineteenth.

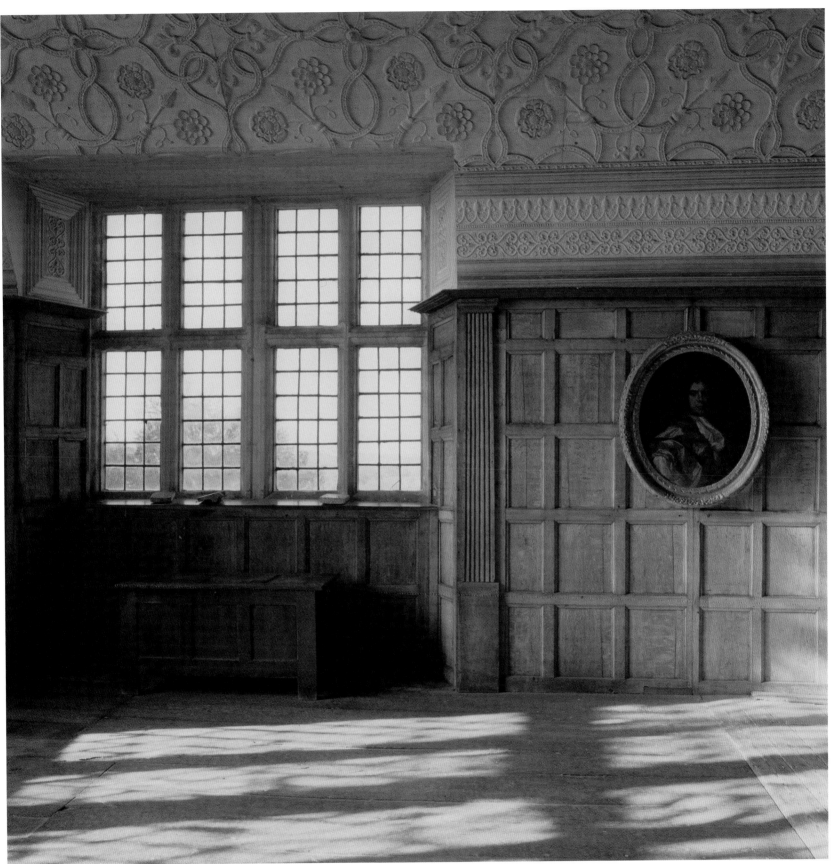

A window embrasure in the Long Gallery at Chastleton House, Oxfordshire (page 33), with moulded plasterwork on the barrel ceiling and dry wood panelling, as at Haddon Hall.

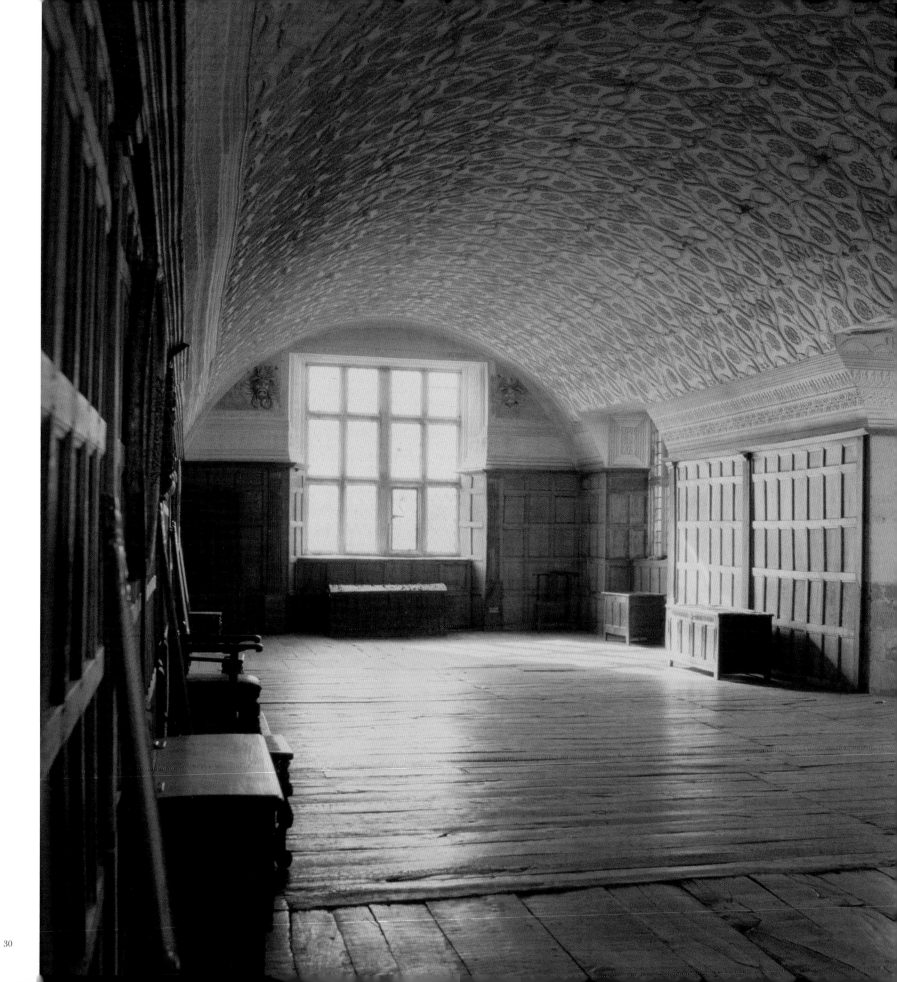

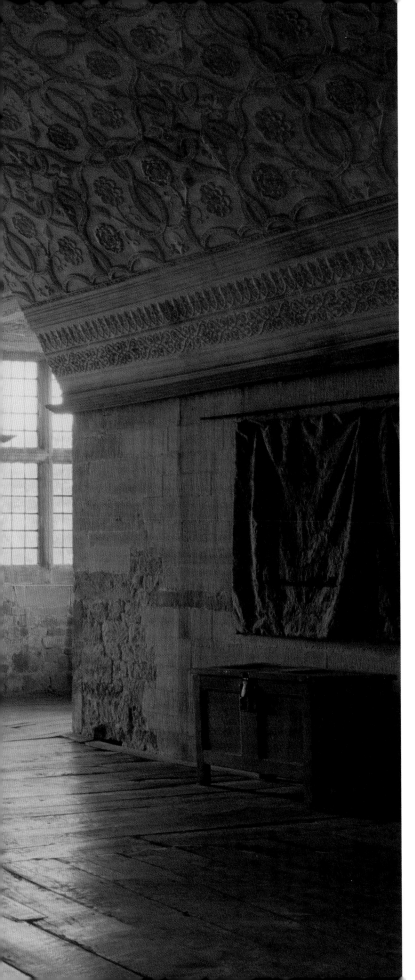

THE SAME CANNOT be said of the change in styling that took place from the sixteenth to the seventeenth century. This was as noticeable as the arrival of the modern in the twentieth century. Both were the result of powerful influences from abroad, and in the seventeenth century this came in the form of a new-found taste for Dutch and French architecture. As we have seen, houses that were square or rectangular in plan superseded the courtyard houses typical of the sixteenth century, and balustrades or parapets that formed straight skylines replaced the irregular gables and pitched roofs that had gone before. The interior of Wilton House (pages 53–57), the first of our seventeenth-century houses, is the best example of this shift. The building was the work of, among others, Inigo Jones, who played such a vital role in the development of English architecture.

There had been signs of what was to come in the prodigy houses of the sixteenth century, but, as Disraeli said shortly before his death, 'England is a very difficult country to move, Mr Hyndman, a very difficult country indeed.' Clearly, it was always thus.

The trial and execution of Charles I in 1649 marked the beginning of the Commonwealth; during this period England and Wales, and later Ireland and Scotland, were ruled as a republic. Although the Commonwealth lasted only a few years, during their brief reign the Puritans ensured that the progression of English aristocratic taste was halted. Not only did Oliver Cromwell's government ban idolatrous art, bear-baiting and morris dancing, but also lack of confidence was such that very few buildings were erected. Three hundred years later, Terence Conran would extol the virtues of 'plain, simple, useful' design – were the Puritans simply exercising an early version of pared-back living?

With the restoration of Charles II in 1660 came an irrepressible yearning for all that was fancy and new, and following the Great Fire of London in 1666, Christopher Wren was given the opportunity of a lifetime. St Paul's Cathedral and the City churches are together one of the greatest sights of the capital. Sir John Vanbrugh and Nicholas Hawksmoor built no less impressively. Buildings were not just appearing in the capital: grand houses again sprang up across the English countryside.

The work of these Baroque architects and their followers changed the architectural landscape of England, and involved commissioning some of the most intricate and beautiful craftsmanship of all historic periods. The stone carving, woodcarving, decorative plasterwork, mural work and ironwork set a standard so high that the next generation simply could not better it.

Despite its splendour, the English Baroque style, which came to glory in the second half of the seventeenth century, was short-lived. Before long it was being mocked by the likes of Lord Burlington, William Kent and Colen Campbell, who, fresh from their Grand Tours, reinstated the canons of Italian taste established by Jones during the first half of the century. The flicker of English flamboyance was swiftly extinguished.

The long gallery continued in English houses until the late 17th century;
this is Chastleton House's. It was nearly always treated in character and use
partly as an outdoor space. In the 18th century some were reworked,
as we shall see for example at Syon House (pages 113–23).

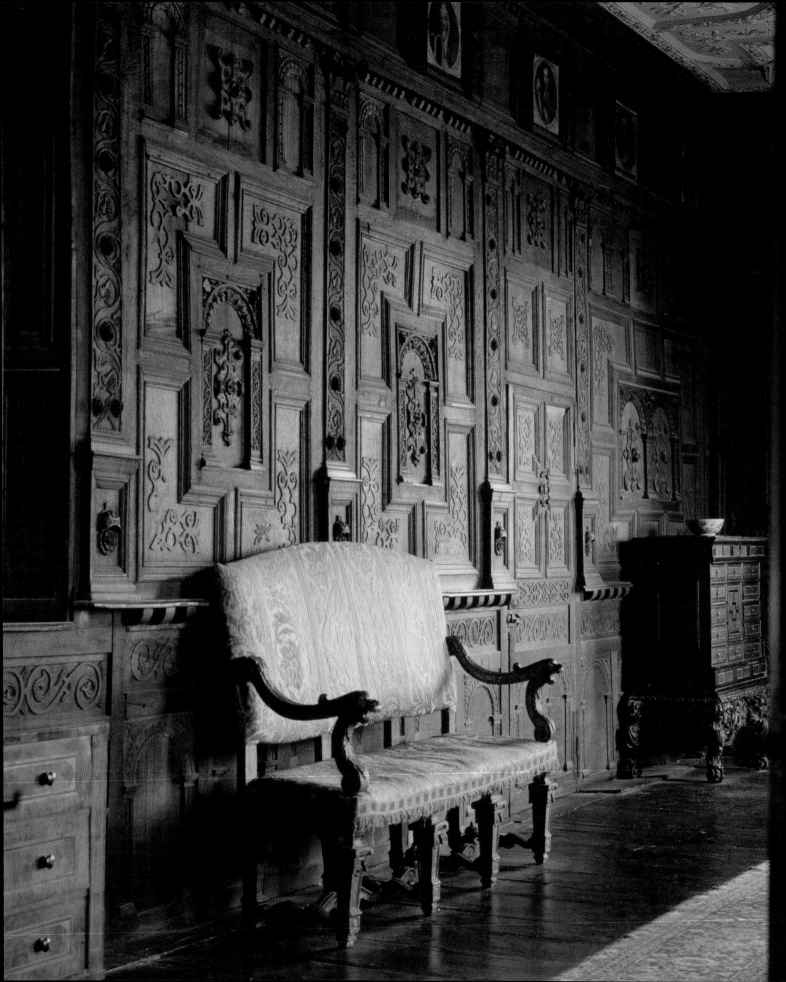

CHASTLETON HOUSE

OXFORDSHIRE

—

A Sensitive Conservation Project

Chastleton house in oxfordshire was built between 1607 and 1612 by Arthur Jones, in an impressive statement of local wealth and authority. The house, which is a remarkable survivor of early seventeenth-century architecture, has an illustrious history. It was built on land bought from the family of Robert Catesby (he of the failed Gunpowder Plot) and was later associated with the Jacobite rebellion and Bonnie Prince Charlie, not to mention being the place where the game of croquet was invented and codified.

The house remained in the same increasingly penniless family until 1991, when it was handed over to the National Trust. However, the lack of money that plagued every generation of the family had fortuitously kept modernisation at bay, and Chastleton has remained something of a time capsule for almost 400 years.

In 1651, during the English Civil War, Jones, a Royalist, bolted home to Chastleton with Cromwell's soldiers hot on his tail. His wife hid him in a secret chamber above the porch, and when his pursuers arrived, she laced their beer with laudanum, allowing her husband to flee once again.

The design of Chastleton is thought to be the brainchild of John Thorpe, a court architect. Unusually for England, the house has never been extended. It is again a courtyard house set between two towers, with a pleasing interplay between the glass windows and Cotswold stone. The front door has been tucked away to the side of the central elevation to create a greater appearance of symmetry. Like many houses of this period, this one is tall, compact and outward-looking. The plain glazed windows denote a hierarchy of the rooms. At the time windowpanes were cut from large sheets, thick at the centre; the glass for the servants' quarters would have been taken from the centre, so you can hardly see out of them. Glass for the grandest rooms was taken from the outside of the sheet, meaning the view out is much clearer.

Although Chastleton was barely touched over the centuries, there have of course been a few small changes. Diaries dating back to the 1840s record the addition of Georgian panels to some of the rooms. Records show that the owners went to the opera in London and the next day went shopping on Oxford Street for antique panelling that was installed at Chastleton. In 1991 the National Trust began work on the house, led by Martin Drury, then historic building secretary, whose order was that his team should 'lay as light a hand as possible on the house' – in other words, conserve rather than restore. Peter Inskip, the architect, achieved this and succeeded in retaining the original character and atmosphere of the house.

With a stroke of luck, Drury caught wind of the fact that many of the contents were up for sale in a local auction house; he went to the sale and managed to buy back a large amount. He ensured that the contents of Chastleton were preserved as they were, so even when the celebrated couturier Hardy Amies, who lived nearby, generously offered some chairs, the Trust refused them because they had no relevance to the house.

The Long Gallery, with its barrel-vaulted ceiling, is particularly impressive. It is the oldest of its kind in the country and, at 72 feet (22 metres), runs the length of the house and is one of the longest. Ornate plasterwork adorns every last inch of the ceiling, patterned with interlocking ribs, daisies and fleurs-de-lis. Photographs from an issue of *Country Life* in 1910 show that at some point the vault collapsed, but it has been carefully reinstated.

In 1919 five notable tapestries were found at Chastleton. Opinions vary, but some suggest that these are the product of the Sheldon Workshop, a tapestry studio set up by William Sheldon in 1570. One of the tapestries is currently on display in the Middle Chamber at Chastleton; another is in the permanent collection of the Victoria and Albert Museum in London.

The survival of this house owes a debt to the love and loyalty of its family, who kept it in spite of their financial difficulties, as well as to those who have looked after it since.

Carved panelling in the Great Chamber at Chastleton House.

KNOLE

A Calendar House in the Garden of England

THE DRIVE THROUGH the beautiful park to the house at Knole is unexpectedly twisting and hilly. Thirty-five minutes by train from Waterloo, it feels in deeper country than one would have thought possible in the twenty-first century. There are ancient trees, patches of bracken and grass cropped short by the resident deer; silver-grey tree trunks left on the ground mark the impact of the great storm of October 1987.

Turn a corner and the house comes into sight. It is built from ragstone, the same shade as the tree trunks, with a stern grisaille elevation and a central gatehouse that leads into the Green Court – the first in a series of enclosed courtyards. Every element is tonally balanced in colour, from the stone elevations to the leaded windows, elaborately decorated lead gutters, downpipes, roof edging and grey-painted woodwork. Even the terracotta roof tiles and brick chimney stacks, both old and restored, are not too bright, and the large oak doors have greyed over time.

In 1456 the Archbishop of Canterbury, Thomas Bourchier, acquired the estate at Knole and began building his new palace. Notably, Knole was unfortified, which would have been unthinkable for a member of the aristocracy; however, a man of the church was in a secure position and could erect a house where fashion not defence dictated design. Knole remained in the ownership of the See of Canterbury until 1538, when Henry VIII, with characteristic cupidity, forced possession of it by gift from Thomas Cranmer. In 1566 Elizabeth I bequeathed Knole to her cousin Thomas Sackville, a poet and a statesman who later became the 1st Earl of Dorset.

Sackville undertook extensive renovations to the house, and was largely responsible for turning Knole into the place we see today. He wanted a home fit for a courtier, and as Lord High Treasurer to James I, he remodelled the staterooms significantly in anticipation of a visit from the king. As so often after such planning, the king failed to come. In the seventeenth century the 6th Earl made similar preparations and added three state beds, lavish tapestries, textiles and Royal Stuart furniture, so that William III would be suitably impressed, were he to visit. Up and down the country, the aristocracy was frantically installing rooms in preparation for royal visits, only some of which took place.

Knole is built around seven courtyards. Collegiate and monastic buildings often made use of such inward-looking sanctuaries, and for the proprietors of private houses the addition of a courtyard was a simple way of enlarging one's home. The story goes that Knole is a 'calendar house', with 12 entrances, 52 staircases (although this number has been reduced by internal renovations) and 365 rooms (depending on how you count).

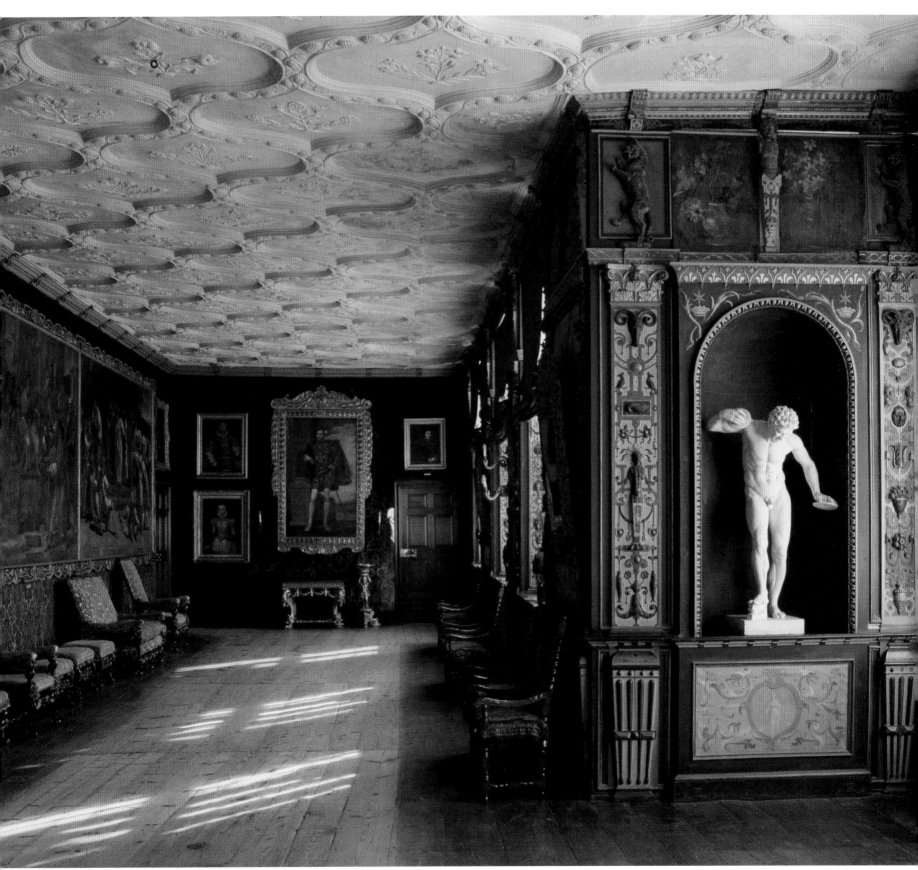

The Cartoon Gallery at Knole is the third of the long galleries on the first floor. It is named after the six large copies of the Raphael cartoons, once housed here, now in the Victoria and Albert Museum in London. All the furniture, pictures, sculpture and surface decoration are equally rich.

35

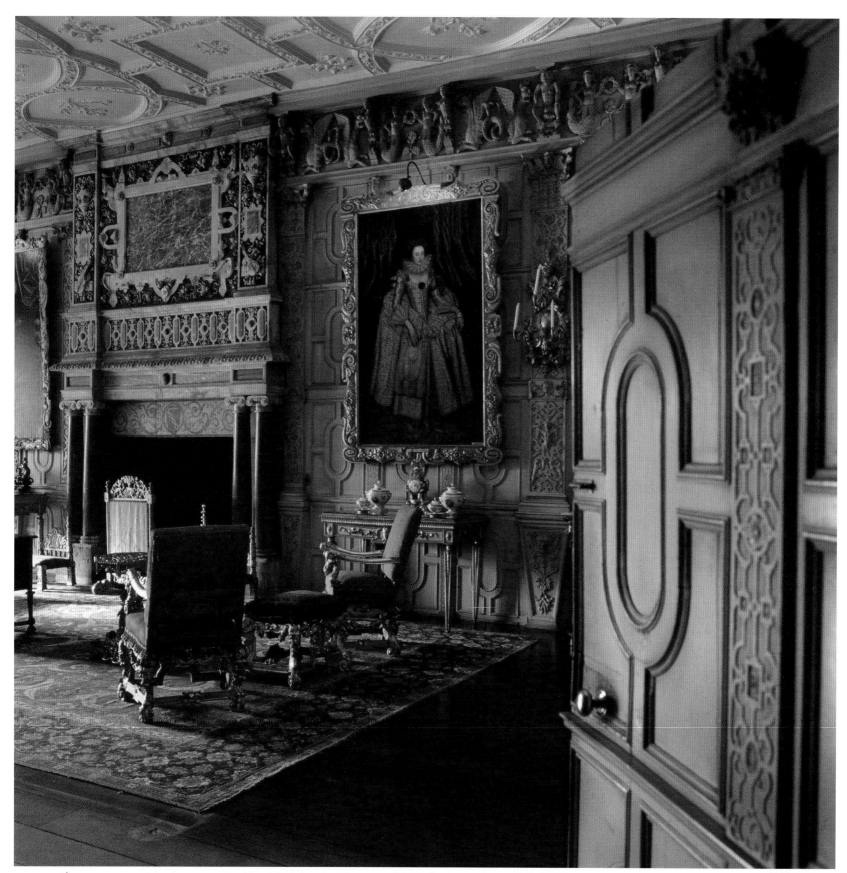

ABOVE *The 17th-century chimney piece was made for the 'With drawing Chamber at Knoll'. The stone-coloured painted panelling is from the early 18th century, when the room was called 'ye great Dining Roome'. It was later enriched with the existing furniture and pictures, and became the Ballroom.* OPPOSITE *The entrance to the Ballroom from the top of the Great Staircase.*

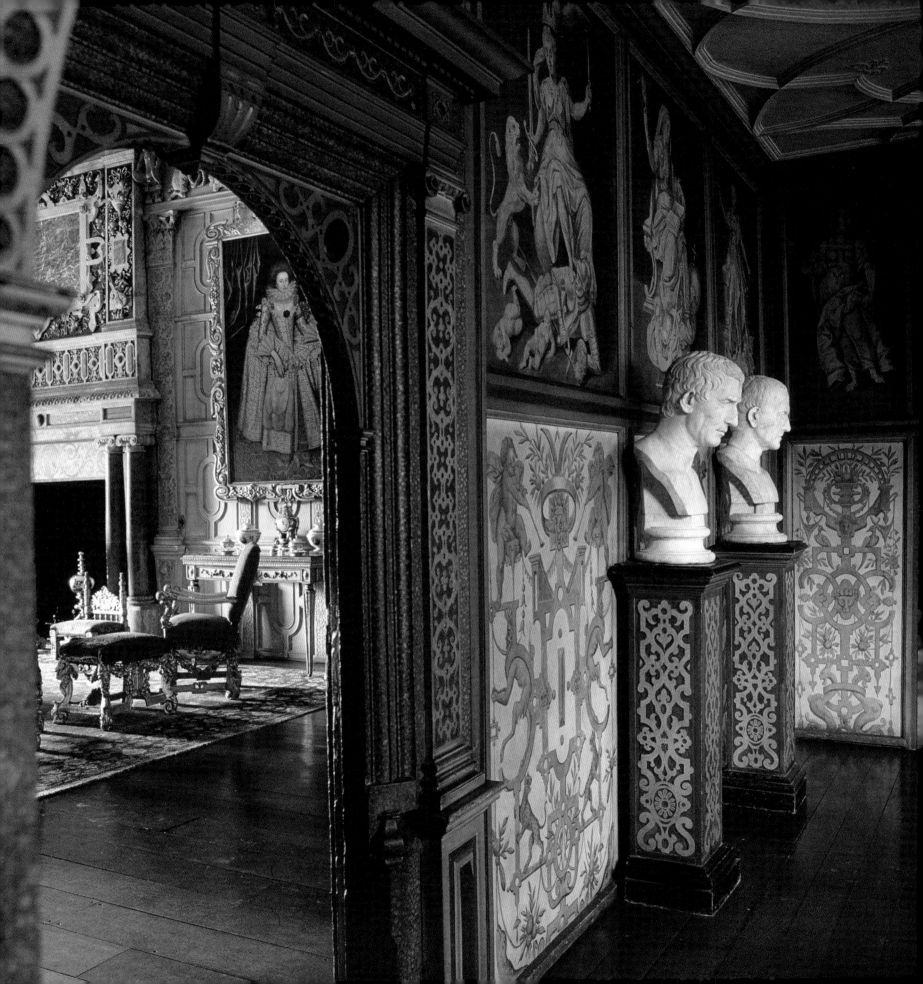

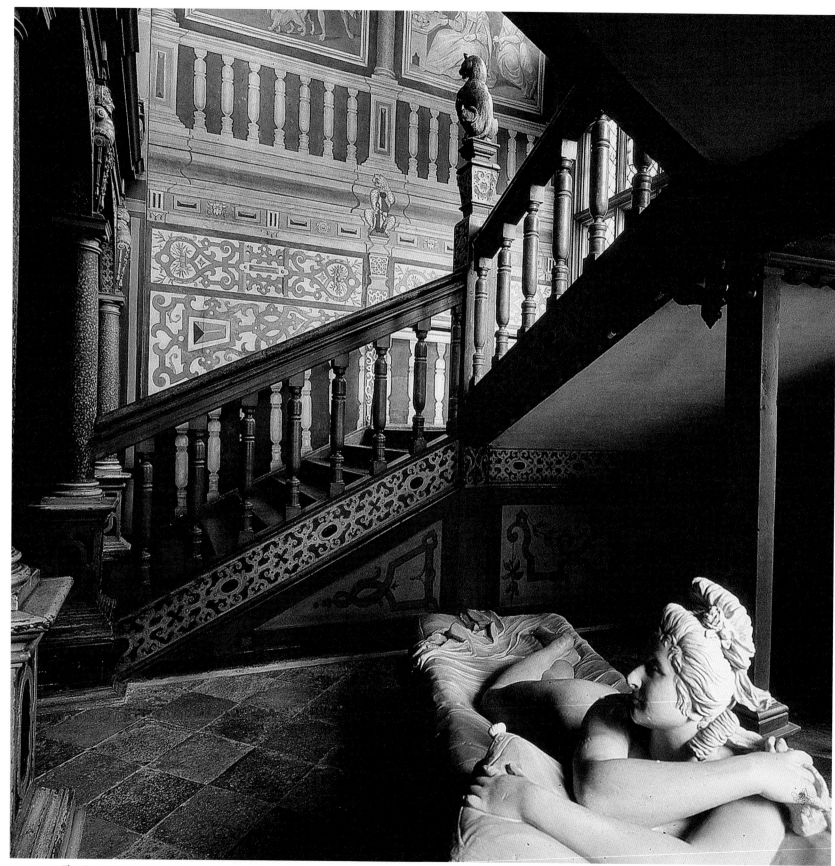

The Great Staircase is the principal way from the Great Hall to the State Apartment on the first floor. The three orders of architecture rise from Doric on the ground floor through Ionic to Corinthian above. The walls are entirely painted in grisaille representing the stages of human life.

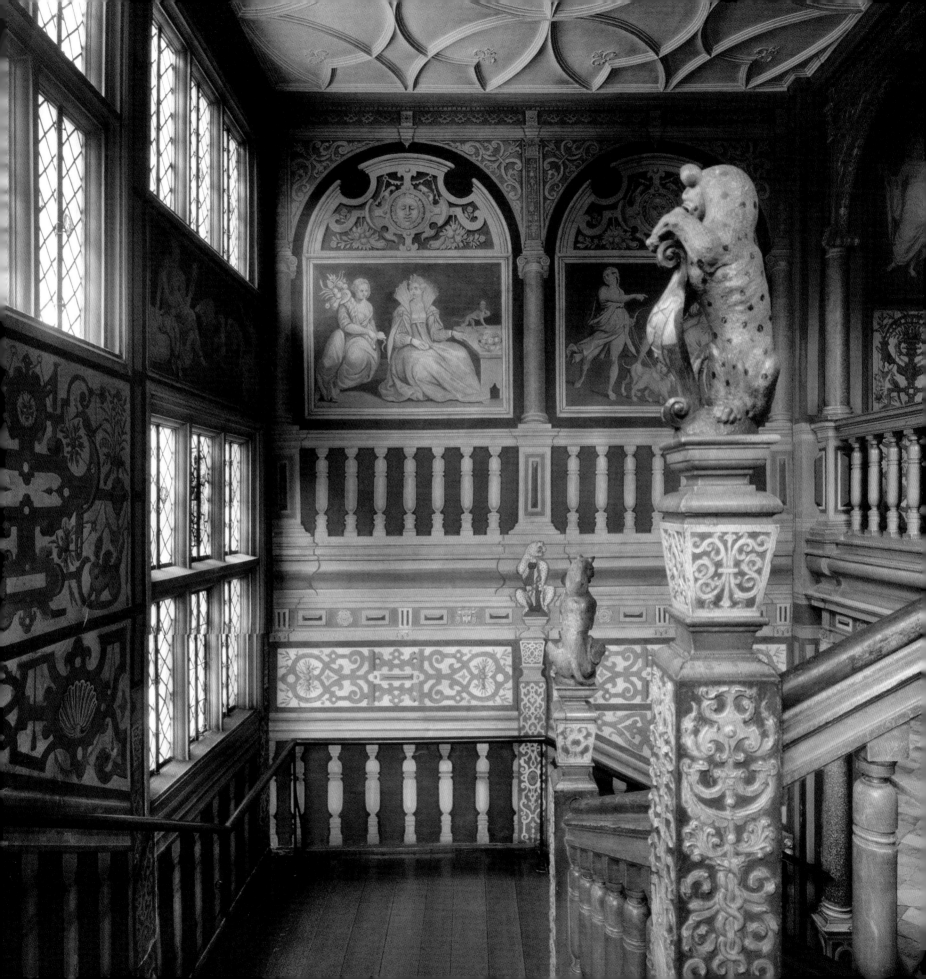

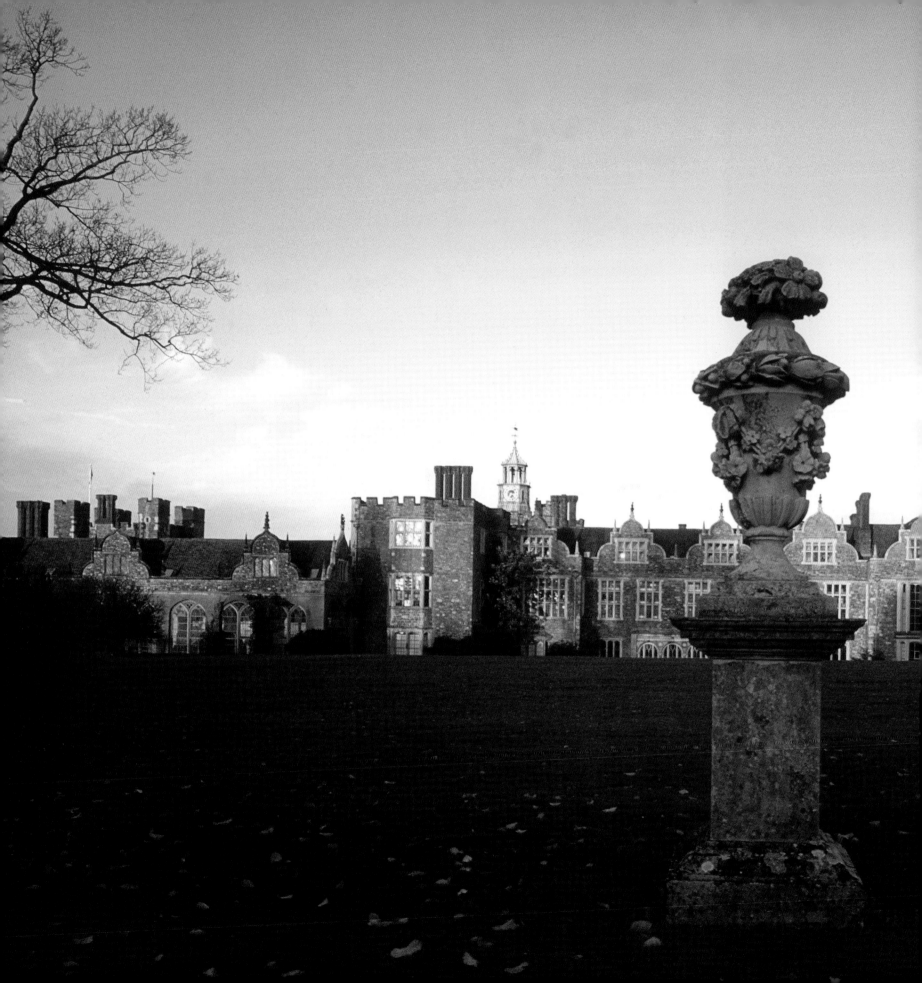

Beyond the green court is the smaller Stone Court, which leads to a colonnaded gallery. Here there are mounted antlers, including a pair of prehistoric elk horns; marble busts, bought by the 3rd Duke during his Grand Tour; and black-painted settles. The effect is harmonious and shows great restraint on the part of the National Trust, which acquired the house in 1946. Pass through the gallery and you arrive at the Great Hall, a medieval, high-ceilinged room that would once have been the centre of the house. The hall leads to the main staircase, which was entirely remodelled by the 1st Earl between 1605 and 1608 with elaborate carving, grisaille decoration and early examples of *trompe l'œil*. The heraldic Sackville leopard seated on a newel post is a repeated motif throughout. There are dashes of colour, but the surfaces are primarily monochromatic; historically, earth colours were less costly than bright hues and so would be favoured for rooms of secondary importance, or used as backgrounds. The Great Staircase played a vital role in the formal procession of the family and their guests from the Great Hall to the staterooms on the first floor.

The upper landing of the Great Staircase leads to the Ballroom, the first room in the state apartment, which was partly the work of Archbishop Bourchier. The panelling was installed during the remodelling of Knole, as was the plasterwork ceiling by Richard Dungan and the elaborate carving by William Portington. In every room, all is colour and luxury, the walls are hung with paintings and tapestries, and there are extraordinary examples of furniture and objects made from fine materials or embellished with rare finishes, from marble and gold leaf to silver, lacquer, marquetry and tortoiseshell. In contrast, the windowsills are made from lead, which has the effect of bringing the outside in. The complicated Renaissance chimney pieces and overmantels are carved from alabaster and black, white and grey marbles. They stand the height of the room and have strangely large but shallow fire openings, presumably to 'draw' the smoke. With the exception of a few objects, everything is over-scaled, particularly when compared to the refinement of what came later in the story of the English decorative arts. All the rooms in the state apartment and their contents spell out the pride and power of the succession of owners.

Vita Sackville-West, one of Knole's most famous residents, wrote that the house 'has a deep inward gaiety of some very old woman who has always been beautiful, who has had many lovers, and seen many generations come and go'.

The west elevation of Knole.

HATFIELD HOUSE
HERTFORDSHIRE

A Jacobean Political Powerhouse

I n 1611 ROBERT CECIL, 1st Earl of Salisbury, completed his grand new Jacobean house adjacent to the site of the Old Palace of Hatfield. Small in stature and notoriously sickly, Cecil was exceptionally influential; he played a central role in English politics, ensuring that James I peacefully inherited the throne on the death of Elizabeth I, and thwarting the Gunpowder Plot of 1605. Hatfield took four years to build, and has remained in the Cecil family for more than four centuries. The house was later home to another key political figure, Robert Gascoyne-Cecil, 3rd Marquess of Salisbury, who was twice prime minister and Queen Victoria's most trusted friend.

The 1st Earl was integral to the authorship of the design, but Robert Lyminge was the professional architect, with Inigo Jones playing a part. The house was built in the tradition of the Elizabethan E-plan from brick with stone accents, as was common in the eastern counties. Where the entrance façade is stern and foreboding, the south garden façade is Italianate in style and a little less severe. Hatfield is surrounded by a beautiful garden, which dates from the early seventeenth century, when Cecil employed John Tradescant the Elder to collect plants for his new house. The garden is surrounded by parkland on three sides and the town of Hatfield on the fourth.

The Long Gallery, looking east. The fireplaces are marbled wood; the ceiling is 19th-century gilding. The punctuation of the placing of the furniture responds to the architecture. By the time of its construction the purpose of the English long gallery was changing from exercise area to domestic room.

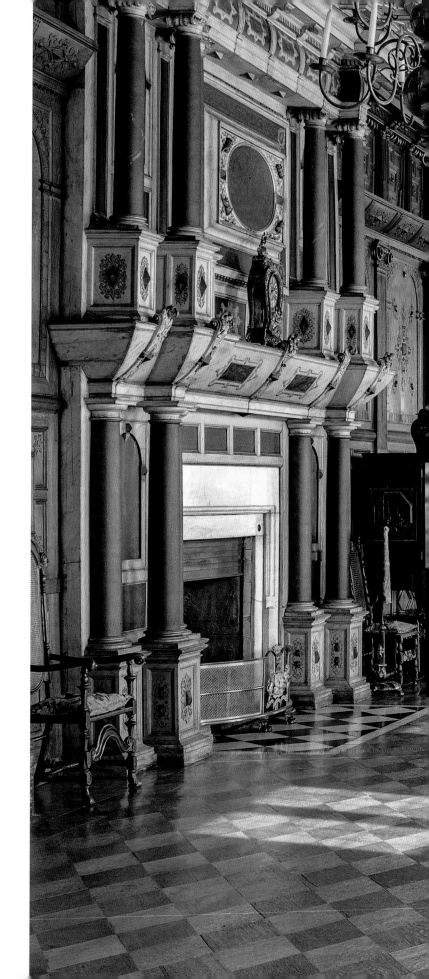

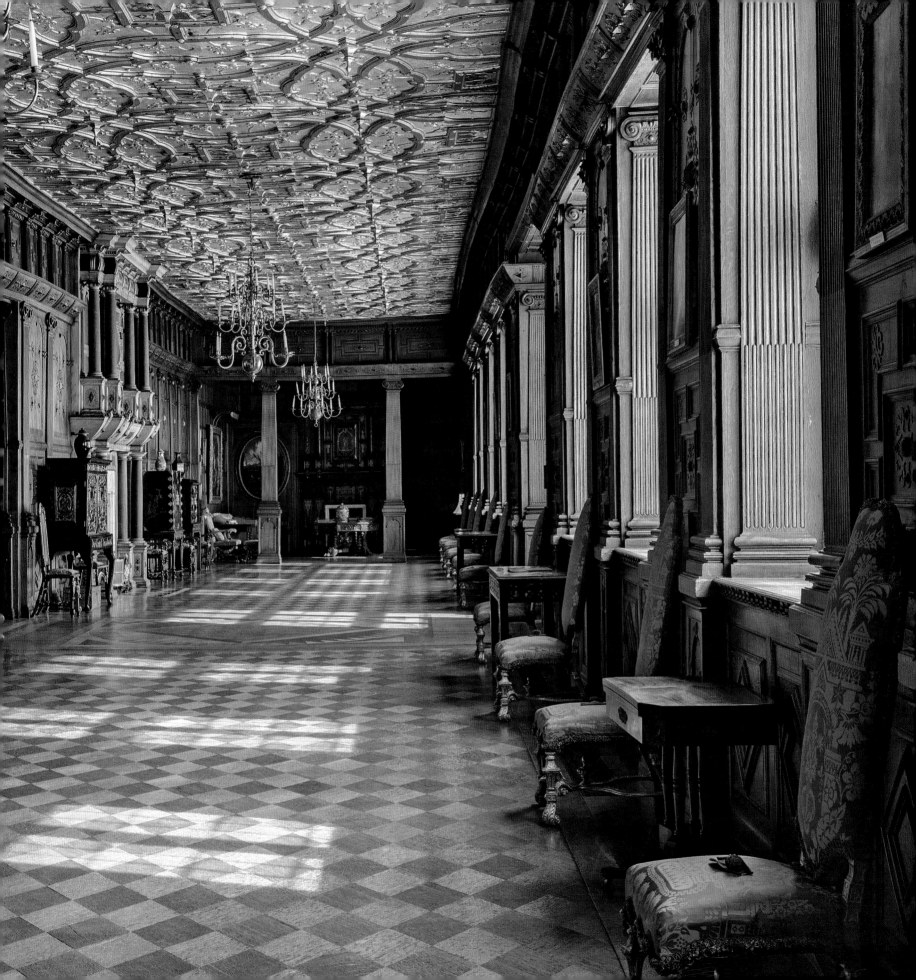

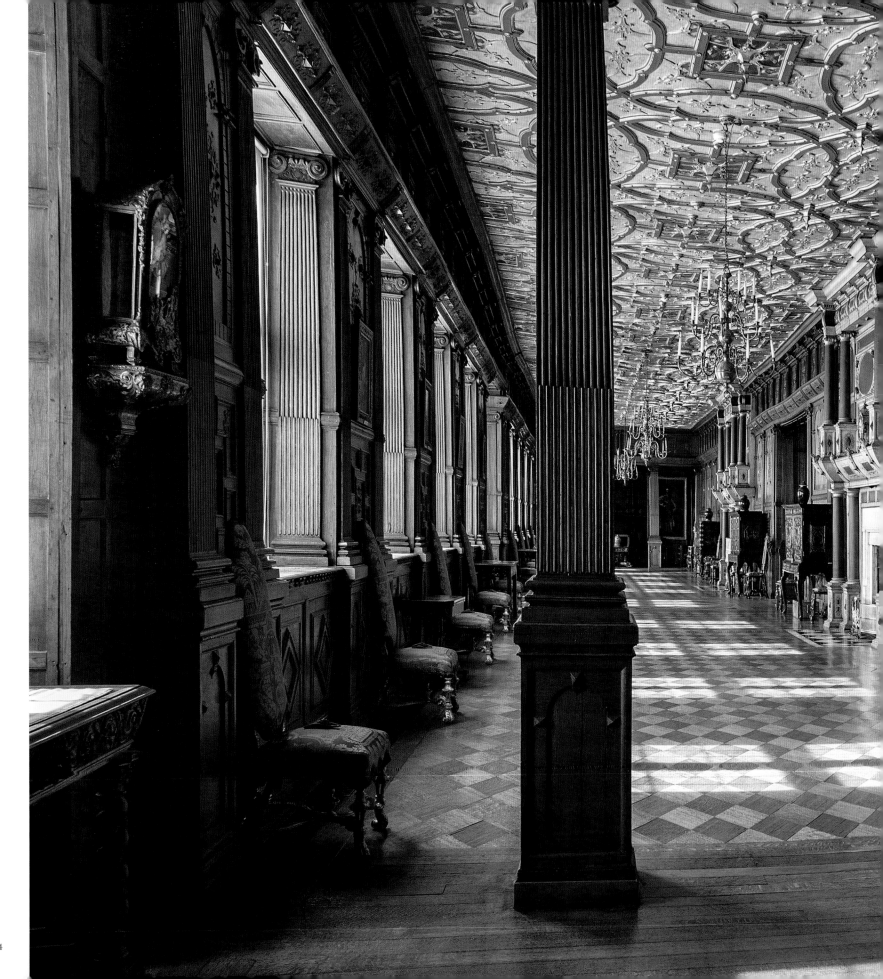

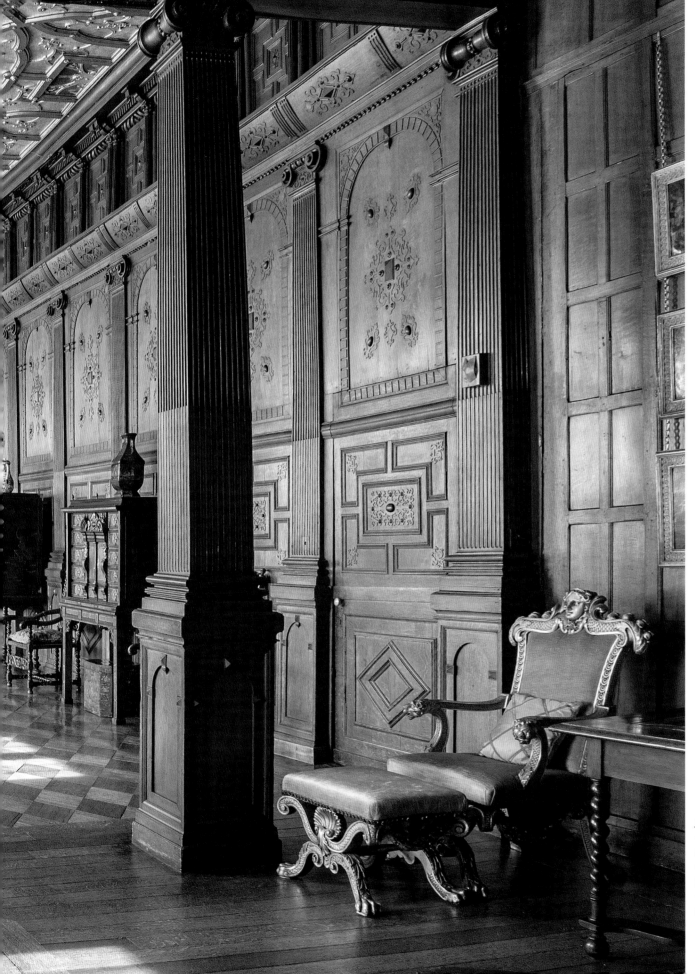

The Long Gallery, looking west from King James's Drawing Room. Because Lord Curzon's favourite great house was Hatfield, and since he wanted and expected to be prime minister, he took a lease on Montacute in Somerset, another great Jacobean house.

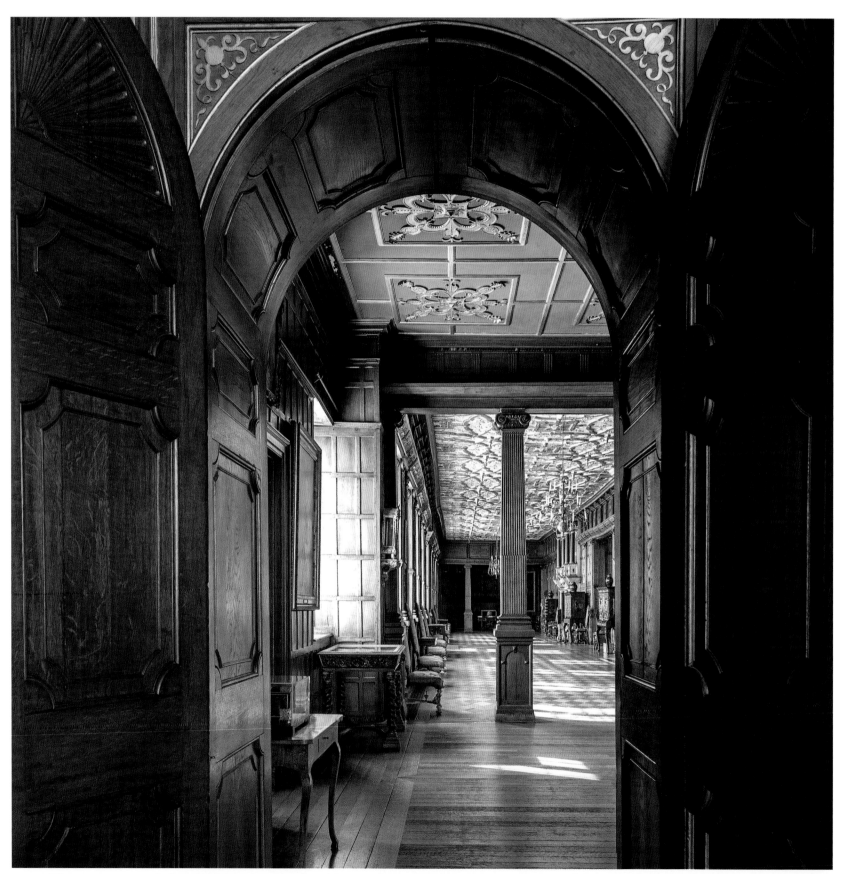

ABOVE *The eastern entrance to the Long Gallery.* OPPOSITE *King James's Drawing Room, where the pictures hang on tapestries. The whole is a display of culture, riches, power and prestige.*

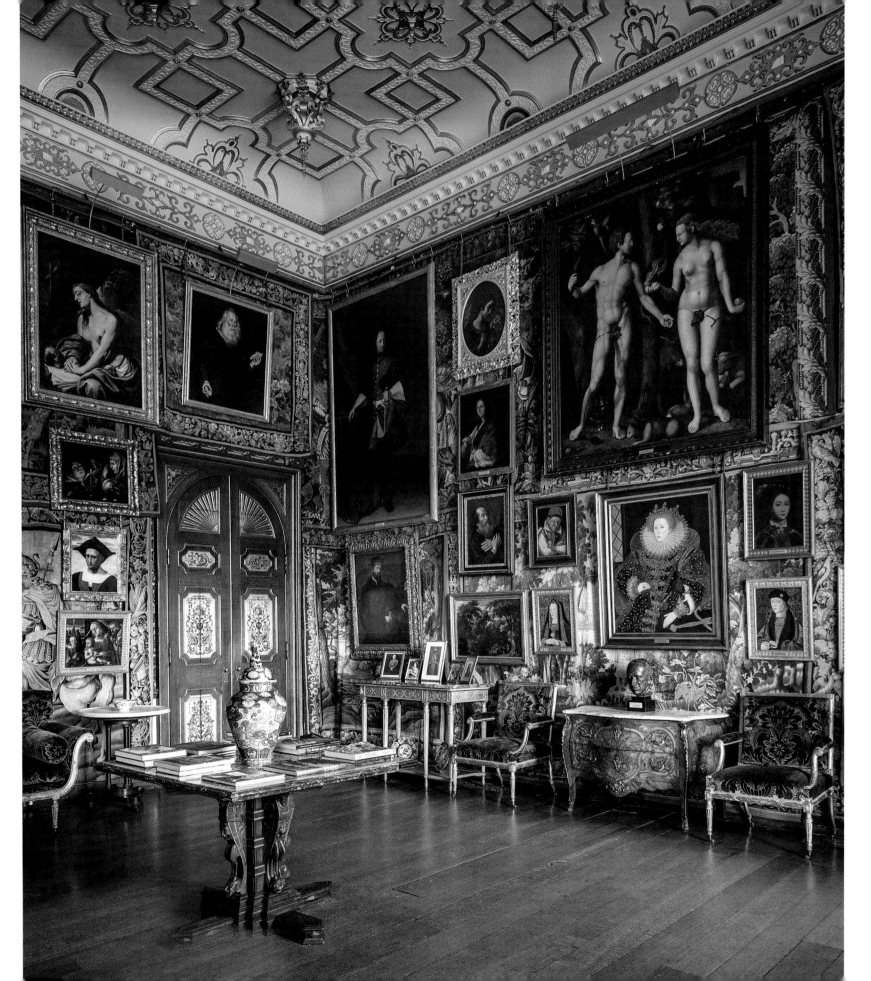

THE JACOBEAN INTERIOR remains largely unchanged; work has been done over the centuries, but Hatfield is a fine example of layering. Any alterations that have been made were done sympathetically and with respect for what was there before. In 1835 a fire took the life of the 1st Marchioness of Salisbury and destroyed the west wing of the house. Despite the fact that fire engines had to travel from as far away as London, the damage was mitigated when the intense heat melted lead water tanks in the attics, helping to douse the flames.

A watercolour depicting a banquet given for Queen Victoria in 1846 shows the Marble Hall – a room that looks much the same now as it did when it was first built, evidence that Hatfield did not suffer from passing fads and fashions. Major renovations have been necessary during the present century, but there is no sign of any disruption.

A long gallery was a central feature in every grand Jacobean house. This one runs the entire length of the south front and is the second longest in England – outdone only by the Long Gallery at Montacute House in Somerset. What appear to be two marble chimney pieces and overmantels are in fact carved from wood and painted to imitate marble. In 1781 the party walls at each end of Hatfield's Long Gallery were removed and the room was made even longer, with a pair of columns added for structural support. The gallery now stretches 170 feet (52 metres). In 1846 the 2nd Marquess gilded the ceiling in anticipation of a visit by Queen Victoria; he had seen similar gold embellishments while visiting Venice, and gilding the once white ceiling was a bold decorative move. Apart from these two alterations, the gallery remains the same as when it was built.

The ceiling of the Grand Staircase was also decorated for Queen Victoria's visit, and was recently restored by the present Marchioness, its red-painted walls providing a striking background for the tapestries and furniture. The elaborate staircase dates from 1611 and demonstrates some of the finest carving of its time. The eagle-eyed might spot a carving on one of the newel posts showing the figure of a gardener holding a rake. This is thought to be John Tradescant, whom Robert Cecil sent abroad to find exotic plants for his new garden at Hatfield.

ABOVE *A cherub on the first-floor landing of the Grand Staircase.*
OPPOSITE *Tapestries and carvings of cherubs and heraldic beasts on the Grand Staircase, with red walls and a brown-and-gold ceiling.*

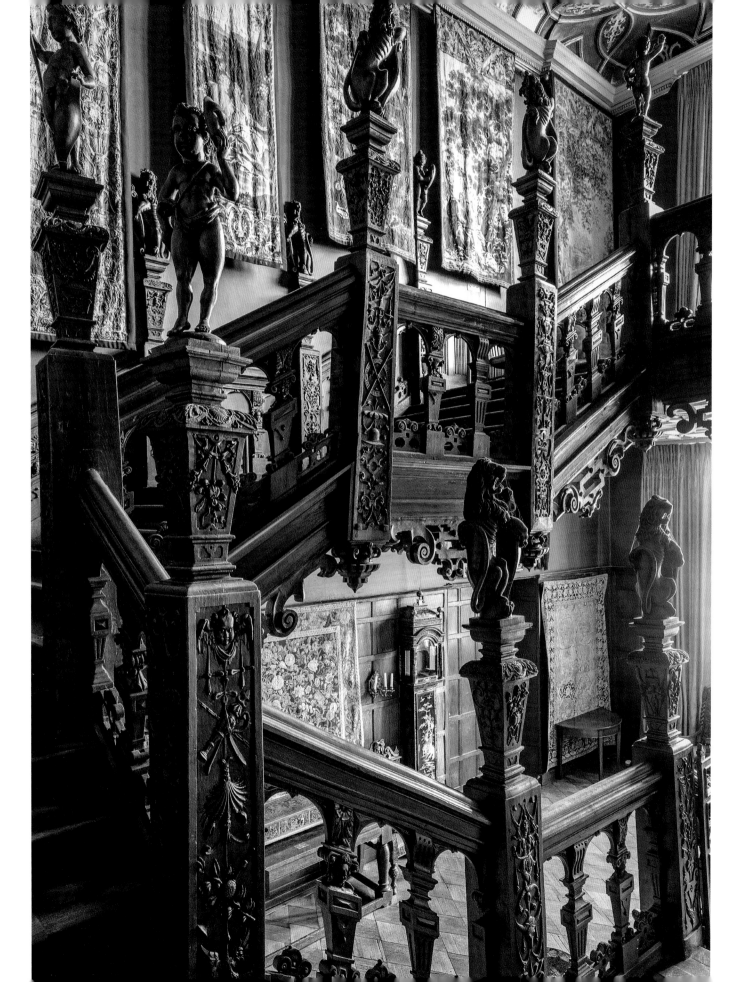

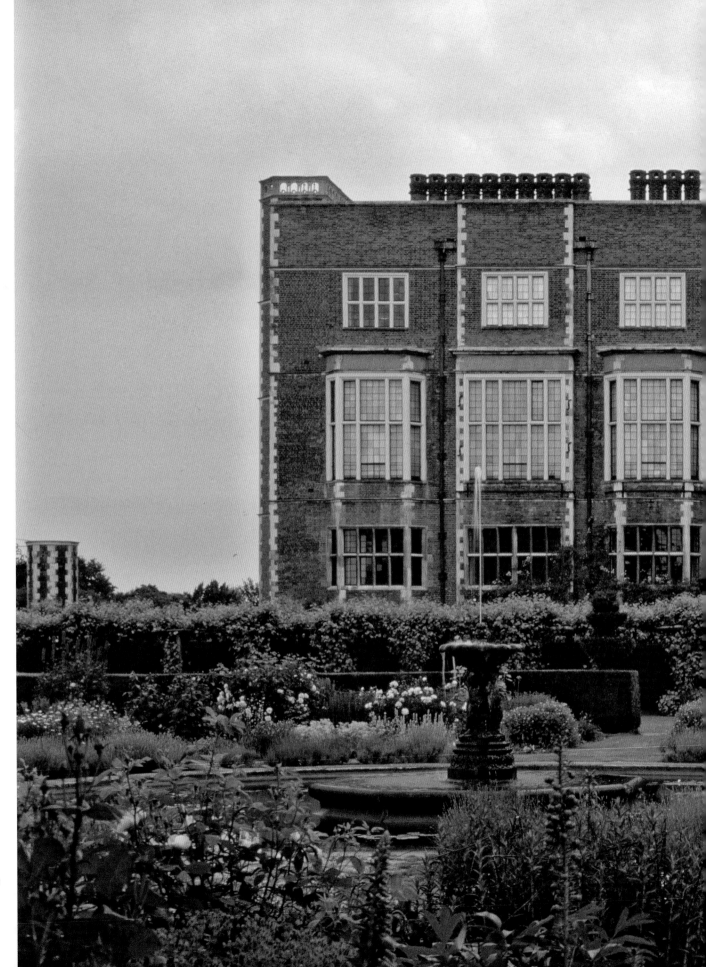

The east front of Hatfield House, from the garden created by the late Lady Salisbury. The north and south fronts face parkland.

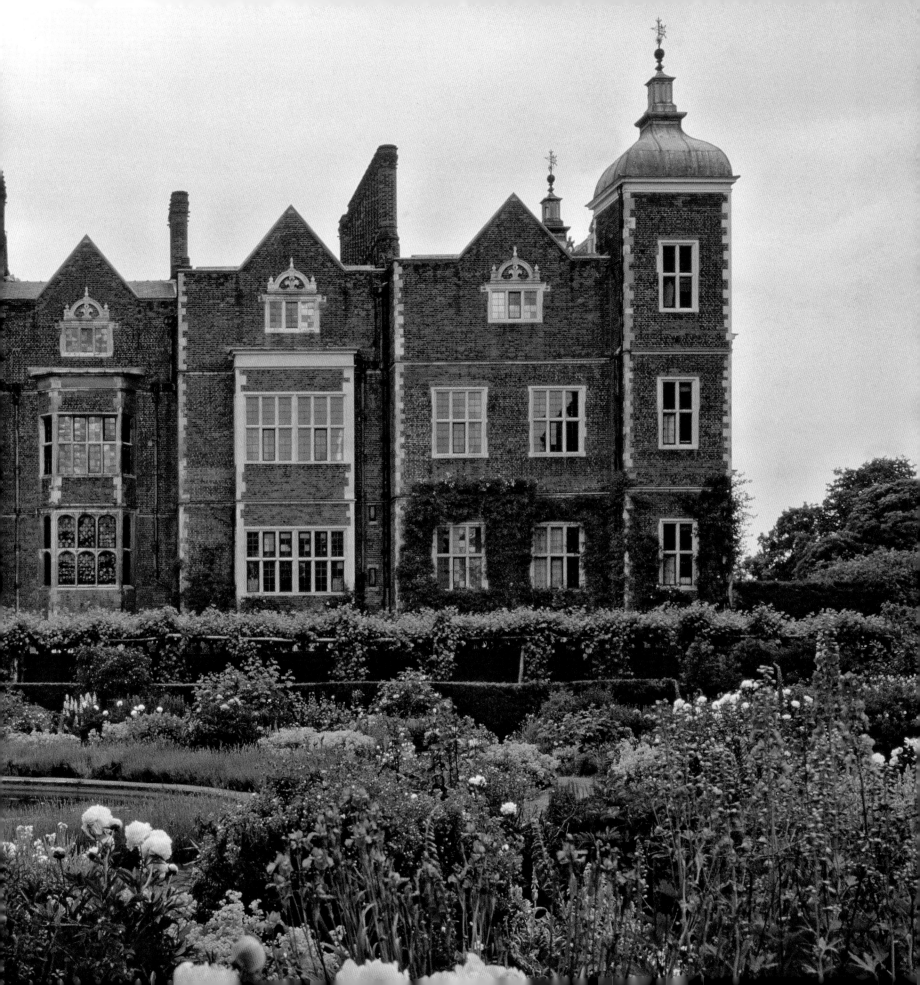

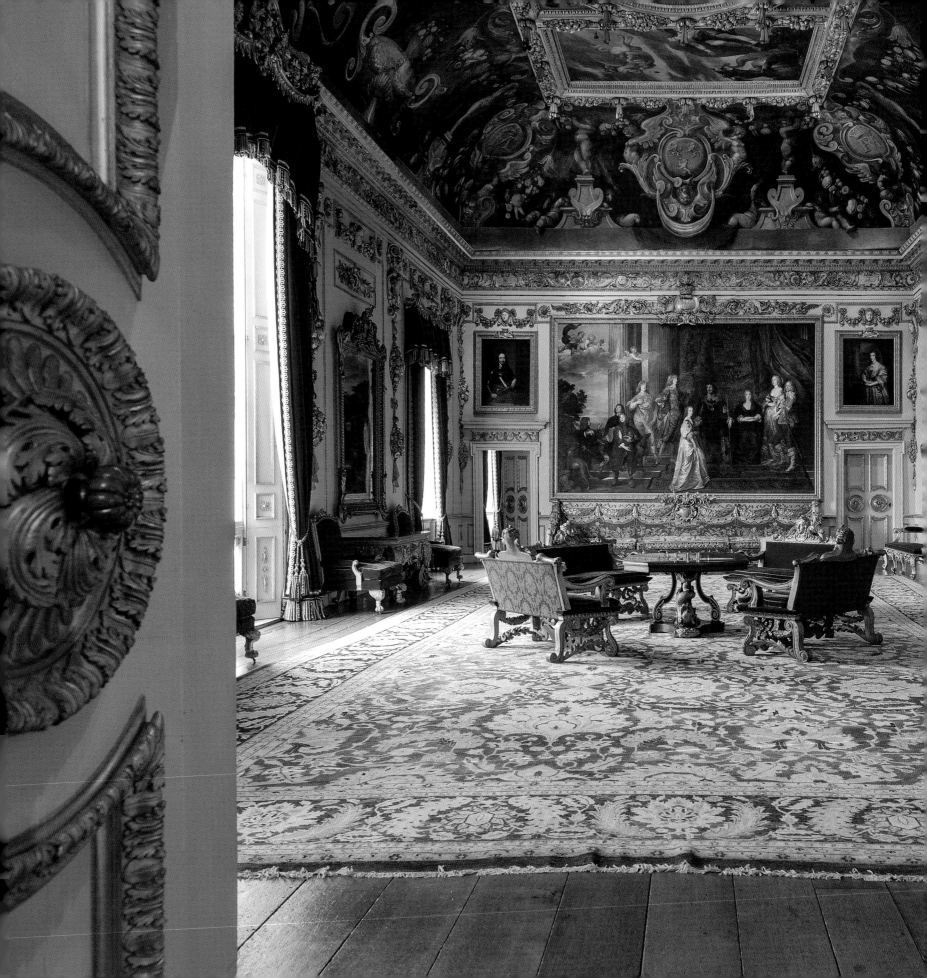

WILTON HOUSE
WILTSHIRE

—

The Double Cube Room

Wⁱˡᵗᵒⁿ ᴴᴼᵁˢᴱ ⁿᴱᵃᴿ Salisbury is a near-perfect example of different historic architectural styles working in harmony. It demonstrates the English penchant for adding to a building rather than simply starting again, which was more often the European way. Wilton House was passed down from generation to generation, so family pride and nostalgia have played an important part in its evolution and a reluctance to demolish it and rebuild. As the Italian historian Claudio Magris astutely observed, 'the past has a future, something it becomes and that transforms it.'

In March 1539, during the dissolution of the monasteries, Henry VIII seized Wilton Abbey and gave it and its attached estates to William Herbert, 1st Earl of Pembroke – a shrewd courtier and favourite of the king. Herbert immediately began work transforming the abbey into a fine house built around a central courtyard. It was previously thought that he consulted the court painter Hans Holbein the Younger about his new house, but there is little evidence to prove that. Whoever the architect, the surviving entrance tower remains at the centre of the east façade, flanked by two seventeenth-century wings.

The Tudor house survived for 80 years, until the succession of the 4th Earl in 1630. He pulled down the southern wing and erected a new complex of staterooms in its place. The result is a magnificent Palladian design. The authorship of this façade and the seven staterooms behind it is complicated, but most probably involves a combined effort, with Inigo Jones advising and delegating to Isaac de Caus (or Caux), a French garden designer already working at Wilton, and Jones's nephew by marriage John Webb.

Jones was busy completing the Queen's House at Greenwich for Charles I's queen, Henrietta Maria (it was started for James I's queen, Anne of Denmark). That is why it has been suggested that he provided only a few sketches for the design of the south façade and rooms at Wilton. However, it is thought by some that the 3rd Earl of Pembroke paid for some of Jones's journey to Italy, where he studied the architecture of Andrea Palladio, in which case he may have felt a certain loyalty to the house and its occupants.

The Double Cube Room at Wilton House, one of the greatest of the great rooms of parade in England. The amount of gilding, the very large portrait by Anthony Van Dyck of the Pembroke family, and the red velvet upholstery are powerful enough to balance the strong colours of the deep, painted cove and ceiling.

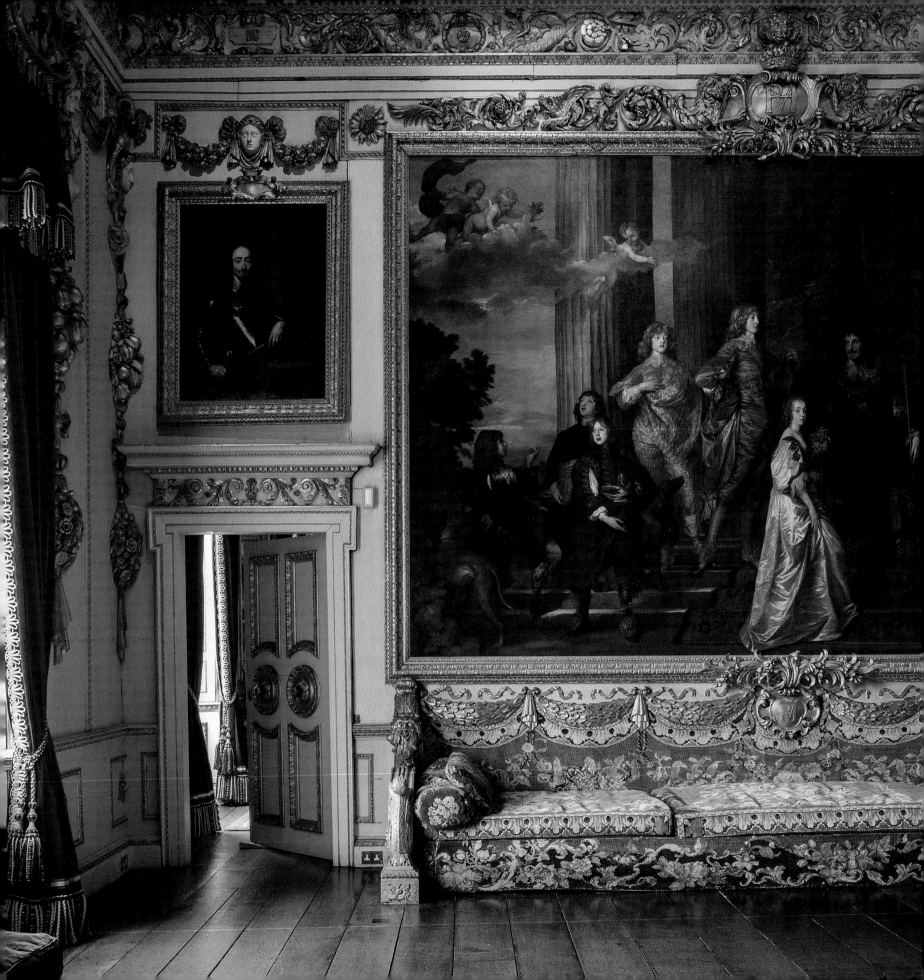

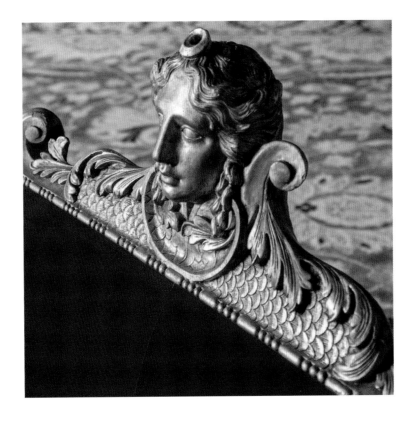

REGARDLESS OF ITS AUTHORSHIP, the south elevation as we see it today is only half of what was planned. The façade was intended to have been repeated, with a large Corinthian portico between the two halves. As it stands today, the staterooms are on the *piano nobile* above a low ground floor, and the roofline is invisible behind a parapet and balustrade, as at the Queen's House.

Soon after completion, in 1647, the new south wing was ravaged by fire. Jones returned to Wilton, accompanied by Webb, and together the pair worked on the interiors of the staterooms. The grandest of them all is the Double Cube Room, which was flanked by a symmetrical but incomplete sequence of withdrawing rooms, state bedrooms and closets.

The Double Cube is 60 feet (18 metres) long, 30 feet (9 metres) wide and 30 feet high. The walls are lined with wood panelling, painted white and gilded; both gold leaf and a truly white pigment would have been difficult to procure and therefore very expensive. Carved garlands of fruit, classical masks, gilded encrustations and swags hang from walls and ceiling. Consider the contrast between this room and the homes of most people at the time. Its magnificence cannot be underestimated.

Thomas de Critz painted the central rectangle of the coved ceiling with the story of Perseus, and its rich tonal palette is complemented by Van Dyck's enormous portrait of Philip Herbert, 4th Earl of Pembroke, and his family. This was the largest painting ever made by the artist. Smaller portraits, also by Van Dyck, depict Charles I, his wife, his children and other members of the Herbert family.

Honey-coloured English oak floorboards and red velvet upholstery contribute to the dramatic impact of the room. The red silk-velvet curtains at the large windows are based on a nineteenth-century design by Westmacott, which was discovered in the archives when I began work on the house in 2011. The furniture is mostly by William Kent, and although it would have been added in the eighteenth century, it is in keeping with the original scheme. The pier glasses between the windows are by Chippendale.

In design terms, this is one of the most complicated yet most successful rooms in England. One barely notices that the great Venetian window and the fireplace opposite are off-centre to each other. Is this caused by the need to connect to a Tudor flue? Is it a mistake in the setting-out drawing? Either way, the bravura of the decoration is such that the imbalance doesn't show in the way it might have done in a strictly neoclassical room of the eighteenth century.

To the west of the Double Cube Room is the Single Cube Room, which is as fine but slightly less elaborate. To the east is the large anteroom. This was originally a staircase, with walls and ceiling possibly painted by de Critz; it would once have been the main way into the state apartment and the Double Cube, hence the double doors on this elevation and the grandeur of their casing. The sense of occasion as one arrived from the painted staircase into the white-and-gold stateroom with the Van Dyck paintings and red and gold furniture can only be imagined. However, it is only a little less impressive now entering from the plainer large anteroom.

OPPOSITE *A corner of the Double Cube Room at Wilton House, leading into the Single Cube Room. The design of the red silk-velvet curtains, with tassels, braids and fringes in yellow and red, in both rooms is based on a drawing by Westmacott in the archive at Wilton. The painting is by Anthony Van Dyck.*
ABOVE *A detail of the gilded carving and red velvet upholstery.*

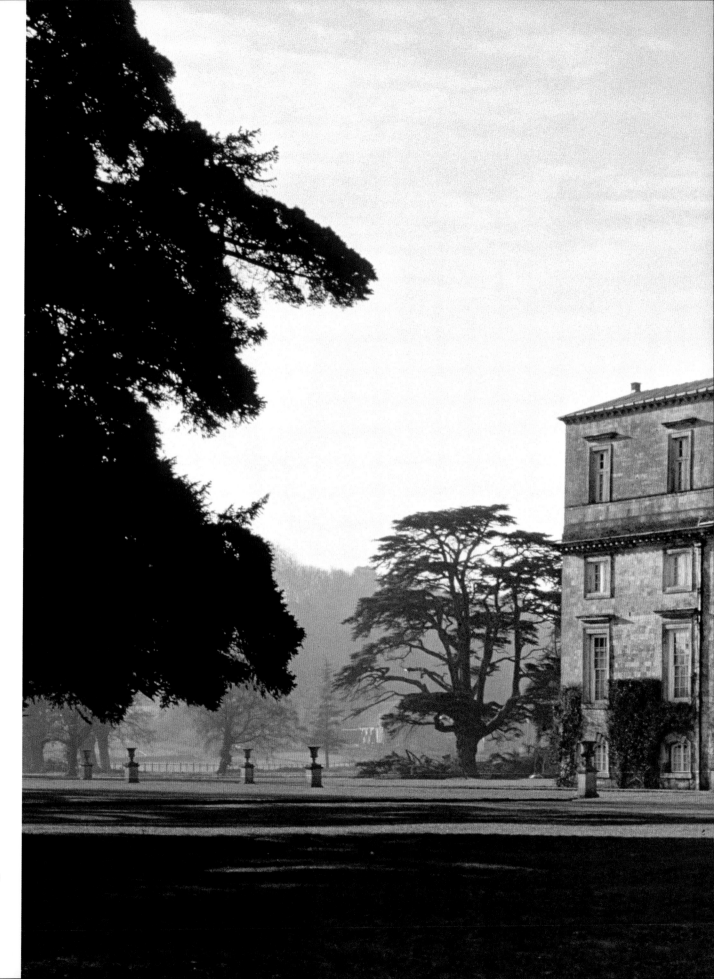

The east front of Wilton House. The central part is earlier, but the architecture of the different periods is unified by the symmetry and the use of similar stone.

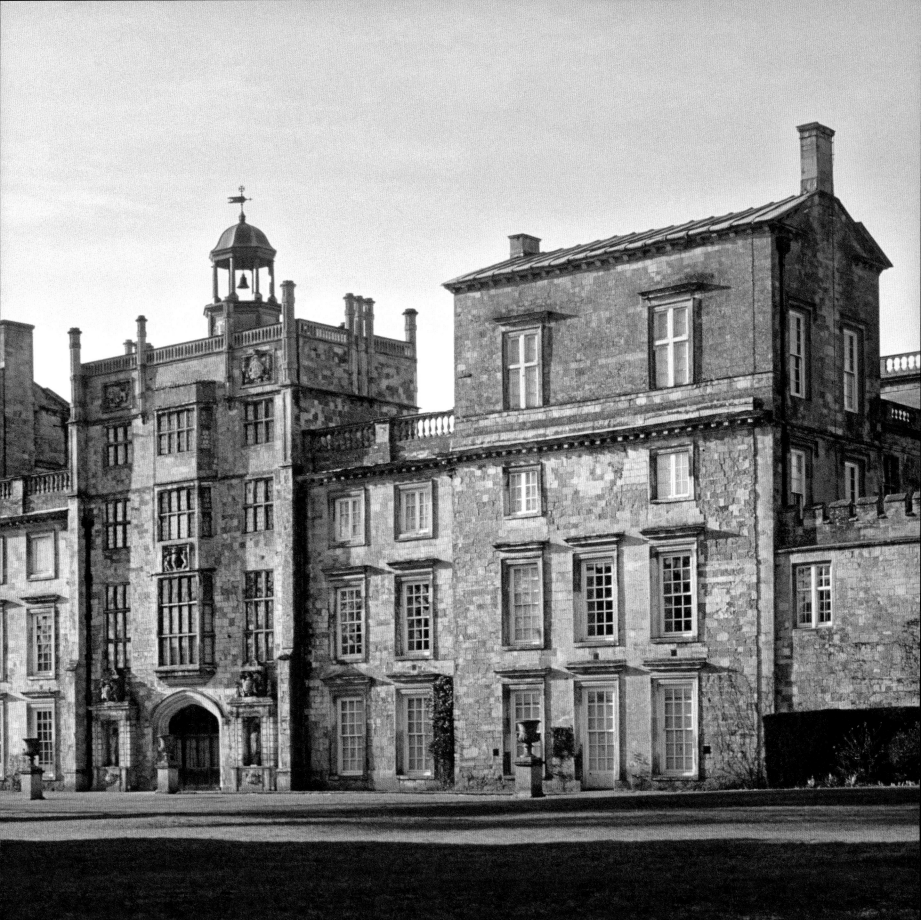

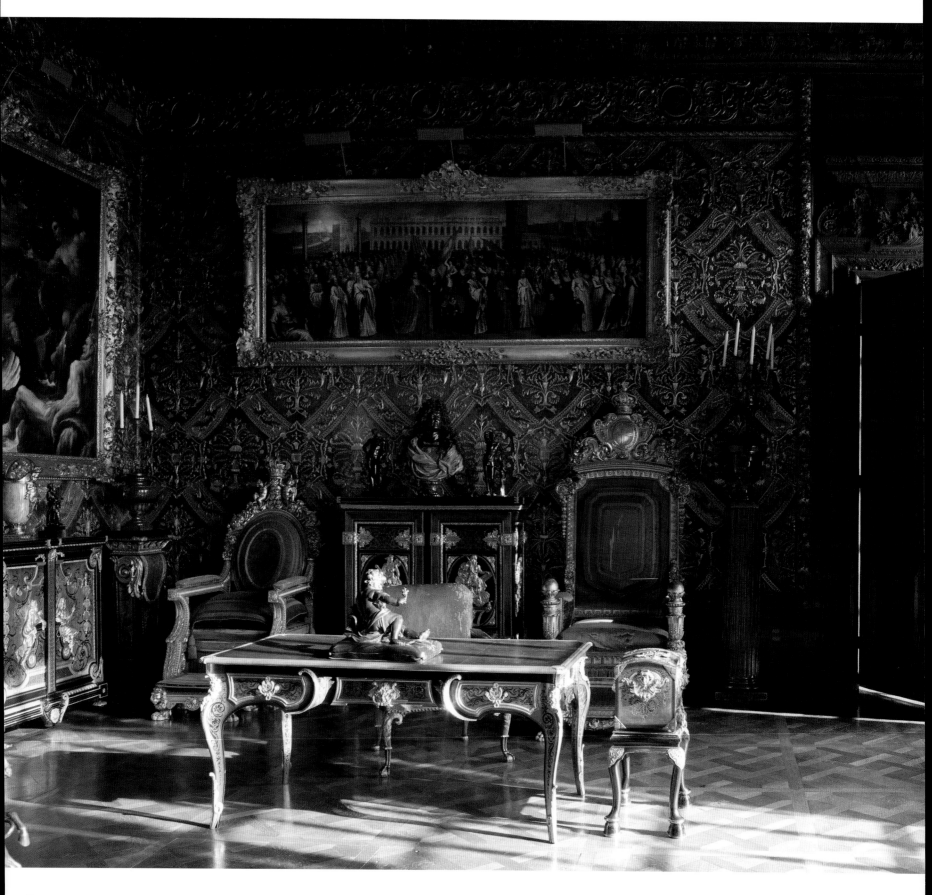

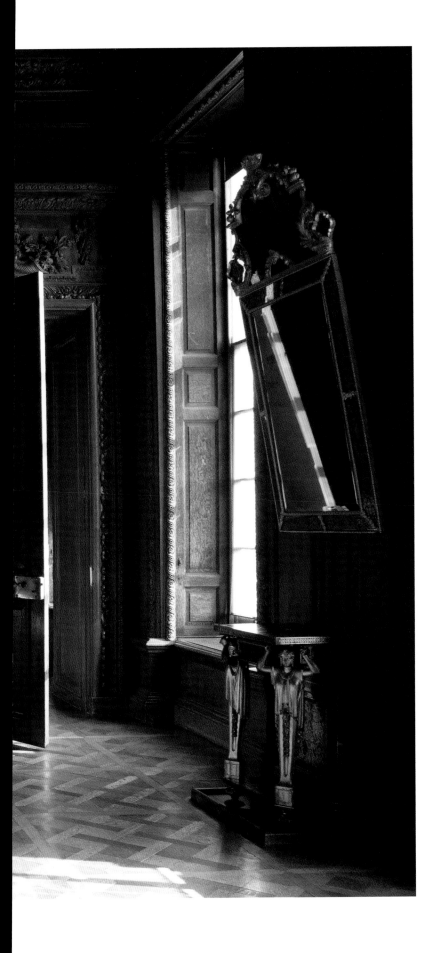

CHATSWORTH
DERBYSHIRE

The Palace of the Peaks

To call chatsworth a stately home is to downplay its magnificence. It is one of England's few palaces, akin to those on the continent, and its architecture and contents are outstanding. The house has been passed down through sixteen generations of the Cavendish family, and as such it is an appealing and irresistible combination of home and museum.

In 1552 the redoubtable Bess of Hardwick married her second husband, Sir William Cavendish, and convinced him not only to settle in her native Derbyshire but also to buy the manor of Chatsworth for £600. There they built the first house on the land. Their Chatsworth was Elizabethan in style and designed typically, around a courtyard, with the State Apartment on the second floor, affording occupants the best views. Bess, who became the most powerful woman in England after the Queen, also built Hardwick Hall nearby, an astonishing masterpiece that survives today in its original form.

By the mid-seventeenth century Chatsworth had fallen into disrepair, and the 4th Earl of Devonshire (later the 1st Duke of Devonshire) employed the architects William Talman and, later, Thomas Archer to undertake much-needed rebuilding work. Initially Cavendish intended only to reconstruct the south block with the State Apartment, but he enjoyed building so much that the reconstruction work expanded to include the west front, which is thought to have been designed by the Duke himself, while the north, with its bow front, was the work of Archer.

The south façade came first; work began in 1687, and it was undoubtedly Talman's great breakthrough as an architect. Here he created an elevation of exquisite classical grandeur that was without precedent in English country house design. It provided the duke with a formal apartment of state reception rooms, and is thought to have been influenced by the court style of Louis XIV, in particular Gianlorenzo Bernini's unexecuted design for the façade of the Louvre in Paris. The State Rooms in their present condition show better than anywhere else what James Lees-Milne calls 'a happy vision of the decorative arts'. The majority of the contents were acquired by the 1st Duke, and to this day these are impressively authentic rooms.

The State Music Room, formerly called the Second Withdrawing Room.
The grandeur and quality of the contents show more than almost anywhere else in England
the character of a state apartment. Much of the furniture is French, from the Louis XIV
period; the coronation thrones are English, made for King William IV and Queen Adelaide.

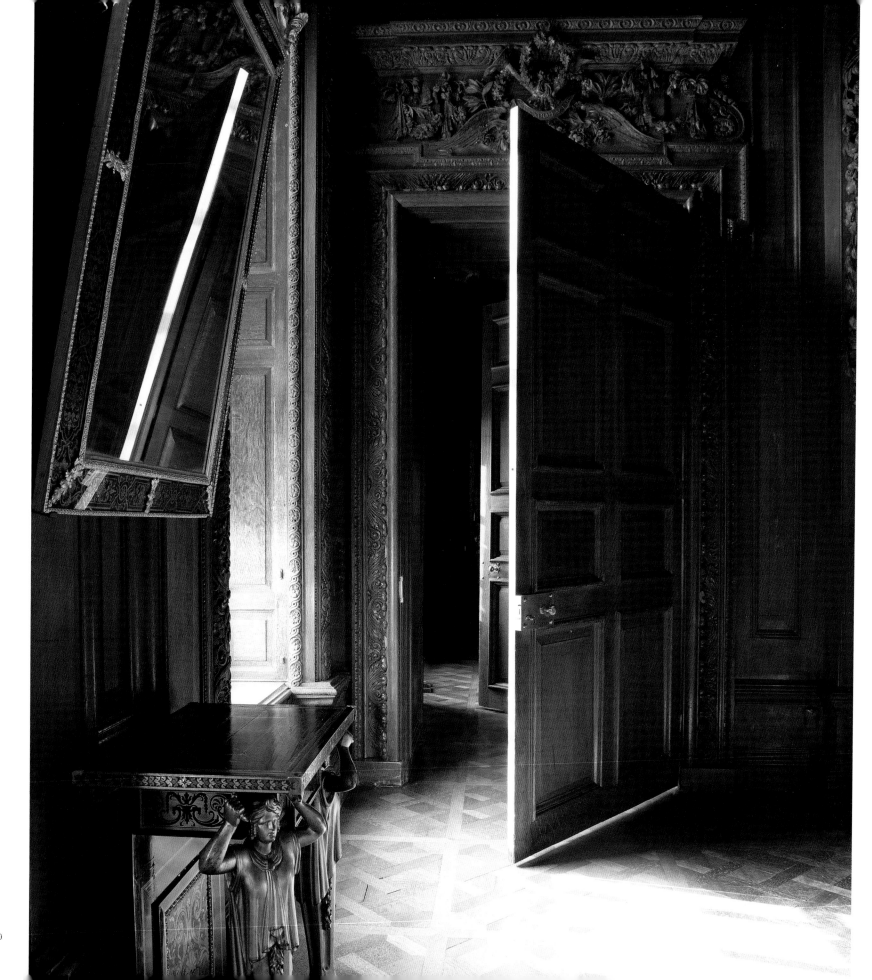

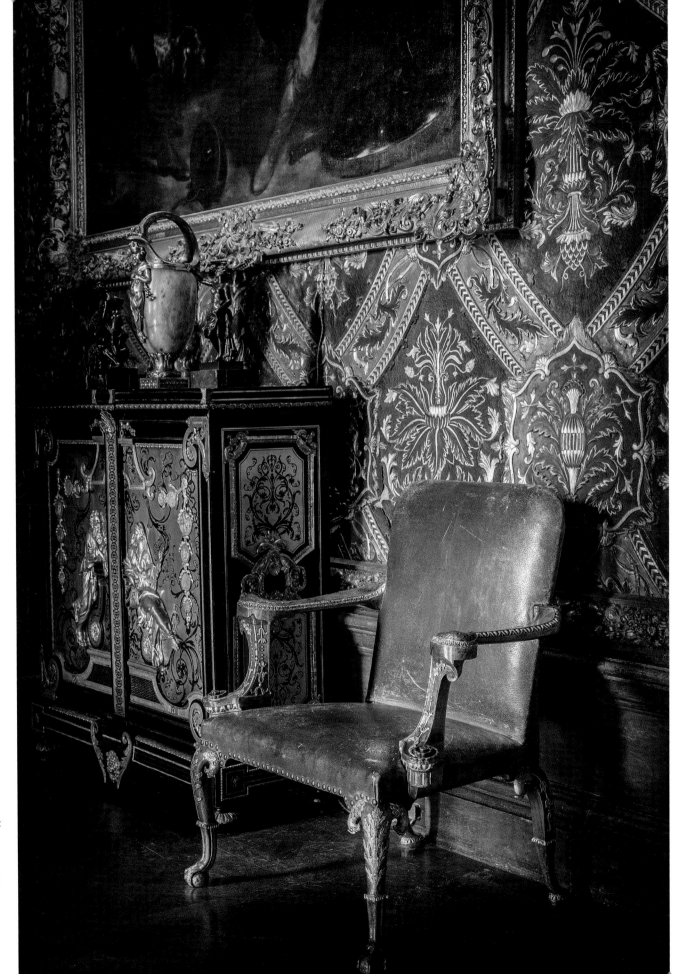

OPPOSITE *Panelling and carving in the enfilade of rooms in the State Apartment on the second floor.*

RIGHT *Detail of the furniture, made by André-Charles Boulle (or in his style), and* cuir repoussé *wallcovering in the State Music Room. The armchair is George I.*

61

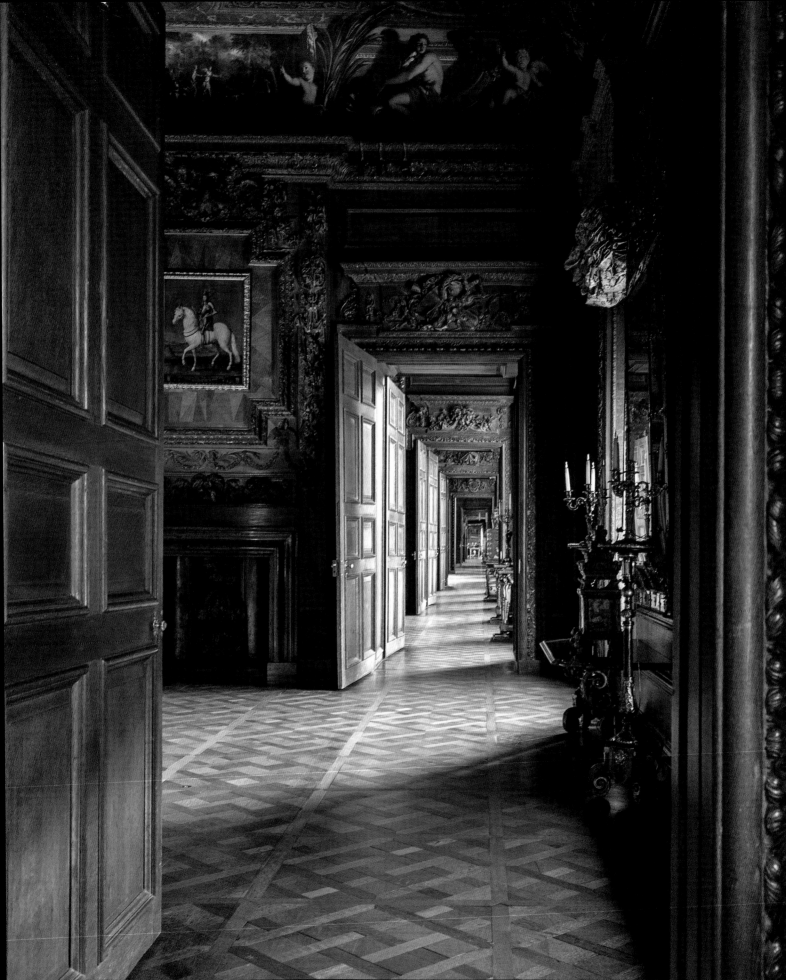

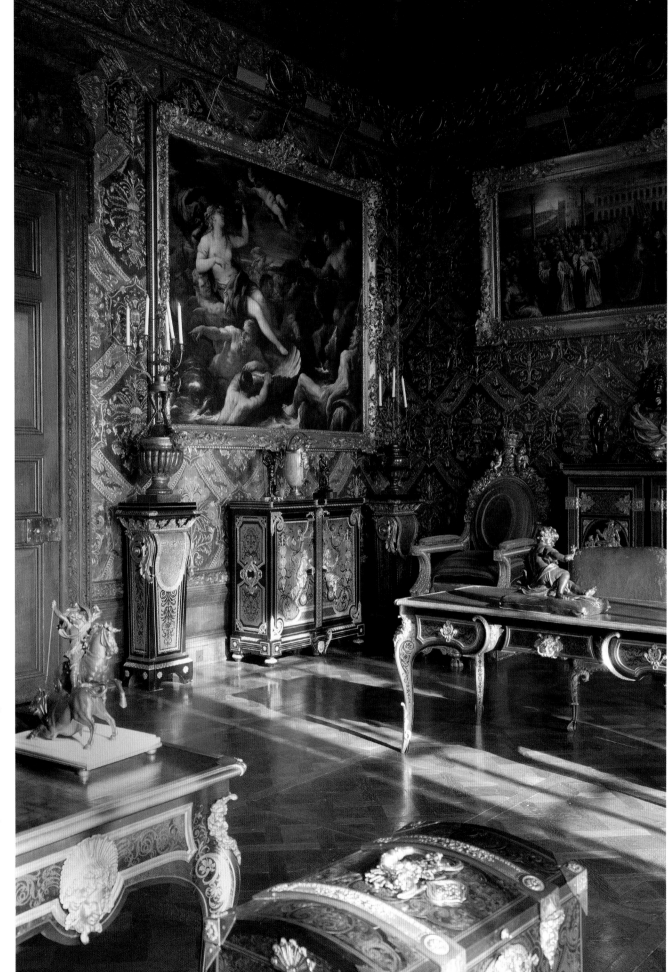

OPPOSITE *The enfilade of State Apartments along the south front, the length of which appears doubled by a panel of mirror glass at the end.*

RIGHT *A corner of the State Music Room, with Boulle furniture.*

PAGES *64–65 In the State Drawing Room, the tapestries, based on Raphael's cartoons, are from the tapestry works at Mortlake (established in about 1620). The coromandel cabinet and coffer are lacquered, and the porcelain is oriental. The secret of making porcelain was not known in Europe until the early 18th century.*

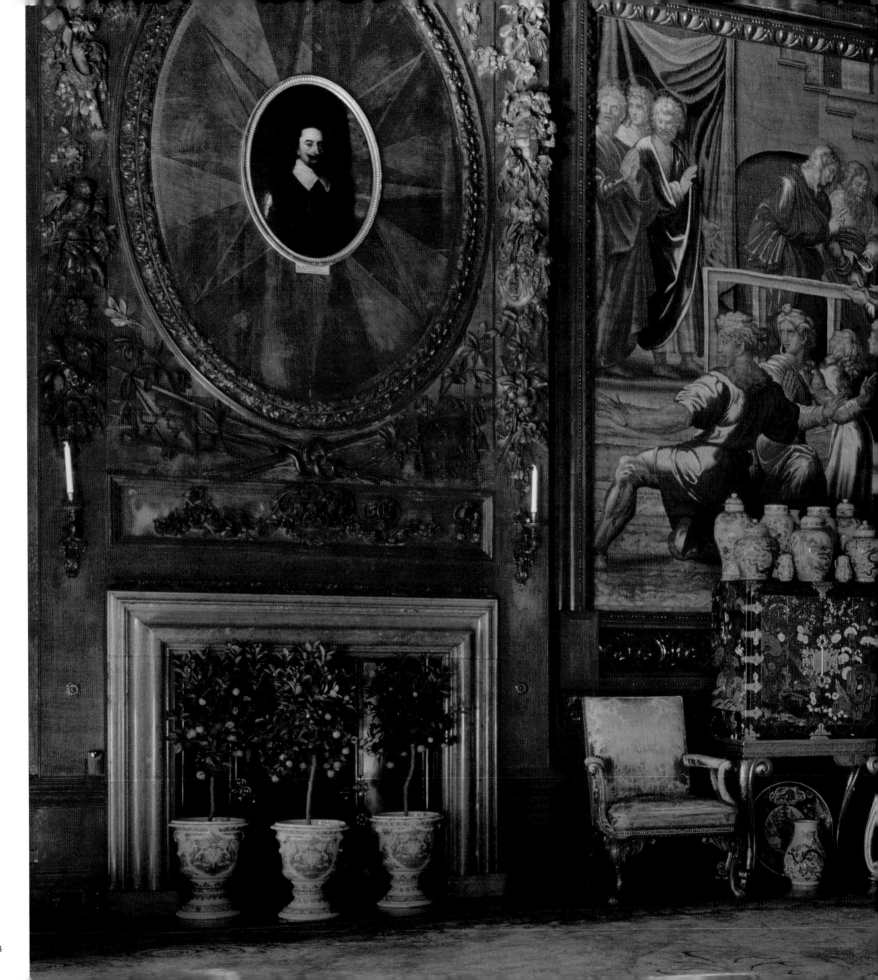

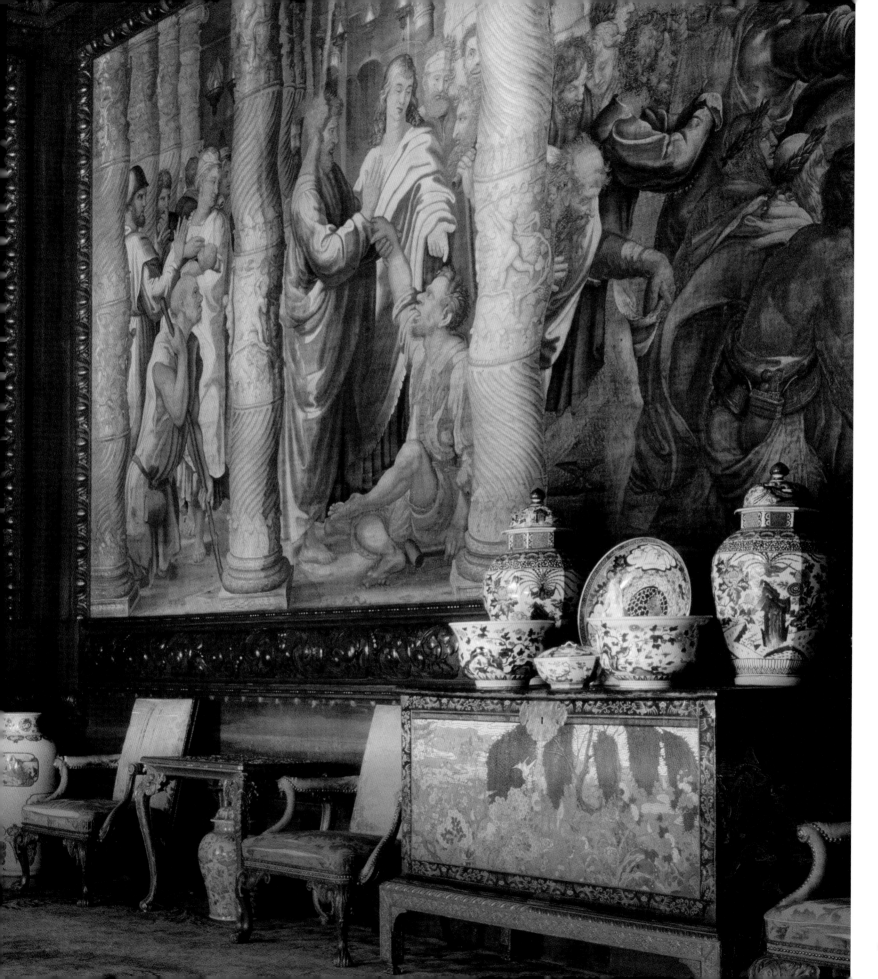

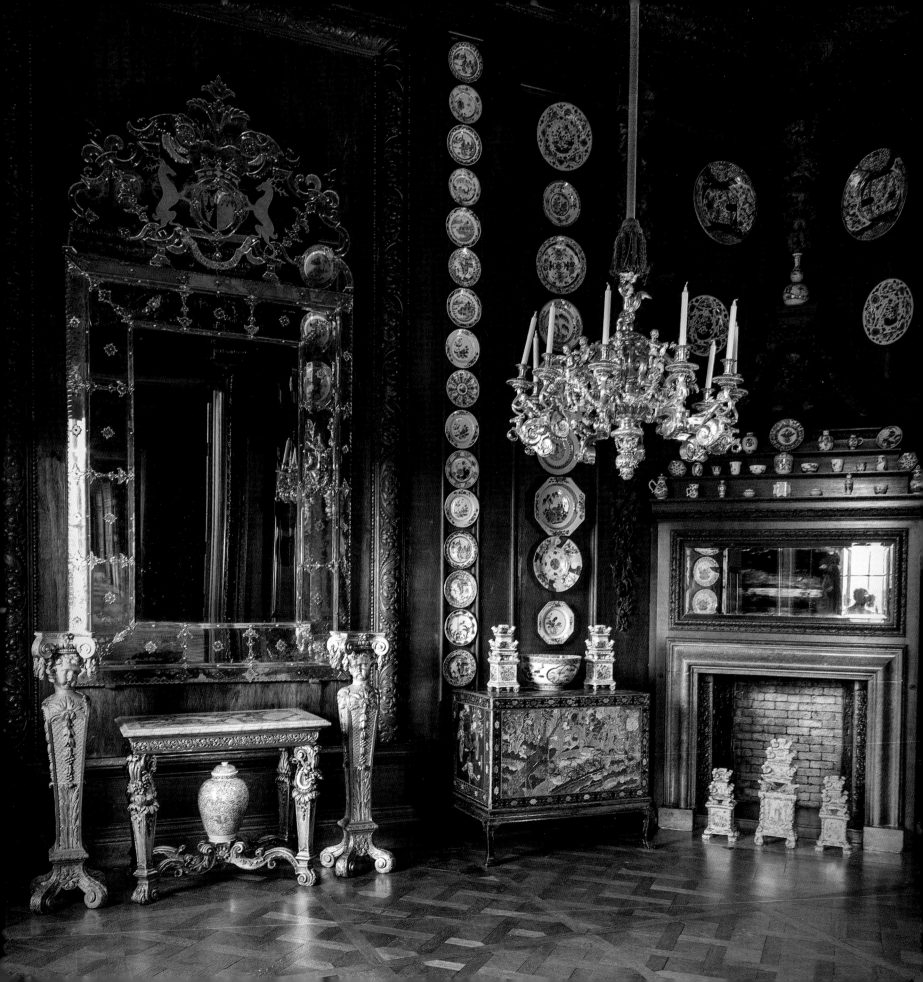

TALMAN ARRANGED the family rooms on the first and ground floors. His lower library is also on the ground floor, but its character was reshaped in the nineteenth century with an overlay of decoration by John Gregory Crace. The mirror glass surrounding the fireplace, the painted wall and ceiling decorations, the bookcases and the furniture almost disguise the seventeenth-century pilasters, cornice and fireplace. Until Crace redecorated the room, there was a beautiful Regency scheme, of which a drawing still exists (reproduced on page 6). It shows a neoclassical Grecian purity and emptiness, an aesthetic that must have had to yield somewhat when it came to the storage of books and the addition of comfortable furniture.

The 6th Duke of Devonshire, known as the Bachelor Duke, was as extravagant as he was amiable. He spent his life improving his many houses, but was particularly enamoured of Chatsworth. 'I enjoy being here before all earthly things,' he wrote. 'I adore it ... I am drunk with Chatsworth.' And so he engaged the architect Sir Jeffry Wyatville to build the long North Wing. The Duke and Wyatville left the seventeenth-century staterooms in their original condition, changing only a few small details of the surface decoration. In other rooms, they added to the shell without destroying the principal elements, and then decorated to the duke's taste. If only others in possession of great interiors would do the same. Wyatville's work was so sympathetic that identifying, for example, which sections of an entablature are eighteenth-century and which were added in the nineteenth makes an interesting game of detective work.

Today, Chatsworth is one of the most loved, admired and popular places to visit in England, but that wasn't always the case. The vast scale of the house meant that it was not to everybody's taste. In 1906 Raymond Asquith, son of the Prime Minister, wrote from Chatsworth to his fiancée: 'Dearest, you would loathe this place. It crushes one by its size,' adding, with horror, 'there is only one bathroom which is kept for the King.'

In the 1950s the 11th Duke and Duchess successfully reversed what might have been a grim fate for Chatsworth. With death duties soaring to a stratospheric 80 per cent, it seemed the family would never live in the house again, but with characteristic hard work, enthusiasm, local help and plenty of flair the Devonshires were able to save the house and make it their home. Hardwick Hall and its estate were given to the Treasury in lieu of cash, alongside several important works of art and many rare books. Thousands of acres of land were also sold. The family were able to restore and redecorate the great ducal palace, and the present duke concedes that were it not for his parents' efforts, he would not have been able to achieve what he has at Chatsworth – namely, a £32.7 million programme of restoration, conservation and modernisation. He and the present duchess have added to the collection, changed the arrangement and decoration of the rooms, and taken on the Herculean task of mending and cleaning all the exterior and interior stonework and gilding the window-glazing bars and urns. Chatsworth is a splendid monument to the care and respect of the family who live there. It succeeds wholeheartedly in being all things at once: a working estate, a tourist attraction, an architectural treasure and a family home.

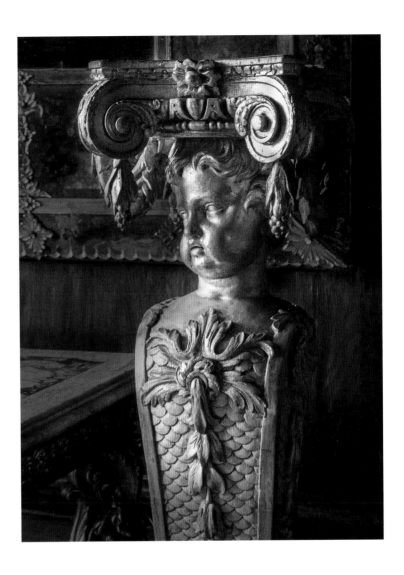

OPPOSITE *The State Closet at the west end of the enfilade. Lacquer, silver, gilding and mirror glass are combined in this relatively small room. In the centre hangs the 1st Duke of Devonshire's silver chandelier.* ABOVE *A detail of a torchère.*

BELOW *The Lower Library as it was for the 11th Duke of Devonshire,*
whose daily use of this room, and his preference, shows a désordre anglais.
RIGHT *The West Front, showing the 'Sleeping Beauty' character of the*
house as it was before the restoration carried out by the 12th Duke.

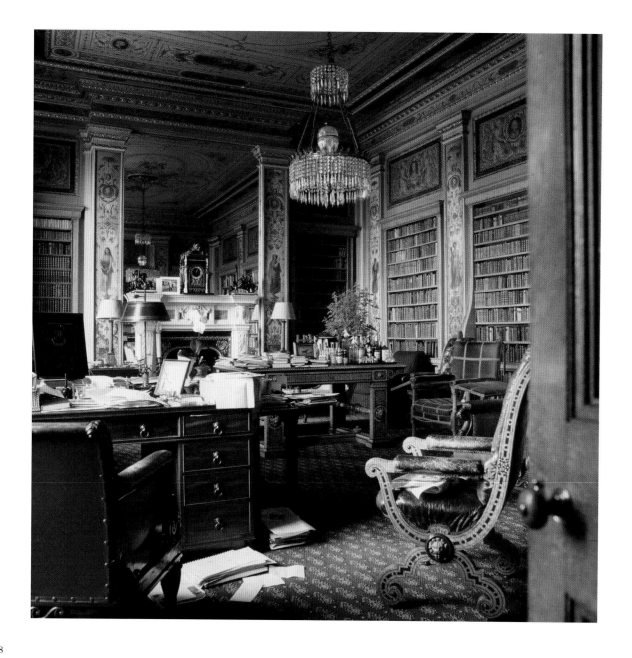

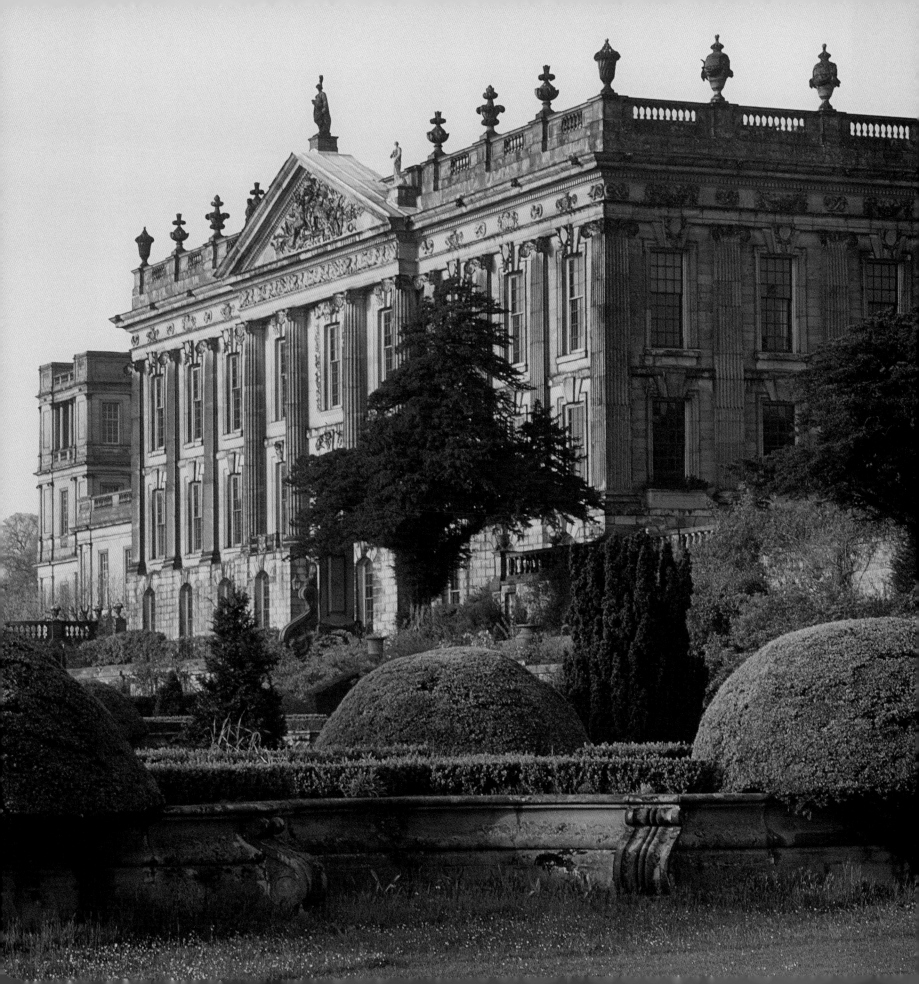

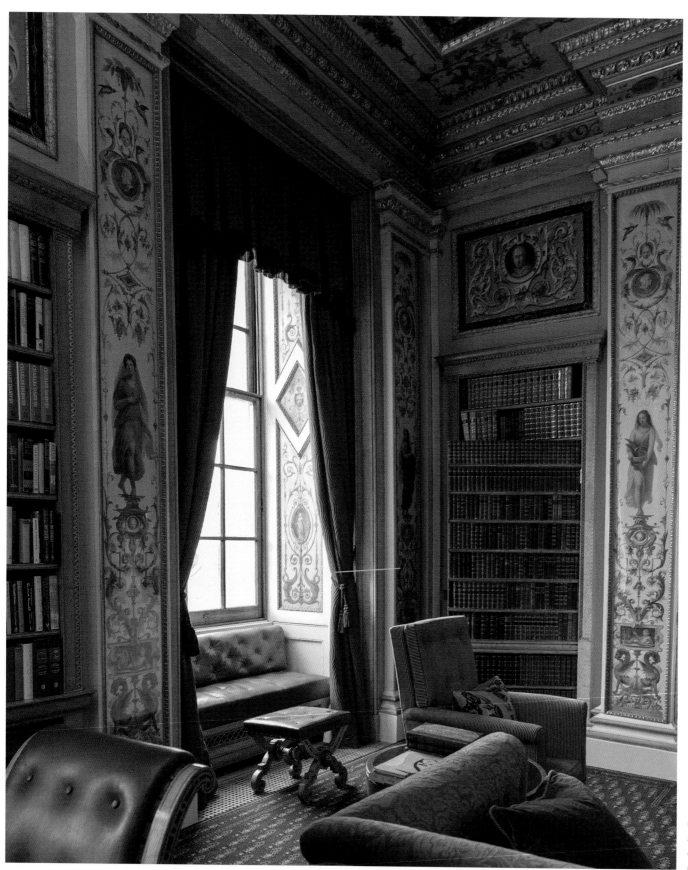

LEFT *A detail of a window reveal in the Lower Library, and an adjacent door faced with book spines showing how the 19th-century decoration almost disguises the 17th-century shell, while remaining respectful of it.*

OPPOSITE *Talman's 17th-century shell and Crace's 19th-century decoration as they are at present, done for the 12th Duke.*

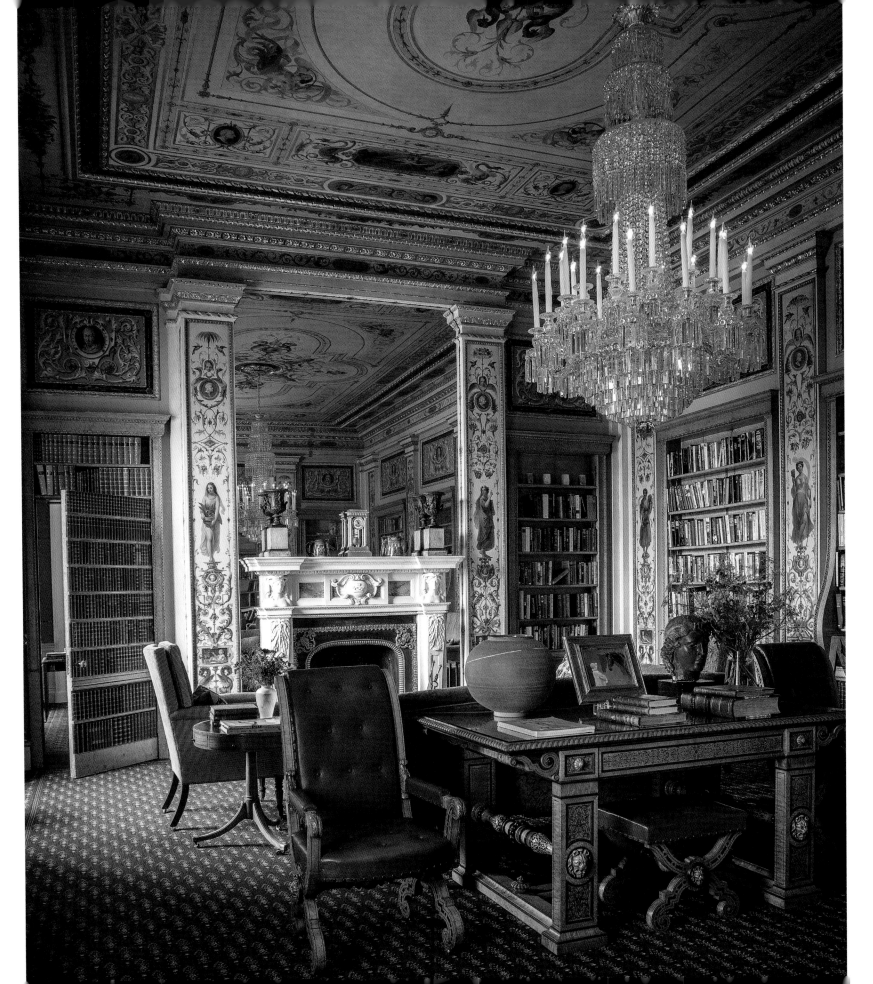

HAM HOUSE
SURREY

The Green Closet or Miniature Room

Ham house sits within a water meadow on the banks of the River Thames below Richmond. Remarkably, the handsome Jacobean house, its setting and garden have remained virtually unchanged since 1610, when the first brick was laid, with the exception of alterations carried out in the 1630s and the 1670s.

Ham House is the work of William Murray, Earl of Dysart, who created a grand suite of rooms between 1637 and 1639, and his daughter Elizabeth. In 1649, when William was exiled during the Civil War, Elizabeth resolutely kept hold of the property. In 1672 she married her second husband, the Duke of Lauderdale, and together they made the house what it is today. The couple travelled widely in France and Holland, and employed the best craftsmen from England and abroad to work on their home. Gilbert Burnet, the Bishop of Salisbury, said of Elizabeth: 'She had a restless ambition, lived at a vast expense, and was ravenously covetous.'

In 1698 the house was inherited by the Tollemaches, descendants of Elizabeth's first husband, Sir Lionel Tollemache. Over the years new furniture was added, but the house was largely preserved and is now an immaculate example of the taste of Stuart England. Ham House remained in their family until 1948, when it was given to the National Trust.

One particular treasure is the Green Closet, a beautiful little room that is above one of two porches that flank the main entrance. The room was fitted out in the 1630s to display William Murray's collection of cabinet paintings and miniatures. Murray engaged Franz Cleyn to install the woodwork and paint the ceiling, which, unusually, is tempera on paper. Cleyn travelled to England from his native Holland in 1632, settled there and became a pioneer of the then unheard-of interior decoration trade. Later, the Lauderdales hung the room with a fringed green damask, which was copied and replaced during recent restoration. The gilding and the paintwork appear nearly untouched.

On one side of the Green Closet is the North Drawing Room, which is hung with tapestries, and on the other side is the Long Gallery, which is wood-panelled, stained brown and gilded. Both are thought to be to Cleyn's design, and they form an elegant sequence.

Ham is one of the finest Stuart houses in England; its contents are superb and the National Trust has maintained it in a way that is both tactful and impressive. There are no gimmicks here.

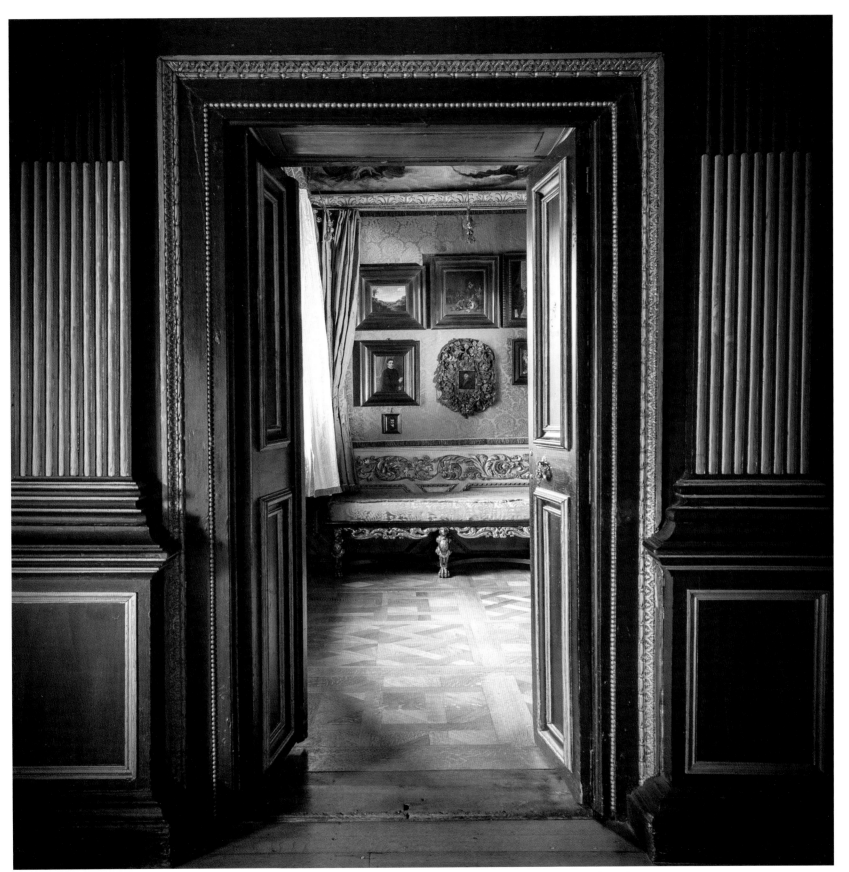

The Green Closet seen from the Long Gallery, showing the sequence from hard wood to soft textile.

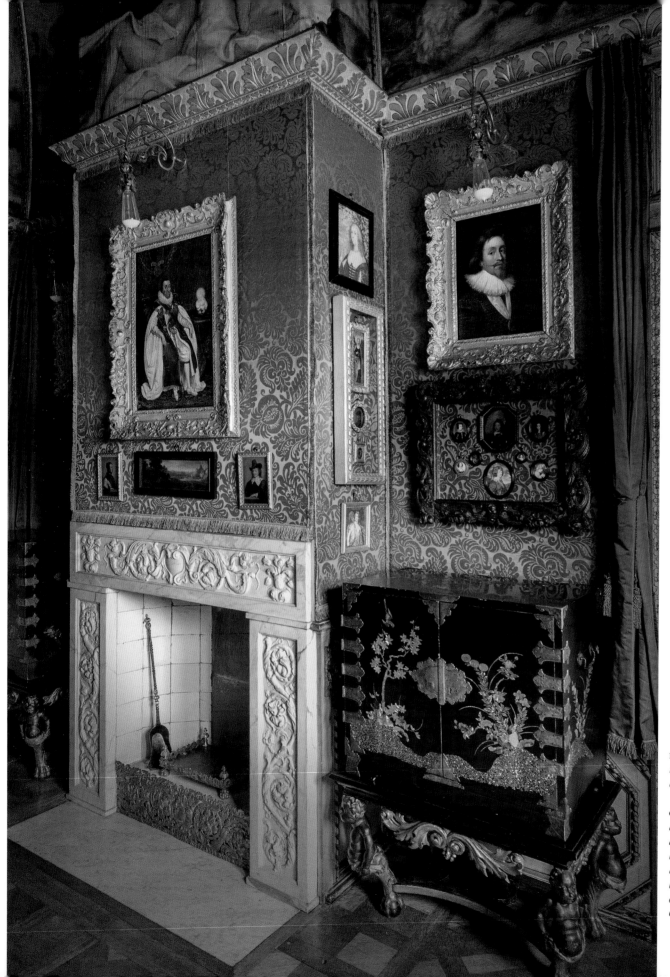

LEFT *The fireplace wall of the Green Closet, opposite the central group of miniatures.*

OPPOSITE *The decoration and contents of this room are original, although the green silk damask has been copied recently. It is a rare example of the high culture, in both the fine and decorative arts, of the English court before the Commonwealth.*

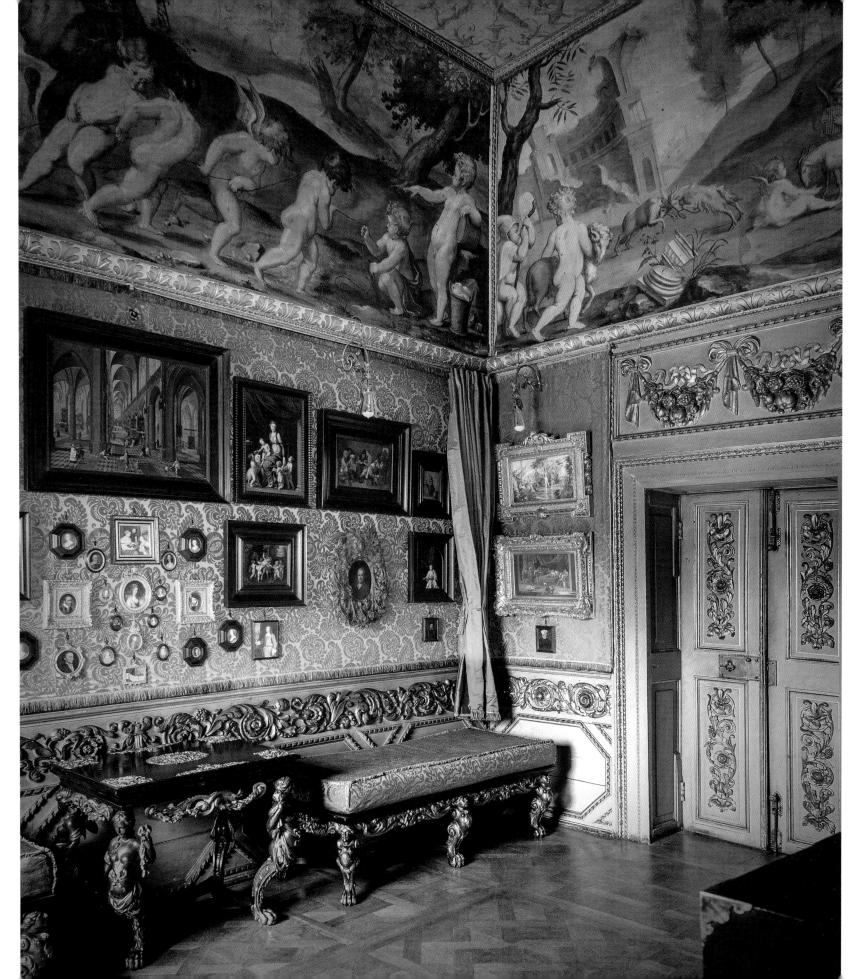

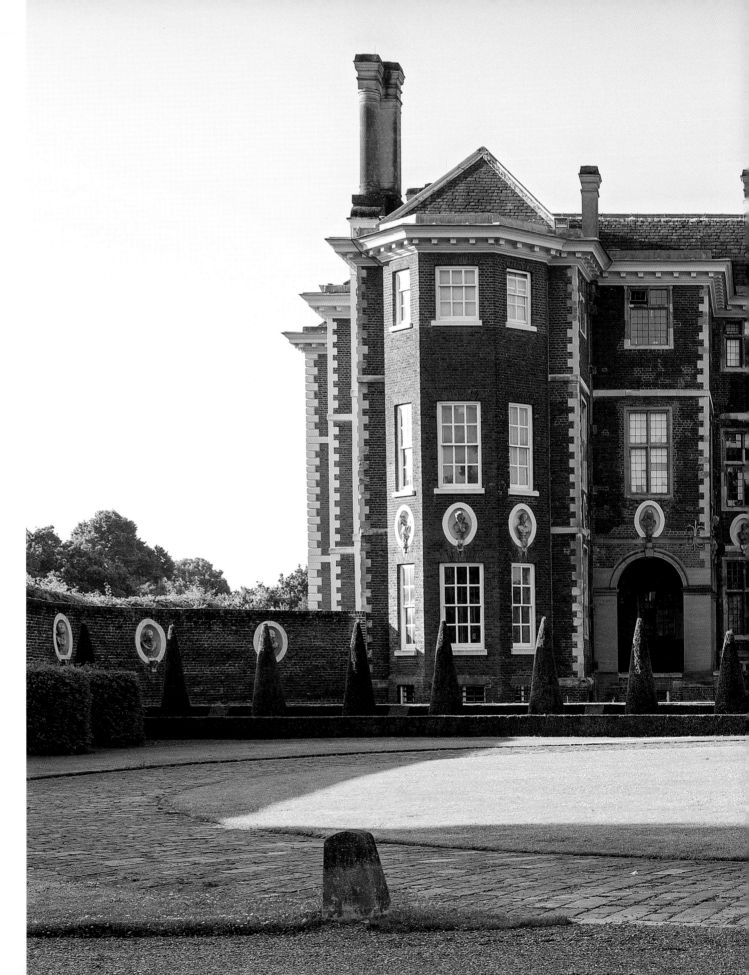

Exterior of Ham House.
The Green Closet is
in the right-hand wing.

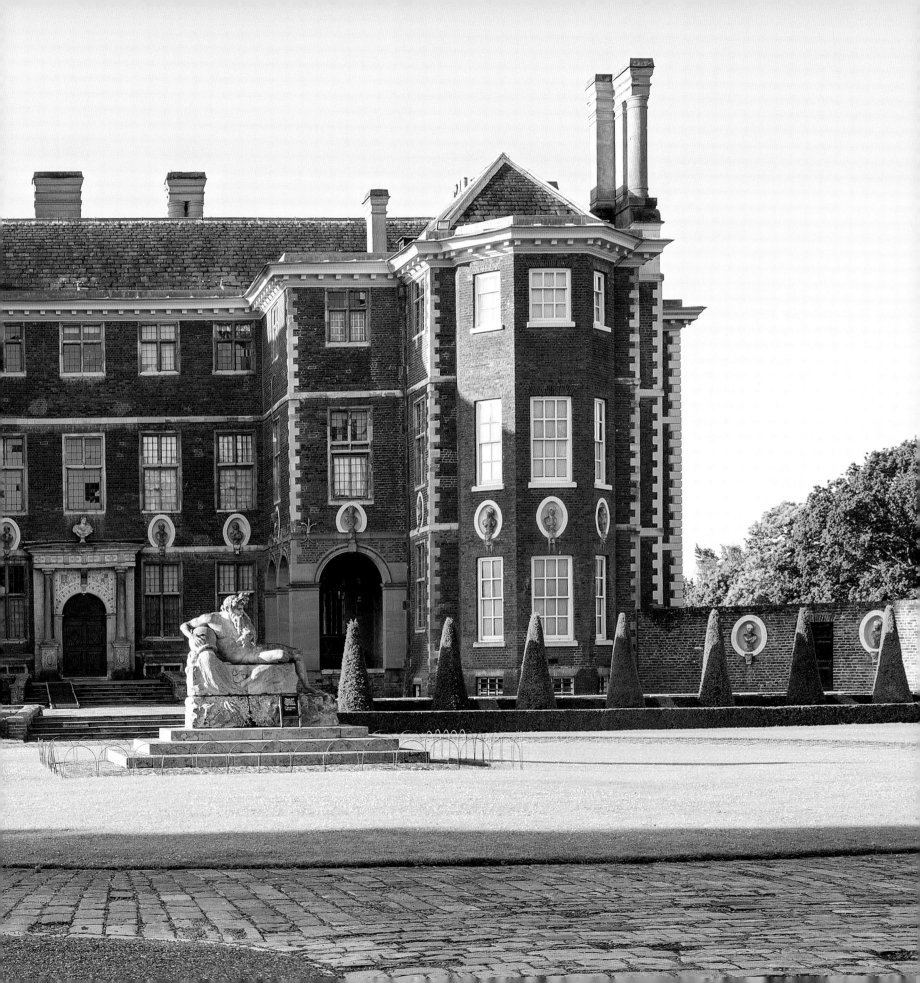

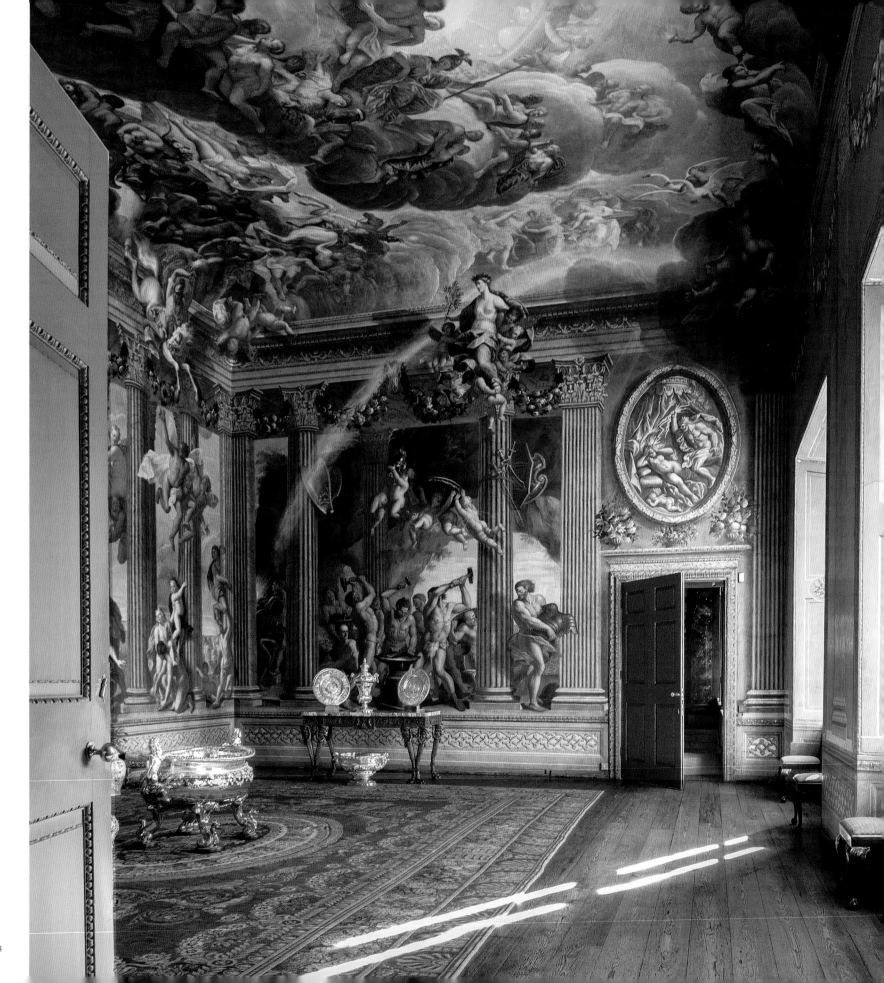

BURGHLEY

LINCOLNSHIRE

—◆—

Heaven and Hell

Burghley is an early example of the Elizabethan prodigy house. It was built between 1558 and 1587 by William Cecil, 1st Lord Burghley, Treasurer and spymaster to Queen Elizabeth I, and is still lived in by his descendants. Cecil seems to have been largely his own architect, enlisting the help of a Dutch mason named Henryk to help with the design and execution. Burghley is the result of many years of building work, and, with its fairy-tale turrets, towering obelisk clock and virtually unaltered Elizabethan façades, it remains as impressive today as it must have been when the last stone was laid.

John Cecil, the 5th Earl of Exeter and proprietor of Burghley from 1678, was an assiduous collector with a taste for Renaissance riches. He was among the first and wealthiest of the Grand Tourists whose extravagant ways encumbered the family estate with decades worth of debt. Unusually for the time, he was buying and commissioning works for his country house rather than saving the cream of the crop for his London residence, and in keeping with his love of Italy the 5th Earl commissioned Antonio Verrio to decorate the 'George Rooms' at Burghley.

The Neapolitan artist had already painted in the staterooms at Windsor Castle, and, as a result of that, he had a high opinion of himself. Depending on his finances, Verrio lived either at the George Inn in Stamford or in a small house on the Burghley estate, for ten years, during which time he established a reputation for carousing in the local alehouses and being exceedingly temperamental. The Earl called him an 'impudent dogg', but nonetheless put up with his lavish demands for silk stockings, Parmesan cheese and caviar.

The Heaven Room looking east, showing Verrio's depiction of the Cyclops' forge.
At bottom left is the artist's self-portrait, half-naked and drawing, the only figure in this
group with two eyes. He worked at Burghley on this and other rooms for ten years.

THE CLIMAX OF Verrio's Baroque scheme of decoration is the 'Heaven Room', which is accessed via the 'Hell Stairs'. The Heaven Room is a large space in which the walls seem to fall away so that the visitor stands in a temple open to the skies. The room took Verrio 75 weeks to complete. Naked bodies tumble from the ceiling in what a Victorian guidebook referred to as 'Gods and Goddesses disporting them-selves as Gods and Goddesses are wont to do ...!' During his tenure at Burghley, Verrio had a number of dalliances with local women and housemaids, many of whom he immortalised on the ceiling in an array of compromising poses. Verrio himself is depicted at the far end of the room surveying the forge of the Cyclops; presumably the heat of the furnace forced him to remove his customary wig. The reclining nude on the bed opposite is supposedly the 5th Countess, who incidentally was a Cavendish, which is why many of the craftsmen employed at Chatsworth (pages 59–71) were also used at Burghley.

The sheer scale of work in the Heaven Room is staggering, and the mural is extravagant even by Baroque standards. A *trompe l'œil* shaft of rainbow arches down one wall, and in certain lights it is just possible to see how Verrio made several attempts at perfecting the angle of the pediment, exaggerating the perspective in order to overcome the curve of the ceiling.

This was a room of parade and would once have been richly furnished with giltwood seating around the walls. As was often the case in England, the floorboards, which were probably laid in the eighteenth century, are made from inexpensive pine. The carpet is an English copy of a Savonnerie, and the solid silver wine cooler, which is reputedly the largest in existence, is a piece of Huguenot craftsmanship. During World War II the Heaven Room became a dormitory and an unfortunate cut was made in the wall in order to install a fire.

The enormity of the 5th Earl's debts was such that the life of the house went into abeyance after his death in 1700. The Heaven Room was not completed until the 9th Earl finished the interiors in a way that was sensitive to his predecessor's sensibilities.

BELOW *Eighteenth-century binoculars for looking at details.*
RIGHT *Part of the north wall of the Heaven Room, merging seamlessly into the ceiling. The pediment is entirely painted on a deep cove.*

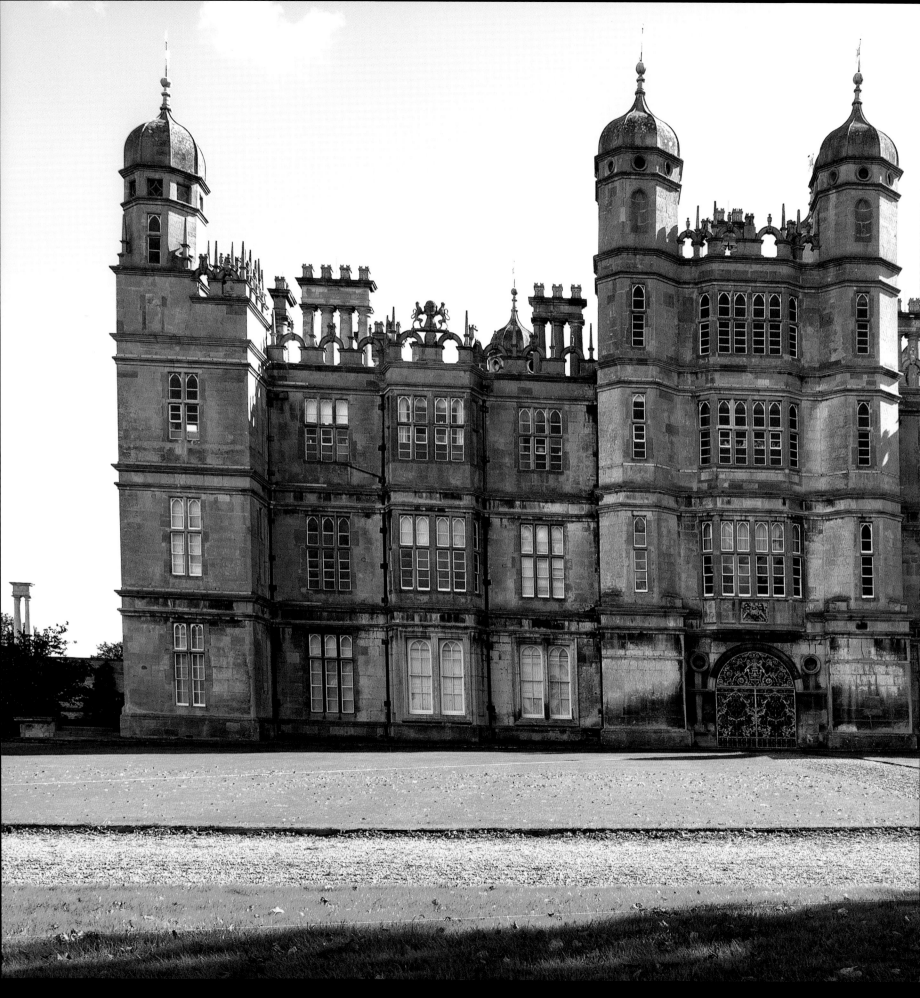

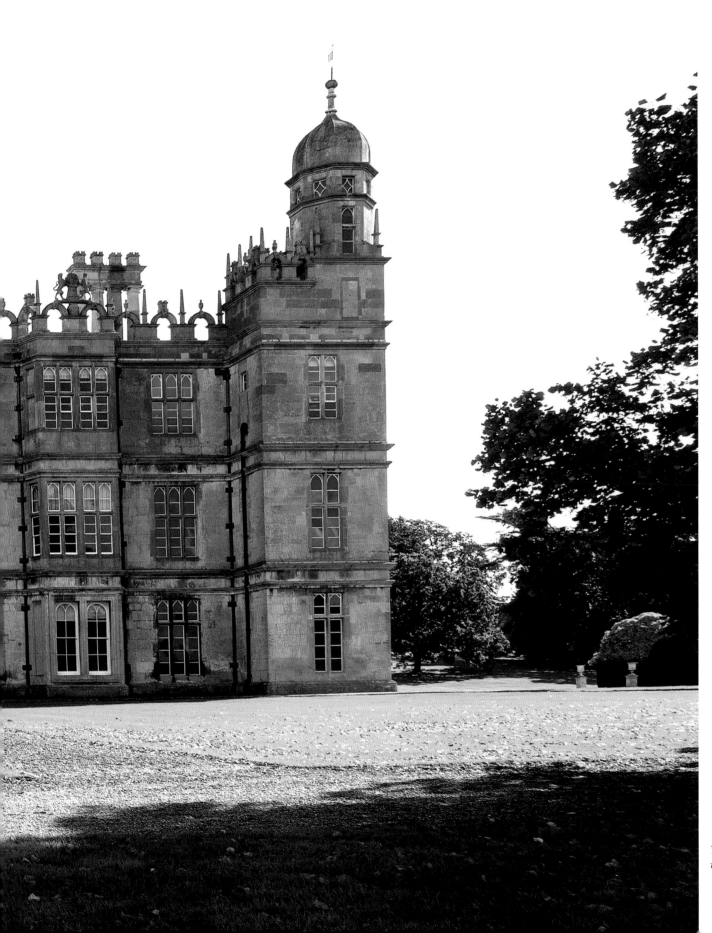

The entrance front of Burghley,
with its notably complex skyline.

EIGHTEENTH CENTURY

Detail of a cherub reclining on a pediment above a door case in the Stone Hall at Houghton Hall, Norfolk (pages 88–95). There are eight cherubs, all different, on four door cases.

The Augustan Age

—◆—

THE LASTING POPULARITY of living in an English eighteenth-century house is a fact that estate agents and lifestyle magazine editors will confirm. These are buildings of great refinement. They are a favourite in both town and country, and suit twenty-first-century life as well as they did life in the eighteenth century. This is because people know what to do with them and how to live in them more easily than they do buildings of an earlier or later date. They are unfussy, well proportioned, well built and beautiful. There is usually a degree of status attached to them, and because of the clarity of their design they are adaptable through changing patterns of ownership.

The story of the decorative arts in England is told in the British Galleries at the Victoria and Albert Museum in London. It starts with the arrival of the Tudors, when England was a minor player offshore from the European power base, and continues into the twentieth century, through the days of Empire, success and riches. The eighteenth-century galleries show how architecture and its attendant arts reached the standards of continental Europe yet remained rooted in all that was British.

Eighteenth-century architecture in England descends directly from the work of Inigo Jones, which in turn bears the hallmarks of classical Greece and Rome, as re-established in Renaissance Italy. The brick façades and sash windows that were commonly used during the period are illustrative of the Dutch influence on Georgian architecture; for those living on the east coast of England, Holland was often more accessible than London, which lay beyond wild and inhospitable fenland. Today bricklayers still refer to 'English' and 'Flemish' bond. Still, all the results are unmistakably English, whatever the source of inspiration.

Just as the parish church had been in the medieval world, the principal eighteenth-century building category was the private house – either built alone or as a terrace. The typical Queen Anne house, which started to appear in numbers at the beginning of the century, developed through Palladianism and neoclassicism as the century went on. Inigo Jones's architectural masterpiece was the Queen's House at Greenwich – England's first truly classical private house – the like of which had not been seen before. Later, Colen Campbell and Lord Burlington, the latter an amateur architect of great talent, picked up Palladianism again, after the Baroque period of Christopher Wren, John Vanbrugh and Nicholas Hawksmoor. Later, Robert Adam and his rivals, principally James Wyatt and William Chambers, refined the classical style to its zenith. From there, the only way to go was reduction of form and detail, and so we have the restraint of Sir John Soane's work, the favourite of present-day architects and designers.

Throughout this period an accepted standard of good taste was understood. This applied to prose and poetry, buildings outside and inside, manners, behaviour, speech, dress and music. It was controlled by money and reason. When I was a student of architecture in the mid-twentieth century, a critic wrote that 'it was a somewhat circumscribed and brittle philosophy in which there was little room for half tones.' Out of it came some of the most beautiful interiors in England.

James Lees-Milne noted in *The Earls of Creation* (1962) that 'there were no two opinions on any question of taste. The early Georgians knew what they disliked and discarded it; they knew what they did like, and produced it.' To anyone studying architecture in the late 1950s, those words could just as easily be ascribed to the confidence of the then Modern movement.

HOUGHTON HALL
NORFOLK

—

A Palladian Masterpiece

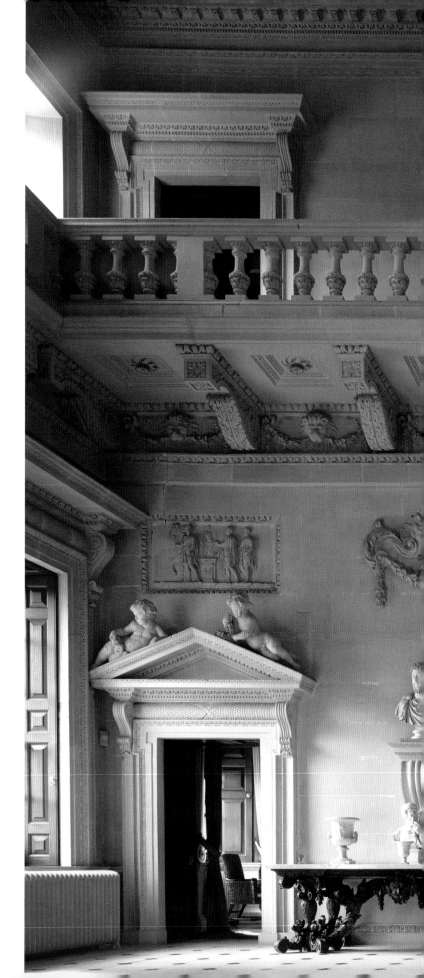

Houghton hall was built in the 1720s for Britain's first and longest-serving prime minister, Sir Robert Walpole. His family had been landowners in the Norfolk Fenland since the thirteenth century, but when his father died and he inherited the estate, Sir Robert decided to build a new country house in which to exhibit his impressive collection of European art, and of course his considerable wealth and power. Houghton Hall was a collaboration between the two eminent British architects of the age – Colen Campbell and James Gibbs – with extravagant interiors by the rising Palladian star William Kent.

Although Sir Robert had built Houghton Hall as a temple to his princely art collection, that would remain *in situ* for only three generations. The 3rd Earl of Orford, Robert Walpole's grandson, George Walpole amassed terrible gambling debts (he had a fondness for horse racing and greyhound coursing), and sold the bulk of the paintings to Catherine the Great of Russia in a sale brokered by James Christie, founder of the eponymous auction house. Works by Rembrandt, Veronese, Rubens, Poussin and many other great painters of the time were removed from the walls and shipped to St Petersburg, where they would form the core of the Hermitage Collection.

Despite this serious loss, the house has otherwise remained mostly unchanged over the centuries, retaining much of its original furniture and fabrics. The preservation of the interiors was helped by the fact that it was practically unoccupied for more than a century, but a significant debt is also owed to the energy and taste of the 5th Marquess of Cholmondeley's wife, Sybil Sassoon, who used her inherited wealth to carry out essential repairs and tactful restoration.

Houghton Hall is one of the best survivals of English Palladianism, and its interiors show Kent at his most brilliantly unrestrained. The touch of his hand is evident throughout the house. He tended to have an easy relationship with his clients, who often became friends with 'poor Kentino'. He was known to be a convivial house guest, who was not deferential in the typically eighteenth-century way and who appealed to his clients' nostalgia for their Italian tours.

The Stone Hall illustrates the use of elements of outdoor architecture in an interior. Devised by Kent as the formal entrance, this was a room of wealth and parade, that would surely impress and intimidate Walpole's guests in equal measure. Designed mainly in stone with sculpture by John Michael Rysbrack and stucco work by the Atari brothers, the two-storey chamber is monochromatic except for the vast giltwood chandelier, François Girardon's bronze copy of the writhing Laocoön and the pale blue field to some of the ceiling enrichments. Carved laurel swags and cheerful putti adorn the ceiling, as do stucco medallion portraits of Walpole and his first wife, Catherine Shorter (who may never have been to Houghton Hall), his eldest son, Robert, and his second wife, Margaret Rolle.

William Kent's Stone Hall at Houghton Hall, a fine example of exterior architecture in an interior. The side tables are attributed to Kent, as is the plinth on which stands the bronze sculpture of Laocoön, a copy by François Girardon from the antique.

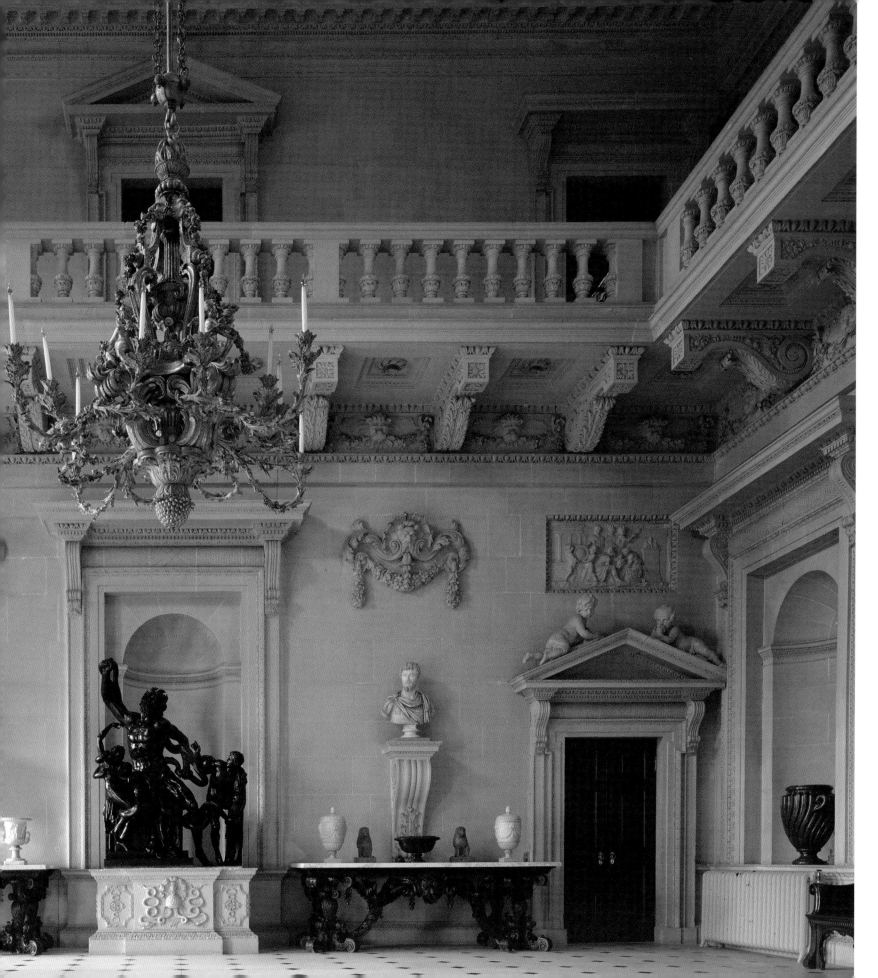

89

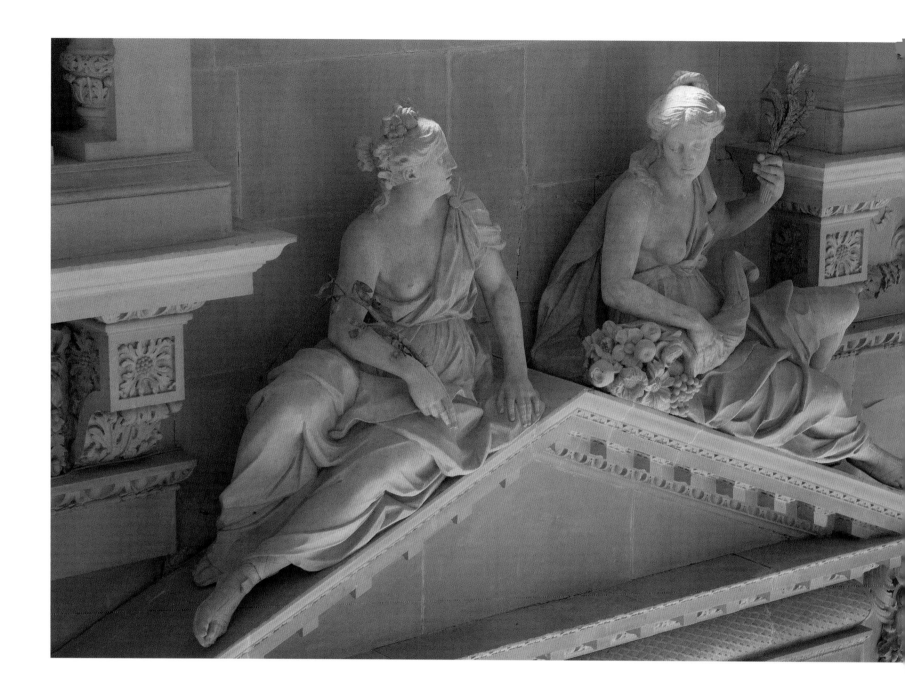

THE DINING ROOM or Marble Parlour, off the Stone Hall, neatly demonstrates the use of interior architecture on a domestic scale and is in my view a rather underrated room. Perhaps this is because it stands in such contrast to the splendour of the Stone Hall, or because it is quieter and less elaborate than the other staterooms. Dining rooms often are, until the table is laid. The Marble Parlour is dedicated to Bacchus, with bunches of grapes and vine leaves embellishing the marble chimneypiece, plaster ceiling and door surrounds. The overmantel frames the *Sacrifice to Bacchus* by Rysbrack, whose workmanship is so fine that the piece might have been carved from sugar.

The coffered gilt ceiling displays yet more scenes of Bacchanalian plenty, and in Walpole's day the walls would have been hung with two portraits by Anthony Van Dyck, depicting Sir Thomas Wharton and Henry Danvers, Earl of Danby;

sadly, these later formed part of Catherine the Great's haul. The grandeur of Kent's scheme for the room was inspired by his travels in Italy and draws on the decoration of the great Roman palaces; it demonstrates not just his decorative prowess, but also Walpole's love of opulence and fine craftsmanship. The complexity of the work in the Marble Parlour meant that it was the last room in the house to be completed.

Houghton has been open to the public since the 1970s, a fact that 'helps to keep the place alive', according to David Cholmondeley, the 7th Marquess. 'The revenue generated is not very significant because of where we are; but I cannot now imagine the house not being open – it should be seen by as many people as possible, particularly schoolchildren. I find it especially rewarding to hear what visitors say, and receive many letters of appreciation.'

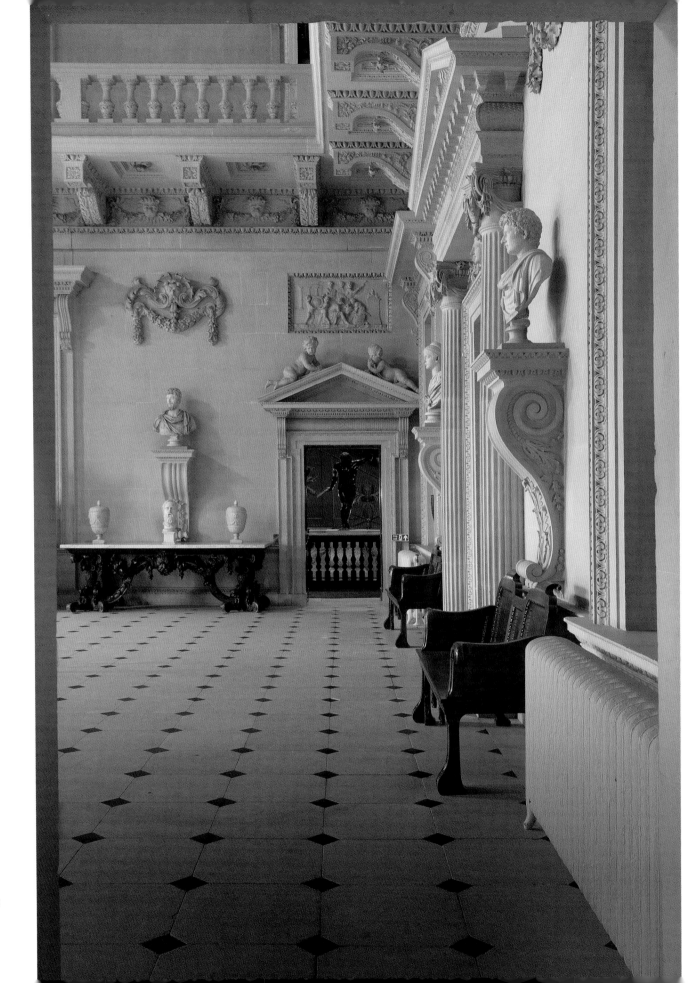

OPPOSITE *Detail of a pediment over a door in the Stone Hall, with figures of Peace and Plenty by John Michael Rysbrack.*

RIGHT *A corner leading to the staircase. The mahogany benches were designed by William Kent.*

LEFT *In the Marble Parlour, the fireplace wall and the recesses either side are entirely of marble. The remainder is mahogany, paint and gilding. The overmantel is by Rysbrack.*

OPPOSITE *The right alcove on the fireplace wall.*

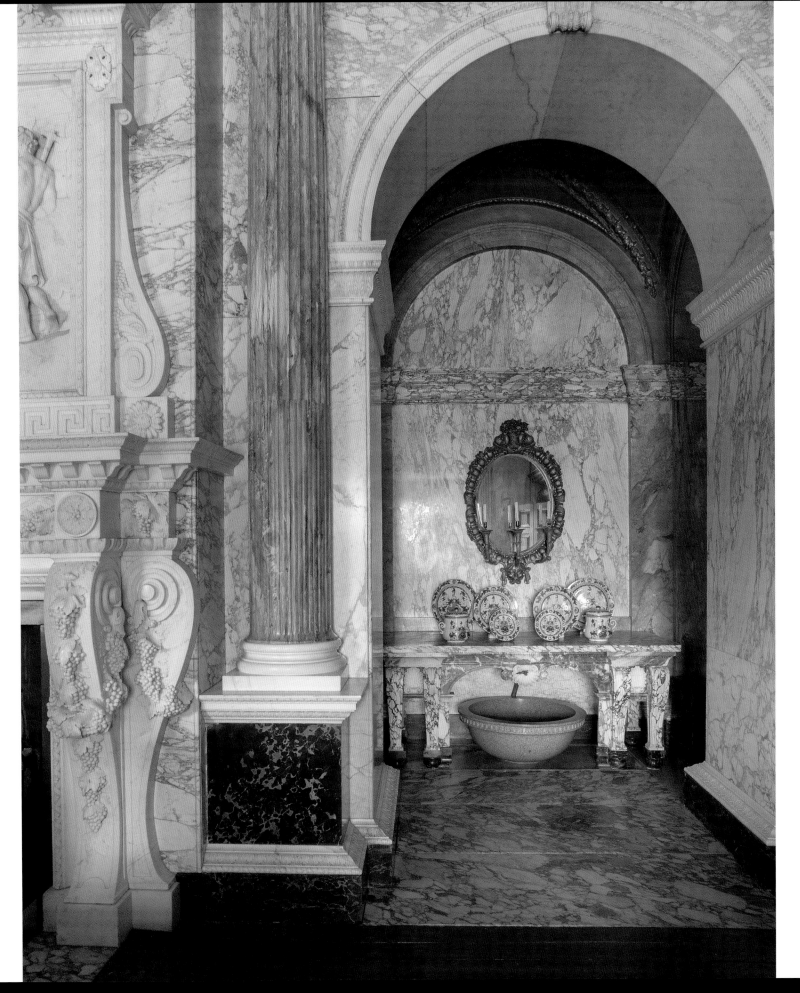

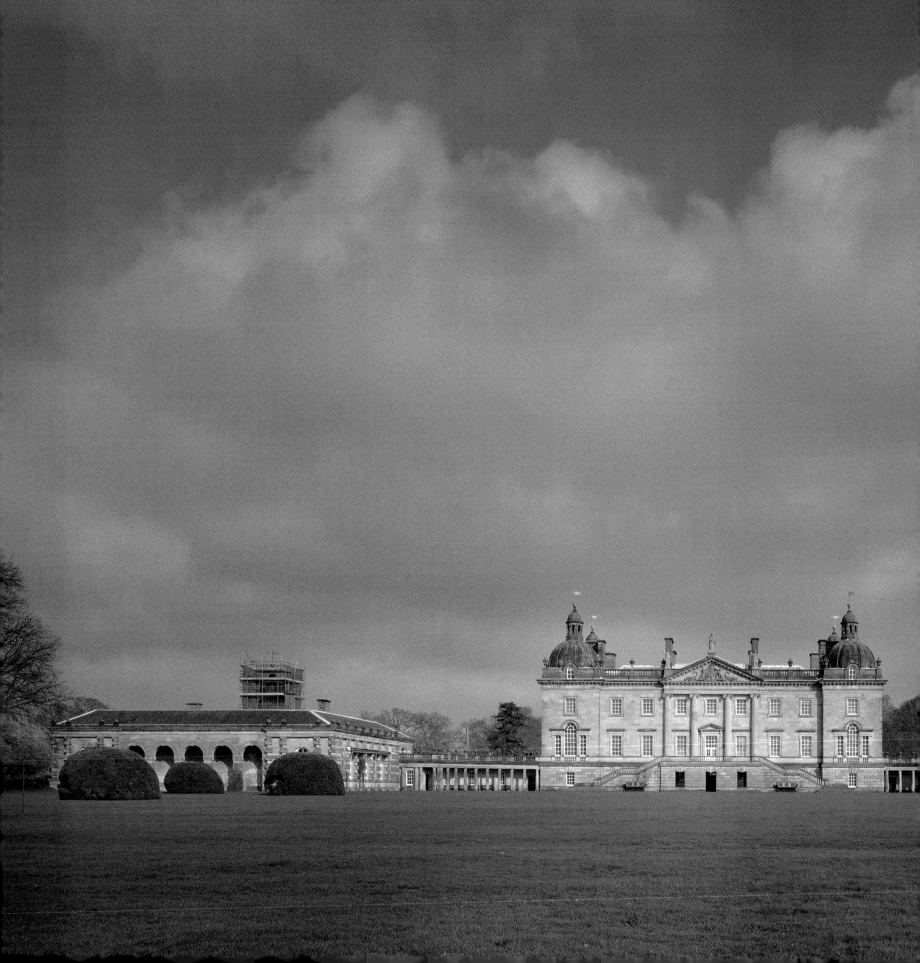

Colen Campbell's south front of Houghton Hall.

WEST WYCOMBE PARK

BUCKINGHAMSHIRE

A Palladian Arcadia

WEST WYCOMBE PARK is the creation of Sir Francis Dashwood, 2nd Baronet. As a young man, Dashwood accompanied his friend Lord Middlesex on the Grand Tour; according to a disapproving Horace Walpole, the pair were drunk the 'whole time they were in Italy'. Unsurprisingly, it was Dashwood who later created the notorious Hellfire Club – a band of rakes who, in Nikolaus Pevsner's words, devoted their time to 'wining and whoring'.

Despite his raffish disposition, Dashwood's time in Italy aroused in him a passion for classical art and architecture. He was a founding member of the Society of Dilettanti, a London dining club founded in 1734 with the specific intention of improving English 'taste and style', and serious about his inheritance, as one can see from the care and attention he gave his buildings and their landscape. His work on his inheritance beautifully illustrates how houses and gardens can be an art form.

West Wycombe Park is a fine example of encasing an earlier inherited house in what was then modern dress. This was a particularly English custom; on the continent, the owner would be more likely to demolish his property and start again, but in England that was not the case. In fact, in the nineteenth century architects went so far as to design houses on purpose to look stylistically as if they had been built at different periods. In an earlier example of this nostalgic sensibility, Dashwood began remodelling West Wycombe Park in about 1750, encasing the earlier house with classical porticos. This gave rise to problems of symmetry between the façades and the axes and alignment of the interior rooms.

The south front is composed as a double colonnade, with Roman Doric on the ground floor and Corinthian on the first. It is based on Andrea Palladio's Palazzo Chiericati in Vicenza, and reminds one of a plantation house in the southern states of America. Just like the pavilions in the landscape, the stucco façade is painted yellow with white accents. The overall effect of the colour scheme is unusual and looks almost central European in its style. The architect for the remodelling was John Donowell, about whom we know little, and the work took place between the 1750s and the 1780s.

In the hall, the columns are Roman Doric as on the south front. The mahogany staircase must have cost a great deal of money, since the wood is fine and the detail

complicated. The colour scheme is as harmonious as Wyatt's at Heveningham Hall (pages 124–29), and it is hard to tell what is eighteenth-century and what twentieth. This is of course ideal, unless the client or practitioner is attempting an interpretive rather than historicist interior scheme, as at New Wardour Castle (pages 105–11).

The character of the interiors as we see them today is attributable in the first instance to Giuseppe Borgnis, whom Dashwood brought to England in 1736 and, again, about whom we know very little. The second debt is owed to the collaboration between Sir Francis Dashwood (the 11th Baronet) and John Fowler, who worked together in the 1960s. What they did was historically based but not necessarily reproduction or academically researched. They worked interpretively with the information available to achieve a balanced and harmonious scheme. Theirs was a continuation of what they thought to be suitable to such rooms, and indeed it was.

In my view, the interiors at West Wycombe demonstrate a compatibility between client and decorator that produces the best work. The twentieth-century Sir Francis clearly possessed the same love and understanding of place as his eighteenth-century namesake and ancestor. The interiors at West Wycombe are a significant example of revived English Romanticism, which emerged in the decorative arts after World War II and is hardly present now. England was very grey after the war, and – through shortage of money and wartime loss – recovery took a long time. Solutions were found in both modernism and traditional or revived romanticism. Sometimes they worked together, as in the Festival of Britain in 1951. Fowler's decorations can be compared to the ballets of Frederick Ashton, the clothes of Hardy Amies, the stage sets of Oliver Messel, the paintings of John Piper, the writings of Daphne Du Maurier and the photographs and other work of Cecil Beaton.

If one was present in conversation with most of the above, one was conscious of their ability to think seriously and discuss their work lightly. There is a story about Sir Francis Dashwood lunching with Nancy Lancaster in the Yellow Drawing Room (pages 196–201) and saying 'we went to quite a lot of trouble to make our faux marbling look real,' to which the retort was 'and we went to quite a lot of trouble to make ours look fake.' This exchange is characteristic of attitudes and behaviour in a less assertive time than ours.

The Mahogany Staircase at West Wycombe. Mahogany was much sought after and very expensive at the time.

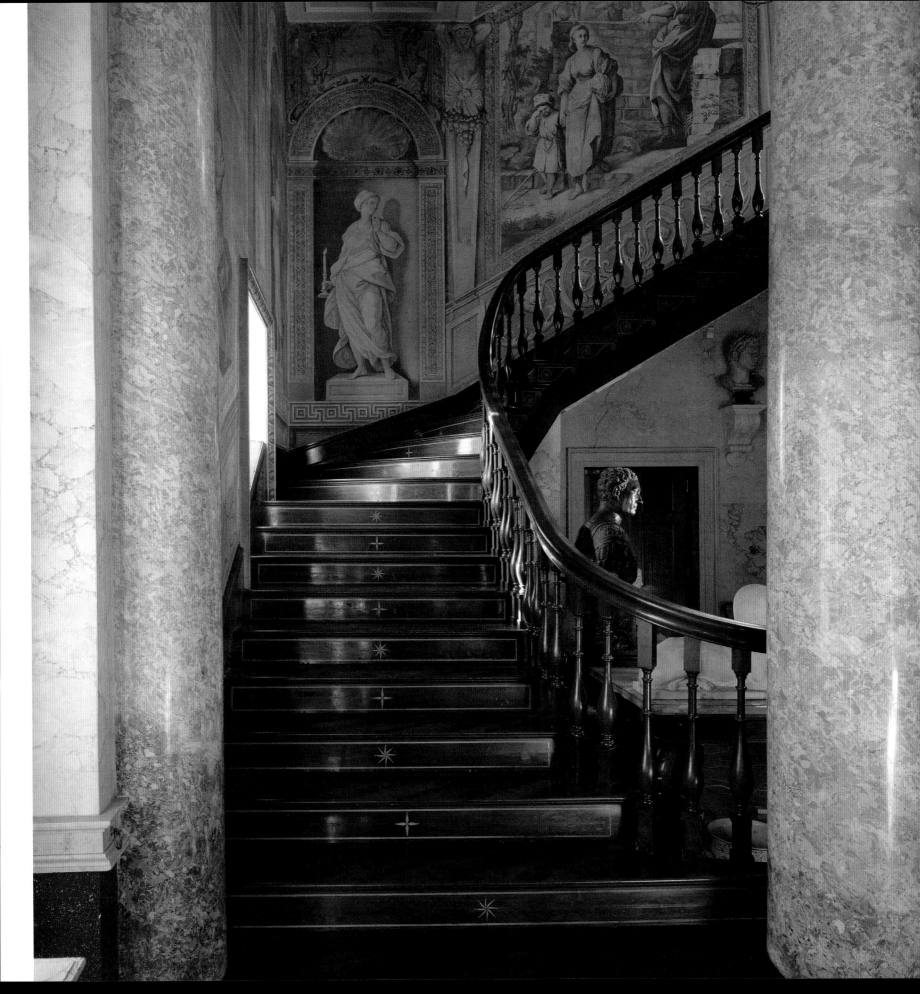

BELOW *View from the Hall to the Green Drawing Room.*
RIGHT *The Hall and staircase, with real and painted marble tonally in harmony.*

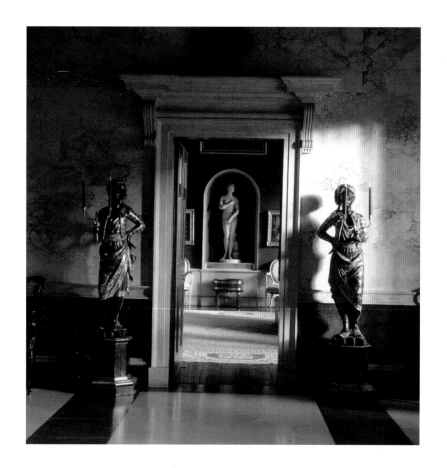

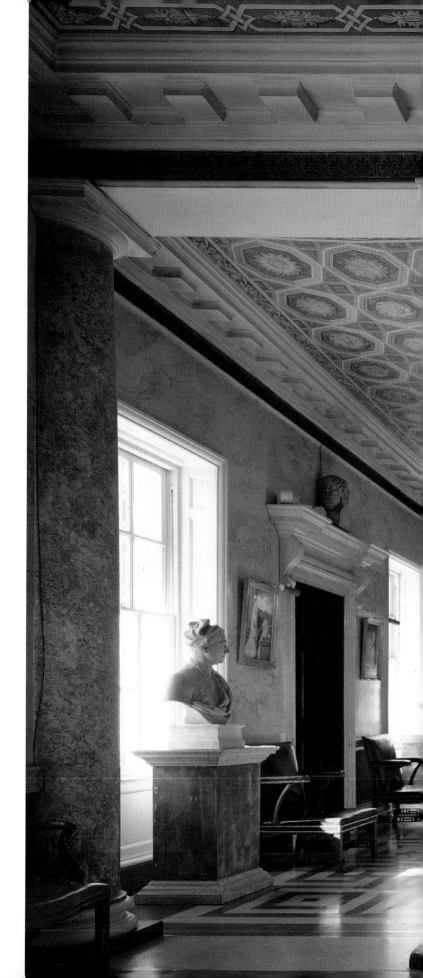

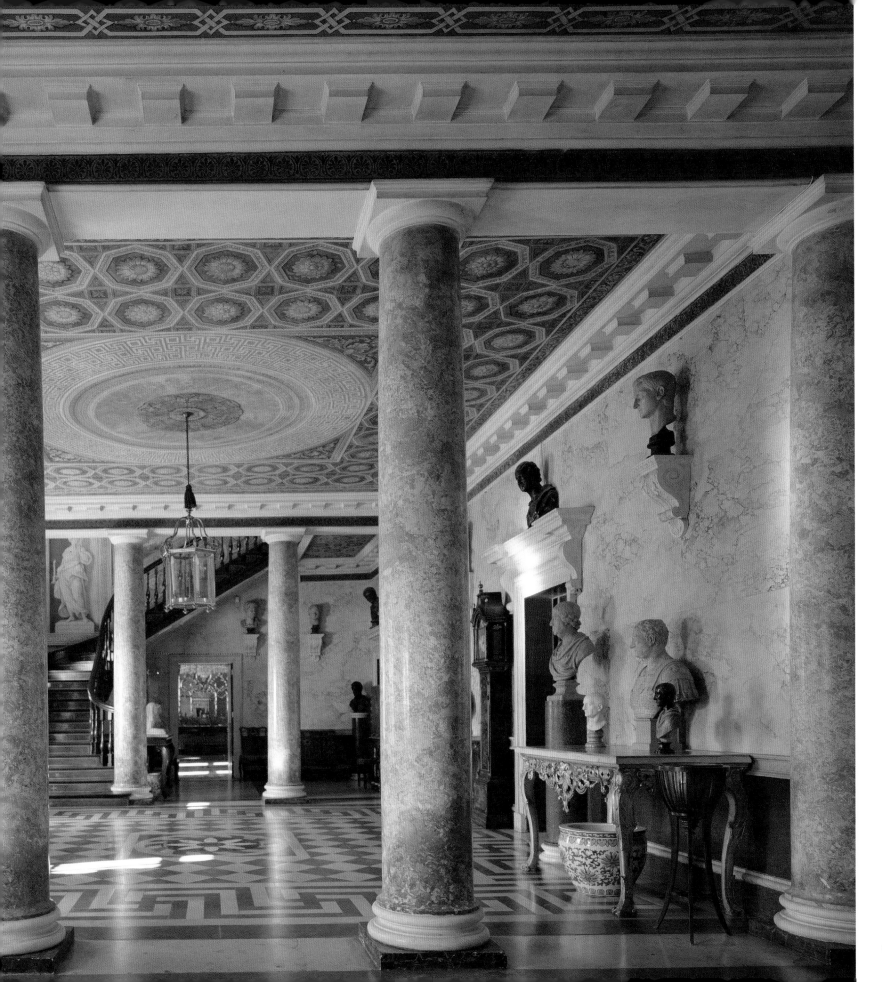

ABOVE *Detail of a sculpture in the Hall.*
OPPOSITE *View from the Green Drawing Room into the Hall.*

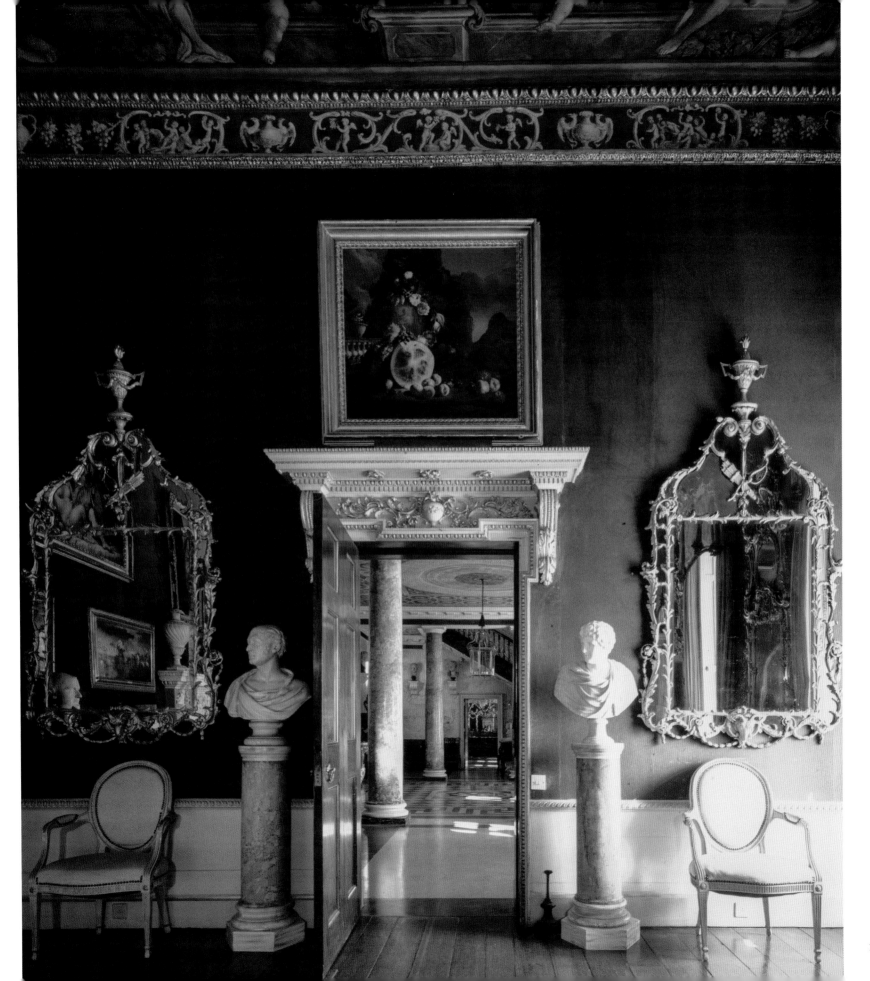

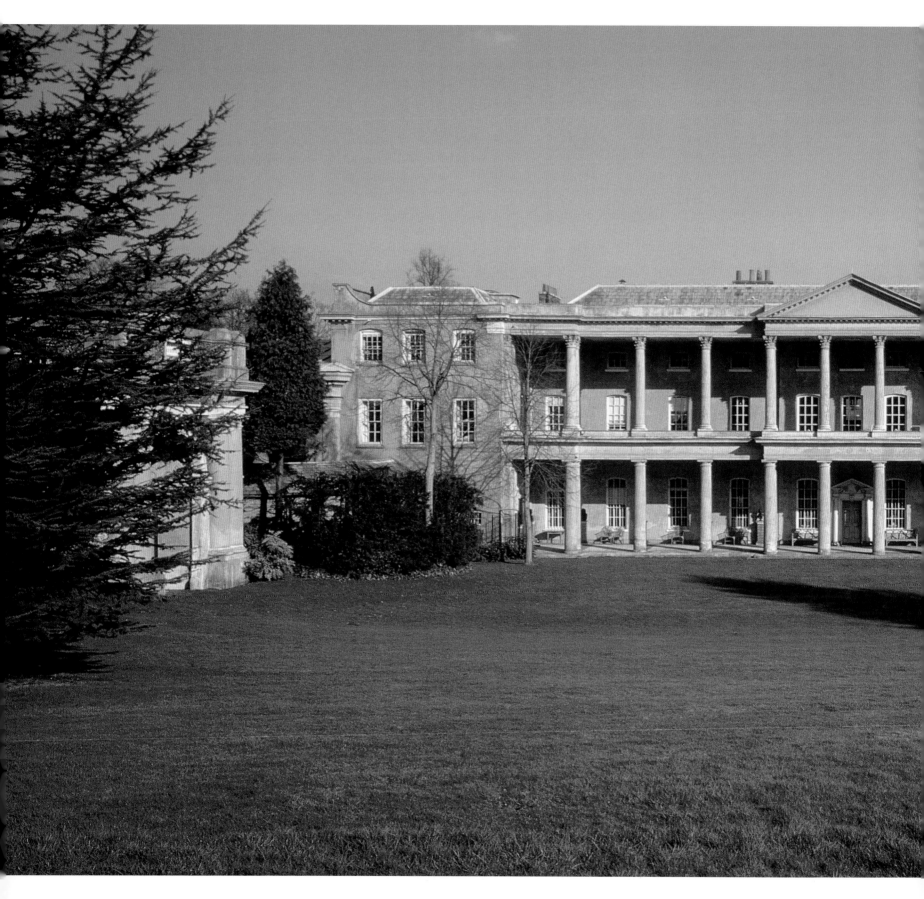

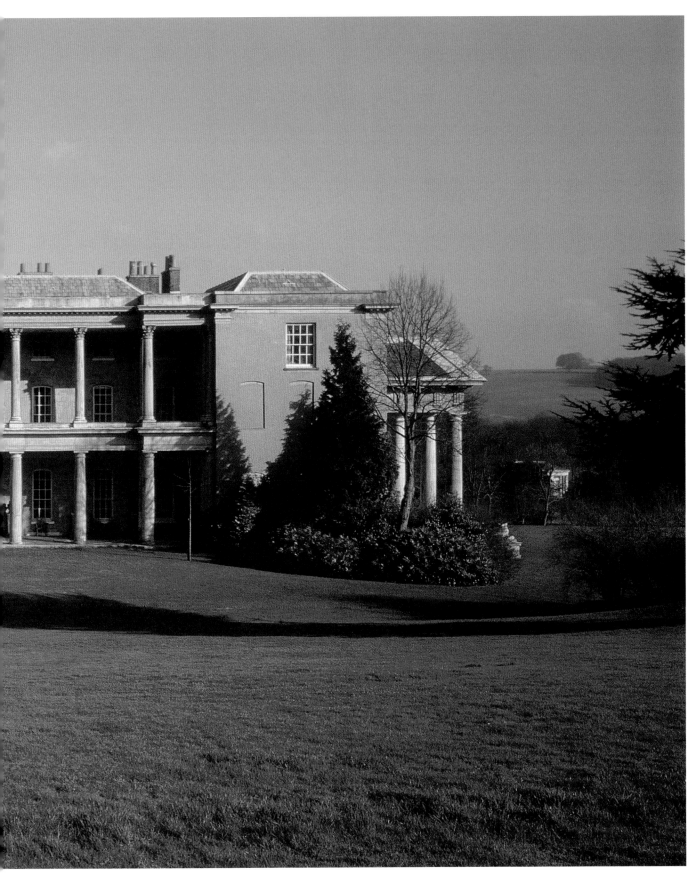

The exterior of West Wycombe. Note the yellow-painted stucco contrasting with the stone columns.

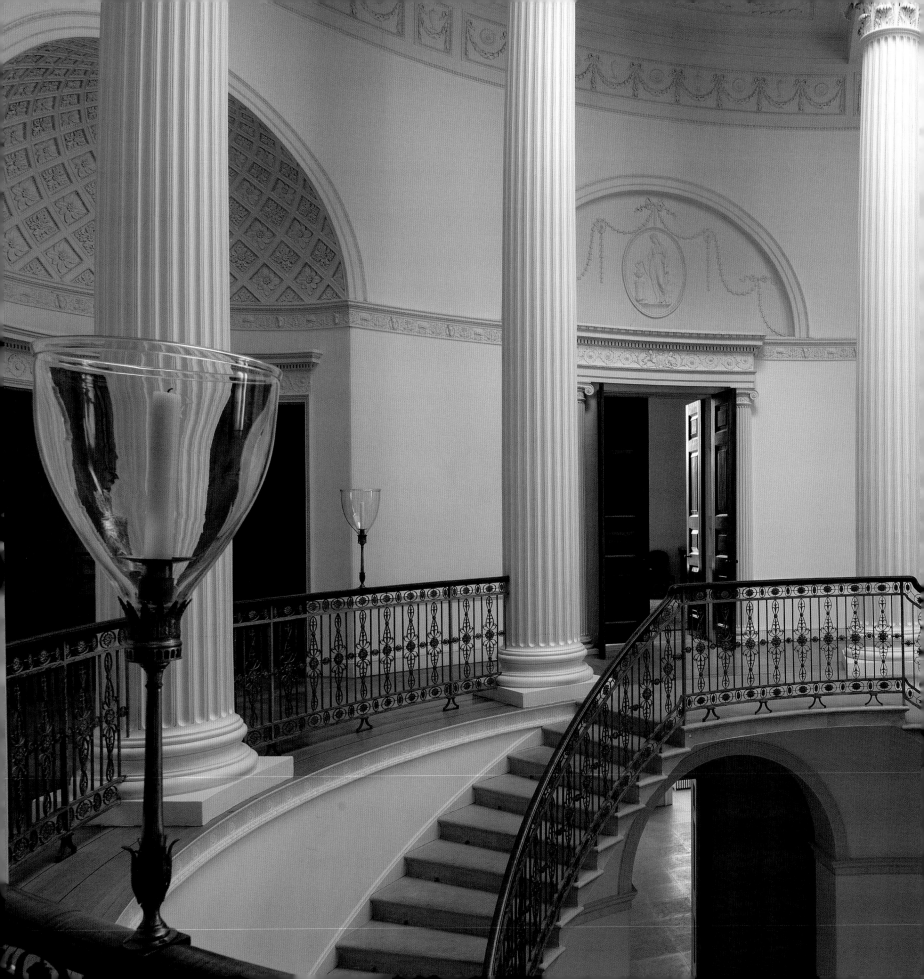

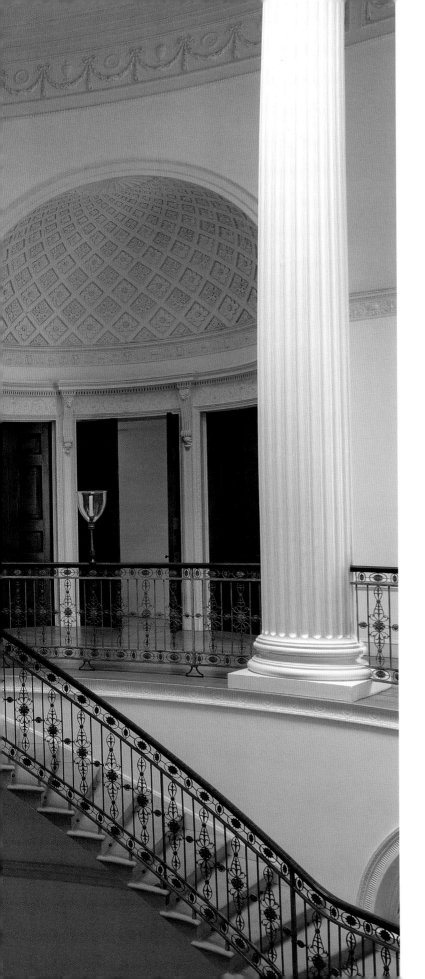

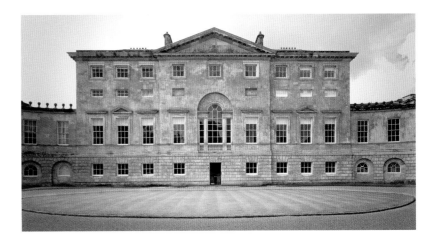

NEW WARDOUR CASTLE
WILTSHIRE

A Spectacular Staircase

In 1770 the 8th baron arundell of Wardour commissioned the construction of New Wardour Castle near Tisbury in Wiltshire. The 30-year-old Arundell built his Palladian house in the grounds of the original Wardour Castle, which had fallen into ruin after being besieged by Parliamentarians during the English Civil War. The remains of the castle lie across the valley, and were kept by Arundell as romantic landscape decoration.

Despite their shattering defeat, the Arundell family gradually regained power through the English Commonwealth and the Glorious Revolution, but it was a precarious recovery that was nearly thwarted by Arundell's project for the new Wardour Castle. His lavish spending was such that the family almost returned to financial ruin. Arundell chose the architect James Paine to realise his vision. Sadly for Paine, history has been unkind to his life's work, and many of his buildings were never completed, or have been severely altered or razed to the ground. Fortunately, Wardour Castle remains intact.

Paine was part of the second wave of Palladian architects in eighteenth-century England and, despite being an Anglican, worked for a number of prominent Roman Catholics. One of the undisputed glories of New Wardour Castle is the chapel, which was originally built by Paine but added to by Sir John Soane a decade later. The implication is that Paine's work was deemed a little old-fashioned at a time when tastes were changing rapidly from Palladian to neoclassical. It is a comparable transition to that between John Vardy and James Stuart in the mid-eighteenth century at Spencer House in London (pages 131–39).

LEFT *The first-floor landing of the Staircase Hall gives on to the principal rooms.*
ABOVE *The beautifully balanced entrance façade has a surprisingly small front door.*

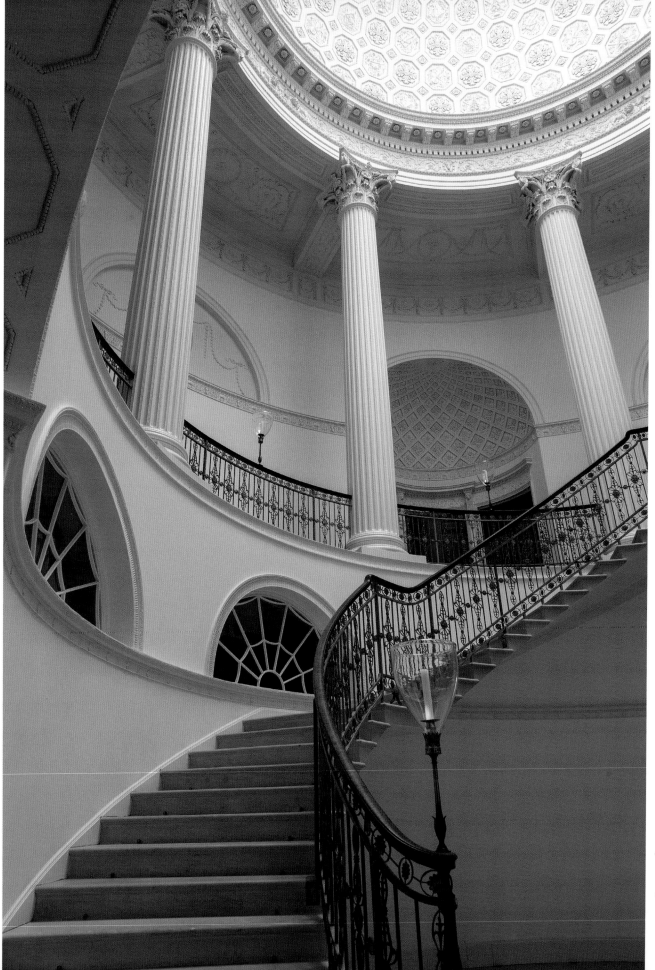

LEFT *The Staircase, leading from ground to first floors.*

OPPOSITE *The ground floor of the Staircase Hall, with rare shaded candles on the newel posts.*

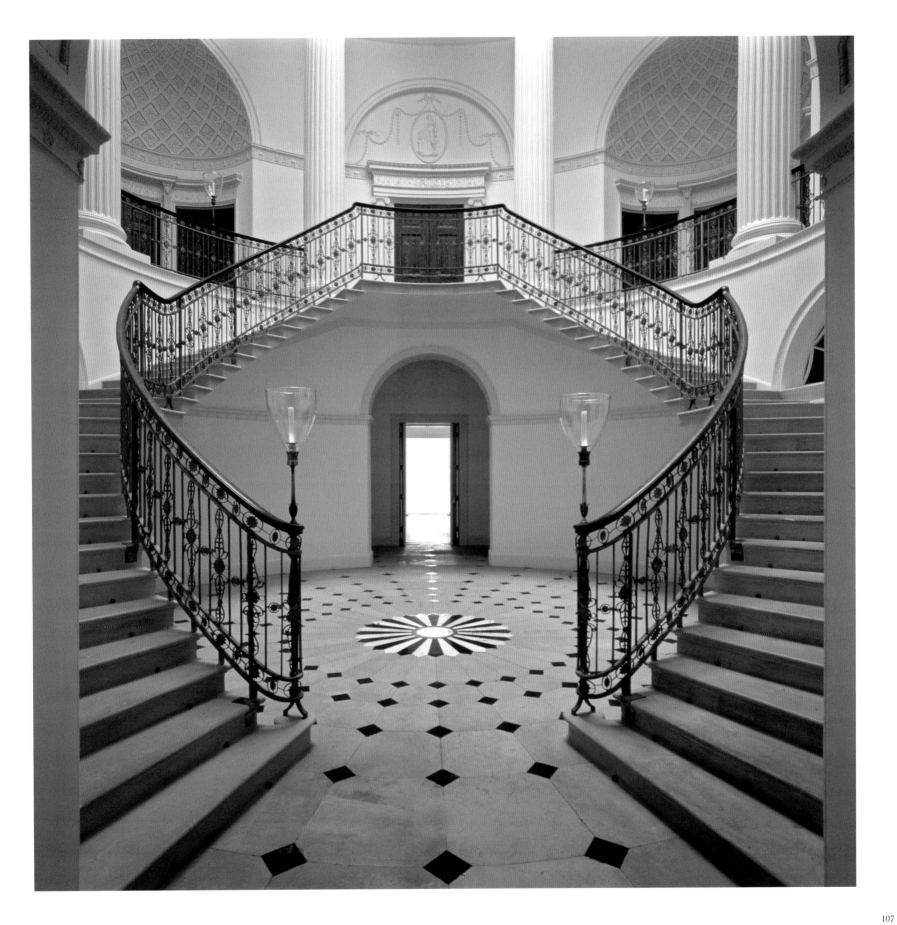

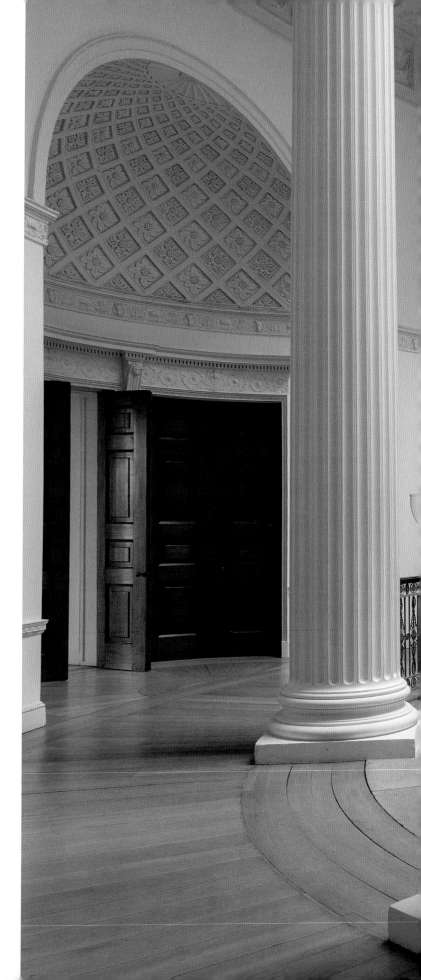

The first-floor landing of the Staircase Hall, looking across the drum.
The confusion of the ironwork clarifies as one walks round.

Paine's north elevation at New Wardour Castle looks like an engraving from an eighteenth-century architectural pattern book. It is balanced, strong, academic and plain; it gives nothing away of the glorious staircase, hall and gallery inside, nor of the more decorative south elevation, which is adorned with the same Corinthian order as the interior staircase. This external severity was common in English houses between the eighteenth and twentieth centuries, and was said to have particularly surprised Diaghilev's Ballets Russes dancers, who were shocked at the austerity of London houses in comparison to the colourful and ornate façades of St Petersburg.

The curiously small front door, which Pevsner terms 'distressingly unstressed', has miraculously avoided the subsequent addition of a portico, porch or porte cochère, as often happened in the nineteenth century, by which time England had become rather richer and more bluff.

The entrance hall is as plain as the front elevation. It is unfurnished, low-ceilinged and symmetrical in design, and houses a rare, black iron stove that is contemporary with the building. In contrast to this unremarkable entrance is the staircase hall, which lies beyond a set of double doors and through a small lobby. The circular hall is 50 feet (just over 15 metres) in diameter, and soars 60 feet (18 metres) above a podium with a giant Corinthian order to an oculus in the dome above. It is like a Roman temple that has been turned inside out, and the change in scale is totally unexpected.

A split, double-cantilevered staircase curves around the podium wall and reaches to the gallery level; it is a deceptively simple design that would have required great skill to set out, let alone build. As striking is the ironwork on the balustrade, which is not only exceptionally fine but also structurally remarkable given the rising and curved element of the stairs. The ornate plasterwork that decorates the arched recesses and much of the upper level is the work of a master, and as refined an example as one can find in England.

After a stint as Cranbourne Chase School, the house was converted into ten luxury apartments in the 1990s. The designer Jasper Conran, who bought the principal apartment containing the hall in 2010, has kept it entirely unfurnished and painted it in two shades of putty white – a stark but successful contrast to how it must have looked in the eighteenth century, when there would most probably have been a polychromatic scheme.

This pared-back aesthetic is highly effective and amplifies the colour and texture of the wood handrails, double doors and gallery floor. The ironwork of the balustrades is stripped of paint and shows grey. The light fittings and door furniture are brass, and the pipes of the organ are gilded and all sing in contrast to their tonally minimal surroundings. The stairs are stone, as is the ground floor, which is inset with marble. It is a beautiful scheme that lets the architecture speak for itself.

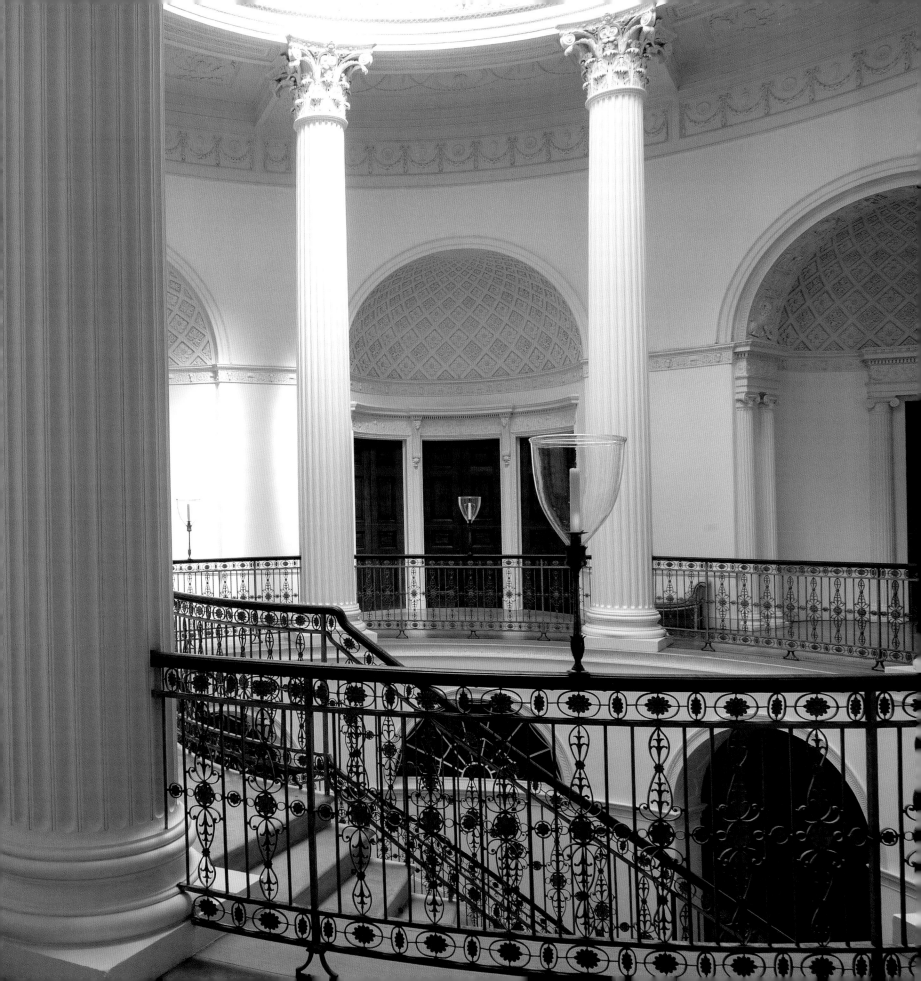

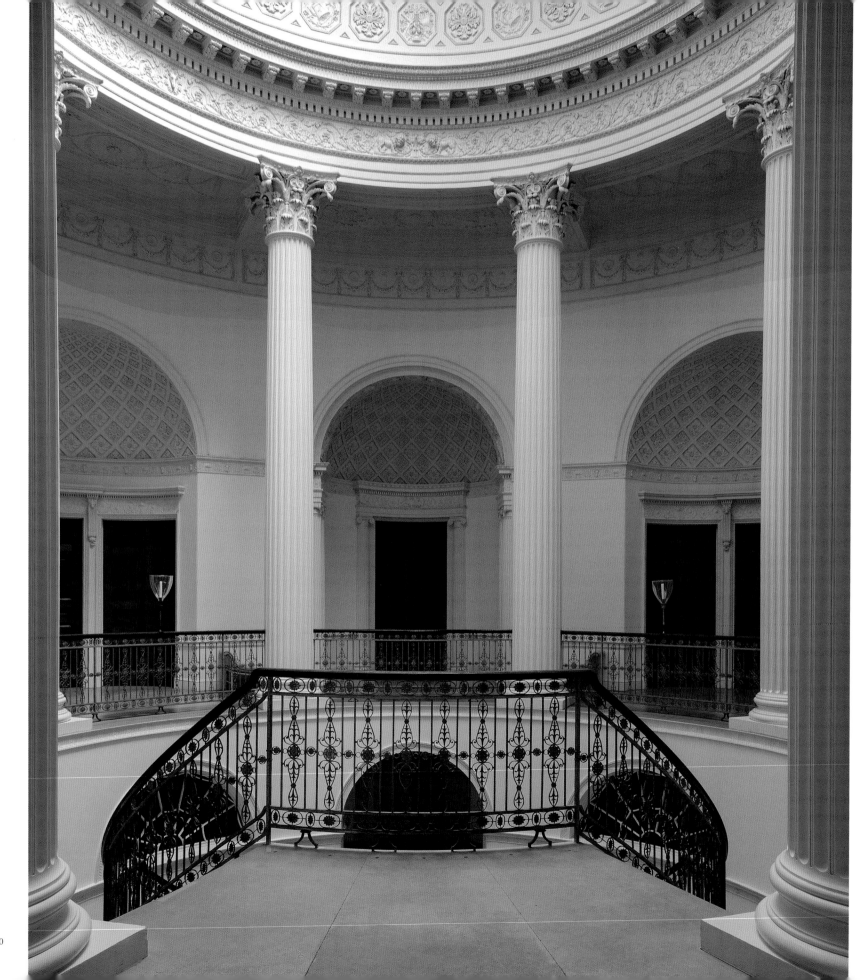

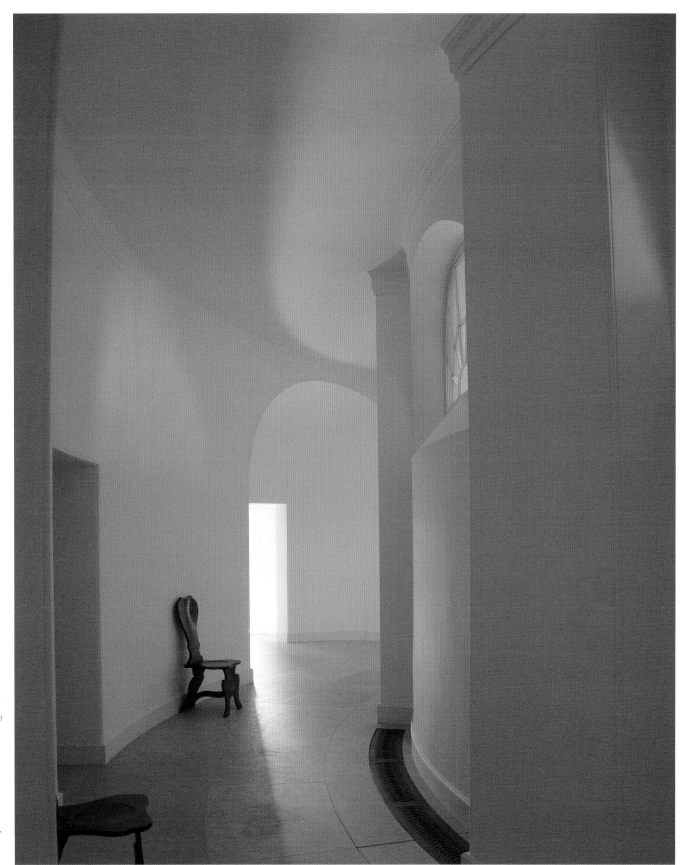

OPPOSITE *The first-floor landing of the Staircase Hall. This is the view on leaving the principal room.*

RIGHT *The passage behind the ground-floor Staircase Hall podium is impressive and beautiful, although plain because it is a service area. This is how an 18th-century Palladian interior might have looked before the mouldings were added.*

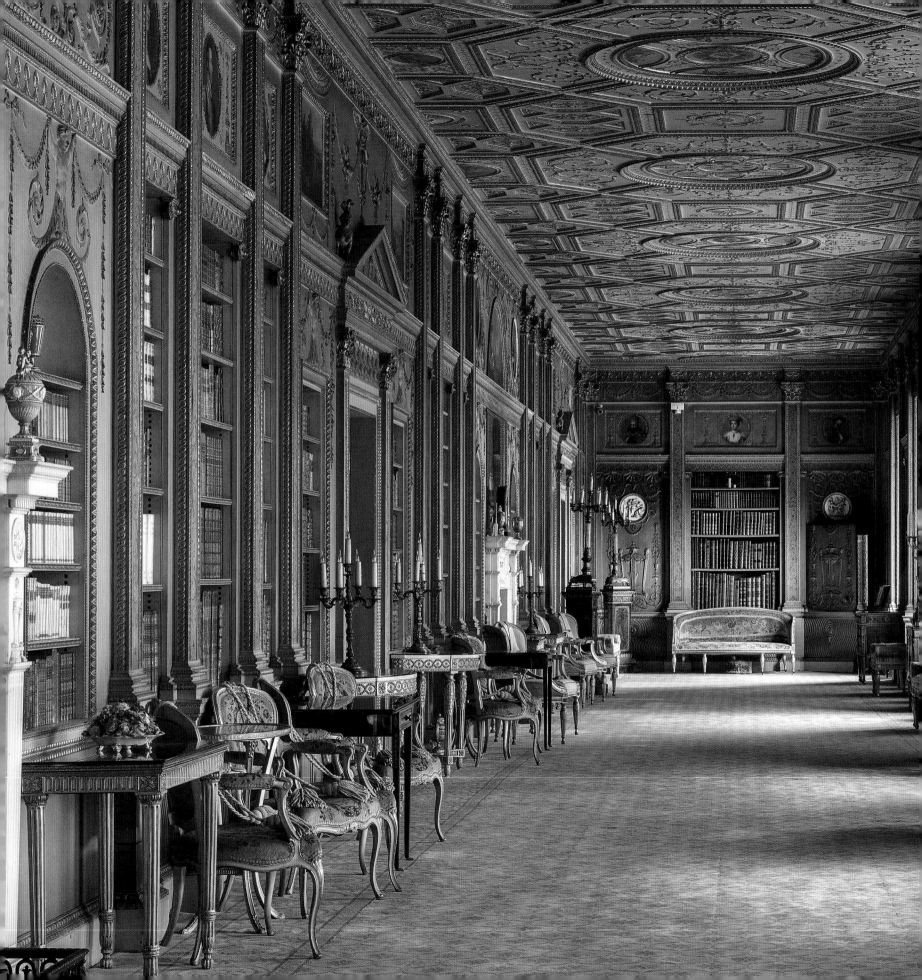

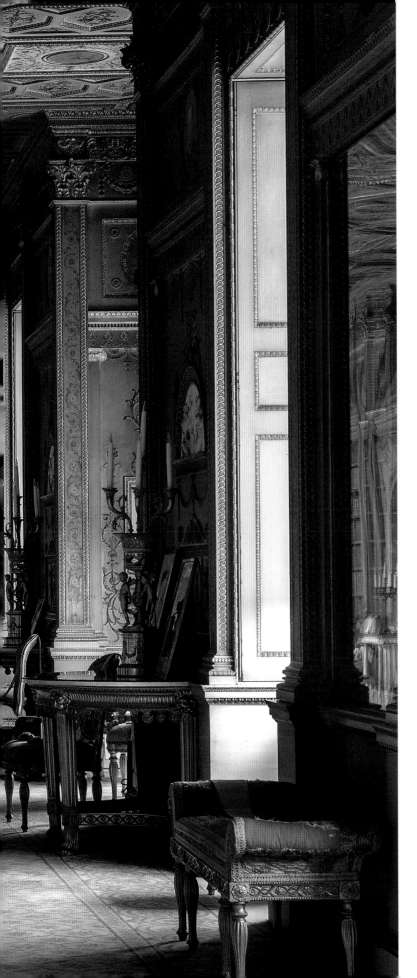

SYON HOUSE AND HEVENINGHAM HALL
MIDDLESEX AND SUFFOLK

—

The Best of English Neoclassicism

Syon house is the london seat of the Duke of Northumberland. Set on the banks of the River Thames in Middlesex, the estate has had a turbulent history. Hugh Montgomery-Massingberd provides a neat inventory of its past in his book *Great Houses of England and Wales* (1994): 'This is the place where Caesar's legionaries crossed the Thames in 54 BC; where Henry V founded a Bridgettine monastery; where Henry VIII's coffin burst open and his rotting corpse was worried by dogs [and] where Lady Jane Grey unwisely decided to accept her father-in-law the Duke of Northumberland's offer of the crown.'

The saga of Syon House could fill countless volumes, but what really sets the building apart for us is its distinguished interiors. As Sir John Betjeman commented, 'You'd never guess that battlemented house contained such wonders as there are inside it.' The Earl and Countess of Northumberland (later the Duke and Duchess of Northumberland) commissioned Lancelot 'Capability' Brown to transform the riverside parkland and Robert Adam – who had previously worked for them at Alnwick Castle in Northumberland – to redesign the then unfashionable interiors.

Adam's initial plans for Syon House were considerably more ambitious than what was managed. The intention was to redecorate the entire interior and add a ballroom, but lack of funds thwarted its completion. Nonetheless, he succeeded in creating a series of striking rooms heavily influenced by Roman antiquity, including the opulently imperial Anteroom (sometimes called the Vestibule), between the entrance hall and the dining room.

In 1762 Adam had recently returned from his Grand Tour, having travelled through Italy and Dalmatia (present-day Croatia), and his schemes at Syon House were influenced accordingly. He designed the entrance hall in a style based on a Roman atrium, with statues, a black-and-white marble floor and decorative stucco work to be made by the master craftsman Joseph Rose. In contrast, the adjoining Anteroom is a striking mix of bold colour, gilding and pattern. Adam drew on contemporary scholarship to illustrate that classical decoration need not be cold, restrained and formal; it could in fact be lavish, grand and elaborate.

Robert Adam's disciplined design for a library in the Elizabethan shell of the Long Gallery at Syon House.

In 1766 ADAM PUBLISHED a set of visual studies of the ruins of Diocletian's Palace at Spalato (now Split) in Dalmatia. The publication of this book of engravings, which demonstrated the exceptional grace and symmetry of the buildings, would prove to be very influential to the development of the neoclassical Georgian style in England, and later in Russia and America. The strength of colour in the Anteroom is unusual for Adam's work in England, and reminiscent of the bolder interiors found elsewhere, for example in St Petersburg. We are more used to seeing his work in pastel shades.

Twelve Ionic columns punctate the room, arranged in such a way as to make the irregularly shaped vestibule appear perfectly square. It is a clever act of visual trickery that is reinforced by the addition of the gilded statues above each column. The majority of the columns were sent to Syon from Rome in 1765 by Adam's brother James, dredged – so the story goes – from the depths of the River Tiber. The remainder were made to match the verde-antique in marble scagliola.

ABOVE *Detail of an 18th-century settee in the Long Gallery at Syon House. Note the golden carved wood, the gold passementerie and the silk damask – all original.*
OPPOSITE *The short end of the Library in the Long Gallery at Syon, with disguised doors.*

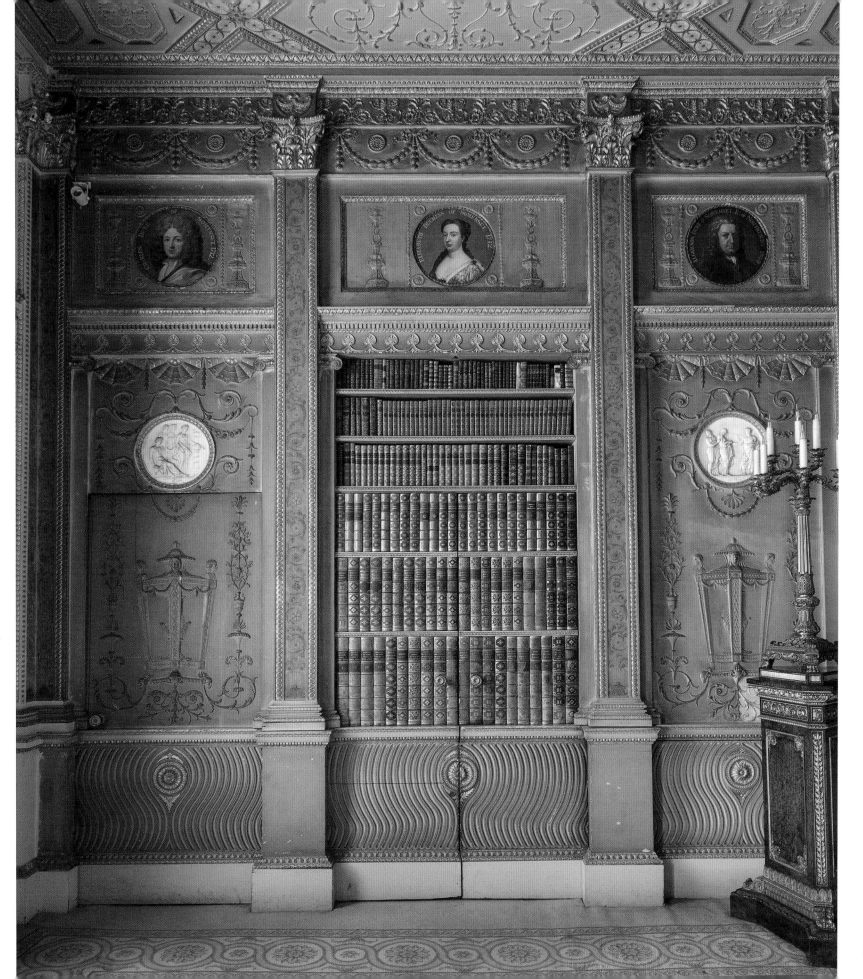

ABOVE *The Anteroom (sometimes called the Vestibule) bell lever at Syon House.*
OPPOSITE *At Syon House, architecture, sculpture, precious materials, gilding and colour combine to give the impression of an 18th-century Englishman's idea of ancient Rome.*

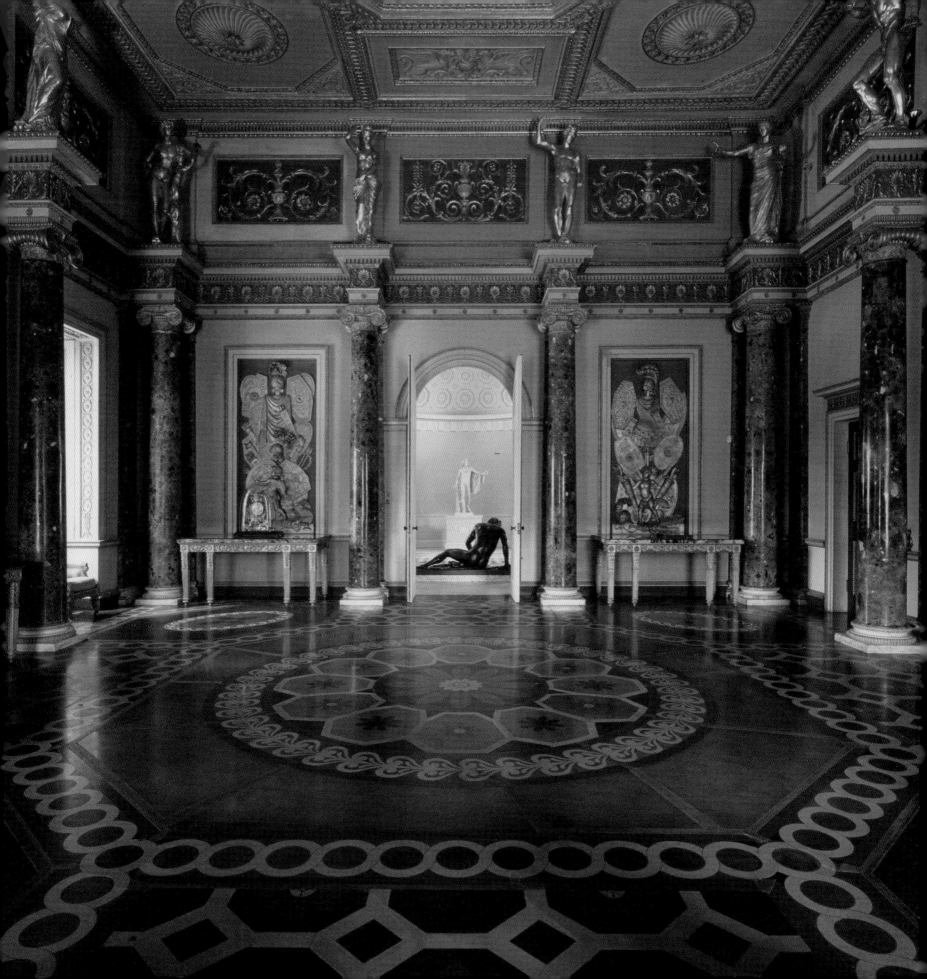

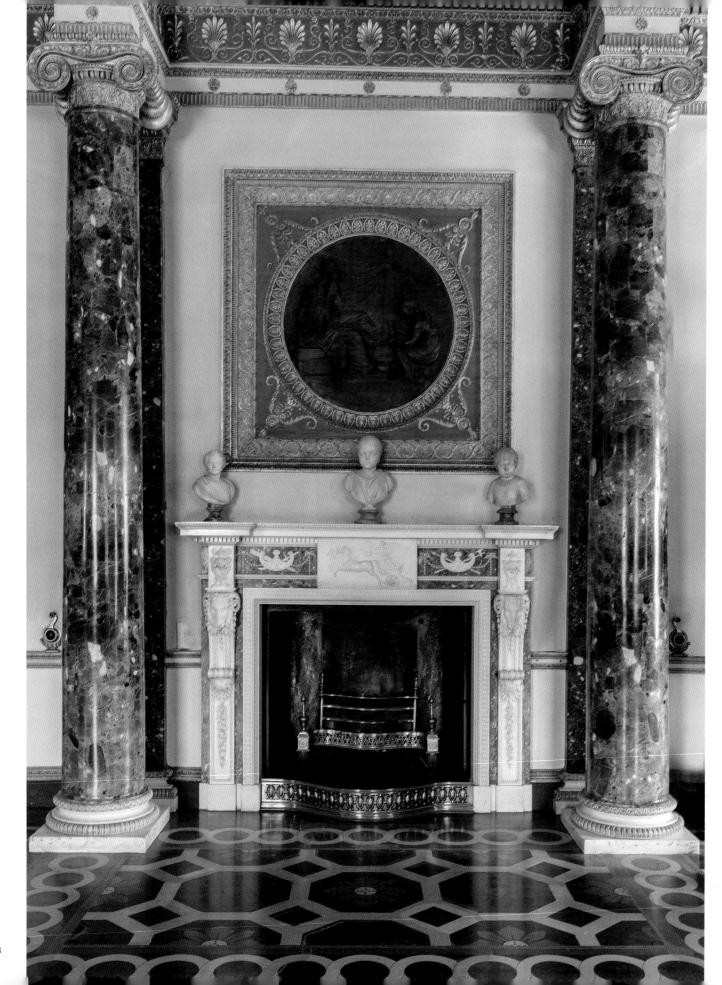

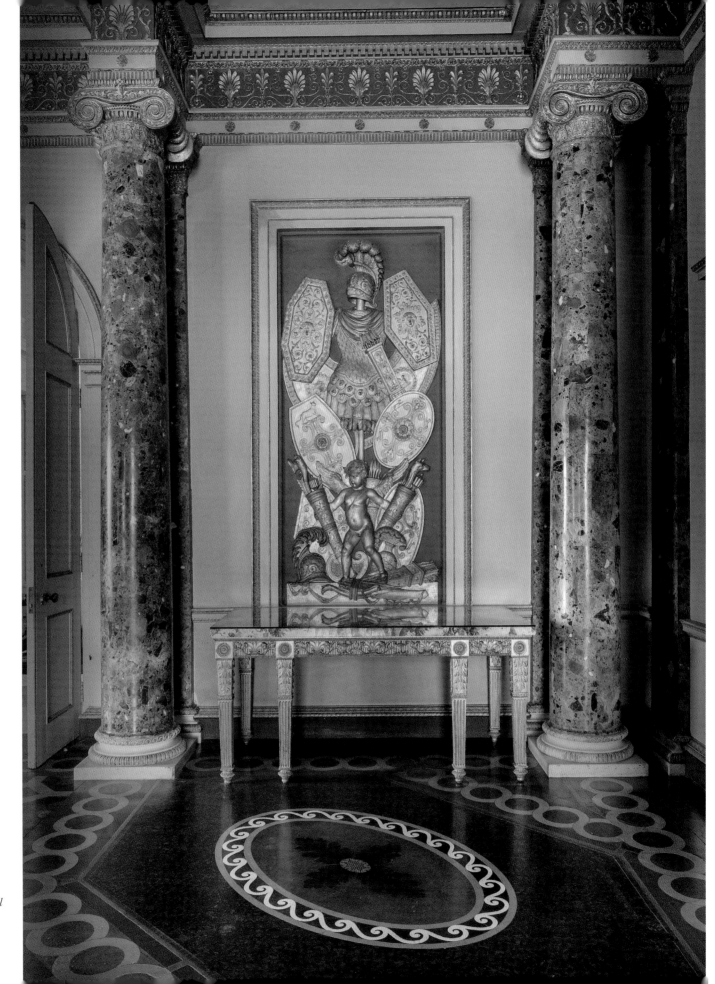

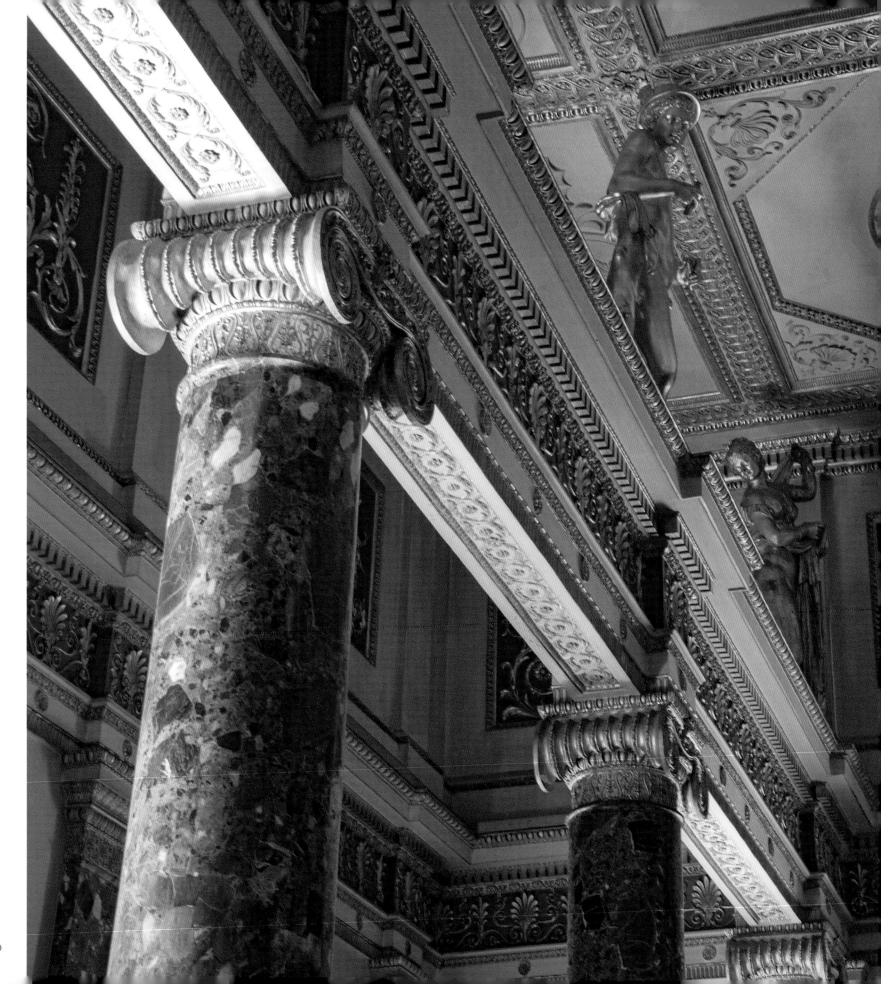

THE PATTERN OF THE POLISHED scagliola floor is reflected in the plaster ceiling, and the two schemes are united by a set of verde-antique scagliola pilasters. Like the columns, these are topped with gilt Ionic capitals. The entablature is adorned with a honeysuckle frieze on a blue ground. The gilded trophies on the walls, by Joseph Rose, are some of the best of their kind. With the exception of the side tables designed by Adam, the room is practically empty of furniture. The scagliola floor had to be made twice before it was deemed to be good enough, which makes one wonder how often perfection was achieved first time in houses such as this.

The room was not simply a showcase for the Duke of Northumberland's extraordinary wealth and confidence; it was, and still is, one of the best demonstrations of academic English neoclassicism. Adam's rich and vital decoration skilfully distils and reworks the classical architecture he encountered on his travels, and was hugely progressive for his time.

Until it was demolished in 1874, Northumberland House on the Strand was the Duke of Northumberland's London residence. It was also home to the Glass Drawing Room, one of Adam's most celebrated interiors. The room, which was built between 1770 and 1775, was famed for its ornate detail, many-coloured ceiling and walls lined with back-painted glass. The glittering red and gold glass and the lavish use of gilded wood and metal must have been equal in impact to the Anteroom at Syon. Drawings exist of the complete room, and one surviving wall panel is in the British Galleries at the Victoria and Albert Museum.

In the 1950s the then well-known dealer in architectural salvage and antiques Bert Crowther had his base at Syon Lodge, which bordered the park at Syon. He would send out panels, including probably the one that is now in the British Galleries, to decorate society balls. The moving about of these objects for use as scenery must have caused great loss and damage, and demonstrates how undervalued such works of decorative art were even until the middle of the twentieth century, and sometimes later.

Detail of the entablature, ceiling, statuary and the high quality of the decorative plasterwork in the Anteroom at Syon House. Most of the columns are from ancient Rome, salvaged from the River Tiber.

This austere elevation of Syon House is crowned by the Percy lion.

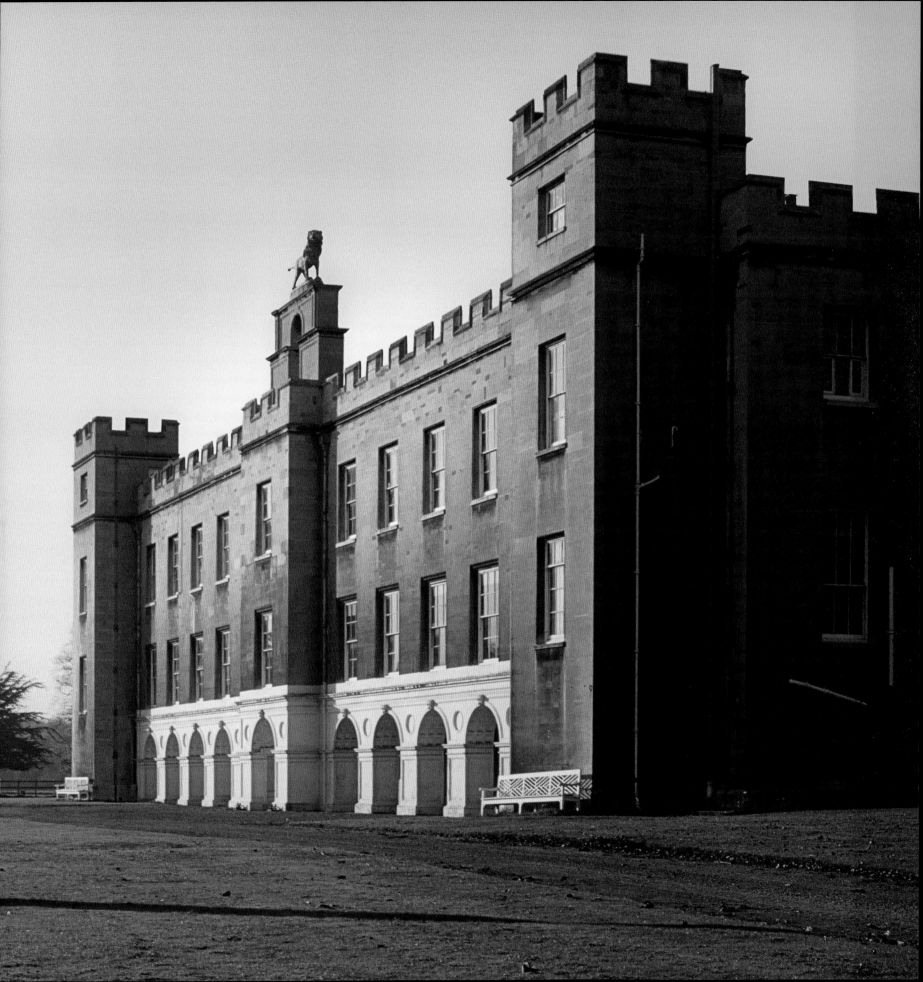

In 1777, SHORTLY AFTER Adam had completed his work at Syon House, the Vanneck family commissioned the rebuilding of Heveningham Hall in Suffolk. The Vannecks were of Dutch origin and part of the rapidly expanding and very successful merchant class in London. When his father died, Sir Gerard Vanneck charged Sir Robert Taylor, the Bank of England's architect, with rebuilding the existing house in the Palladian tradition.

In 1780 Taylor was superseded by James Wyatt, a young architect who was fast acquiring a considerable reputation. He took on sole responsibility for the interiors, including the entrance hall, which is incidentally one of my favourite rooms in the country.

I first visited Heveningham Hall in 1970 and was greeted with a cup of tea by the housekeeper, who was acting as a guide and who showed me around. In continuation with the county's rich oral tradition, she told me that on commissioning the house Sir Gerard had said that 'he wanted to walk into a palace out of a cornfield.' To my mind, this is exactly what he achieved.

Wyatt created a vaulted ceiling supported by pilasters in the entrance hall, which is unexpectedly based on the perpendicular Gothic style but blends in with the otherwise neoclassical design. In contrast to the Anteroom at Syon House, this is a room of chaste restraint. Wyatt created a subtle and harmonious scheme of decoration as well as design. The walls and ceiling are enriched with delicate stucco work, and painted in shades of apple green. There are yellow sienna scagliola pillars and pilasters. There is a floor of pink and black marble and dressed natural stone that echoes the design of the ceiling. There are two pairs of handsome mahogany doors, 12 feet (3.7 metres) high, on the principal axis. There is no gilding, but astonishingly precise paintwork. It is important to note that this is one of the few examples of original paint in England on the scale of a complete room.

This is a room that could very easily have fallen victim to changes in taste, yet, despite its relative simplicity, it miraculously survived the nineteenth-century appetite for ostentatious decoration. There is an argument that Wyatt's pared-back scheme was not a decorative choice but rather the result of Vanneck's frugality. He was a merchant and self-made man, who, unlike many members of the English aristocracy of the time, was not endlessly rich or ostentatious.

Regardless, this room is Wyatt's best surviving example of unaltered interior decoration. Alongside Adam's Anteroom at Syon House, it ranks as one of the outstanding neoclassical rooms in Britain.

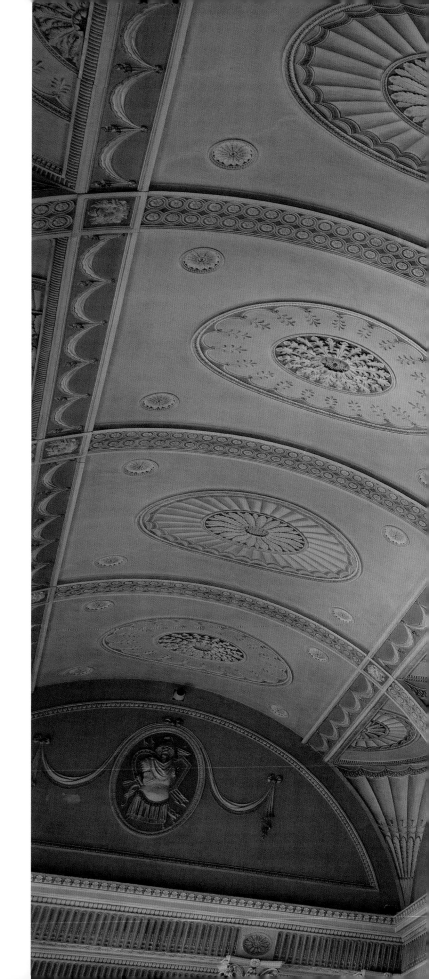

Sage-green ceiling and apple-green walls at Heveningham Hall.
The grading of the tones in the paintwork is subtle and emphasises the modelling
of the plasterwork. The trompe l'œil *is restricted to the fanlight spandrels.*

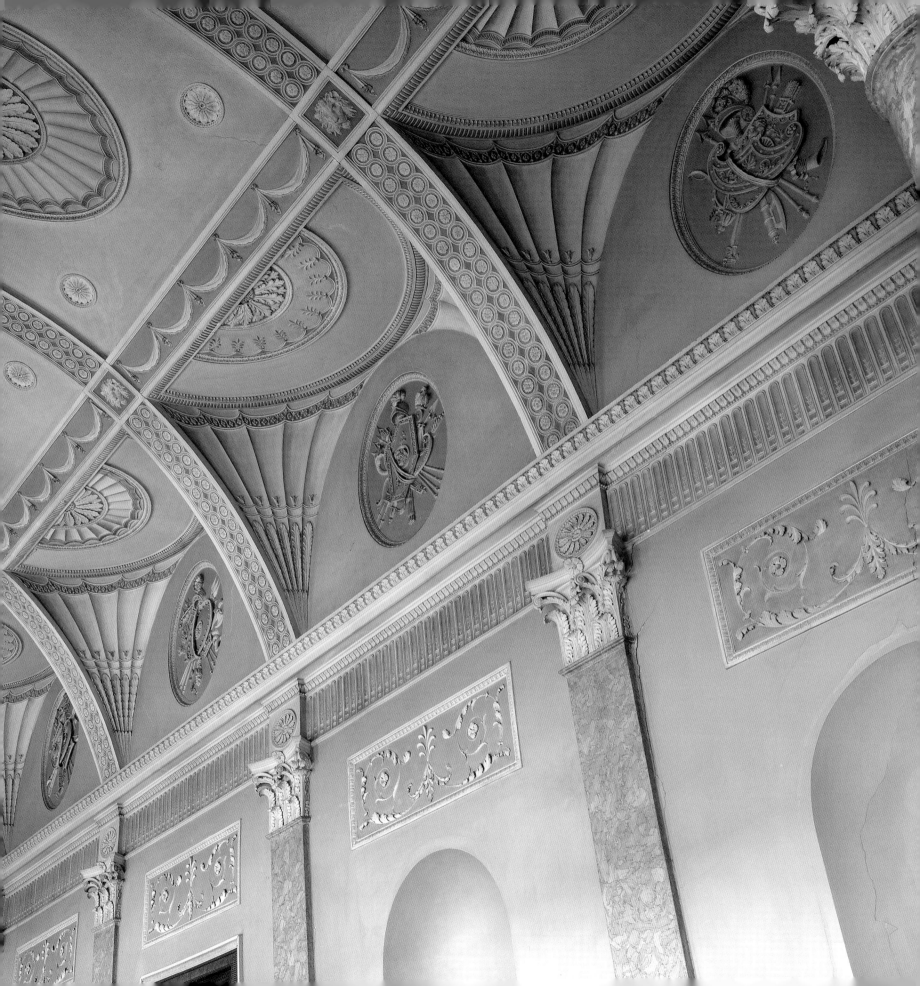

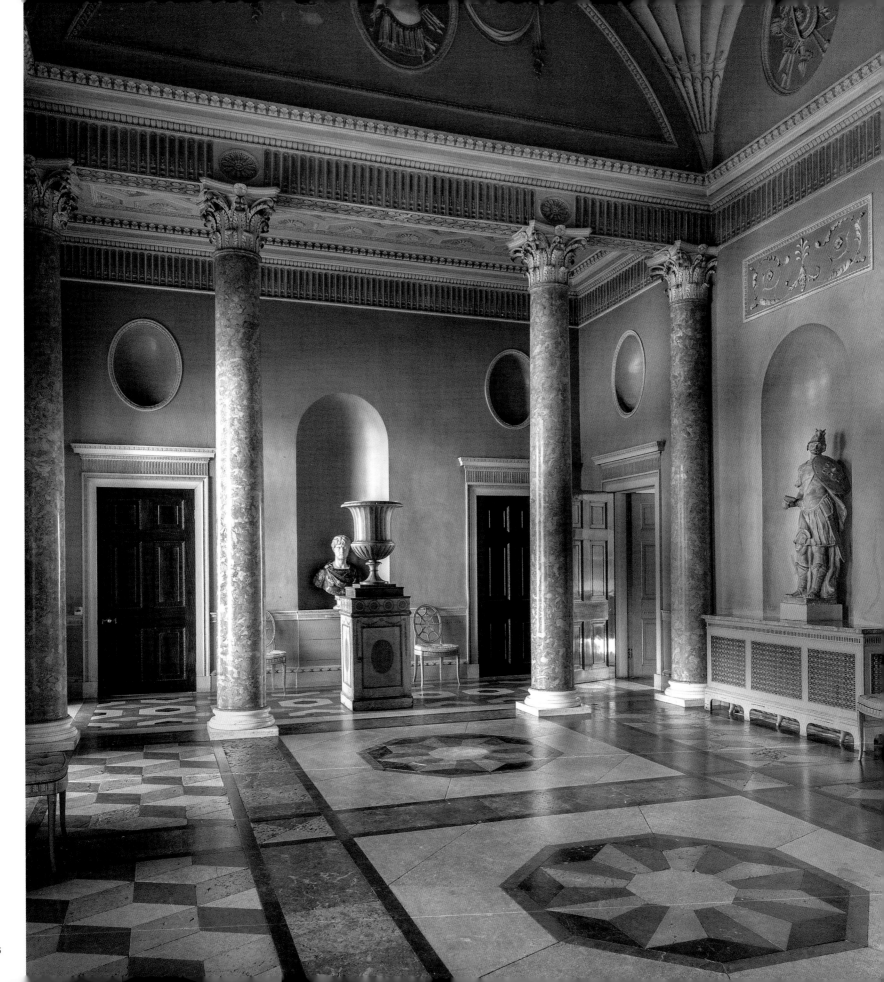

OPPOSITE *The entrance hall at Heveningham displays one of the very few surviving 18th-century schemes of painted decoration.*
The floor is of four different stones. The doors are mahogany, the chairs are original to the room and the columns are scagliola.
ABOVE *From a pink Saloon into a green Anteroom at Heveningham. The colour schemes harmonise with*
each other in weight of tone. As usual in England, throughout the centuries, the floors are plain oak boards.

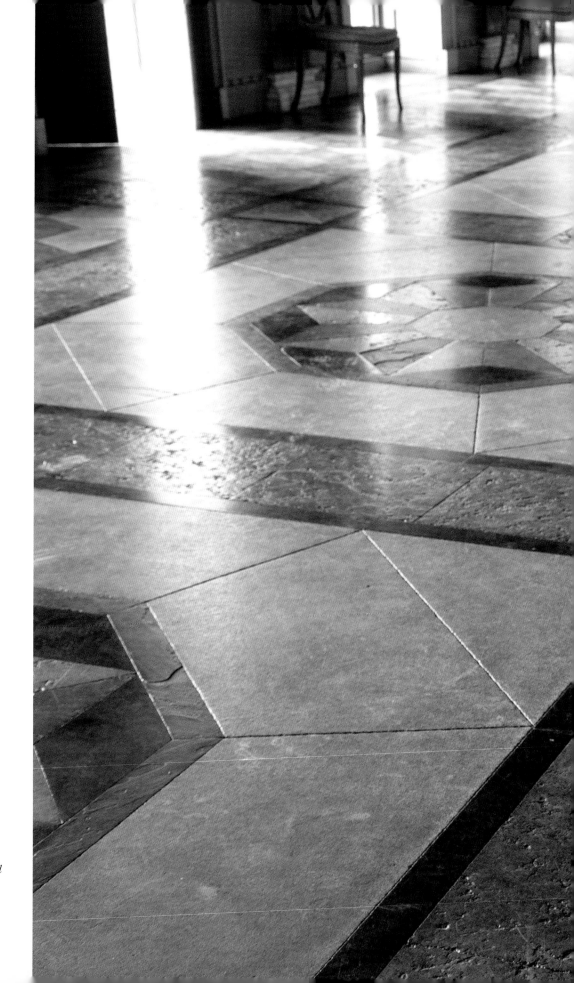

The floor of the entrance hall at Heveningham, showing the four different stones and their relationships.

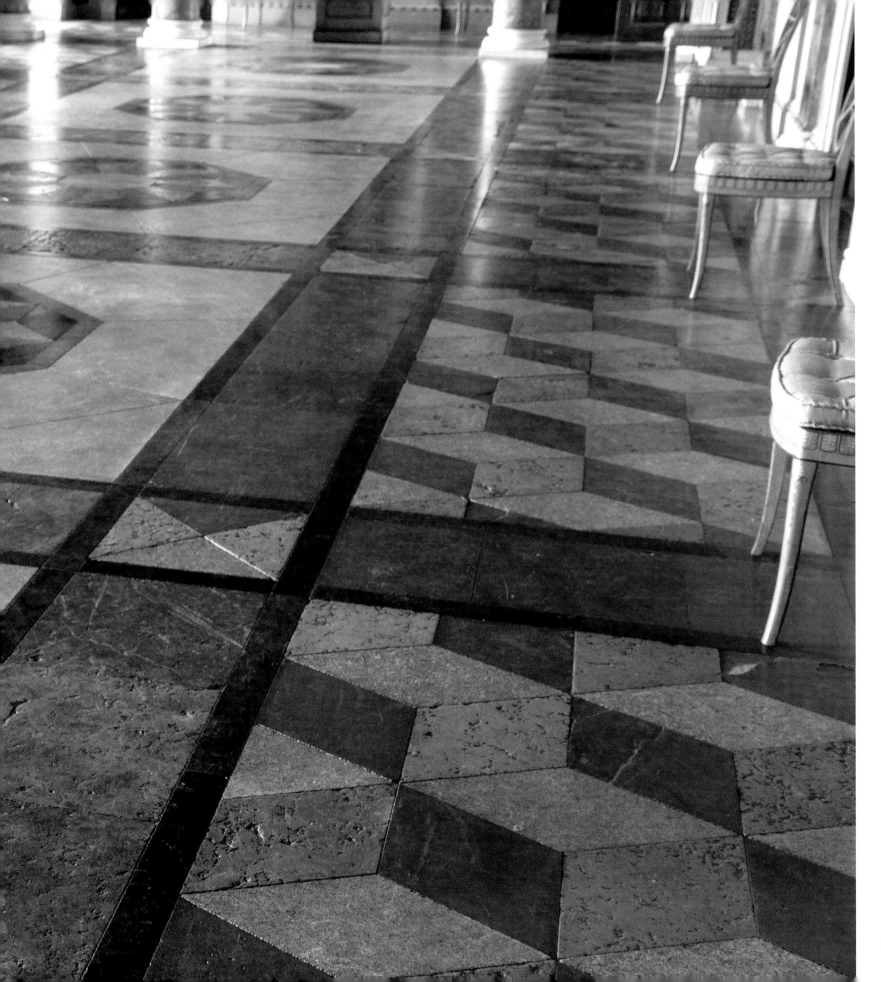

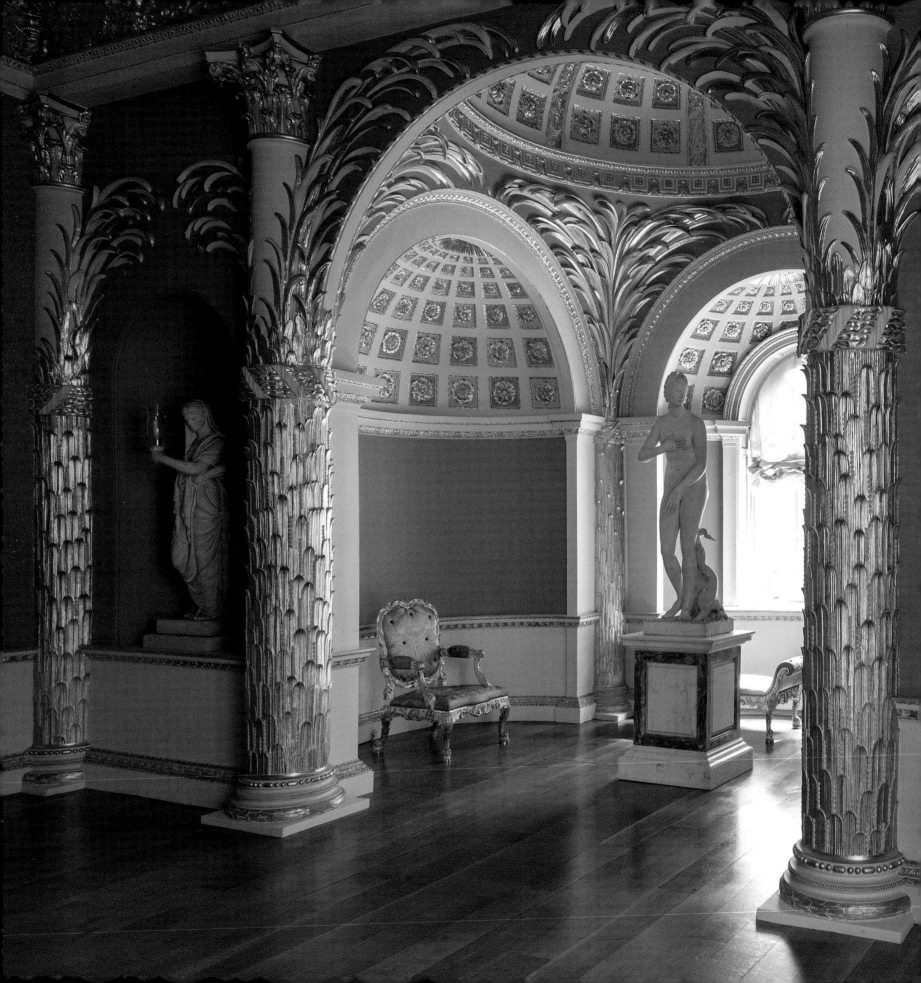

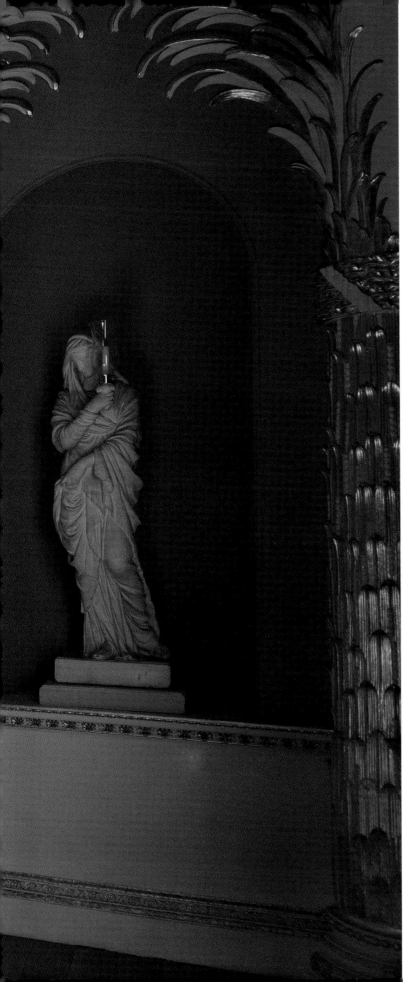

SPENCER HOUSE
LONDON

Two Rooms of Parade

Spencer house is set on the edge of Green Park in the heart of London; it is one of the loveliest town houses and the best examples of eighteenth-century architectural design of its kind. In 1772 the writer Arthur Young wrote: 'I know not a more beautiful piece of architecture ... all in richness, elegance, and taste superior to any house I have seen.' Its story is one of romance, political ambition and artistic patronage.

Spencer House was built between 1756 and 1765, a period of considerable affluence and great change. During this time, the Seven Years War ended, the Stamp Act was passed and the eight-year-old Wolfgang Amadeus Mozart performed his first symphony at Hampton Court. The population of England had almost doubled since 1500, and in the five years between 1761 and 1766 the number of private houses in the capital had increased two-fold; London was the wealthiest city in Europe, with a rapidly expanding merchant class.

From the outset Spencer House was hailed as one of London's greatest buildings; it was commissioned by the 21-year-old John Spencer shortly after his marriage to Georgiana Poyntz. The pair wed in secret at Althorp, the Spencer family seat in Northamptonshire, after a passionate love affair. Young Spencer was a Member of Parliament for the Whig Party and would become the 1st Earl Spencer, in 1765 – a title that would be passed to his descendants. He was also the great-great-great-great-grandfather of Diana, Princess of Wales. Spencer House was a declaration of his love for Georgiana, and a demonstration of his extraordinary wealth.

He employed the architect John Vardy, whose most notable achievement in the house is the Palm Room. The walls are painted green, as they were originally, and the coffers in the apses are alternately pink and green. The enrichments are white and gold. In fact, during the restoration of Spencer House we found evidence of green in a number of surviving paint fragments and textiles.

Significantly, Vardy had worked with the eminent Palladian architect and interior designer William Kent, who owned a drawing of the design for Charles II's bedchamber at Greenwich Palace by John Webb. Webb was 'brought up by my unckle [sic] Mr Inigo Jones'. The project was never fully completed but the room was designed with palm trees, and it is highly likely that Vardy saw and was influenced by this drawing.

The Palm Room. The palm occurs frequently as a decorative feature in 18th-century England. The most recognisable example to most people is on the Coronation Coach (1760) by Sir William Chambers, which is still in use.

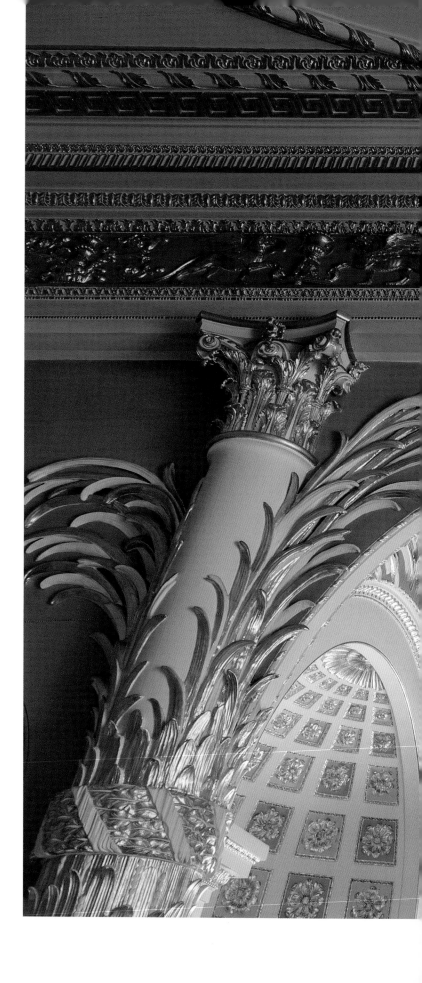

T HAT THE HOUSE WAS born of Spencer's love for his new wife is apparent in the Palm Room, where palm leaves, then a symbol of marital fertility, adorn the columns. A detailed frieze of griffins and candelabra is influenced by a similar one in the temple of Antoninus and Faustina in Rome; the Emperor Antoninus Pius initially dedicated the temple to his deceased and deified wife, Faustina the Elder, but when he died and was deified the temple was jointly re-dedicated to the couple.

The room survives largely as designed by Vardy, and is as impressive now as it must have been to eighteenth-century visitors. From its location on the ground floor, next to the dining room, it is assumed that its primary use was for entertaining Spencer's gentlemen guests for tea after dinner. To the modern homeowner the notion that such an elaborately decorated room would be used for this purpose might seem extravagant, but in the eighteenth century tea was a rarity and a delicacy.

Just as Spencer House was being built, the King of Prussia, Frederick the Great, was constructing a garden pavilion in the grounds of the Sanssouci Summer Palace in Potsdam, near Berlin. The China House – so called because tea was a Chinese import – was supported by columns designed by the Swiss sculptor Johann Melchior Kambly. As at Spencer House, the gilded columns are adorned with palm fronds, but in this case gold Chinese figures sit at their base and sip from cups of tea. This is illustrative of the eighteenth-century misidentification of palm trees as part of the Chinese flora and fauna; a misplaced idea that bolsters the assumption that the Palm Room's primary purpose was indeed for drinking tea.

Sadly for Vardy, the ground-floor rooms are the only ones that he finished before Spencer had him replaced on the project. Spencer was a member of the Society of Dilettanti (see page 96). It was there that he met Sir George Gray, a founding member and secretary of the society, who convinced Spencer to dismiss Vardy in favour of a far more fashionable architect by the name of James Stuart.

Stuart, known as 'Athenian Stuart', was a Scottish architect, archaeologist and artist who had travelled across Italy and Greece to study the ancient ruins. He later published the influential *Antiquities of Athens* (1762), a book that placed him at the forefront of the transformation from Palladian tastes to neoclassical. Although Vardy clearly possessed an understanding of Palladian classicism, his taste and style were thought dated by the Society of Dilettanti, while Stuart was seen to represent the epitome of advanced European architecture and interior decoration.

One cannot overestimate the effect such a rejection would have had on Vardy; to be dismissed as archaic in comparison to Stuart must have been devastating. Although the architectural framework had already been created by Vardy, most principal interiors are Stuart's design. While the Palm Room is a tour de force, it is one of the few remaining examples of Vardy's work in Britain. He did not live to see the completion of Spencer House, which was finished in 1766 – a year after his death.

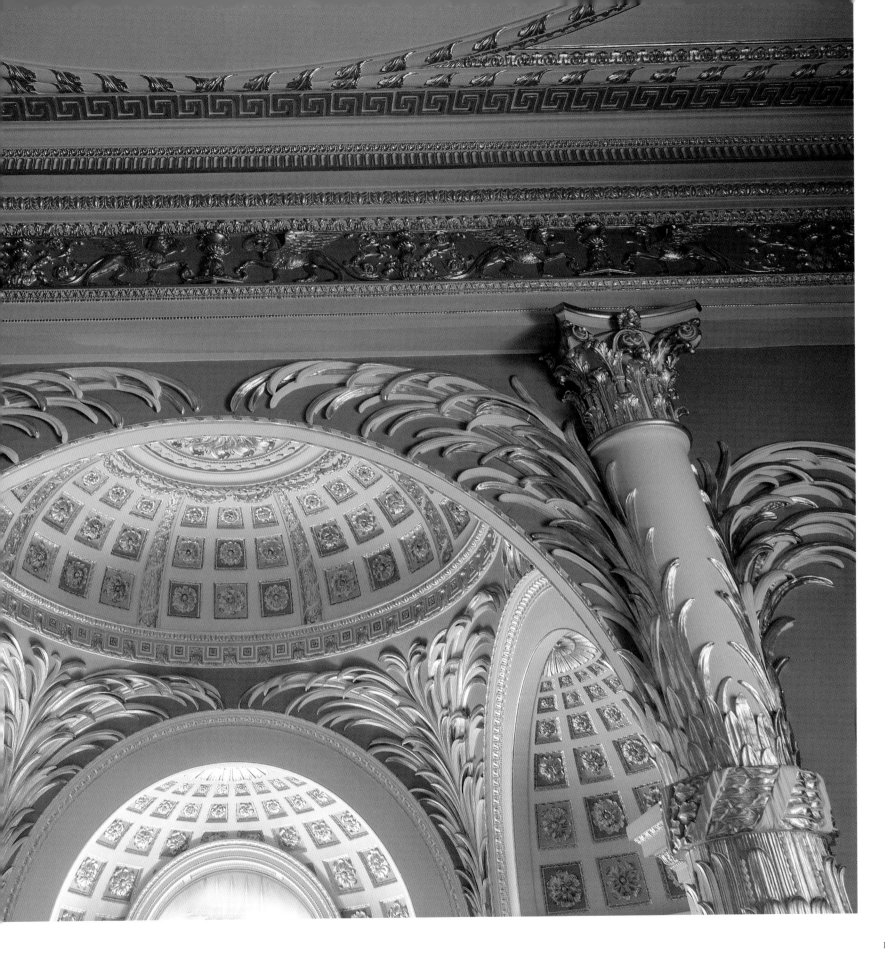

BELOW *Detail of the arm of a sofa in the Painted Room.*
RIGHT *The Painted Room, one of the first neoclassical rooms in Europe, survived a bomb that fell nearby during World War II with minor damage to parts of the ceiling. The background of the wall paintings was originally ivory-coloured, similar to the pilasters – a fact that has been discovered only very recently.*

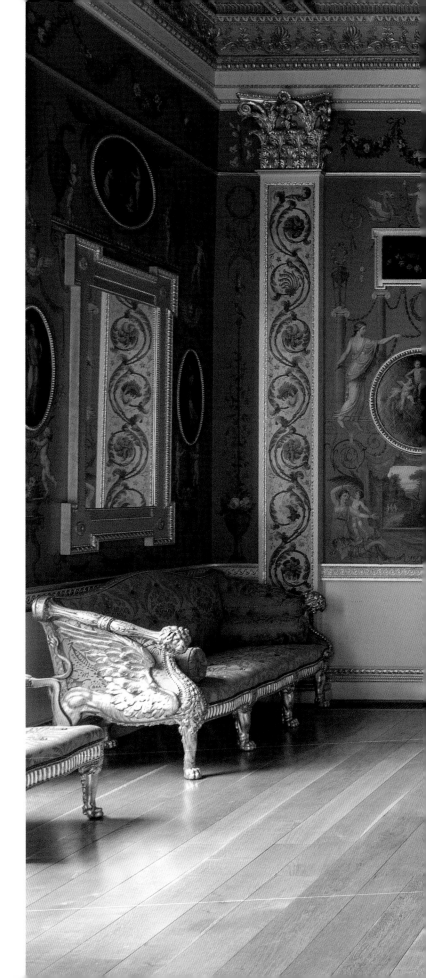

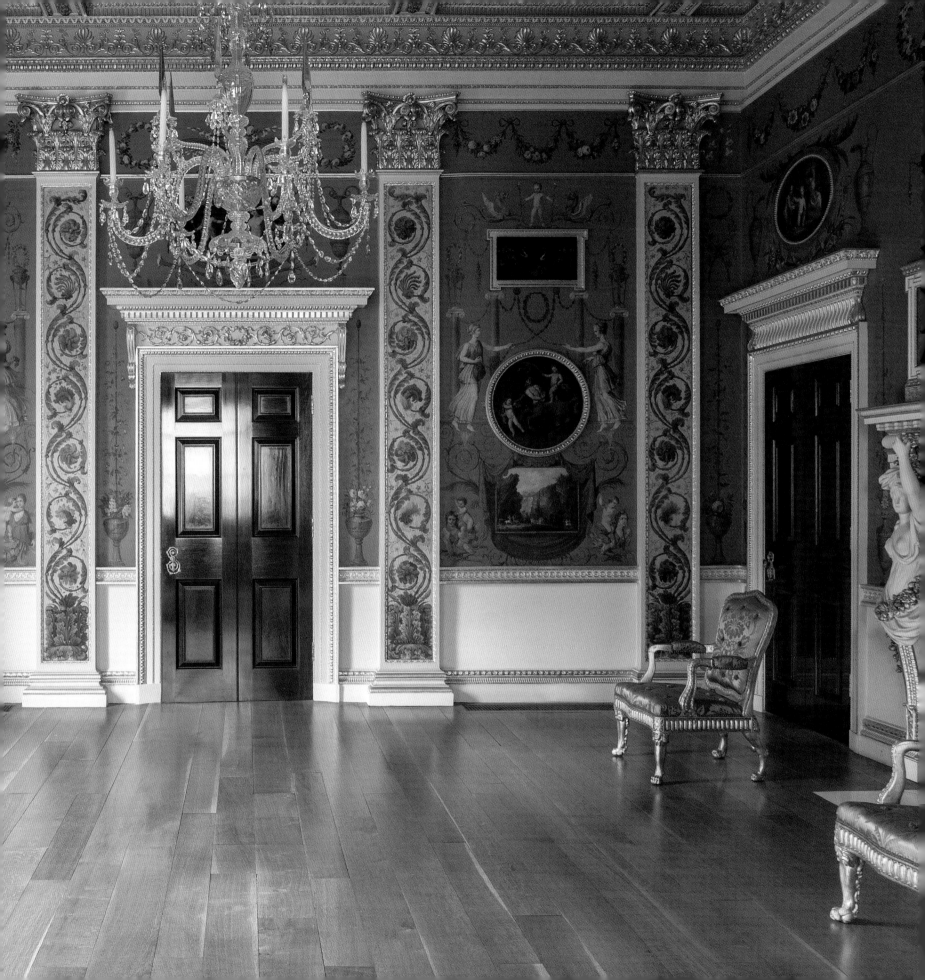

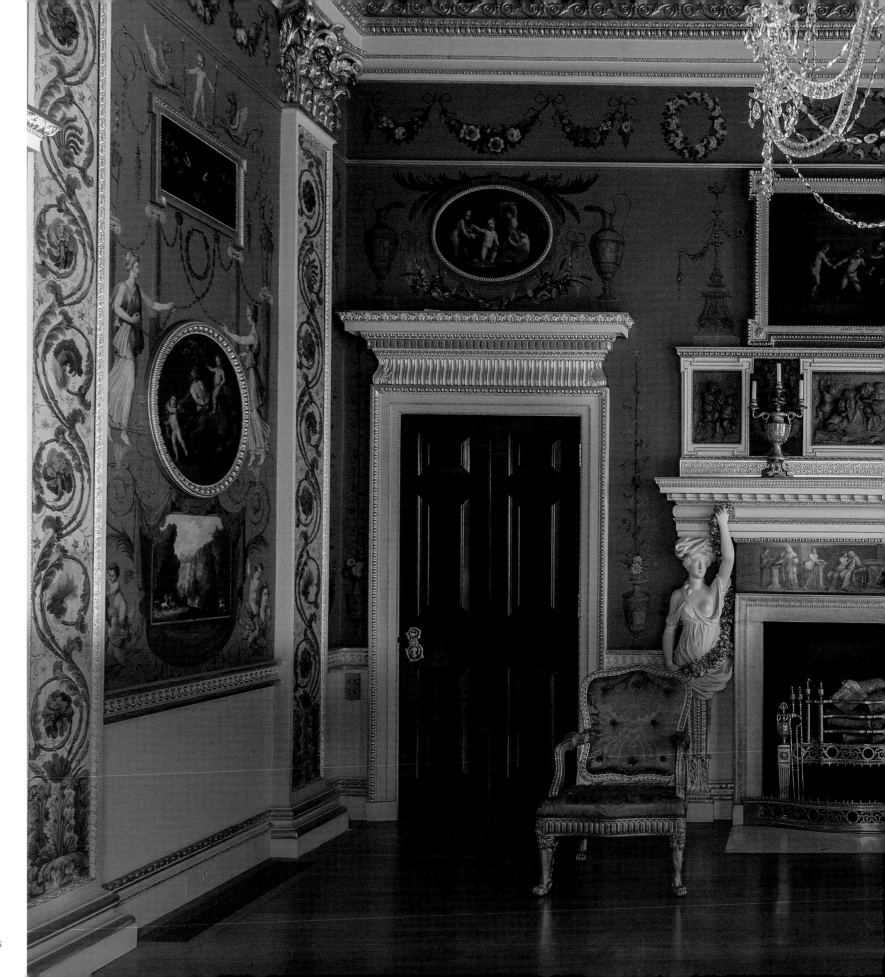

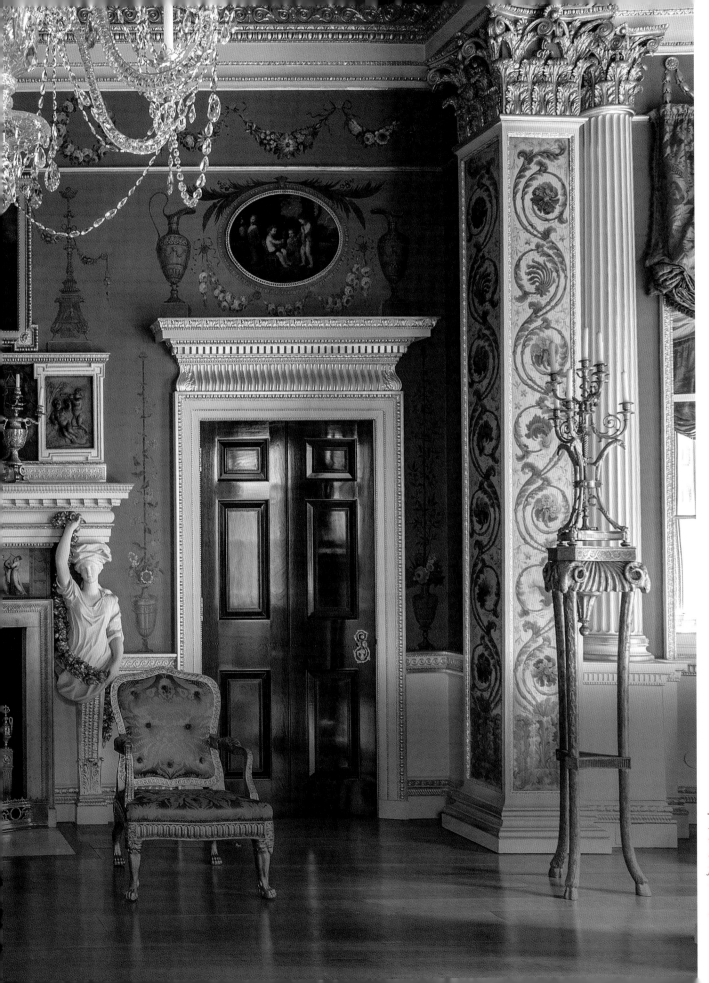

North elevation of the Painted Room. The seating was made for the room and covered in green silk damask, fragments of which were found beneath the upholstery nailing. The chandelier is contemporary and was made for the room.

Directly above the Palm Room is Stuart's Painted Room. In fact, the columns in each room are exactly aligned. The walls, which are painted green, provide a backdrop to the painted decoration, but paint analysis after a recent leak in the room above tells us that the room was originally ivory. The principal enrichments are white and gold. The decorative theme for the wall paintings in the room is the triumph of love, in particular Lord and Lady Spencer's own happy marriage. The magnificent Painted Room provides the climax to Stuart's first-floor apartment.

It is impossible to write about Spencer House and not mention the major restoration project that took place in the 1980s. With World War II looming in the 1930s, the then Earl Spencer believed that even if it survived the war no one would ever be able to live in such a house again, and so he gutted it. Everything was removed, from fireplaces to carved mouldings to door cases and doors, and refitted at Althorp. His concerns turned out to have some basis, since during the war the house was damaged by a bomb that fell nearby. This combination of factors meant that over the following decades it fell into disrepair, and in the period following the war it was converted into offices.

Jacob Rothschild, 4th Baron Rothschild, purchased a lease on Spencer House in 1986 and committed a large sum of money to its restoration. The project took ten years to complete – almost exactly the amount of time it had taken for the house to be built in the eighteenth century. I was fortunate enough to be involved in the restoration project, which was a large undertaking. Because all the interior fittings had been moved to Althorp, and remain there to this day, we had to copy and re-create practically everything. What I found particularly interesting was that the research couldn't provide all the answers, so there was plenty of room for historical imagination and interpretation.

Owing to Vardy's dismissal and Stuart's subsequent hiring, the interiors act as a fascinating barometer for a turning point in eighteenth-century taste. The interiors at Spencer House are some of the best examples of both neoclassicism and Palladian design that can be found.

The exterior of Spencer House. West elevation by John Vardy, facing the Green Park.
The modern block on the left was designed by Denys Lasdun in the 1970s.

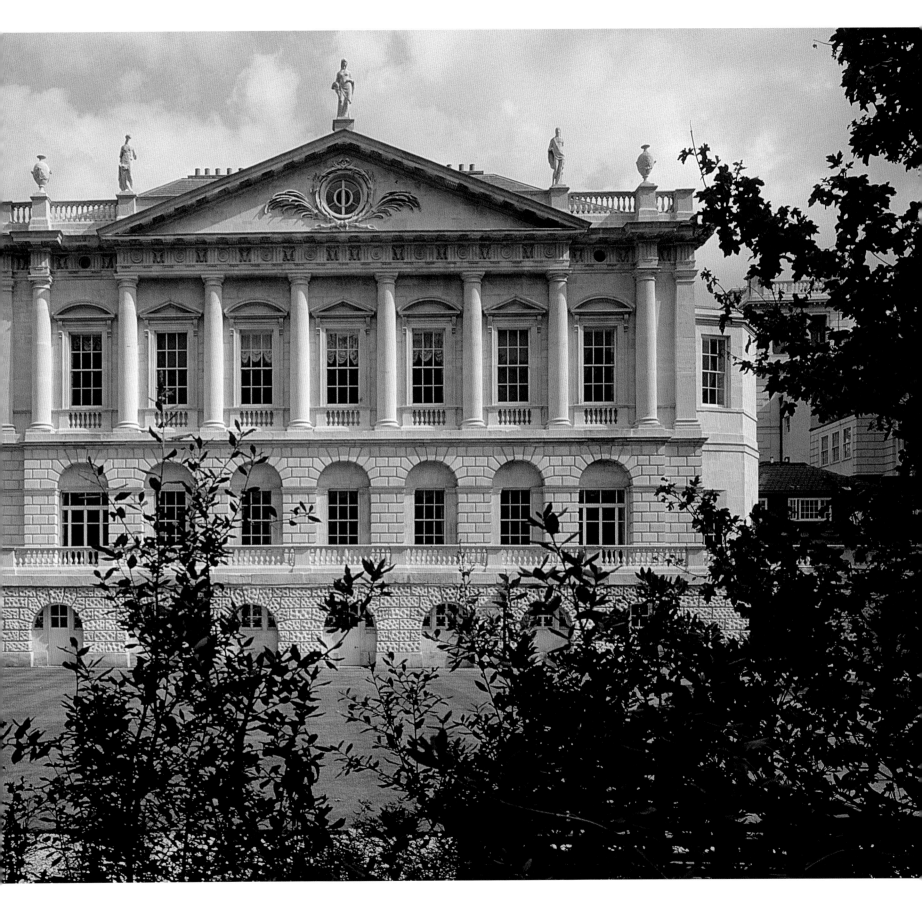

NINETEENTH CENTURY

The British Century

T HE NINETEENTH CENTURY was a time of great contrast. Grandeur, elegance and extraordinary confidence were mirrored by a grimness and insalubrity that lurked in the shadows. The architecture of the era can be divided into three principal strands, each of which embodies the spirit of the age. The first is what people call the 'Regency Style', which includes the Nash terraces in Regent's Park, striped wallpaper and the world of Jane Austen; it is easy to forget that the actual Regency was a short period between 1811 and 1820. The second is the 'revived styles', which borrowed from the past and from abroad. The third is the architecture of the Industrial Revolution, with triumphant achievements in engineering, innovations of construction and the dominant use of iron and glass. The building projects of the nineteenth century were extremely large and ambitious. They employed many people for long periods, resulting in a shortage of labour. The army was notably affected, with a lack of suitable recruits for the Crimean War.

The refined aesthetic of the Regency was a continuation of and development from the Georgian tradition. However, the classicism of the period was challenged fiercely by the historicist revivals. These 'revived styles' were shaped partly by the Prince Regent's exuberant tastes, which in turn were a reaction to the frugality of his father, George III, and an envious response to Napoleon's dramatic rise. The Emperor's conquests were such that, unlike the eighteenth-century 'Grand Tourists', the English could not travel abroad, because the country was under constant threat of invasion. When Napoleon abdicated in 1815, restrictions on continental travel were lifted and European taste flowed freely across the English Channel, influencing food, fashion and, of course, architecture.

Meanwhile, the Romantic movement that had been stirring in the eighteenth century took a more serious turn. Increased industrialisation brought with it spectacular feats of engineering and mass production, but there was also a perceived surge in ugliness, squalor, poverty and immorality. Refuge was sought in the medieval past, with its chivalric and supposedly more genuine values, from which came the Gothic Revival. This was the most popular of all the 'revived styles', and nearly every town and village in England has an example of its architecture, ranging from a one-roomed school to a grand country house or an often over-scaled church.

Feelings ran very high and tempers were lost in what became known as the 'Style Wars', especially where proponents of the Gothic and the Classical clashed.

The Waterloo Gallery in Apsley House, London (page 145), showing the sliding mirror-glass shutters that screen the windows at night and add to the scale and glamour of the room. The mechanism still works well.

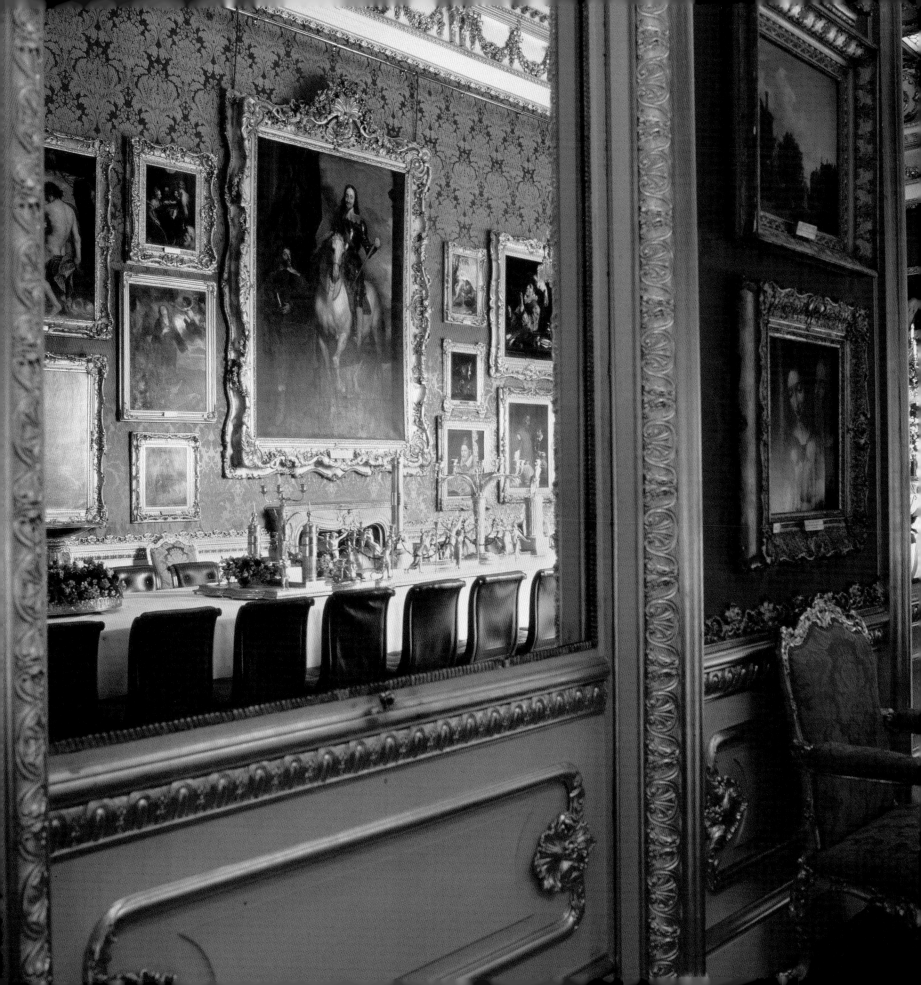

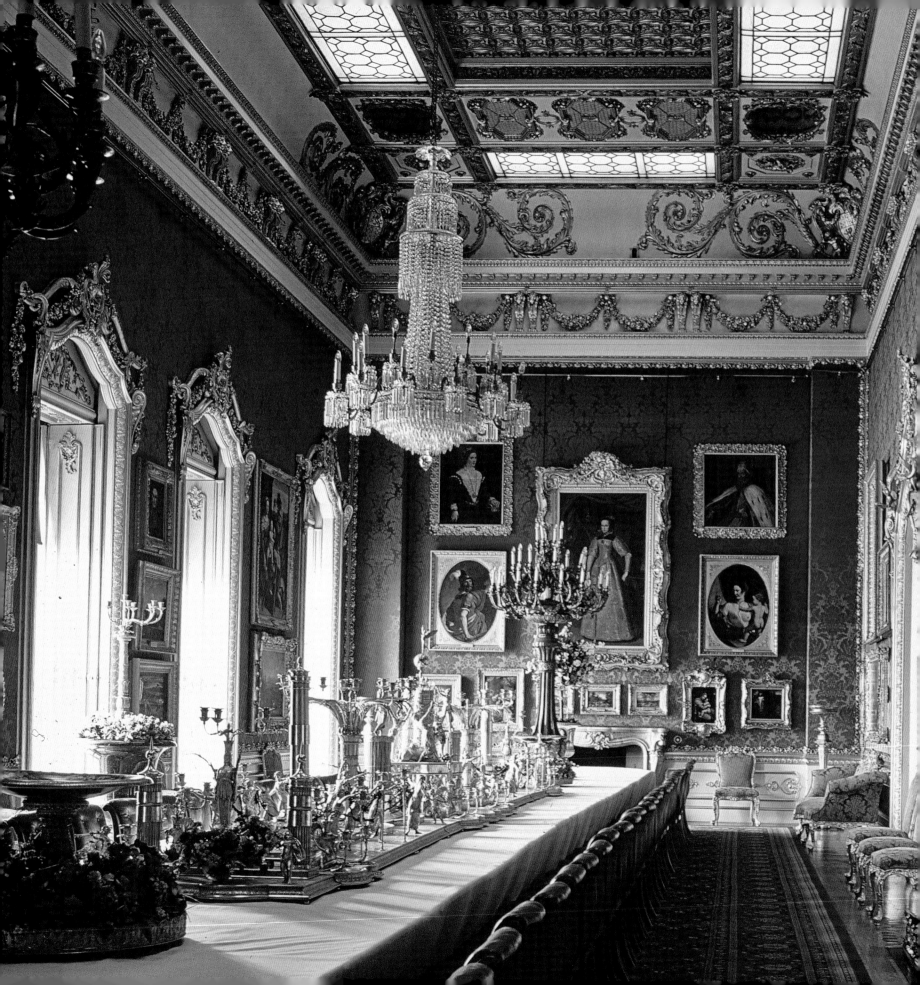

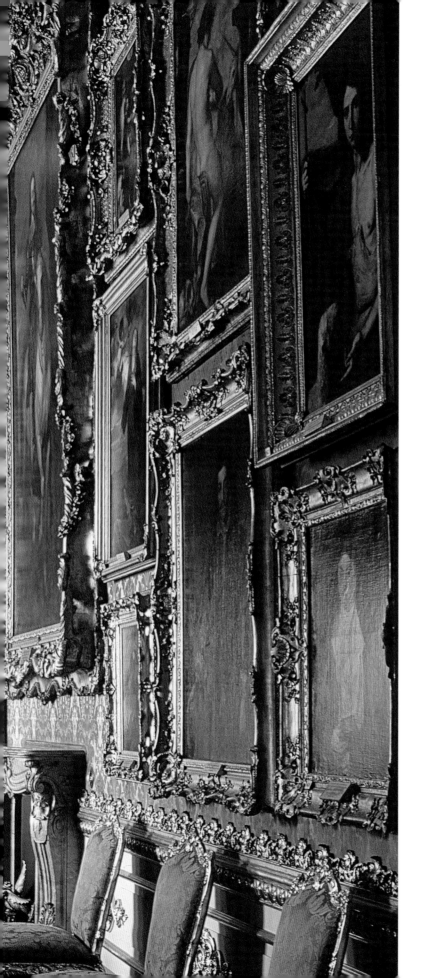

APSLEY HOUSE AND STRATFIELD SAYE
LONDON AND HAMPSHIRE

Two Galleries

The original apsley house was built between 1771 and 1778 for Henry Bathurst, 1st Baron Apsley. Designed by Robert Adam, it was a neat, red-brick building that might have been plucked from the pages of a Jane Austen novel, but it would not remain like that for long. In 1807 the 2nd Earl of Mornington, by then Marquess Wellesley, bought the house, but ten years later Arthur, 1st Duke of Wellington, purchased the lease from his eldest brother, who was hopelessly in debt.

Having returned to England victorious against Napoleon's forces, the 'Iron' Duke was given £700,000 by the grateful nation. The intention was for him to build a splendid country residence – the sort to rival Blenheim Palace. Instead, he chose to extend Apsley House in stages, and employed the architect Benjamin Dean Wyatt to help him do so. In 1820 he added the dining room, and eight years later he refaced the entire building in Bath stone and added a portico, two bays on the west side of the house and an extension to the east.

The first Waterloo Banquet was held there in 1820 in celebration of the Napoleonic defeat. In those early years, the Duke would host relatively small gatherings in the dining room at Apsley House, but as the years marched by and the number of veteran generals dwindled he decided to expand his guest list to include those younger officers who had fought at the battle and later risen through the ranks. And so the Waterloo Gallery was built in 1828.

This magnificent room could seat 85 guests for ceremonial banquets. It is more than 91 feet (28 metres) long, runs the length of the house and fills two storeys. The addition of the Waterloo Gallery elevated Apsley House to a palatial status fitting to the members of the royal family and politicians the Duke received there.

The room is decorated in Louis XIV style, and is one of the first examples of French influence on English taste on such significant scale. Wyatt, with his brother Matthew Cotes Wyatt, spearheaded the introduction of the French revival style, known as 'Tous-les-Louis' and incorporating design elements from the reigns of Louis XIV, XV and XVI.

In the Waterloo Gallery at Apsley House is a very fine collection of paintings in a room that is unusual in its mixture of French and English decorative details. Note the silver surtout de table and the mirrored shutters open.

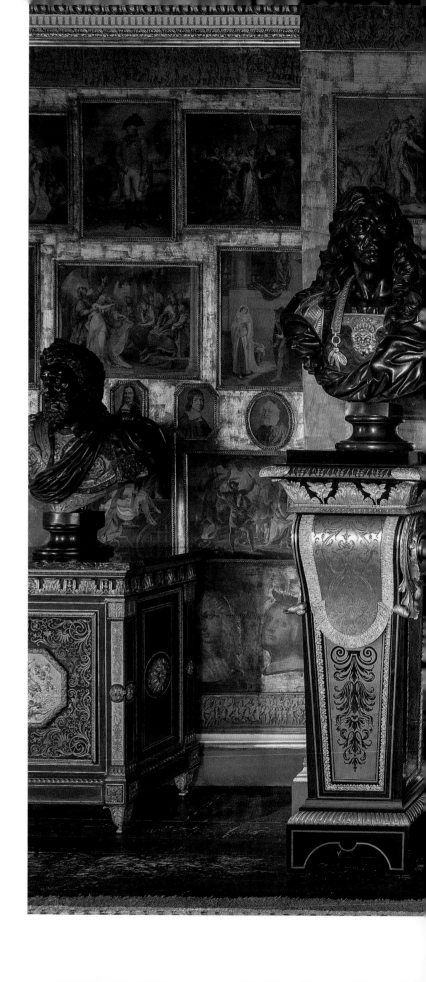

Today the gallery is hung with red damask, as was Wyatt's wish, but Wellington was insistent that yellow should be used instead. Relations between the pair were strained owing to the project's spiralling costs, so the Duke's close friend Mrs Arbuthnot was brought in, not only to help with the interiors but also to act as intermediary. Even she disagreed with Wellington when it came to the colour scheme: 'I am rather discontented to think he is going to spoil his gallery and, as I took infinite trouble about it, it vexes me ... He is going to hang it with yellow damask, which is just the very worst colour he can have for pictures and will kill the effect of the gilding', she wrote in 1828. Happily for the naysayers, the Duke's amber walls were short-lived: his son swiftly hung the gallery in red after his father's death.

By day sunlight floods the gallery through the glass-panelled ceiling, but at night candlelight flickers from the torchères and central chandelier. The sliding mirrored shutters over the windows, which evoke the Galerie des Glaces at Versailles, were conceived by Mrs Arbuthnot.

A painting by William Salter depicts the banquet of 1836 and is in good company. The walls are hung with extraordinary masterpieces; there are works by Velázquez, Correggio, Rubens, Murillo and Van Dyck. After the Battle of Vitoria in 1813, when the French were on the run, Wellington and his men discovered an abandoned carriage containing an enormous number of rolled-up canvases that had been cut from their frames. The French had looted the Buen Retiro Palace in Madrid, and Wellington had stumbled upon their spoils. When the war was over, the Duke wrote no fewer than three letters to the Spanish Court so that he might return the collection; eventually he received a reply from the Spanish Minister in England, who wrote: 'I gather that His Majesty, touched by your delicacy, does not wish to deprive you of that which has come into your possession by means as just as they are honourable.' The Waterloo Gallery provided a fitting home for the paintings.

In contrast to the grand Waterloo Gallery, the 1st Duke's private rooms were decidedly modest. Watercolours of these rooms painted during his lifetime illustrate the austerity typical of a soldier. Stratfield Saye in Hampshire was the Iron Duke's country house. It was the intended site for the 'Waterloo Palace' for which Wyatt drew very ambitious designs. However, as Wellington decided to limit future liabilities for himself and his heirs, plans for the palace were forgotten. Instead, additions and improvements to the existing building were made. His descendants must have been very grateful!

The Duke's wife, Kitty, was a reluctant hostess who disliked pomp and circumstance and so lived at Stratfield Saye with her sons. Her husband reputedly spent very little time there while she was alive, complaining to his friend Mrs Arbuthnot that Kitty 'made his house so dull that nobody would go to it'.

As at Apsley House, there is a gallery at Stratfield Saye, although on a much smaller scale. Opinions vary as to whether the room had been added by the previous owner, Lord Rivers, in 1745 or by his father a little earlier; the pair of fireplaces suggest the latter. The room is decorated with contemporary and later prints of portraits and Shakespearean scenes attributed to the engraver John Boydell.

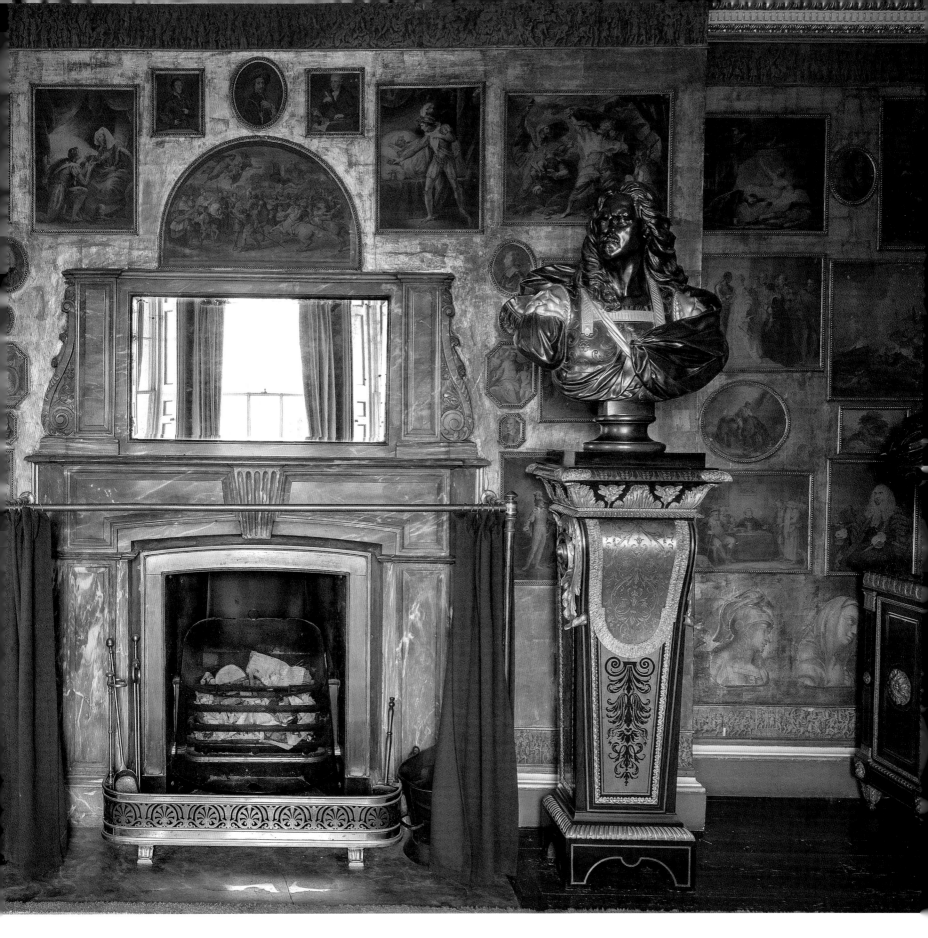

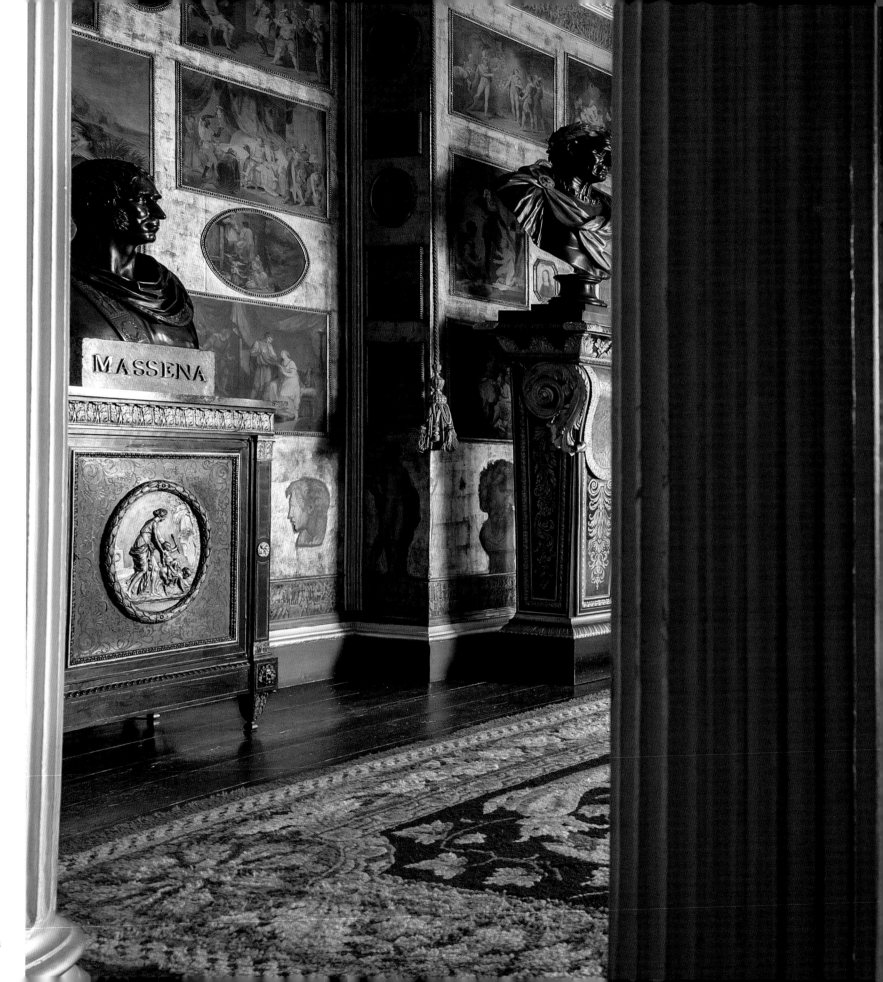

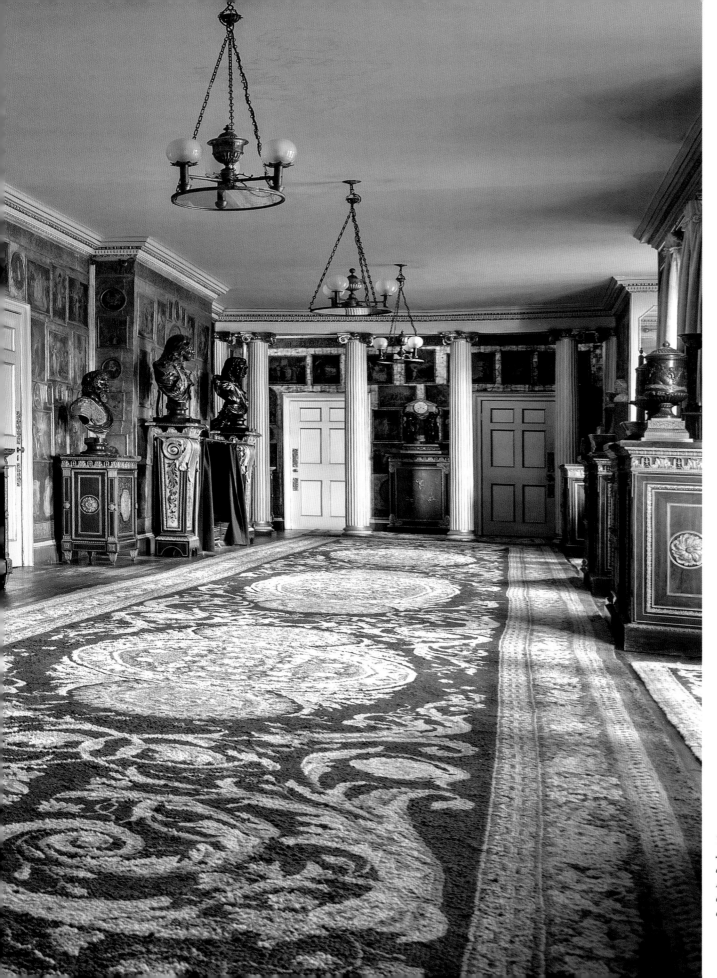

The Long Gallery at Stratfield Saye represented a further development of the English long gallery with French contents. The 20th-century carpet was woven in Madrid.

149

During the time of the 1st Duke the prints would have been hung against a dark distemper, but in 1838 that was changed to off-white. In the 1890s the 3rd Duchess added the gilded beadings and gold leaf to the walls to create this beautifully imaginative scheme of decoration. A frieze that runs around the gallery under the cornice depicts the relief carvings from Trajan's Column and the Antoninus Pius Column in Rome.

The 7th Duke, Gerald Wellesley, was an architect and one of the pioneers of the Regency revival after World War I. The gallery as we see it today was his conception. He commissioned the carpet from the Spanish Royal Carpet manufactory in the early 1950s, and gathered the Boulle pedestals and bronze busts – some of which had been at Apsley House – and took them to Stratfield Saye. The busts were bought in Paris by the 1st Duke with the help of his art dealer, Féréol Bonnemaison, and many of the Boulle cabinets are signed by Etienne Levasseur, although the mounts may have been taken from actual Boulle furniture.

In the 1960s the 8th Duke engaged the services of John Fowler, who worked on just a few rooms at Stratfield Saye and applied the lightest of touches in the gallery, painting the faux bois mahogany columns white and gilding some of the architectural details. It shows the mark of a very confident decorator to hold back his skills so carefully. The combination of gold walls with prints, ornate furniture and the oversized bronze busts makes a wonderfully unique room.

The Long Gallery at Stratfield Saye, with a bust
of Louis XIV and prints mounted on gold-leaf wallcovering.

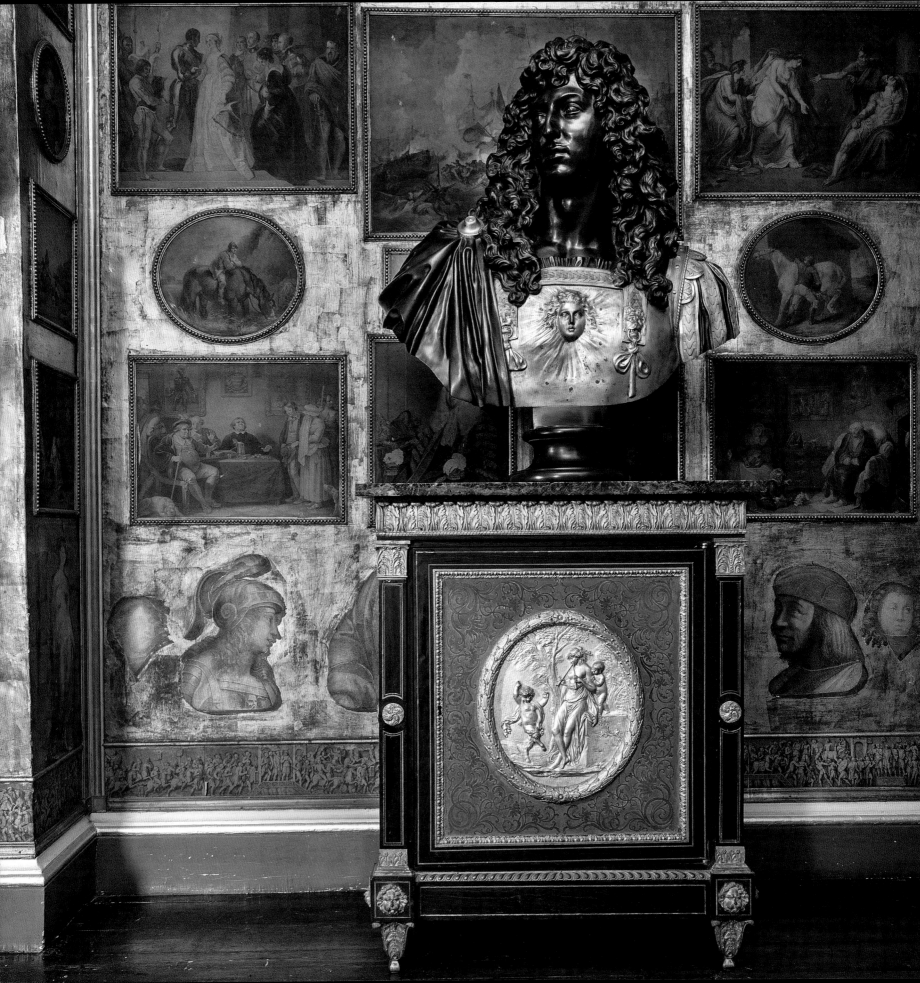

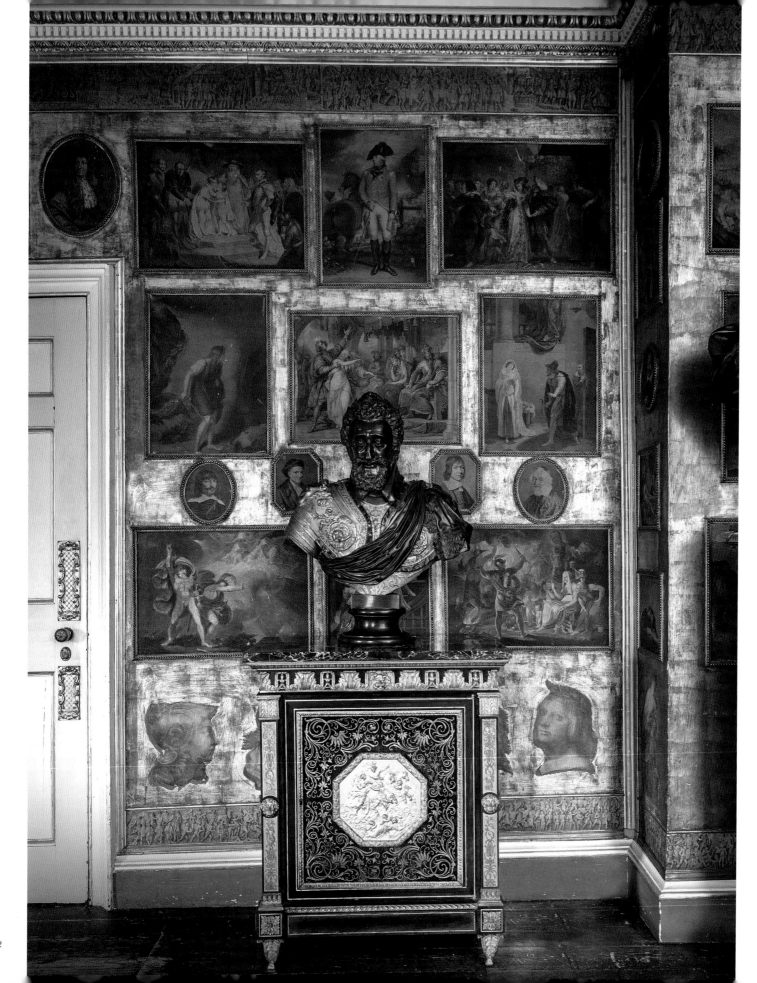

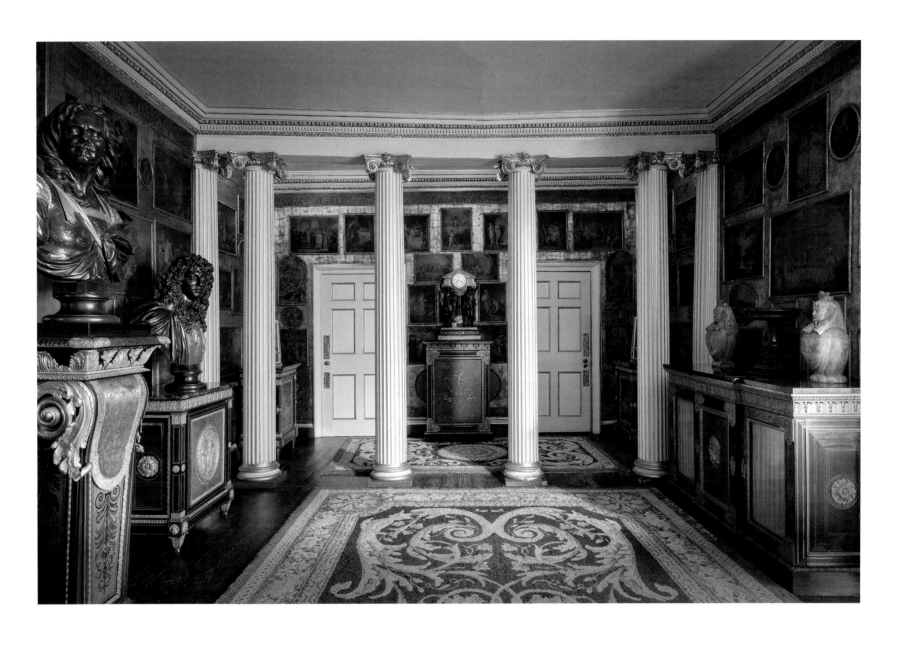

OPPOSITE *Detail of the Long Gallery at Stratfield Saye, with a bust of Henri IV.*
ABOVE *Note the painting and gilding of the doors, the panelling and skirting, and the columns, a subtle contribution of John Fowler.*

153

PALACE OF WESTMINSTER
LONDON

The Lords' Chamber

ON 16 OCTOBER 1834 fire ripped through the Houses of Parliament with such fury that the medieval building was all but destroyed. A brisk wind helped the blaze to spread, and a crowd soon gathered to watch. The fire began when the Clerk of Works was asked to discard two cartloads of wooden tally sticks (an obsolete accounting system dating back to William the Conqueror that had survived until 1826). He was charged with burning the rods of hazel and willow using the underfloor stoves in the basement of the House of Lords. By 6pm the building was in flames.

The architect Charles Barry was in the crowd, as was A.W.N. Pugin, who watched the blaze with somewhat merciless glee as he saw what he considered to be the shoddy recent work of the architects John Soane and James Wyatt catch fire. He later wrote to a friend: 'There is nothing much to regret and much to rejoice in a vast quantity of Soane's mixtures and Wyatt's heresies [having] been effectually consigned to oblivion.' But the old House of Lords was undoubtedly good in its way, and Pugin's remarks serve as an important reminder not to be hasty in judging the work of one's contemporaries. This seems to have happened as much in the past as in the present.

The destruction of the old Houses of Parliament provided one of the best architectural opportunities since the Great Fire of London in 1666. In 1836 a public competition was launched to design a new palace according to either the Classical or the Gothic style. The Royal Commission received 97 entries, each distinguishable only by a pseudonym or symbol. From these, four were chosen, of which the commissioners were undivided in favouring entry number 64, which bore the emblem of the portcullis. This was the submission of Charles Barry.

View of the Palace of Westminster from the south bank of the River Thames.

Barry enlisted Pugin's help with both the initial drawings and later the execution of his scheme. While Barry's strengths lay in form, planning and organisation, the younger Pugin was extremely knowledgeable when it came to the Gothic style, and possessed a unique flair for pattern. Barry had had a trial run at Highclere Castle, Hampshire, a Classical building in Gothic dress, and so he set the tone while Pugin applied the detail. This seems to have been influenced by the surface decoration of Henry VII's chapel at Westminster Abbey, across the road.

The resulting Palace of Westminster is surely one of the world's iconic buildings, marking the climax of the northern European nostalgia for historicism. The House of Lords, which occupies the southern half of the building, surrounds a series of six courtyards; its exceptionally complicated interiors were entirely conceived by Pugin.

Pugin had published the first of his controversial books on Gothic architecture in 1836, and believed that if Gothic were to be truly revived, it was simply not enough to copy its forms and ornamentation. Instead, medieval methods of building must be used and building materials respected, so that architecture might once again articulate its structure and function honestly. He wrote that 'all ornament should consist of enrichment of the essential structure of the building.'

On seeing the interior of the House of Lords in 1847, the *Illustrated London News* wrote breathlessly that it was 'without doubt, the finest specimen of Gothic civil architecture in Europe ... its proportions, arrangements and decorations being perfect, and worthy of the great nation at whose cost it has been erected'. The Lords' Chamber is the most lavishly decorated room in the Palace of Westminster.

ABOVE *A detail of the carving in the Chamber of the House of Lords.*
OPPOSITE *The Chamber, looking towards the throne. The leather upholstery is red for the Lords, in contrast to green for the Commons next door. The effect is more elaborate for the Lords, and the amount of detail, quality of materials and standard of workmanship are superior. This reflects the hierarchic attitude of the time.*

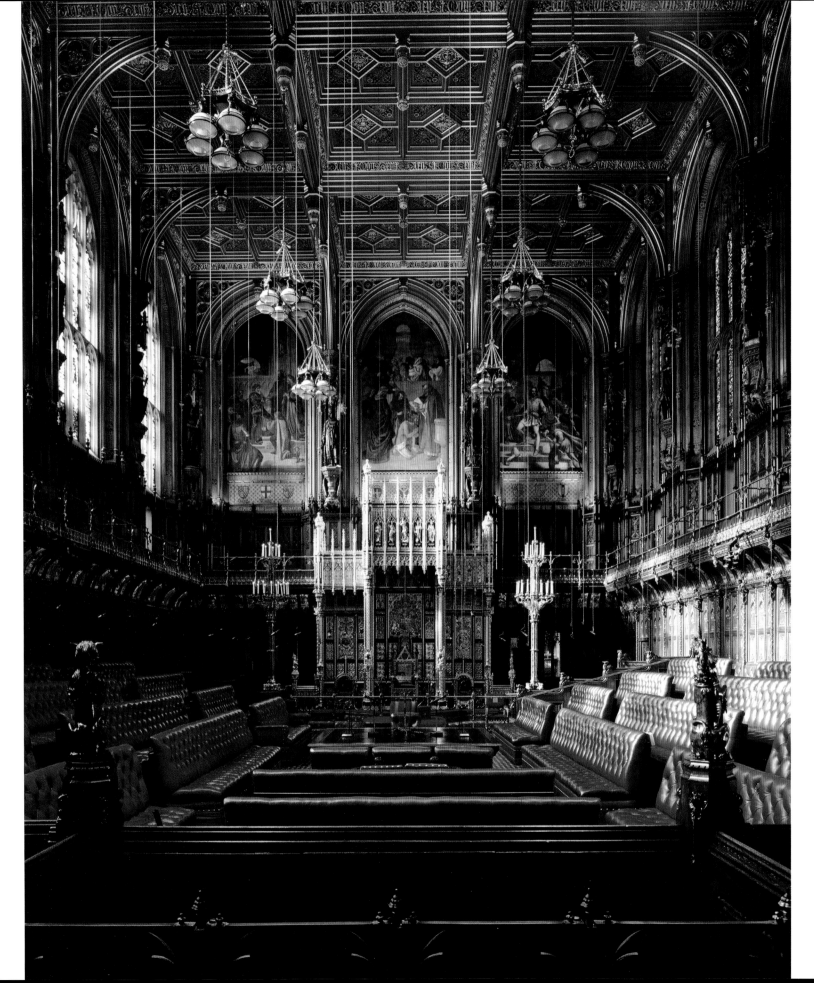

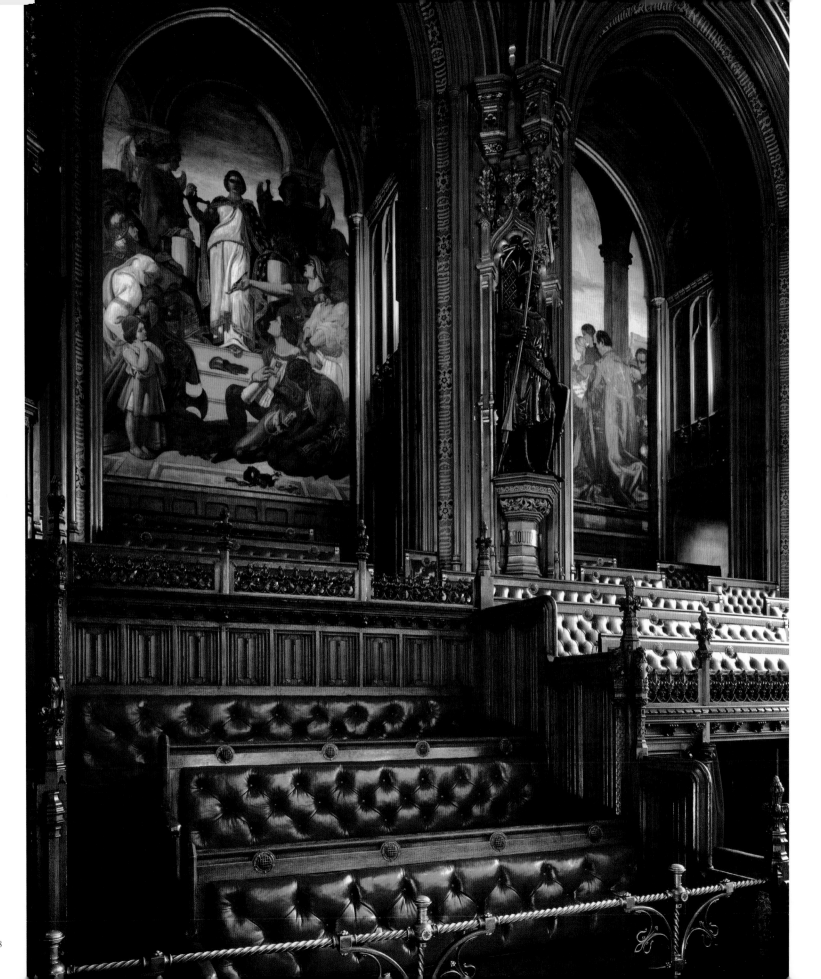

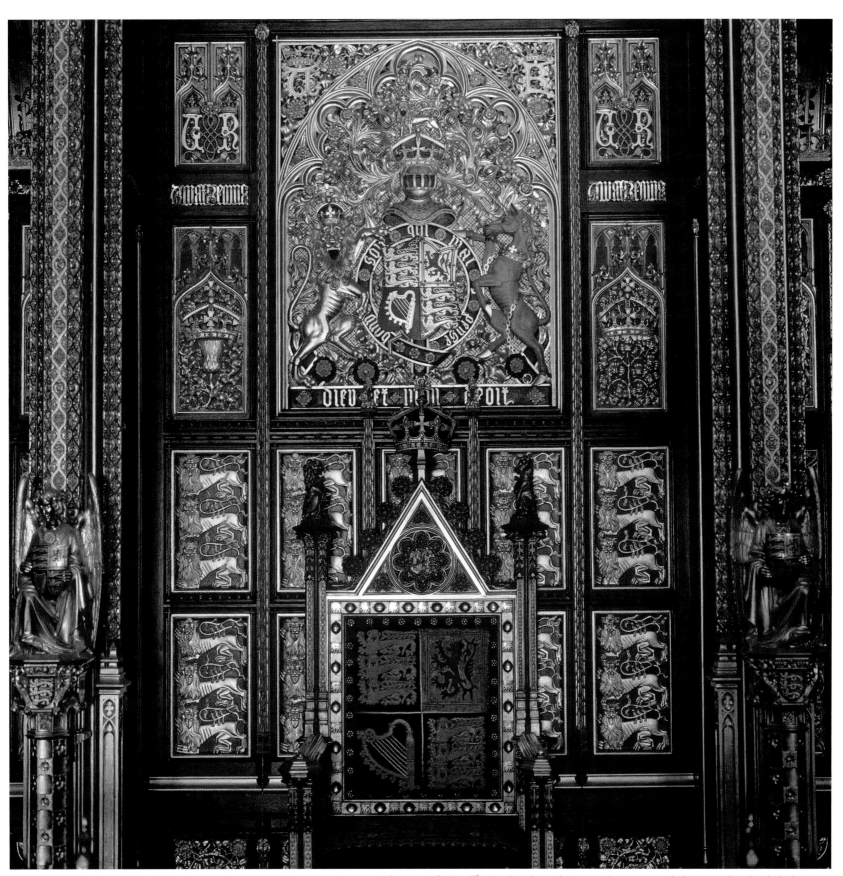

OPPOSITE *Painting (by Daniel Maclise), sculpture and architecture combine in the Strangers' Gallery. The knight in his niche is treated as a saint might be in a medieval cathedral.*

ABOVE *The throne and its background used for the state opening of Parliament, with the royal arms of the United Kingdom above.*

In THE CENTRE OF the Chamber, tiers of red benches on which the peers sit face each other. Red was considered the colour of royalty. At the southern end of the room is the throne, and the northern end is separated from the rest of the Chamber by the Bar, a railing beyond which guests may not pass when the House is in session.

Oak panels line the walls and are carved with complicated knot motifs; beasts and angels bearing heraldic devices mark the end of the benches, and twelve tracery windows occupy arches between which gilded angels project. The wood-panelled ceiling is sumptuously patterned and adorned with intricate insignia. The gilded royal throne provides the decorative zenith to the entire building. It stands on a dais, and is based on the early fourteenth-century Coronation Chair in Westminster Abbey.

It was Pugin's intention that wherever you rest your eyes, you are always met with something edifying and enriching. His acute visual memory allowed him to glean from a large repertory of authentic details for his patterns, and remarkably he drew every last element of the building, from the uppermost finial of the Victoria Tower and the clock face of Big Ben to the wallpaper, coat hooks, inkwells and umbrella stands in the House of Lords.

Pugin's scheme for the House of Lords is one of exceptional detail, self-confidence and sheer industry; it is an aesthetic controlled by logic and hierarchy that provides the perfect backdrop to authority. Together he and Barry created an icon for parliamentary government that remains unaltered almost two centuries on.

In 1851 Pugin lapsed into psychosis and was committed to Bedlam. He was eventually released to his home in Ramsgate, where he enjoyed a brief period of lucidity before dying aged 40. Likewise, Barry suffered from bouts of illness, and at the age of 64 his life was also cut short. It was a Herculean effort on every front that built the Palace of Westminster.

BELOW *A carved greyhound sits astride one of the bench ends.*
OPPOSITE *One of the carved angels in the Chamber, with a heraldic escutcheon: a symbol of Church and State.*

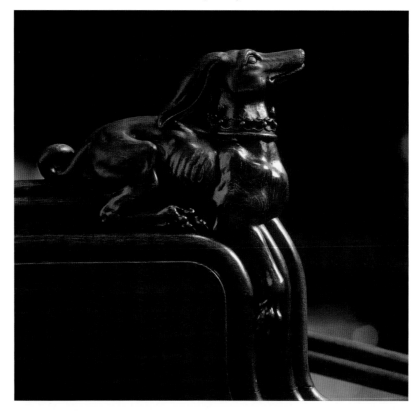

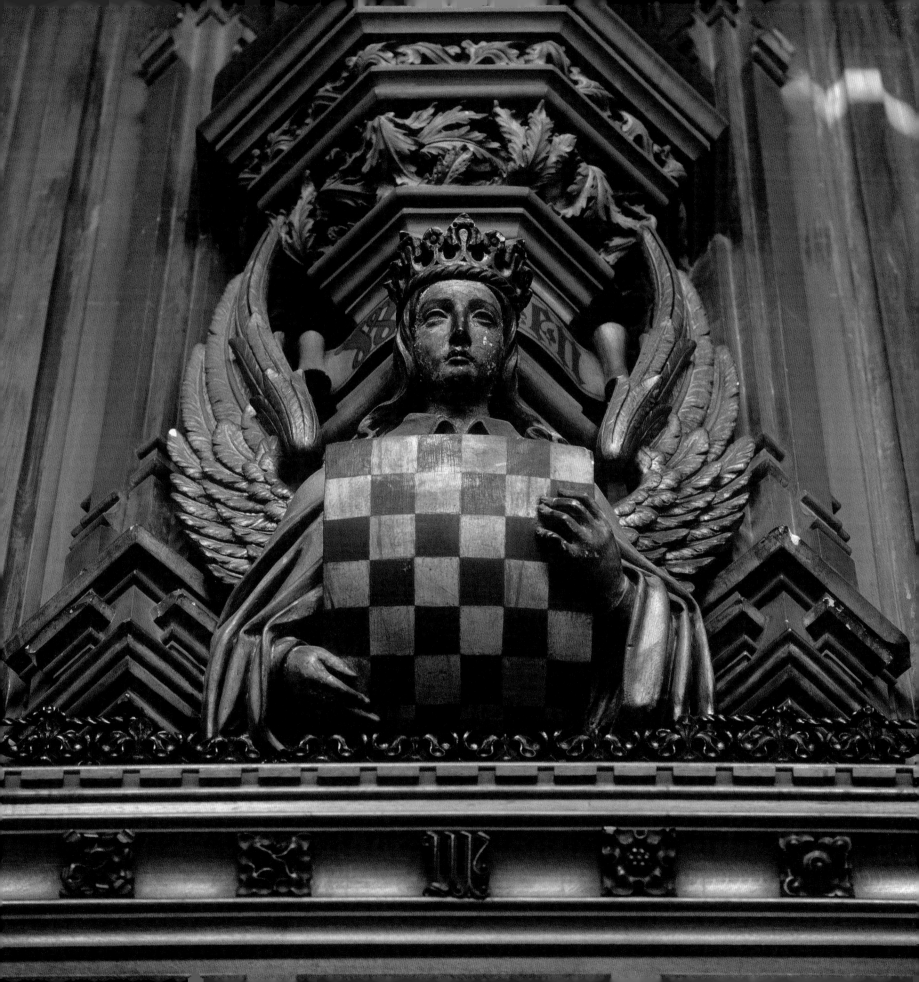

Details of carving and surrounding decoration: a king and a heraldic lion.

GREAT CONSERVATORY
MIDDLESEX

Iron and Glass

Tʜᴇ ɪɴᴅᴜsᴛʀɪᴀʟ ʀᴇᴠᴏʟᴜᴛɪᴏɴ brought with it new building types and new methods of construction. Iron and glass became the material of choice for many functional buildings, including railway stations and conservatories, for example Paddington station in London and the Palm House at Kew. But the most famous iron and glass building in England is – or more accurately was – the Crystal Palace, which was designed by Joseph Paxton and built in Hyde Park for the Great Exhibition of 1851. The vast structure was the apogee of early Victorian technology, and proved the spectacular possibilities afforded by these new materials. After the exhibition, the Palace was moved to Penge Common in south London, where it remained until its destruction by fire in 1936.

In 1840, a decade before work began on the Crystal Palace, Paxton designed and completed the Chatsworth Stove for his patron the 6th Duke of Devonshire. It was a fittingly ambitious precursor to his subsequent marvel. The Bachelor Duke, as he was known, had early on identified and encouraged Paxton's talent, and together they planned the glasshouse. It was 275 feet (84 metres) long, 121 feet (37 metres) wide and 62 feet (19 metres) high, making it the largest glass building in the world until it was bettered by the Crystal Palace.

Earlier still was the Great Conservatory at Syon House, designed by a Devon man, Charles Fowler, in the 1820s. It measures 230 feet (70 metres) in length with a dome 125 feet (38 metres) in diameter, making it the first conservatory to be built in iron and glass on such a large scale. Its footprint is like that of a cross-plan church, but the building is more domestic in character than its successors; it is as much a winter garden as it is a conservatory. It is also less complicated and demanding in its engineering, yet one can see how structurally faultless it is. Six years later Fowler designed the piazza at Covent Garden using ideas borrowed from the conservatory at Syon. Neither is as brave in design, or as spectacular as what came later, but as always it is interesting and important to see something of the genesis.

ʙᴇʟᴏᴡ *The exterior of the Great Conservatory.*
ʀɪɢʜᴛ *A structure like this with such slender columns holding up the dome would have been possible only as a result of the Industrial Revolution. Still, it is contained by classical architecture in the stonework.*

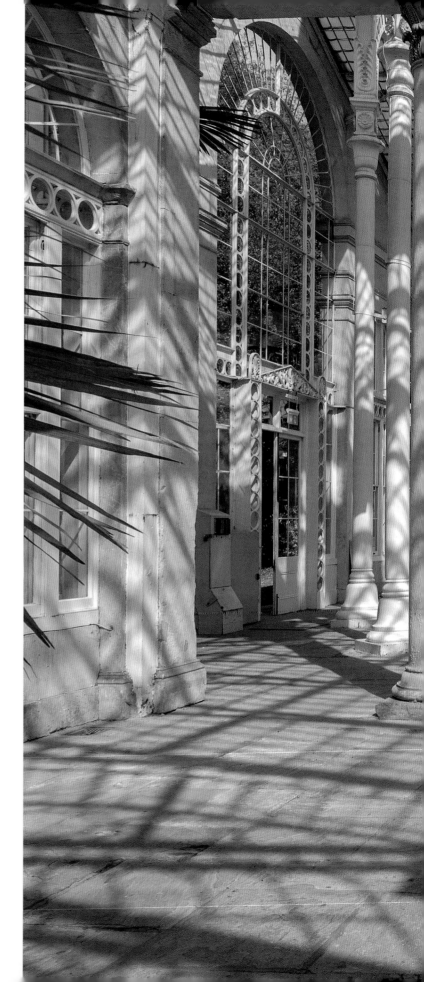

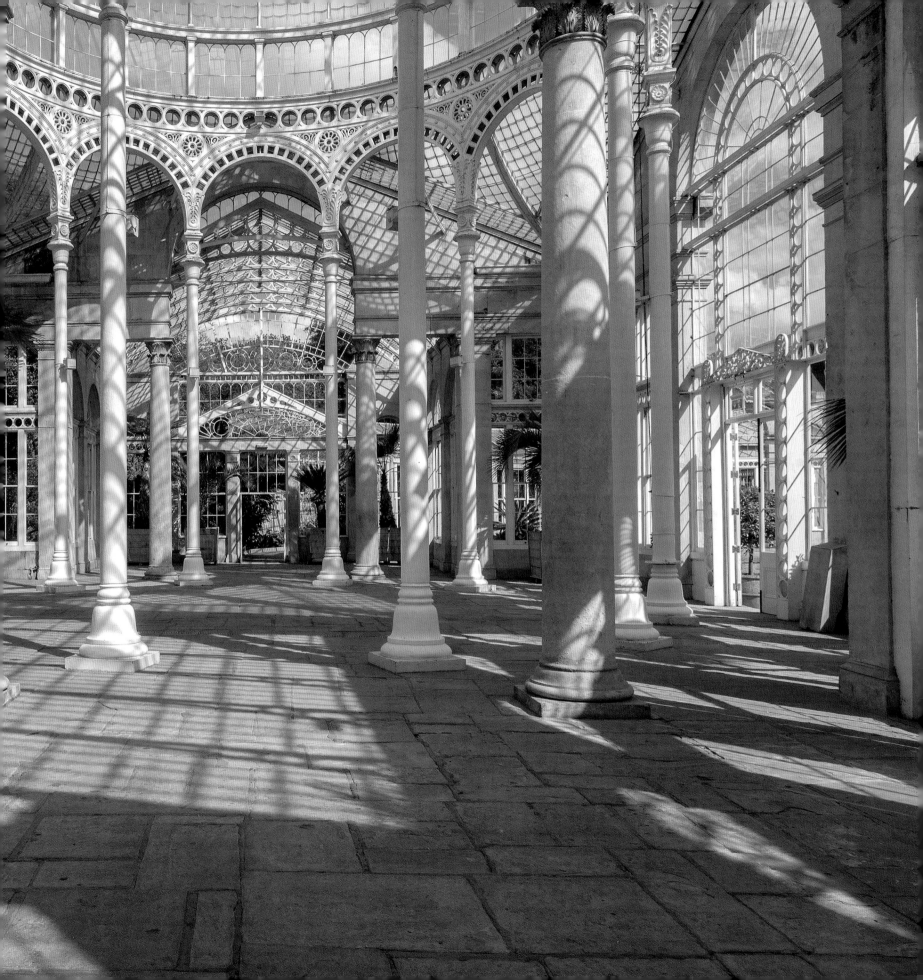

WADDESDON MANOR, THE RITZ AND THE ROYAL AUTOMOBILE CLUB
BUCKINGHAMSHIRE AND LONDON

Three Dining Rooms

I<small>N</small> 1874 <small>BARON FERDINAND DE ROTHSCHILD</small> bought 'a lovely tract of land [with] beautiful soil … and very pretty scenery' in the Vale of Aylesbury. It was a stretch of Buckinghamshire so noticeably populated by members of his family that it was often referred to as 'Rothschildshire'. Three years after purchasing the agricultural estate, Baron Ferdinand engaged the French architect Gabriel-Hippolyte Destailleur to start work on Waddesdon Manor, an early Renaissance-style country house inspired by the chateaux of the Valois kings of France in the Loire Valley.

Waddesdon Manor was built with the dual purpose of housing Baron Ferdinand's collections and lavishly entertaining his fashionable guests (Queen Victoria and the then Prince of Wales both visited). Despite being used only for summer weekends, the house was exceedingly comfortable and equipped with running water, central heating and, later, electricity. One particularly enamoured visitor wrote: 'Waddesdon surrounds you with essence, and then in a way you have too much essence. It is a hilarious paradox, but the truth is – bask in the jovial aesthetic that is offered.' He concluded his note by optimistically asking if the Baron might marry him.

In 1883 Baron Ferdinand celebrated the completion of his new house with the first of many parties. His hospitality was legendary, and he liked nothing better than spoiling his guests. Naturally, the most glamorous events took place in the dining room – a place of high cuisine, luxury and ritual. A typically extravagant Edwardian menu would boast the likes of Duckling with Ortolans and Petits Soufflés à la Royale, garnished with gold leaf. Baron Ferdinand's London chef was Auguste Chalanger, and his confectioner Arthur Chatagner; both would have travelled with Ferdinand and cooked for his guests at Waddesdon. Following Queen Victoria's visit, she sent her Royal Cook to learn from Baron Ferdinand's chef the secret of making three dishes from the menu. Unfortunately, Baron Ferdinand had bad digestion and tended to eat only toast and drink only water. 'I am lonely, suffering and occasionally a very miserable individual despite the gilded and marble rooms in which I live,' he wrote.

The Dining Room at Waddesdon Manor, looking towards the Conservatory, with the table laid as for a formal banquet. The room was inspired by Louis XIV's state apartments at Versailles. The food was as complicated as the decorations.

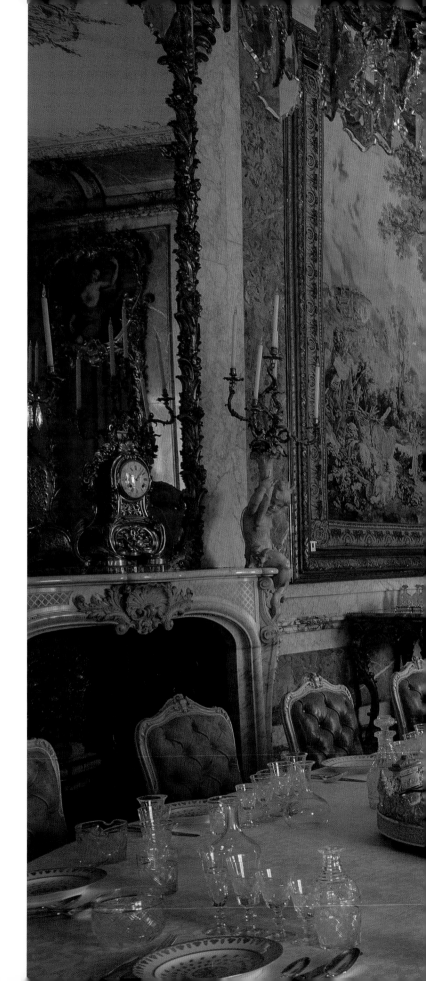

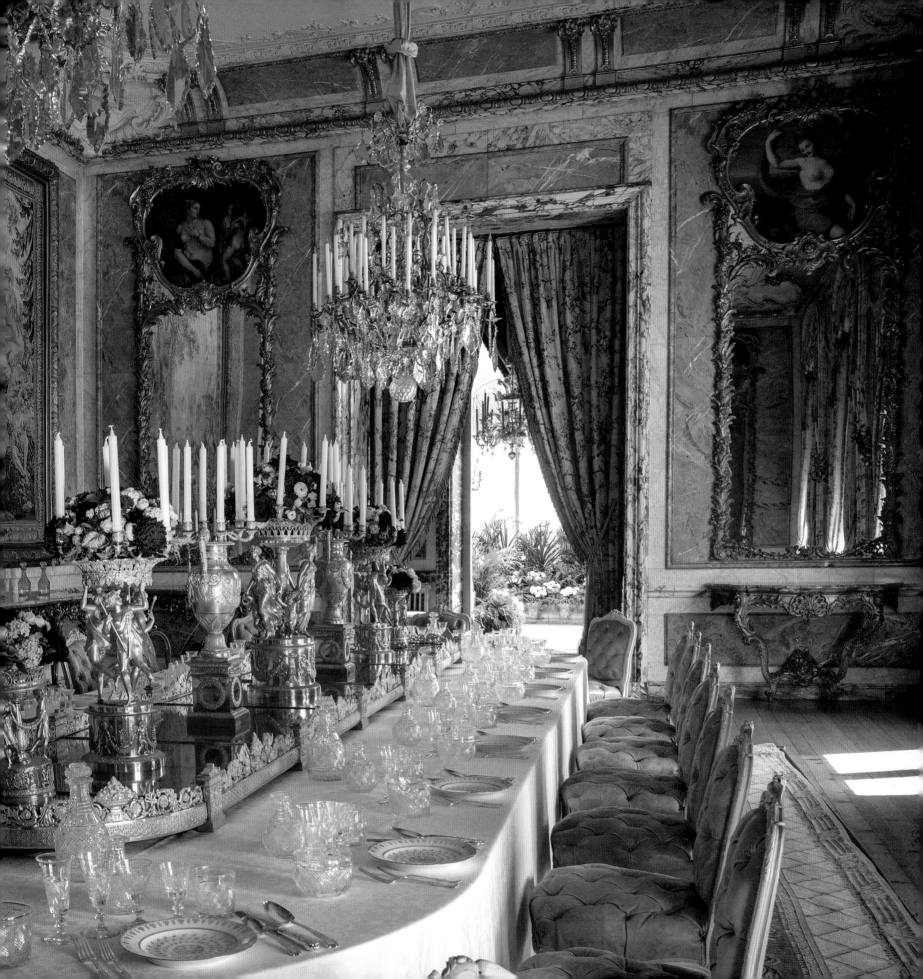

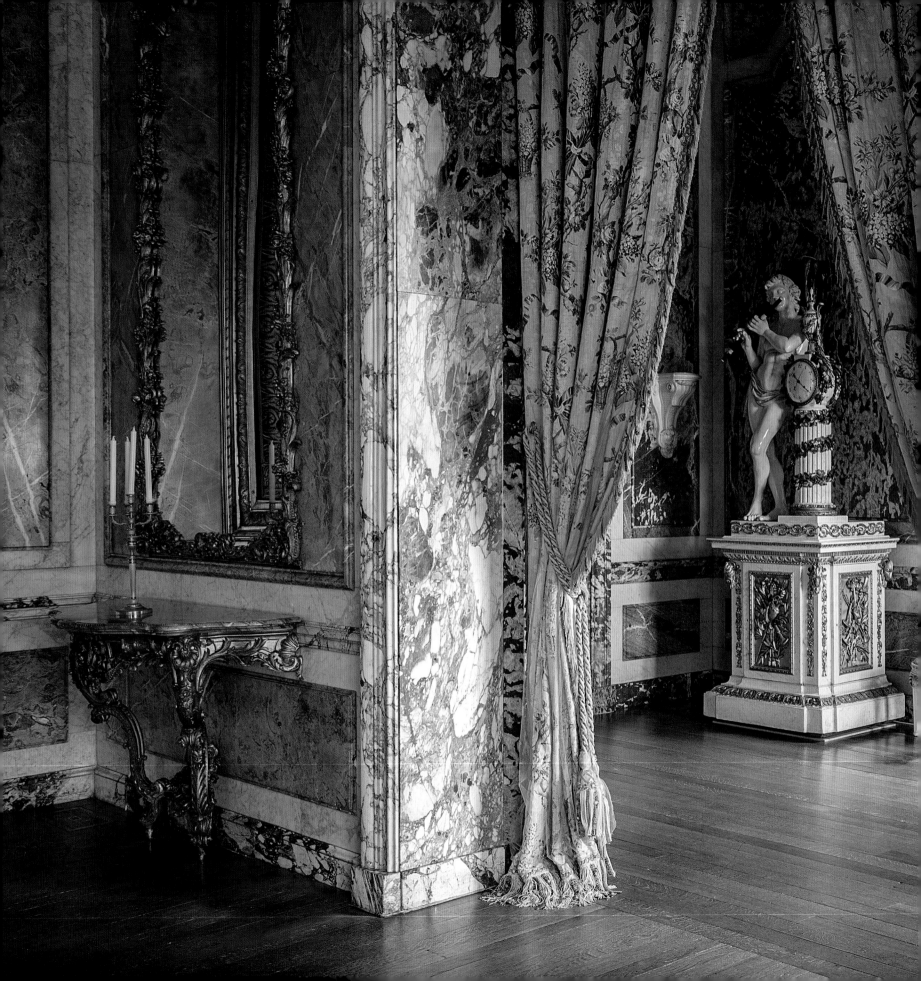

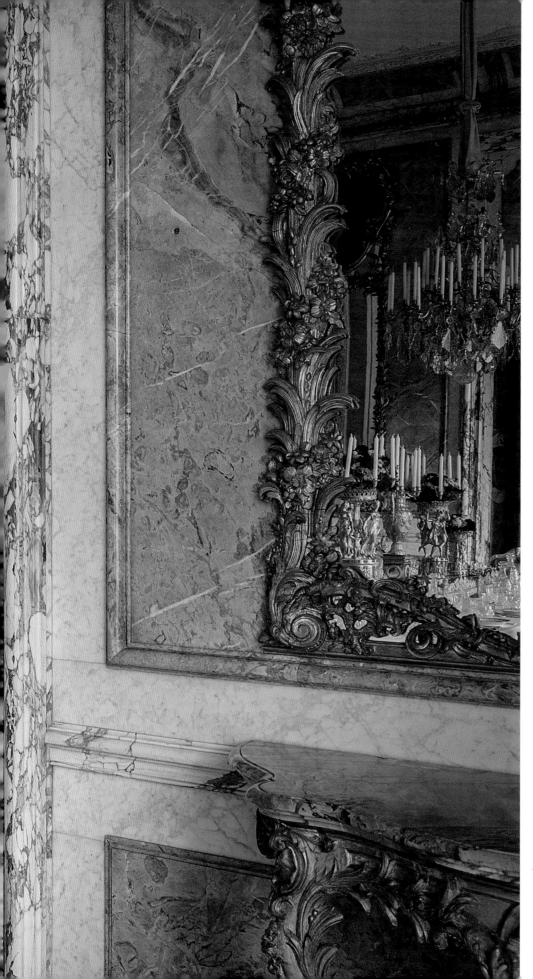

A corner of the Dining Room leading into the Conservatory, through which the food would have been brought from the kitchen some distance away.

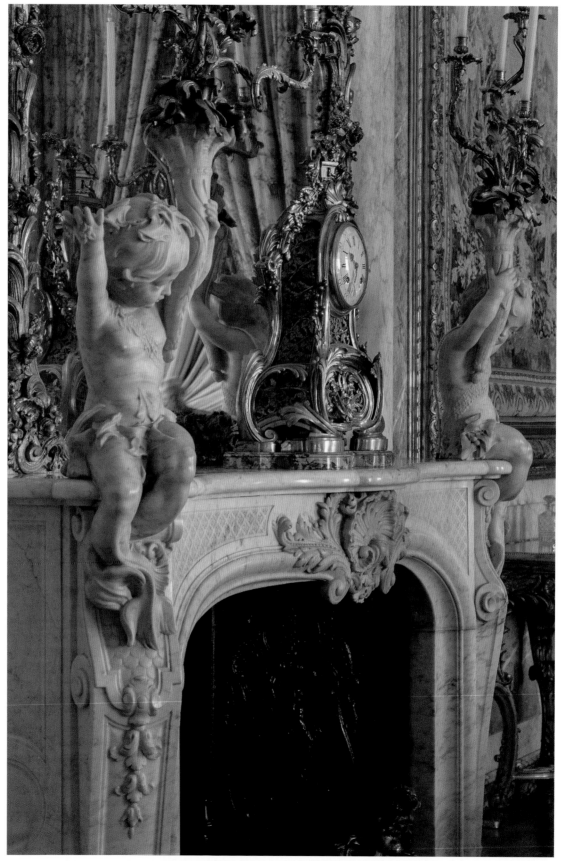

ABOVE *The Dining Room fireplace was designed specially for the room.*
OPPOSITE *Textiles, marble and gilding and a corner of the Aubusson carpet on the plain English oak floor, unexpected in this extravagant French setting.*

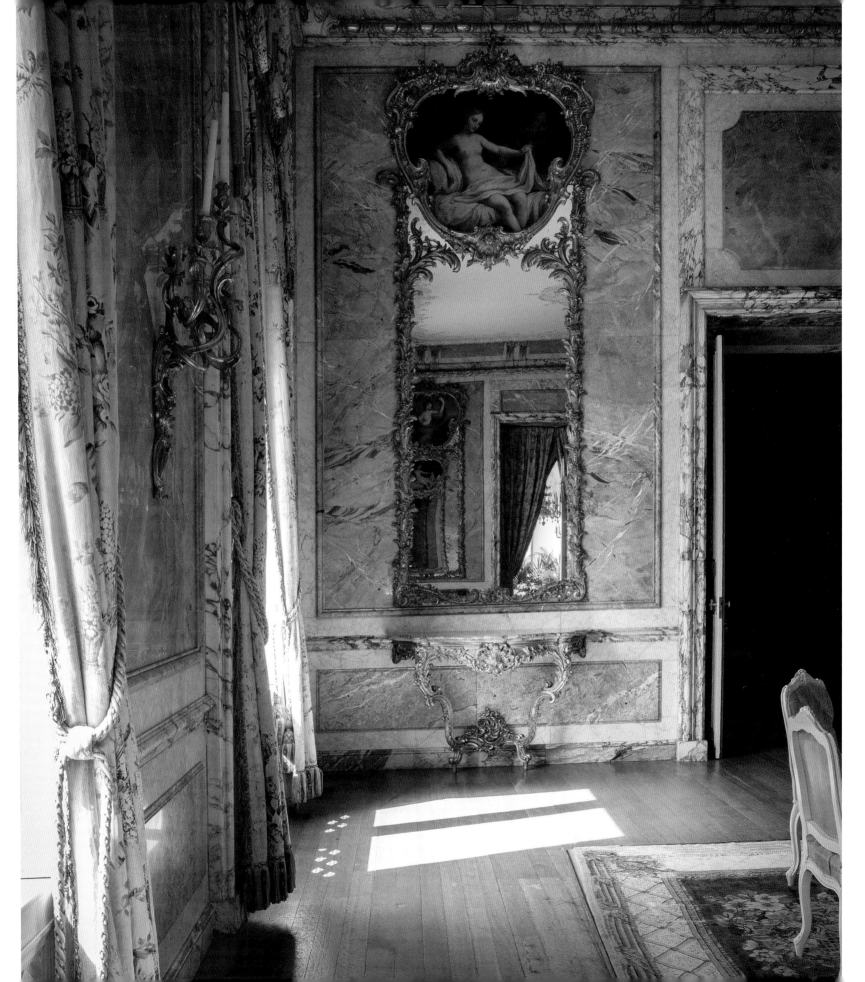

THE RICHLY DECORATED Dining Room conjures a miniature Versailles and typifies the gilding and marble that Baron Ferdinand speaks of – a statement of taste so closely associated with the elaborate style of interior decoration favoured by the Rothschild family that it simply went by the name 'Le Goût Rothschild'.

The walls are faced with sections of four different varieties of rare marble. The large wall panels, for example, are a mottled grey and pink. The effect is deceptively simple, but in fact it would have been incredibly difficult to achieve, with its large, unwieldy panels and hidden fixings. An Aubusson carpet covers most of the wooden floor, and a beautiful series of Beauvais tapestries designed by François Boucher line the walls. The view looking out to the formal garden along the windowed south wall would have echoed the views within the tapestries hanging on the opposite wall, giving each guest a taste of the outdoors while they enjoyed their meal. In addition, the table would have been laden with flowers grown in the Waddesdon glasshouses.

Baron Ferdinand seamlessly mixed old with new in a way that was unusual at the time. One of the five mirrors in the room, made by the rococo designer Nicolas Pineau in 1732, was installed above the Louis XV-style fireplace, designed and made specially for the room by Destailleur.

Today Waddesdon Manor boasts extraordinary visitor numbers; it is not un-heard of for 10,000 people to pour through the estate on a Sunday in December. Baron Ferdinand's penchant for collecting has been continued with vigour by his scions. Jacob Rothschild, who has been responsible for the house and its contents since 1988, has embarked on a sensitive yet persistent search for excellence, and in doing so he has ensured that the quality at Waddesdon Manor has never wavered, and that its collection has increased.

This is now the only English Rothschild house in which the original collection of pictures, objects and furniture remains intact. In the intervening years the house has been loved and restored and the contents added to by three further generations of Rothschilds.

Part of the south front of Waddesdon Manor, showing the fountain
that is the centrepiece of the parterre.

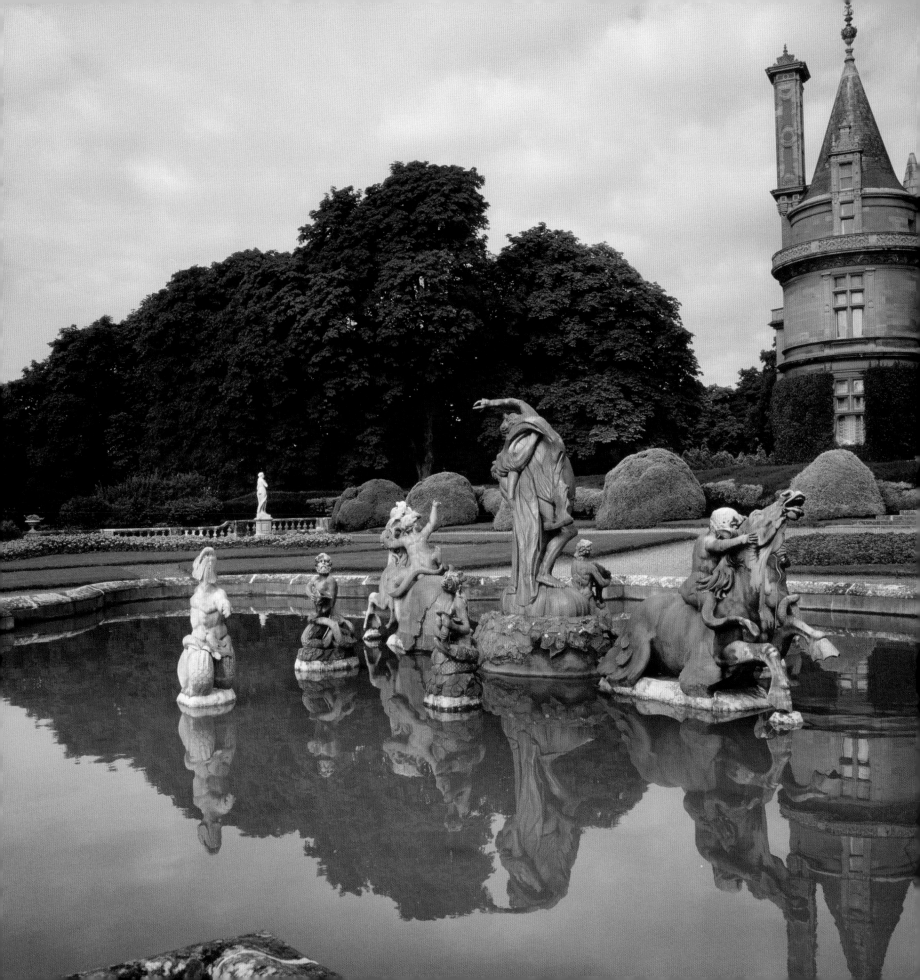

We are lucky still to have the Ritz Hotel in London. In the 1950s plans were made to pull it down and develop the site, but thankfully its demolition was permanently halted. In the years since the hotel opened, in 1906, the name 'Ritz' has become synonymous with luxury. The aesthetic is one of decadence and expense – a stylistic revival of eighteenth-century France during the reign of Louis XVI.

The hotel was founded by César Ritz and the architects were Charles Mewès and Arthur Davis. The extravagant French neoclassical furnishings were typical of the period, but must have felt decidedly old-fashioned when compared to the likes of Charles Rennie Mackintosh's pioneering design for the Glasgow School of Art, where work started in 1897.

The architects were educated at the École des Beaux-Arts in Paris and were proponents of traditional French classicism; they lived and worked together until Mewès died in 1914, and were hugely influential on the sort of Beaux Arts architecture that emerged in London in the early twentieth century. Their continental style was well suited to the late imperial tastes of the era, and can also be seen in the dining room of the Royal Automobile Club in Pall Mall, which was built between 1908 and 1911.

Although from the outside the Ritz appears to be built of stone, it is in fact constructed from steel and concrete. Everything you see is cladding or decoration applied in beautiful shapes or volumes. As at the RAC, Mewès and Davis were clearly working to a tighter budget than that of Destailleur at Waddesdon Manor, but the sense of theatre is undeniable in all three rooms.

The Ritz's interiors were decorated and fitted out by the English furniture maker Waring & Gillow, which specialised in historical styles; as such, the decorative schemes elegantly answer the questions posed by the architecture. Everything was made to measure, and the Louis XVI style is consistent throughout. This historically typical uniformity serves only to highlight quite how daring Baron Ferdinand had been to mix old and new at Waddesdon just over twenty years earlier.

The recess on the south wall of the Restaurant at the Ritz, with gilded sculpture and sconces backed by pastel-coloured painted decoration and marble.
PAGES 176–77 *Opulence, luxury and food.*

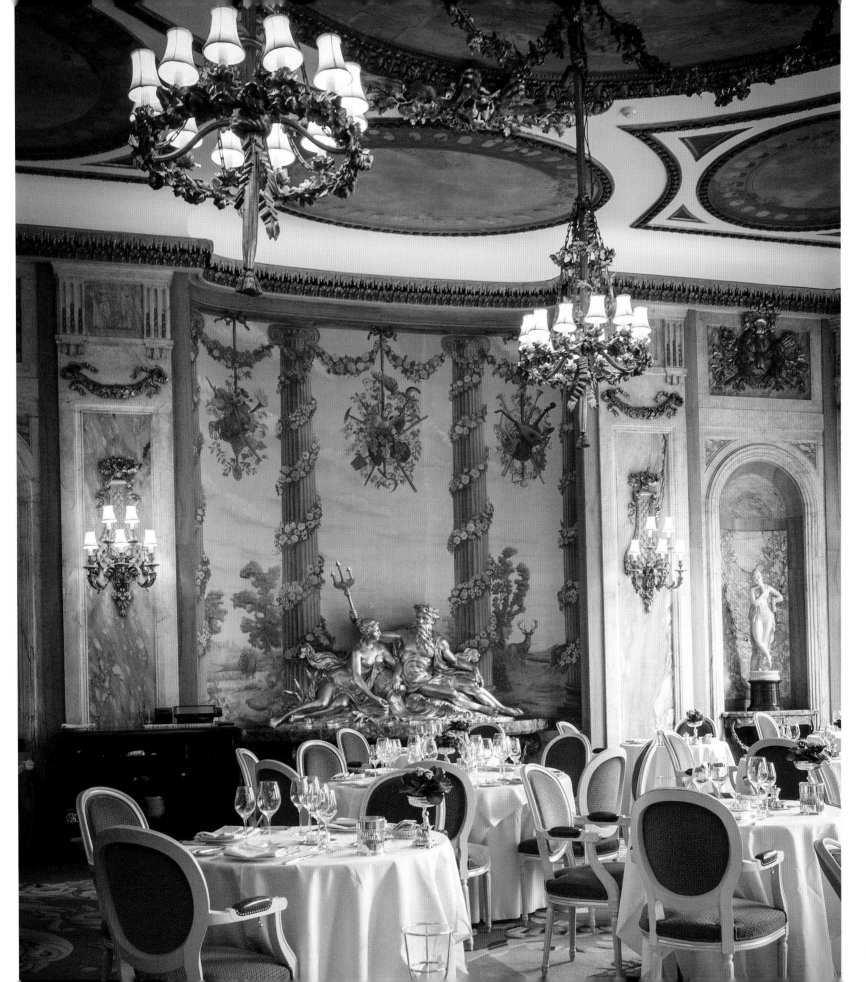

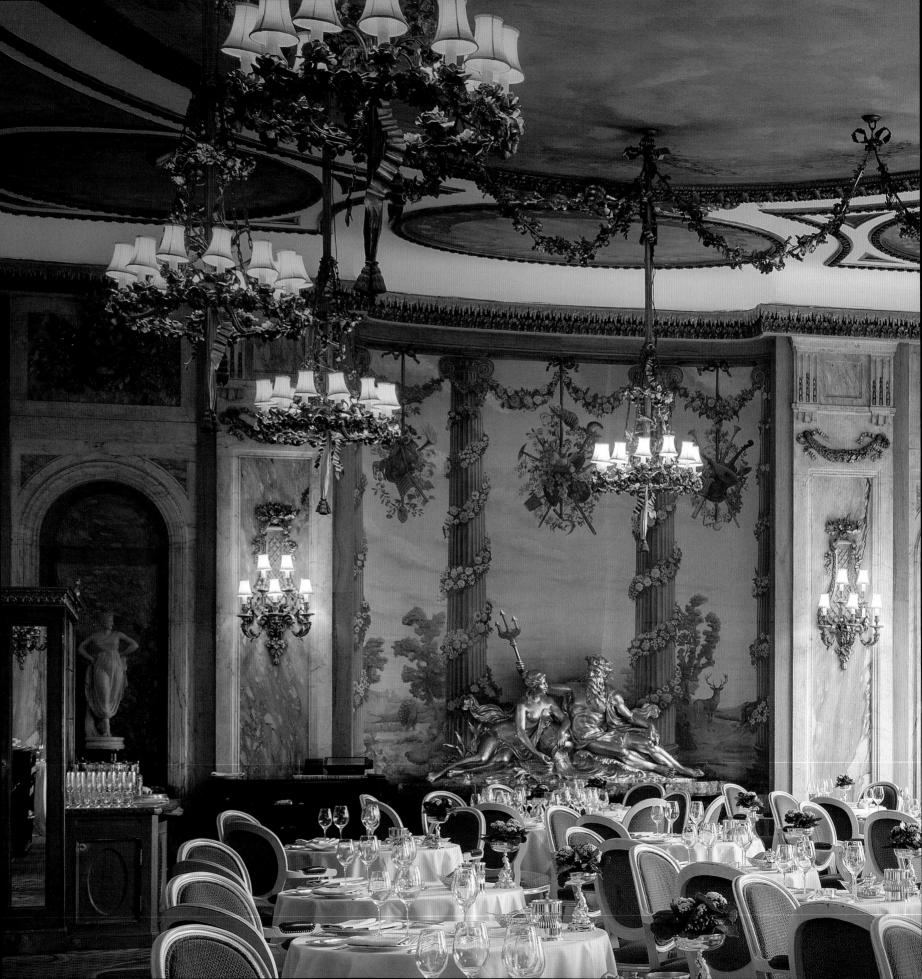

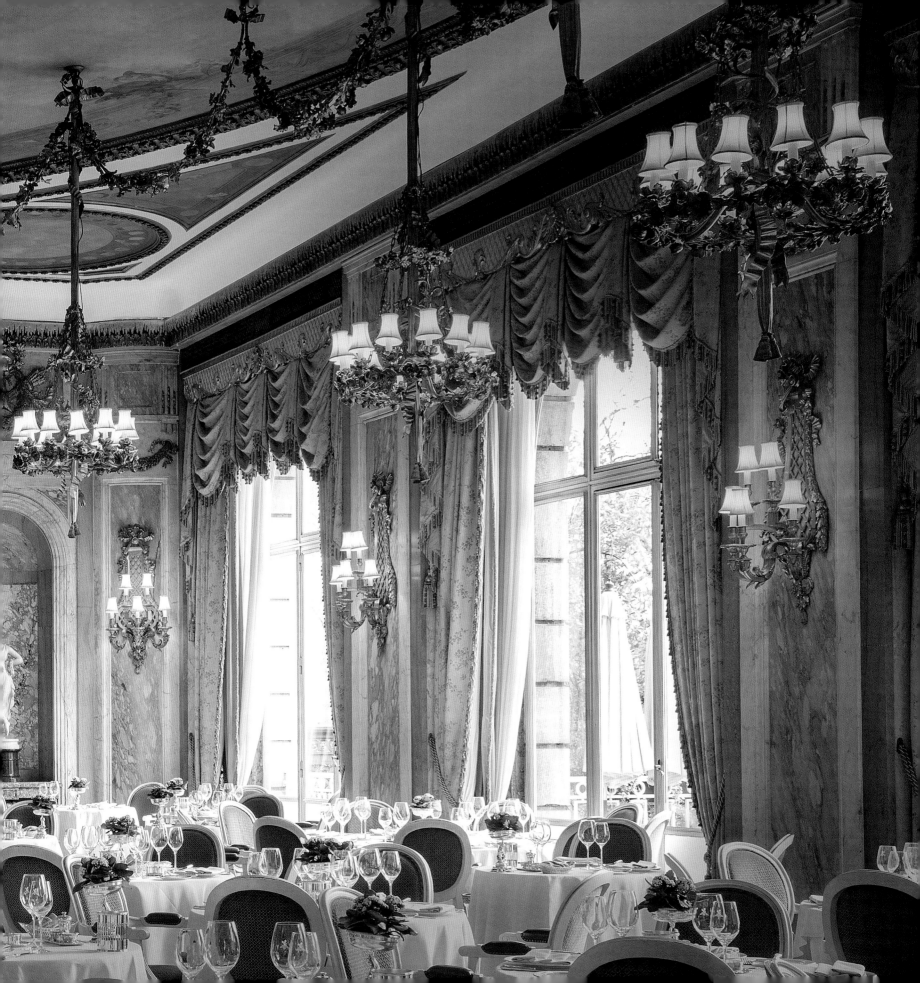

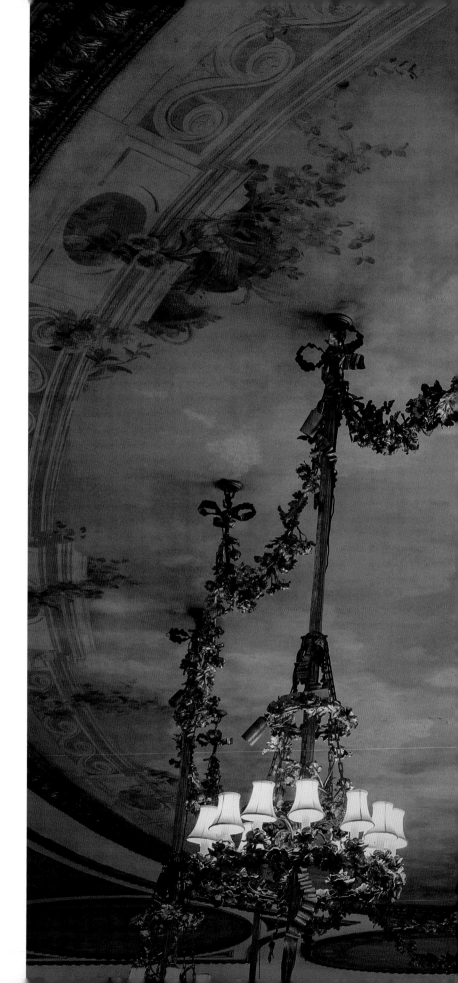

The unexpectedly and imperceptibly wedge-shaped Restaurant at the Ritz is faced entirely in marble, bronze and mirrored glass, and decorated in shades of pink, green, cream and, of course, gold. One can only marvel at the workmanship, for, as at Waddesdon, there are no visible fixings to the marble cladding or bronze fittings. The air grilles are ingeniously fitted between the mouldings, as at the RAC. Clouds float across the *trompe l'œil* painted ceiling, and eight bronze chandeliers linked by garlands hark back to the carved frieze decoration of Roman temples. César Ritz once noted how fortunate it was that the hotel was built from steel, or 'the walls would collapse with the weight of all that bronze'. The balance of colour, texture and proportion is extremely carefully considered. With its views across Green Park, this dining room is arguably more beautiful than any other hotel room in London. Famously, Sibyl Colefax (John Fowler's business partner) refused to re-decorate it when she was asked, in the 1930s. The fact that it is still fit for purpose and remains just as the architects intended is a testament to the high quality of the design and workmanship.

As at Waddesdon and the Ritz, the dining room at the RAC is a fairyland designed to lift guests out of the real world. The style is again Louis XVI interpreted by Mewès and Davis with its flourishes of eighteenth-century detail. It is one of the last demonstrations in London of luxury and privilege before World War I; a place of parade, much like the state apartment in a great English house, but French in character. The motoring enthusiasts who frequent the club profit from views across the garden and into St James's Park beyond.

Despite its luxury and excess, the Dining Room at the RAC is to some extent the poor relation of the dining room at the Ritz. Here all the stonework and marble is in fact painted plaster. Nonetheless, this is still a place of exceptional beauty and one of the last bastions of decorative excess. Not everybody admired the Edwardian French eighteenth-century revival style, though: Max Beerbohm called it 'Lulu Quinze', and others later 'Louis the Hotel'. Such showmanship is a mark of Edwardian over-confidence, a sense of self-assurance that was swiftly swept away, starting with the sinking of the 'unsinkable' *Titanic* in 1912 and the outbreak of World War I in 1914. It was a fantasy that could not endure on this scale.

RIGHT *The Ritz Restaurant ceiling with gilded bronze garlands connecting the chandeliers.*
PAGES 180–81 *The Restaurant looking north. The panelled mirror glass appears to double the size of the room.*

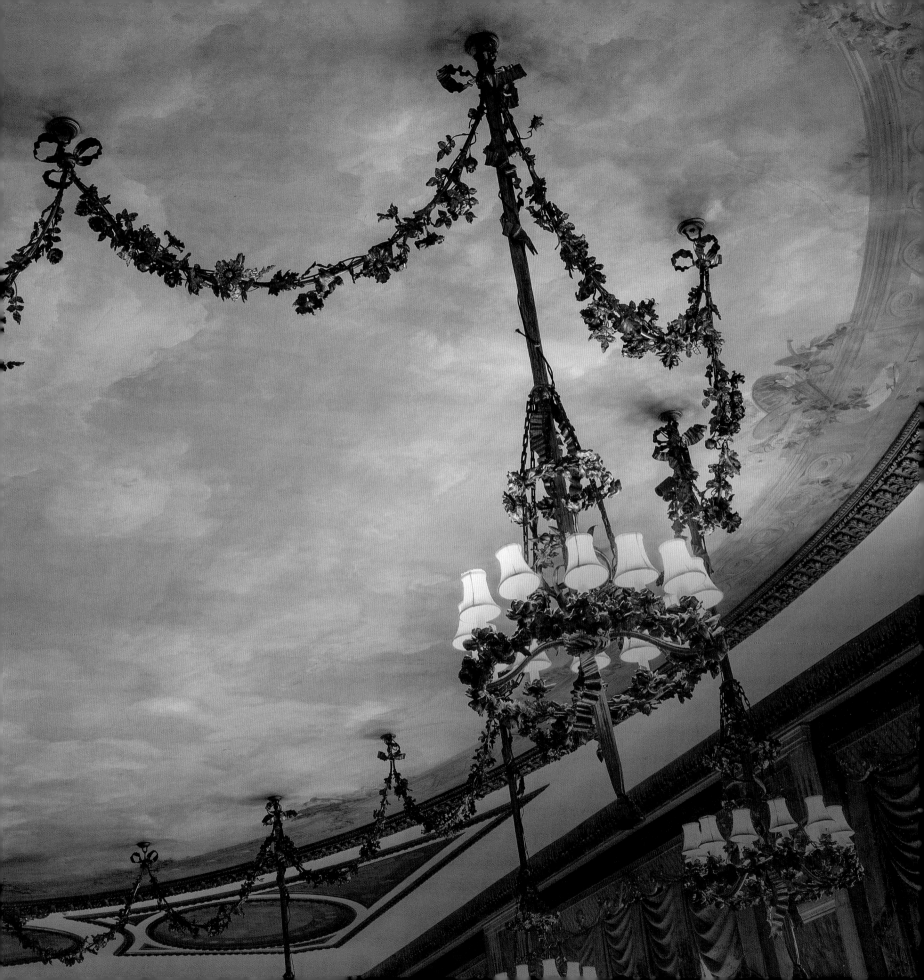

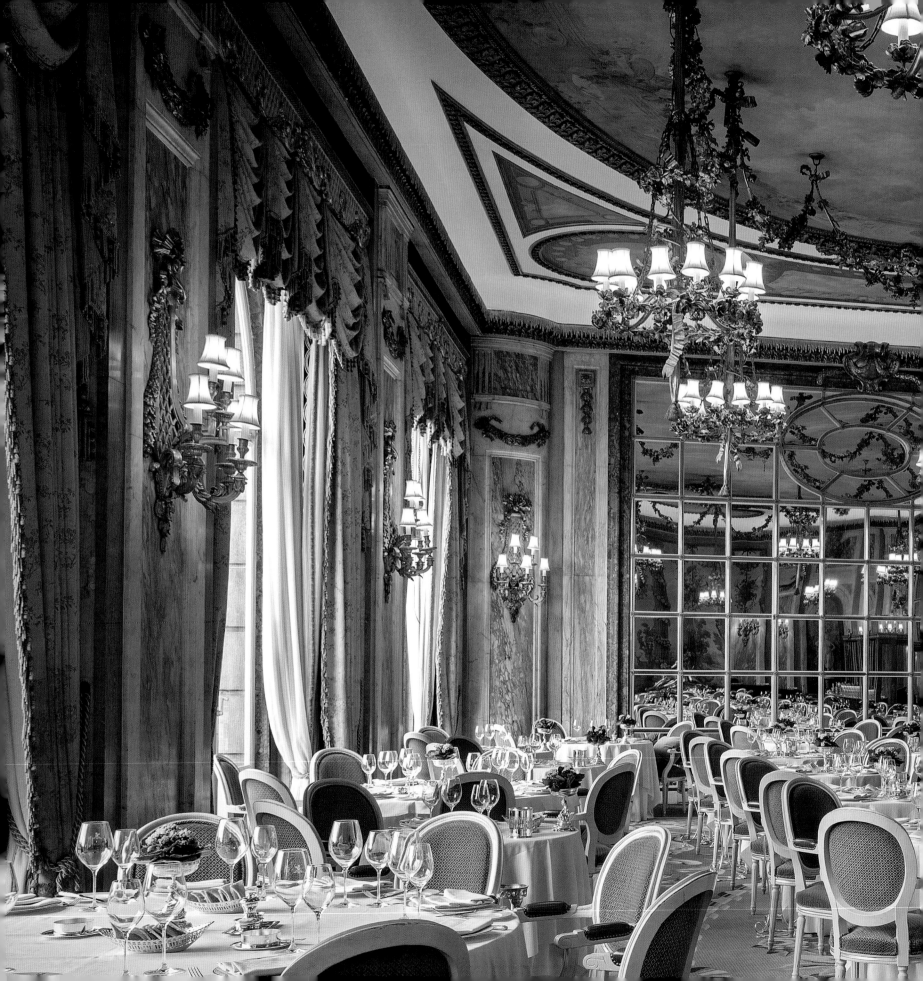

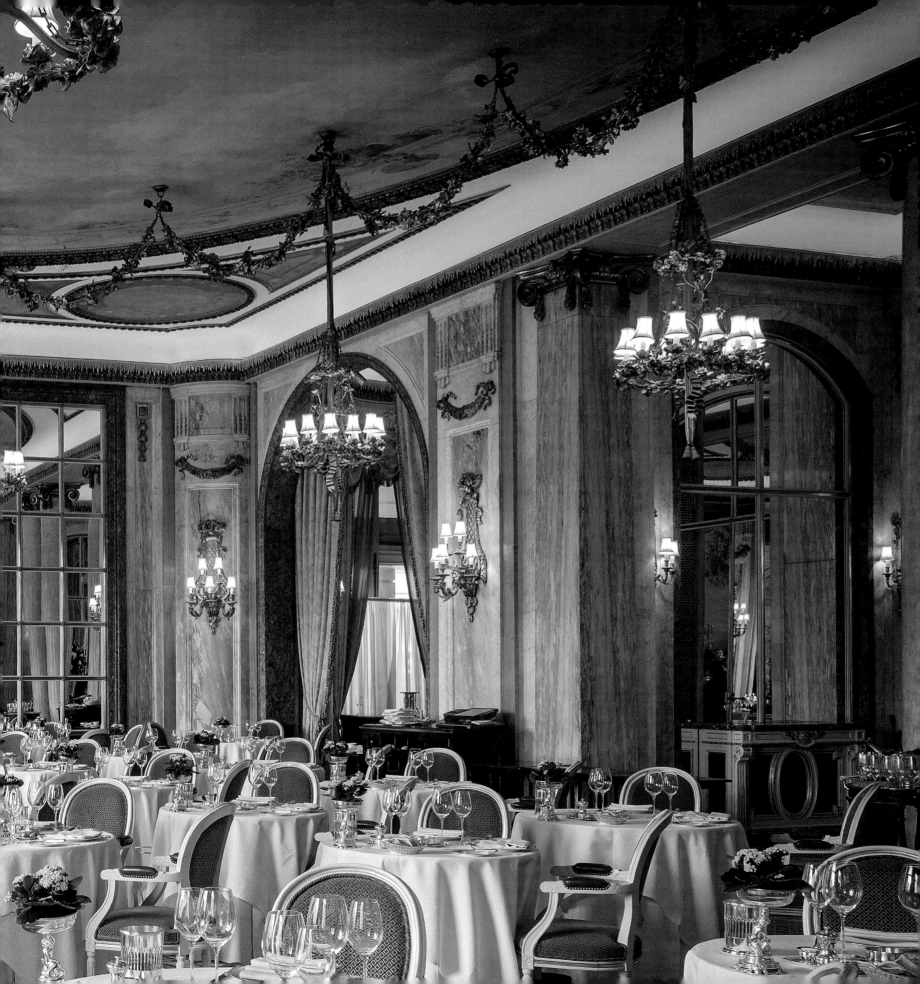

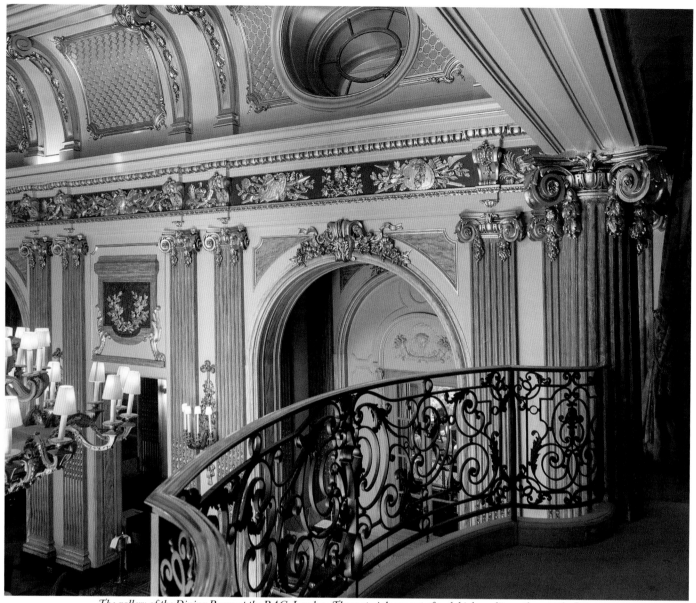

The gallery of the Dining Room at the RAC, London. The materials are not of such high quality as those at the Ritz, but they are equally ingenious and impressive in design.

The stairs leading to the raised end of the RAC dining room.

183

There are 32 light bulbs in each of the chandeliers in the RAC Dining Room. Note the œil de boeuf, with a mirror in lieu of plain glass.

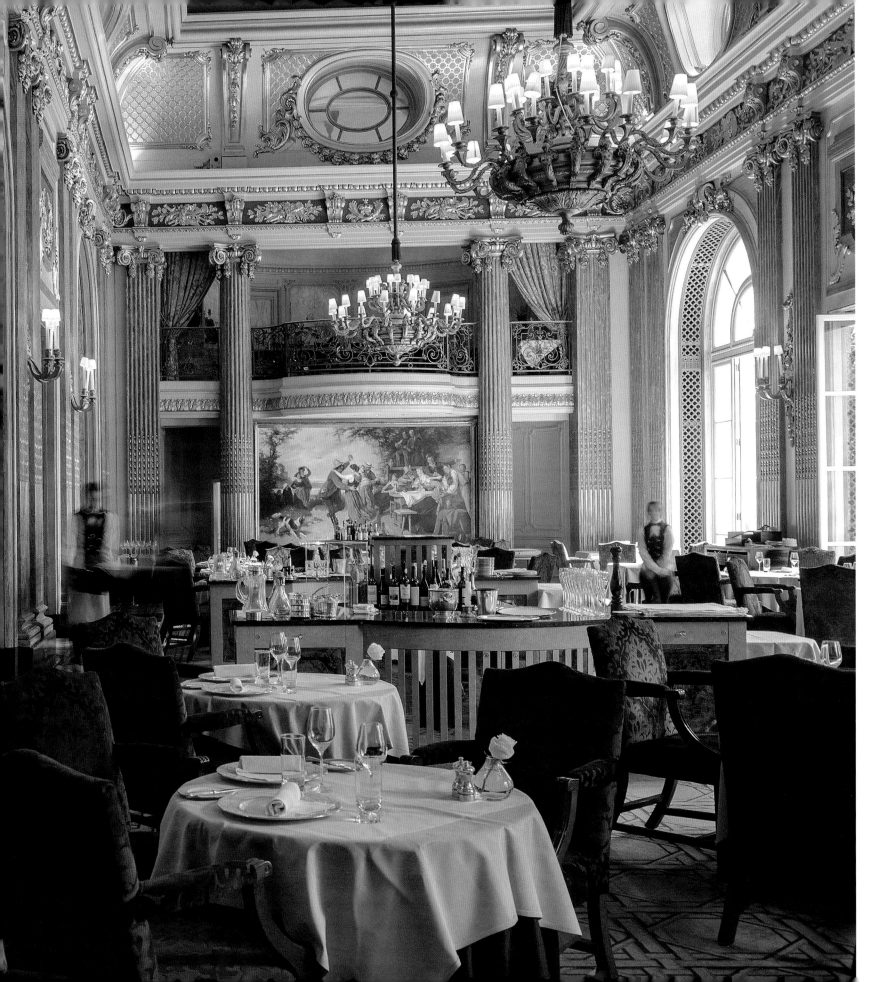

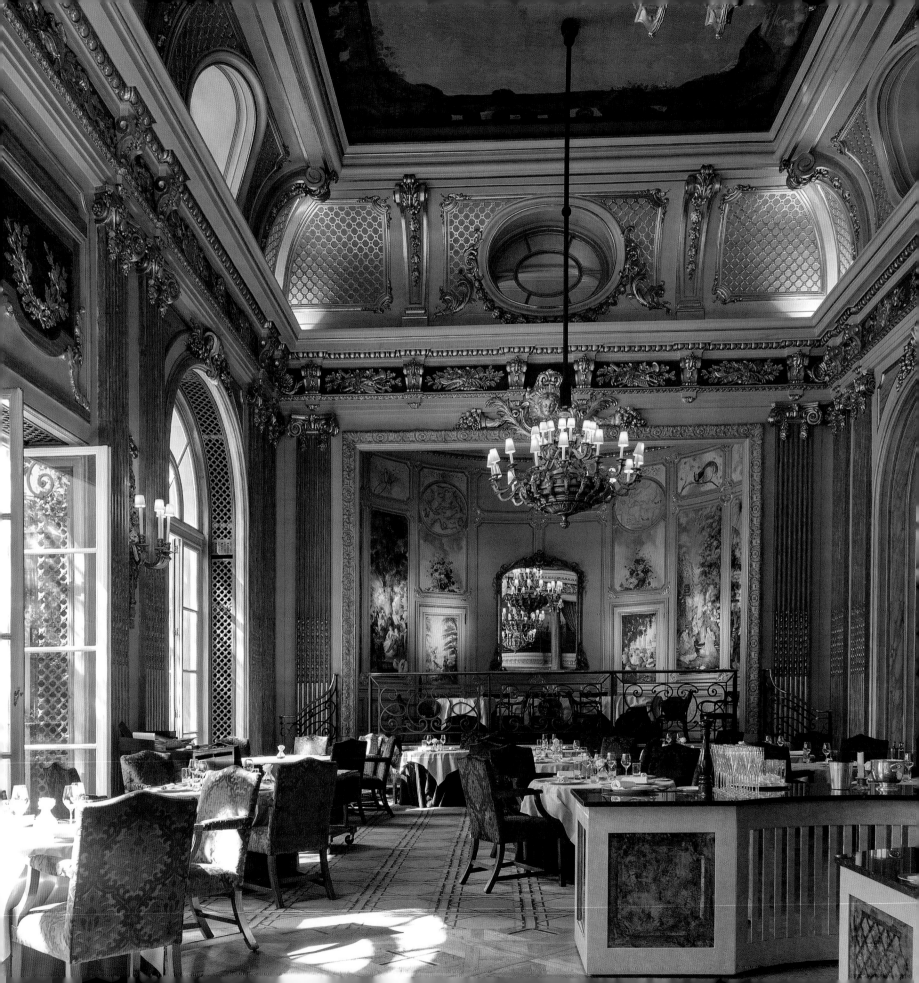

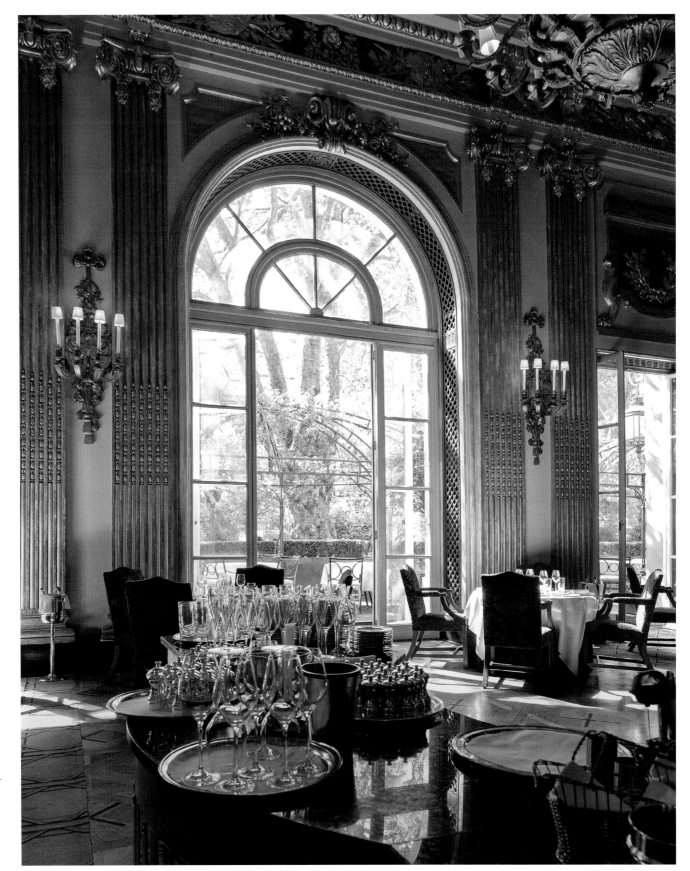

OPPOSITE *The RAC Dining Room.*

RIGHT *The Dining Room, looking towards the garden. This view gives it something of the feeling of an orangery, an atmosphere the Ritz Restaurant shares.*

TWENTIETH
CENTURY

Diametrically
Opposed Attitudes

———

The twentieth century is particularly confusing for the layperson looking at interior design and decoration. For 100 years a rivalry persisted between the modern (now thought of as an historic style) and the traditional. The latter was a great consolation in times of massive change after the two devastating world wars. The former, always the more important because it broke new ground, proved difficult for many people to like. This was particularly true in England, which was deeply rooted in its past, its conventions, its pride and its sense of correctness.

It now seems remarkable that changes did not take place more quickly, but lack of money and technology seems to have hindered designers both from experimenting and from thinking imaginatively. In the 1950s, across the Atlantic, seminal buildings such as the Lever and Seagram buildings on Park Avenue, New York, were being erected. The only analogous example I remember being told to look at, as a student of architecture at the time, was the former Castrol building on Marylebone Road in London. Although it lacks the scale and quality of its American cousins, its form and use of turquoise glass panels is comparable to that of the Lever Building.

The modernists and the traditionalists opposed each other as fiercely as they had done in the nineteenth century during the Style Wars. The traditional movement found its voice and purpose in the conservation and restoration of historic buildings. In my view, the tidying up of buildings – now known as the heritage – was essential before the modern movement could make great strides. Following the wars a great deal had been abandoned, lost or disfigured, and the regret that came with that loss prevented many people from appreciating and understanding the new. People felt that the buildings going up were considerably less agreeable than those that were being pulled down, both in appearance and for their purpose. With hindsight, we can see more clearly than our predecessors how important it was to keep both categories of building.

This serves as another important reminder of how prejudiced contemporaries can be about their respective achievements. The Russian composer Tchaikovsky searingly referred to Tolstoy's *Anna Karenina* as 'aristocratic babbling'; not to be outdone, Tolstoy thought Wagner's *Siegfried* 'fit for a circus. Idiotic. Pretentious', and Shakespeare's *Hamlet* and *King Lear* 'such affectation'. Closer to our subject, Palladianism became unpopular and disregarded from the time of the Adams' neoclassicism and throughout the nineteenth century.

The Garden Room at Charleston (pages 192–95), showing a little
of le désordre anglais, *but beautiful and comfortable.*

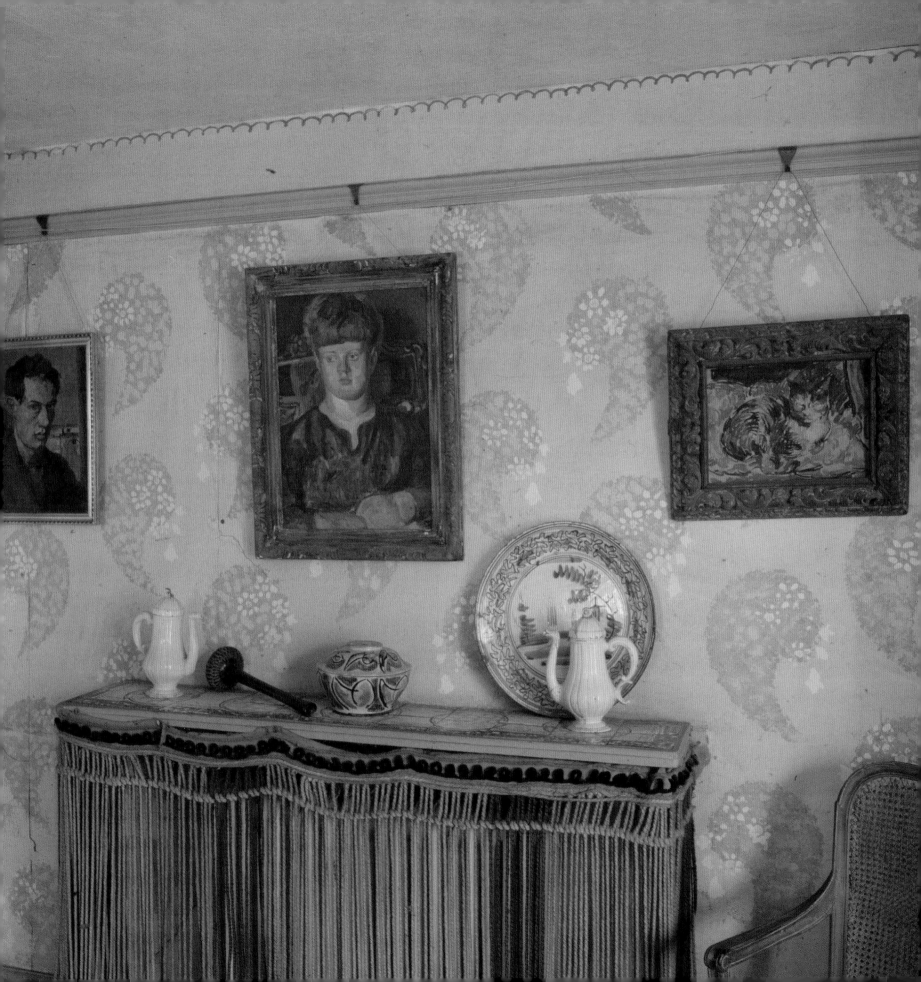

CHARLESTON
EAST SUSSEX

A Bloomsbury Retreat

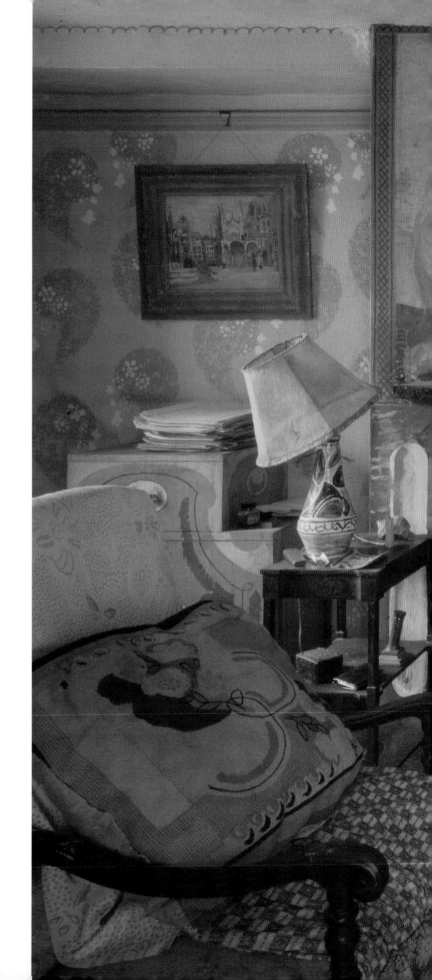

In 1916, at the height of World War I, the painters Duncan Grant and Vanessa Bell, his friend and lover David Garnett, her two young sons Julian and Quentin and their dog Henry moved to Charleston, a brick farmhouse at the foot of Firle Beacon in the South Downs of East Sussex. Both Grant and Garnett were conscientious objectors, so needed to find 'work of national importance' if they were to avoid imprisonment. At Virginia Woolf's suggestion, they rented Charleston and spent the war years working on the land surrounding their new home.

Charleston became the rural outpost for the group that is now known collectively as 'Bloomsbury'. For the next 64 years, the farm was home to a ménage of friends, lovers and partners, whose romantic affairs, sexual fluidity and experimental living arrangements would prove as enthralling as their creative output. As Bell's daughter Angelica Garnett later wrote, Charleston was conceived as 'a spiritual refuge from the tougher aspects of the outside world'.

Among their number was Clive Bell (who was married to Vanessa), John Maynard Keynes, and Woolf (Vanessa's sister) and her husband, Leonard, who lived nearby. But it was Vanessa Bell and Grant who created the visual setting at Charleston. The house neatly encapsulates their talents, skills and personalities, illustrating what they thought was beautiful and how they wanted to live. 'It's most lovely, very solid and simple, with flat walls in that lovely mixture of brick and flint that they use about there, and perfectly flat windows in the walls and wonderfully tiled roofs,' wrote Vanessa Bell to her friend Roger Fry in about 1920.

But the house was very uncomfortable. Until 1919 there was no bathroom and no hot water, and the rooms were icy unless heated by open fires, which of course depend on being fed. There were rugs and screens throughout the house, but these could barely combat the pervasive cold. A nurse, a housemaid and a cook moved to Charleston with Bell and Grant in 1916, and cooking was done on a coal-fired range. 'Vanessa … was an excellent, if rather formal hostess. Drink, supplied by Clive, flowed; food, although simple in style, was succulent and appetising,' wrote Angelica Garnett. But most remarkable about Charleston are the decoration, furniture, textiles and objects.

Every room is painted, papered or stencilled, with no unified colour schemes of the type now identified in magazines. The choice of colour is spontaneous, and none of the textiles and patterns 'go' together; many of these are antique, others were embroidered by Duncan Grant's mother, Ethel. There are curtains made from several chintzes sewn together, and there are designs from the Omega Workshops. But despite the fanciful decoration, the overall effect is harmonious. These rooms could not have been achieved by anyone other than the owners and their friends; they were created in complete opposition to the way interior designers work today. One could say it constitutes a beautiful parody of designed interiors. There is a feeling of 'abroad' to the house, although it is unmistakably English.

Every component of the house would have been chosen and put in place with as much thought, care and love as any of the more disciplined rooms in this book. The overmantel in the Garden Room was painted by Duncan Grant. These photographs were taken when he was still living at Charleston.

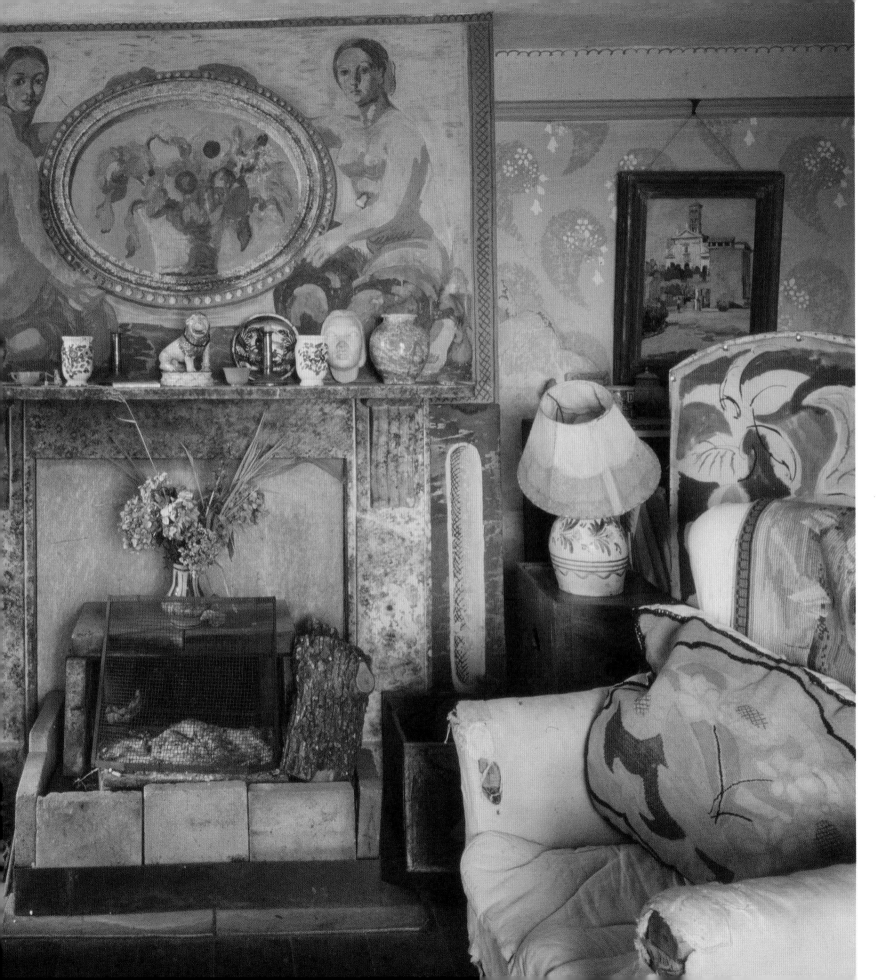

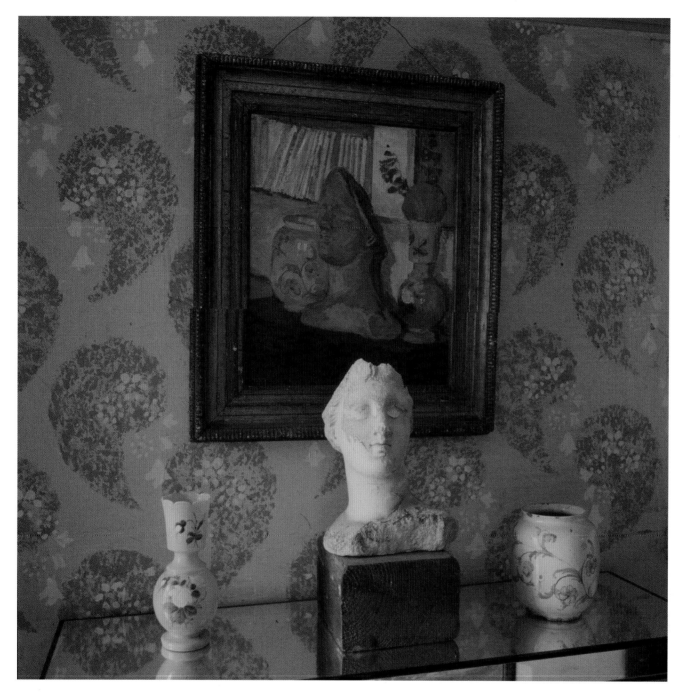

LEFT *The Garden Room, with walls stencilled by Vanessa Bell, as is the still-life painting, which depicts the plaster head underneath it.*

OPPOSITE *The Garden Room window, with harp and violin chosen for their beauty rather than the sounds they wouldn't make.*

THE COLOUR SCHEME is reminiscent of the French Impressionist palette and the sets and costumes of the Ballets Russes. Most of the best pieces of furniture are Dutch, French or Italian, some of which have been left in their original condition while others have been painted. There are also pieces made by English carpenters – rather than cabinetmakers – which are decoratively painted in the manner of the rooms. It is remarkable to think that Charleston came into being just a decade after the grandeur of the Ritz in London. The two sets of interiors are worlds apart.

Bell and Grant created a house in the style of their paintings, turning it into a stage set for the people who lived there. But by the time Grant died, in 1978,

Charleston was extremely dilapidated. Nonetheless, what the interiors lack in durability they make up for in authenticity, and this has been carefully preserved by the current curators. The Bloomsbury Group typified the perennial English love of escaping to the countryside and living informally with taste and clutter combined. The difference is that this was a house of artists. Everything in it was chosen for its beauty and practicality. Nothing matches; the relationships between the various contents are to do with compatibility rather than sameness. These are choices of individuals who have spent a lifetime looking at objects in their surroundings and rejected or accepted them as precisely as any collector or connoisseur.

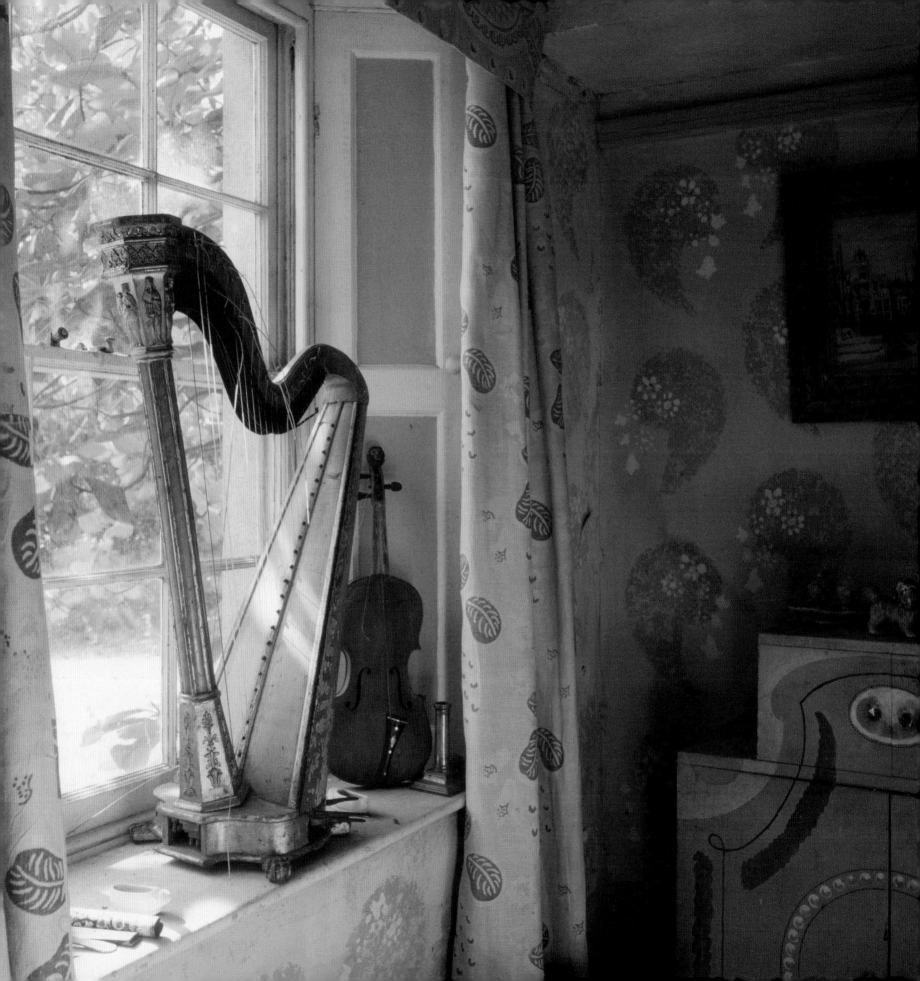

NANCY LANCASTER'S YELLOW DRAWING ROOM AND PAULINE DE ROTHSCHILD'S ALBANY SET
LONDON

Two Fashionable Drawing Rooms

As the second half of the twentieth century began, few people had the instinct, taste or money to decorate their rooms. Between the two world wars and in the 1950s there were only a handful of magazines and books about designed interiors. Such rooms were undoubtedly envied but unattainable, except by a privileged few. But all this changed quite rapidly, influenced strongly by the US, where interior design and decoration was taken seriously as a profession. Leading the charge for English interior design were John Fowler and David Hicks.

Fowler was backed financially and greatly influenced by Nancy Lancaster, an American from Virginia, who was credited with formalising the English country house look after she bought the firm Sibyl Colefax and John Fowler. She was also responsible for one of London's most celebrated and joyful interiors, her 'Butter-Yellow Drawing Room'.

The room had been Sir Jeffry Wyatville's drawing office in the nineteenth century, but by 1949, when it was acquired by Mrs Lancaster, it adjoined the existing premises of Colefax and Fowler. We know from written records that on Monday 23 February 1959 Fowler was 'mixing glaze for Nancy's drawing room'. Rather like a lacquer, the glaze had several coats, and Fowler tinted it in such a way that it would be impossible to copy. It was oil-based, so it has yellowed and intensified over time.

Nancy Lancaster's Yellow Drawing Room had been Sir Jeffry Wyatville's drawing office, and has a small courtyard garden outside. Mrs Lancaster composed the room at a time, after World War II, when very few people had the taste, the money or the energy to do so. It contains pieces of a kind that were readily available in contemporary shops and salerooms.

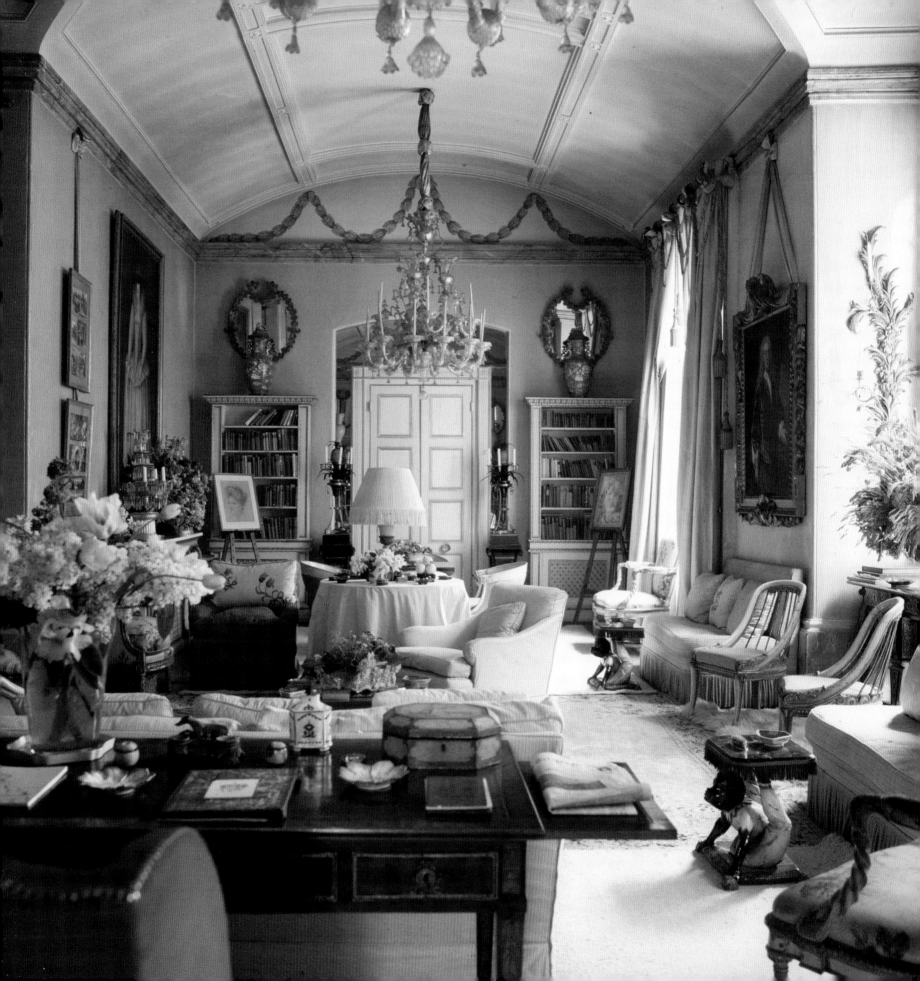

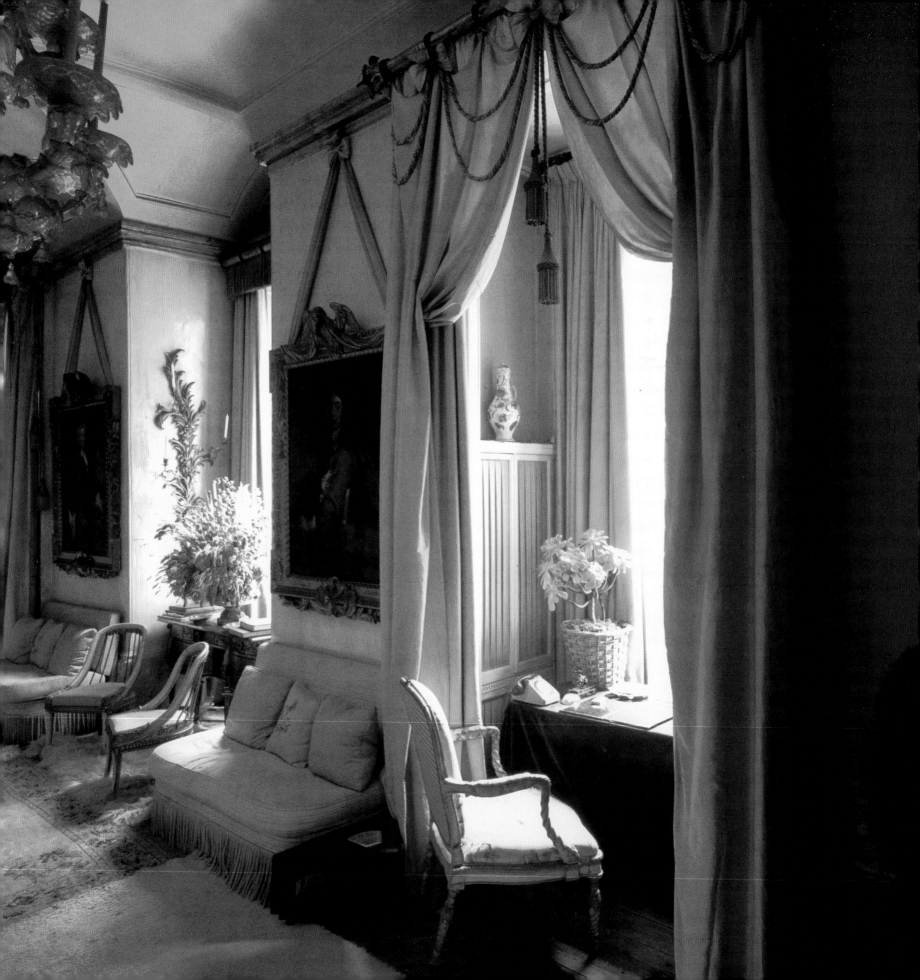

THE ROOM WAS FURNISHED from Mrs Lancaster's previous houses – Ditchley Park and Haseley Court, both in Oxfordshire – and with additional pieces bought in the London salerooms. This was a time of copious choice, when one could go shopping without spending a great deal. Some of Mrs Lancaster's purchases had distinguished provenance, for example the two pairs of bookcases, which were made from a single large breakfront bookcase bought from the auction of the contents of Ashburnham Place in Sussex in 1953. A further two bookcases are thought to have come from Chiswick House, and the pineapple chandelier was said to have been made for Versailles. Although the days of shopping at this standard are now long gone, it was essential to Fowler's work. The popularity of the 'stately homely look' and 'shabby chic' became too great for dealers and other sources of supply to keep up with.

Unlike much work of the same period, Fowler's interiors were distinguished by the high quality of the materials and workmanship. Almost everything was hand-made, and the finish, especially of the upholstery and curtain work, was second to none, and nearly all done by hand – as is clear from the Yellow Drawing Room.

The window wall of Nancy Lancaster's Drawing Room, showing both her and Fowler's taste in furnishings and textiles.

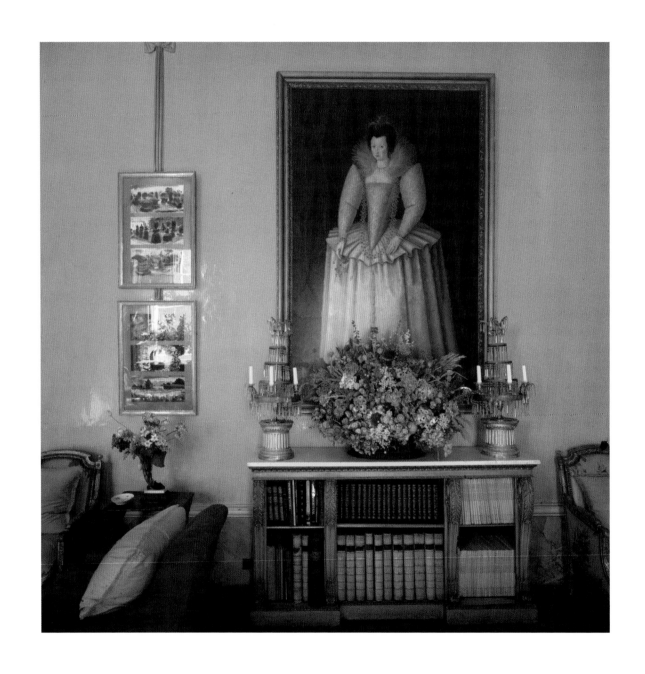

ABOVE *A composition in the Yellow Drawing Room, with Elizabethan portrait, bought at a time when such paintings were not fashionable.*
OPPOSITE *The Drawing Room, seen from the oval lobby.*

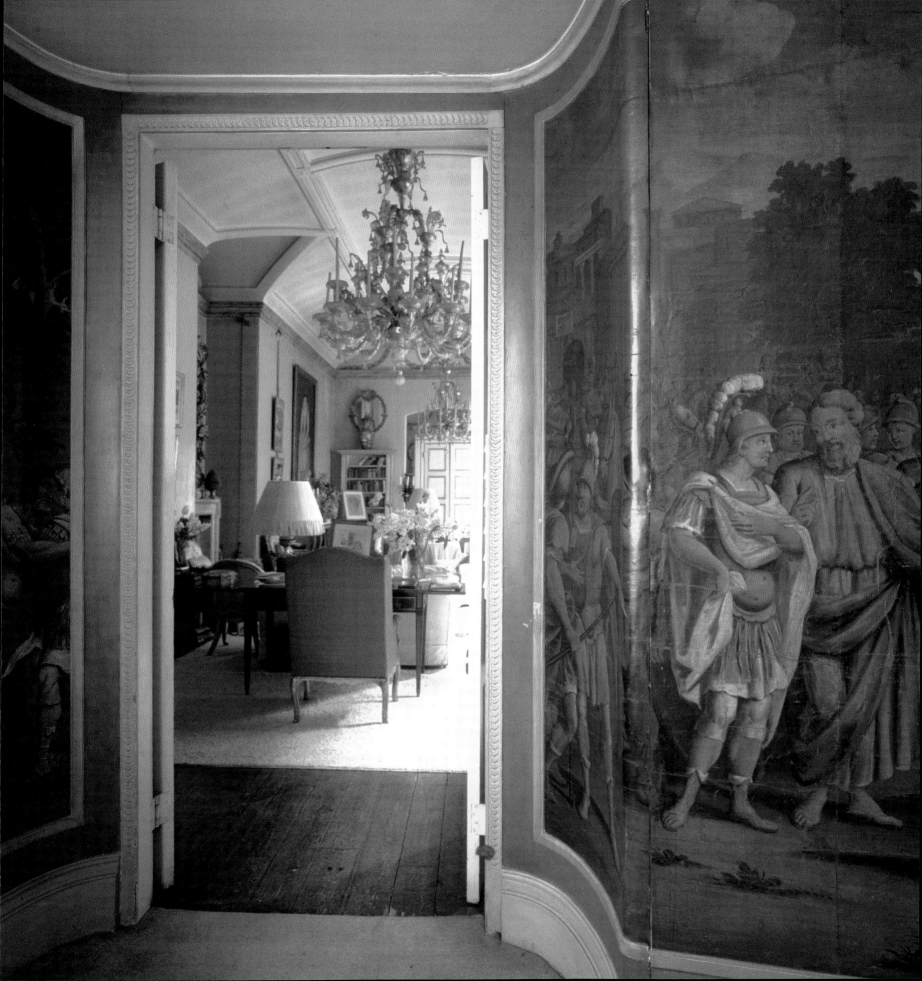

For more than 200 years Albany in Piccadilly has provided a discreet home for London's elite, housing film stars, poets, politicians and even the fictional Jack, from Oscar Wilde's *The Importance of Being Earnest* (1895). Until recently, women were strictly forbidden from entering the building, let alone renting one of its 'sets' (as the flats are known), although Lord Byron famously circumnavigated the rule by smuggling in his lover Lady Caroline Lamb disguised as a pageboy.

By 1970, when Edward Heath became Prime Minister, the rule was no longer in play, and he was able to pass on his set to Pauline, Baroness de Rothschild. The American fashion designer-turned-hostess was married to a Frenchman and had already created beautiful homes in Paris and near Bordeaux. These had been photographed for magazines and books in a way that showed the spirit of their character and atmosphere. This sort of photography marked a movement away from the straightforward full-room shot and instead allowed more considered compositions that showed off the decorator's prowess.

In 1972 Pauline de Rothschild asked John Fowler to prepare schemes for her Albany set. Fowler loved the Baroness. He called her 'the dear B' and collaborated with her on rooms that are unlike any others that he designed. They were both perfectionists, and in an interview with *Architectural Digest* in 1977 the baroness's husband, Baron Philippe, described Fowler's inestimable value to his wife: 'If you asked her, she would have said it was all to his credit. I suspect John Fowler would say it was her genius. I would say it is the result of remarkable cooperation.'

In 1966 the Baroness had published a book, *The Irrational Journey*, describing a voyage she made with Baron Philippe across Russia. While their set in Albany is an unmistakably English interior, it was influenced by the decoration of Tsarist Russia, with additional elements from eighteenth-century France.

Fowler was notably not a traveller, and declared that he preferred to sleep in his own bed. He had not been to America, let alone Russia, yet he knew from photographs how grand Russian houses looked and, according to the architectural historian John Cornforth, was able to discuss the sequence of their rooms and describe their contents.

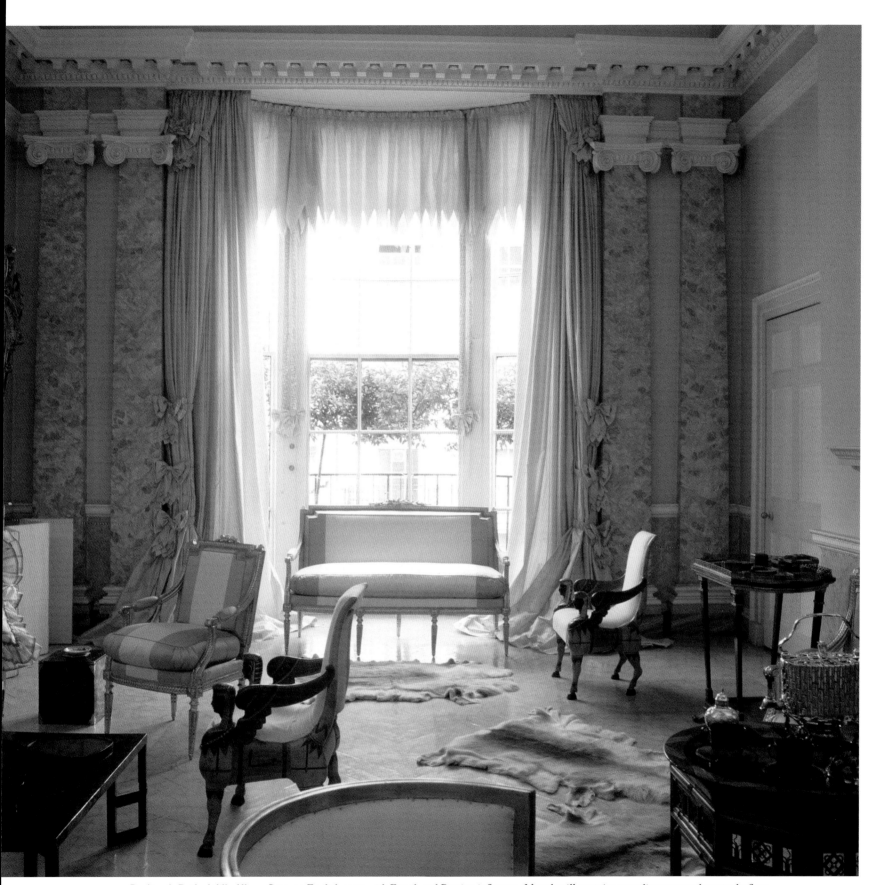

Pauline de Rothschild's Albany Set is an English room with French and Russian influences. Note the silk curtains spreading generously on to the floor.

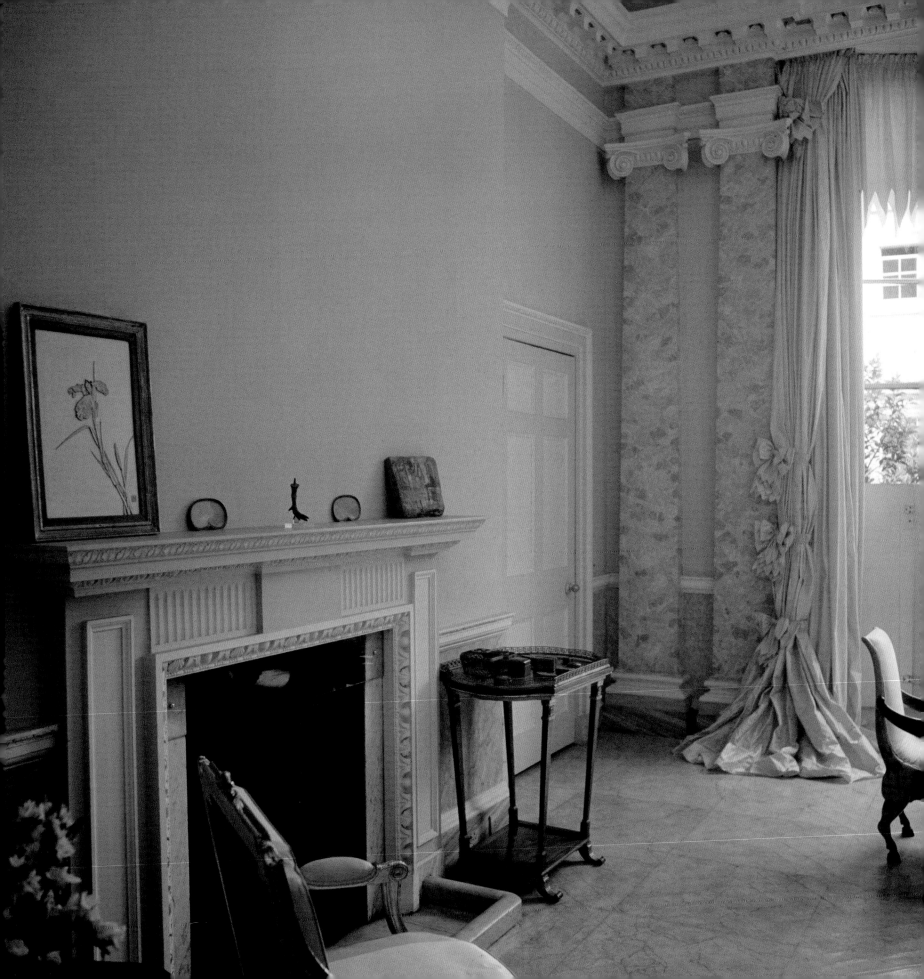

I SUSPECT IT MIGHT HAVE BEEN one of Fowler's most difficult commissions, as tends to be the case when one attempts something that would now be referred to as 'off brand'. The curtains in the drawing room are a case in point. They were first mocked up in linen before being made in unlined lemon-yellow silk taffeta. The taffeta versions were made twice and altered twelve times before they were deemed acceptable by both Fowler and the Baroness. They were said to have been left unfinished on purpose. The oyster-coloured chintz valance was cut into exaggerated zigzags, which, it is thought, emulated the icicle-lined windowsills she had seen during her Russian travels. These curtains may be based on an eighteenth-century painting by Nicolas Lancret depicting the bedchamber of Marie-Thérèse Geoffrin, a heroine of the French Enlightenment. The curtains in the painting are gathered with tasselled cords into four balloons of fabric, a technique that Pauline de Rothschild mimicked in her Paris apartment. However, in her London set she changed the design, deflating the puffs of fabric and replacing the cords with extravagant double bows. In Albany they spread a yard or so on the floor, as they do in the painting, and are less tailored than Fowler's usual designs.

All the painted surfaces except the ceilings were textured in some way. The walls were dragged horizontally and the pilasters, dado and floor were marbled. The panelled doors were painted in three tones of off-white, a French technique that Fowler often used on English six-panelled doors. The painted floors were influenced by those in Scandinavian castles, where marble was a rarity and so painted marbling became a fashionable alternative.

The colour scheme, which extended to the painted decoration and furnishings, consisted of off-white, pale grey, pale blue and lemon yellow. The antique furniture was from France and Russia and was either gilded or made from dark wood. Deerskin rugs were scattered across the floor, seemingly at random.

Imaginative and in some ways impractical, the drawing room, just like the rest of the apartment, resembled a stage set. If ever there were an instance of a decorator composing a room as a portrait of its owner, this was it.

Pauline de Rothschild's Albany Set. Note the unexpected arrangement of the mantelpiece, instead of the normal painting or mirror hung centrally above.

DAVID HICKS AT HOME
OXFORDSHIRE AND LONDON

— ◆ —

What a Key Designer Kept for Himself

Mᴏʀᴇ ᴛʜᴀɴ 50 ʏᴇᴀʀs have passed, and yet photographs of David Hicks's early work still demonstrate his tremendous skill and unique way of composing a room. He thoughtfully reduced the clutter that characterised houses of the period, and chose each piece of furniture so that it would relate to the next, whether in scale, style, colour or texture. Furniture and objects were selected for their strong profiles and placed at right angles to one another or to the view on entering a room. Objects were arranged like still-life paintings – he called them 'tablescapes'. This approach suggests the influence of American designers such as Billy Baldwin, whose work Hicks admired; rooms arranged in this way photograph well and show, in Hicks's work, the beginning of the powerful influence of photography and media on design and decoration. To add to that, although high in styling, they can still be very comfortable.

However, it was the colour schemes that made the strongest impression. England was filled with pale, safe, dull rooms that bore a striking resemblance to the schools their owners had recently left, but Hicks worked with all the strongest colours of a painter's palette: aubergine and scarlet, orange and fuchsia pink, emerald green and black. The quality of the workmanship was exceptionally high, allowing inferior products such as mattress ticking, brown wrapping paper or plain gloss paint to be used as effectively as silk, leather or marble. After World War II many houses were fitted out poorly with flush doors, applied mouldings and shoddy workmanship. Like John Fowler, Hicks took a lot of trouble to ensure the rooms were mended and their shells put to rights before decorating began.

David Hicks's Drawing Room in Oxfordshire demonstrates ease and elegance
with a lighter touch than much of his commercial work.

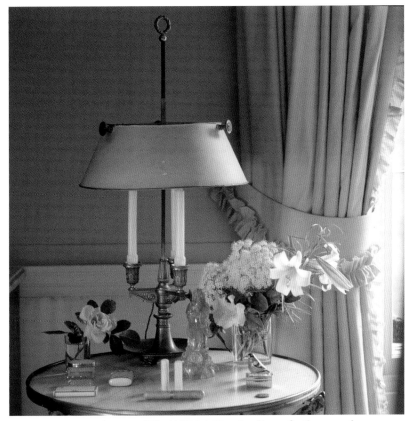

OPPOSITE *A corner of David Hicks's Drawing Room. On the commode
and the centre table are what he referred to as 'tablescapes'.*
ABOVE *Detail of another 'tablescape'.*

HICKS HAD AN UNUSUALLY STRONG sense of pattern for a decorator of his era. In 1963 he started to design patterned fabrics and carpets, which became instantly fashionable and commercially successful. Some of his designs referred to Owen Jones's seminal publication on colour, geometry and abstraction, *The Grammar of Ornament*, a book first published in 1856 that remains a useful source today. Hicks continued to design fabric and carpets throughout his career, but nothing surpassed the brilliance of his early geometric designs.

The two rooms illustrated here are from Hicks's own homes. The red bedroom was in Albany, Piccadilly, and the pink drawing room in the country. Both show his taste at the sustained height of his career, illustrating his way of arranging a room and his sense of colour and pattern. He would sometimes decorate with a tongue-in-cheek attitude, but crucially he knew how to take decoration seriously. He once declared: 'Bad taste is, specifically, gladioli, cut-glass flower bowls, two-tone motor cars and dollies to hide telephones,' adding, with characteristic confidence, 'good taste is, frankly, what I think is good taste.'

Rooms created by and for artists, interior designers and architects are often the most interesting to analyse, but, owing to the fugitive nature of interior decoration, few survive today. Thankfully, photographs can provide an important record; they illustrate that the work done by the likes of Fowler and Hicks – however short-lived is a vital part of the history of architecture and the decorative arts. Rooms will never again be composed as were those we have just described. They are the product of a certain time, now over, and of the attitudes of certain people, now dead.

David Hicks's bedroom in Albany, Piccadilly.
A typically bold David Hicks colour scheme and carpet.

APOLLO VICTORIA
THEATRE
LONDON

—

A Remarkable Art Deco Survival

Since the first brick was laid, London has been a perpetual building site, a fact owed largely to the city's urgent need and enthusiasm for the new. While this inclination has produced some architectural treasures, it has also brought about a large number of serious losses. Not even work by the great Robert Adam escaped unscathed: practically all of the Adelphi was pulled down, and parts of the elevations at Portland Place and Fitzroy Square were destroyed, with unsympathetic twentieth-century additions inserted. Within living memory, the interiors of many twentieth-century cinemas have been demolished, altered or rearranged.

Right up until the 1950s, half of all houses in England were without indoor bathrooms; they were also notoriously cramped and unbearably cold in the winter. Theatres, cinemas, music halls and pubs became the principal means of escape and so were designed and decorated comfortably, lavishly and imaginatively. Art Deco became the favoured high-budget building style, of what John Betjeman called 'the architecture of entertainment'. Movie theatres were designed, in his words, 'as an exotic day dream', and cinemas were 'the chapels of most of our people who feel it a sin not to attend each change of programme'.

This all changed in the 1950s and 1960s, when people had more money to spend, first on owning cars and then on improving their houses. Home comforts increased and television took over as the main source of entertainment. Cinema audiences dwindled and their buildings were either demolished or divided into three or more smaller auditoriums, which meant the destruction of their exotic interiors.

The stairs leading down to the auditorium from the restored foyer.
The architectural details and colour scheme are as original.

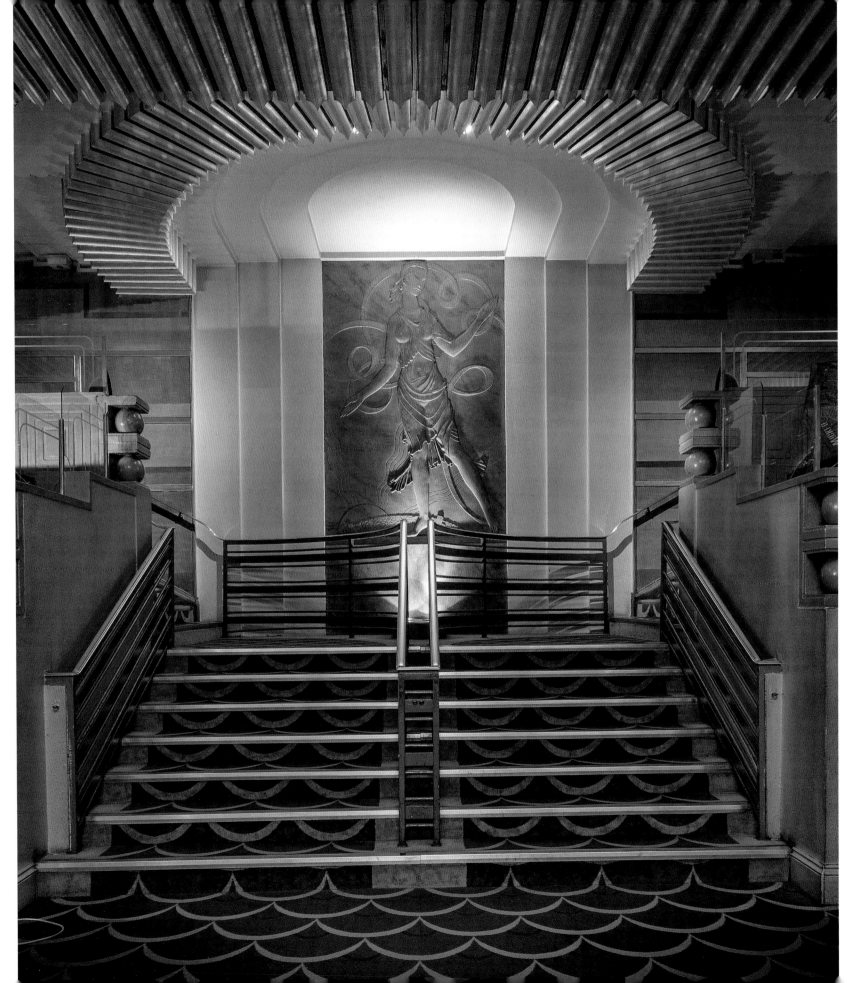

THE NEW VICTORIA CINEMA, now the Apollo Victoria Theatre, narrowly escaped demolition in the early 1970s. It was built on a site between Wilton Road and Vauxhall Bridge Road in 1929, two years after Le Corbusier's *Towards a New Architecture* was translated into English. The architects were William Edward Trent and Ernest Wamsley Lewis, both of whom started their careers with historicist pastiche buildings. It is one of the first buildings in England to be built in the modern European style, and was conspicuously horizontal in its arrangement with its grouped bands of windows. Virtually everything built before it was designed to be read vertically.

The sculptor Newbury Abbot Trent, a cousin of William Edward Trent, was both responsible for the relief panelling on the exterior and involved in the designs for the interior. He also worked on the Gaumont cinemas in North Finchley, Chelsea (home to Habitat until 2018) and Hammersmith (now also called the Apollo).

The auditorium is below ground, which meant a large excavation. It is reached down a set of stairs from the entrance foyer. Upon its official opening in 1930, the Gaumont British News called the interior of the theatre 'a fairy cavern under the sea, or a mermaid's dream of heaven'. The range of tones extends from black to silver through every colour in the spectrum, and even now, without the original kaleidoscopic lighting scheme, the effect is outstanding. The walls are adorned with aquatic murals, concealed lighting is decorated with scallop shells and columns burst into sculptured fountains at the ceiling. Unexpectedly, these remind one of the fan vaulting at Heveningham Hall (pages 124–29).

However, by the mid-twentieth century Art Deco was unpopular with both modern and historically minded observers, who were unified in their distaste for the style. The Apollo was left untouched until the 1980s, when a string of musical theatre successes enabled it to be restored as far as purpose would allow.

The entrance foyer of the theatre is off a busy London street
and the even busier forecourt of Victoria railway station.

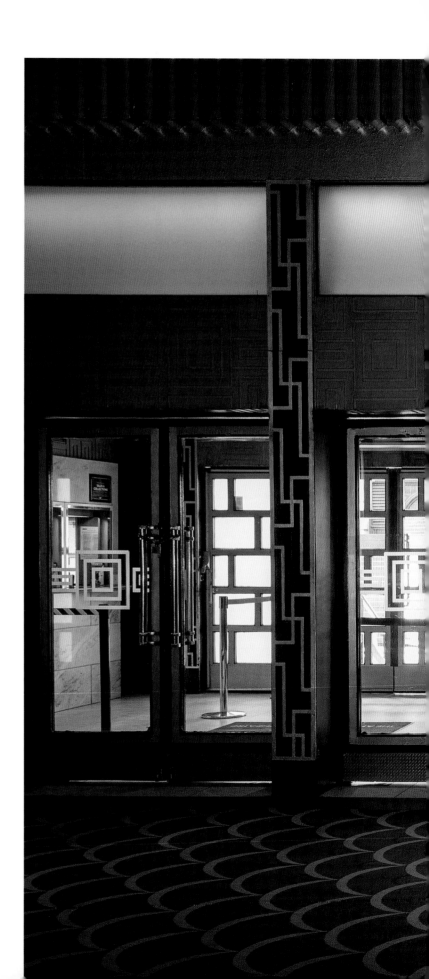

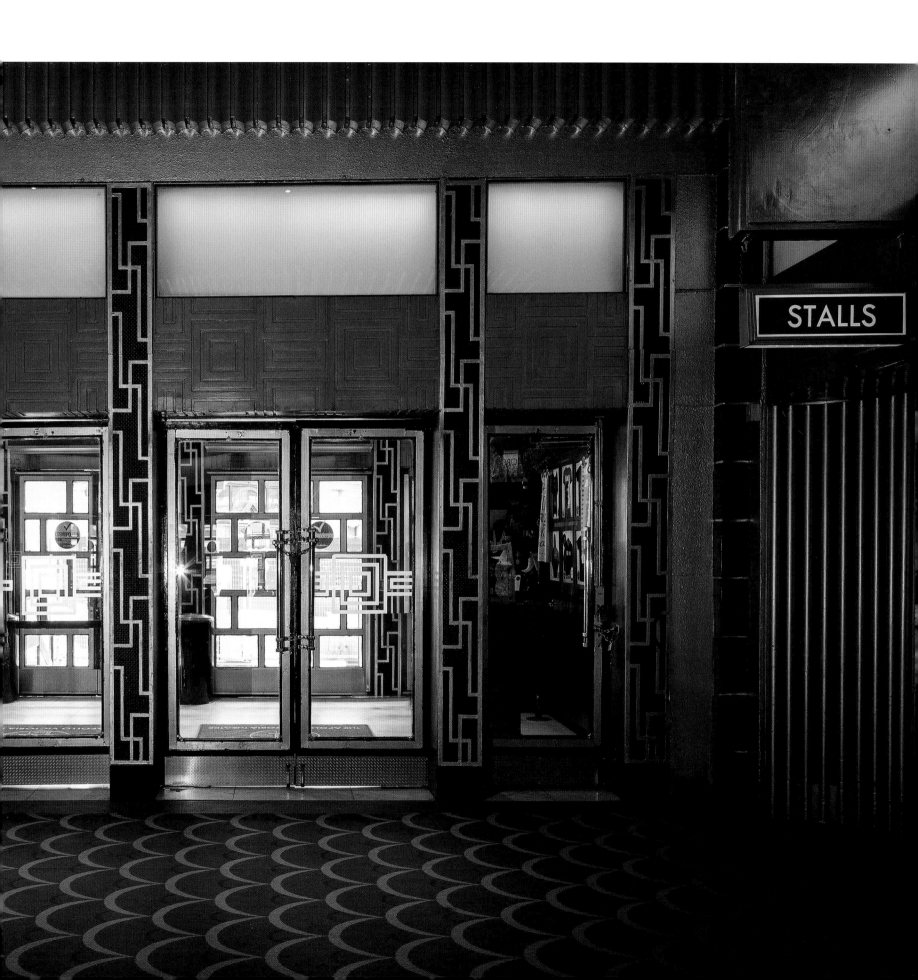

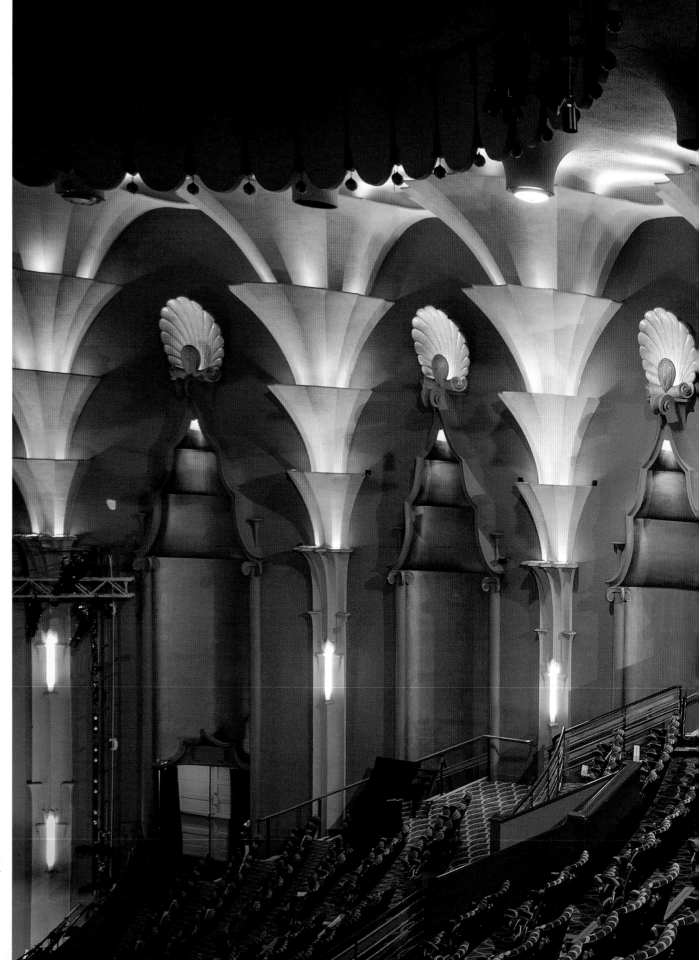

The restored auditorium imaginatively suggests being under the sea, while actually being below street level.

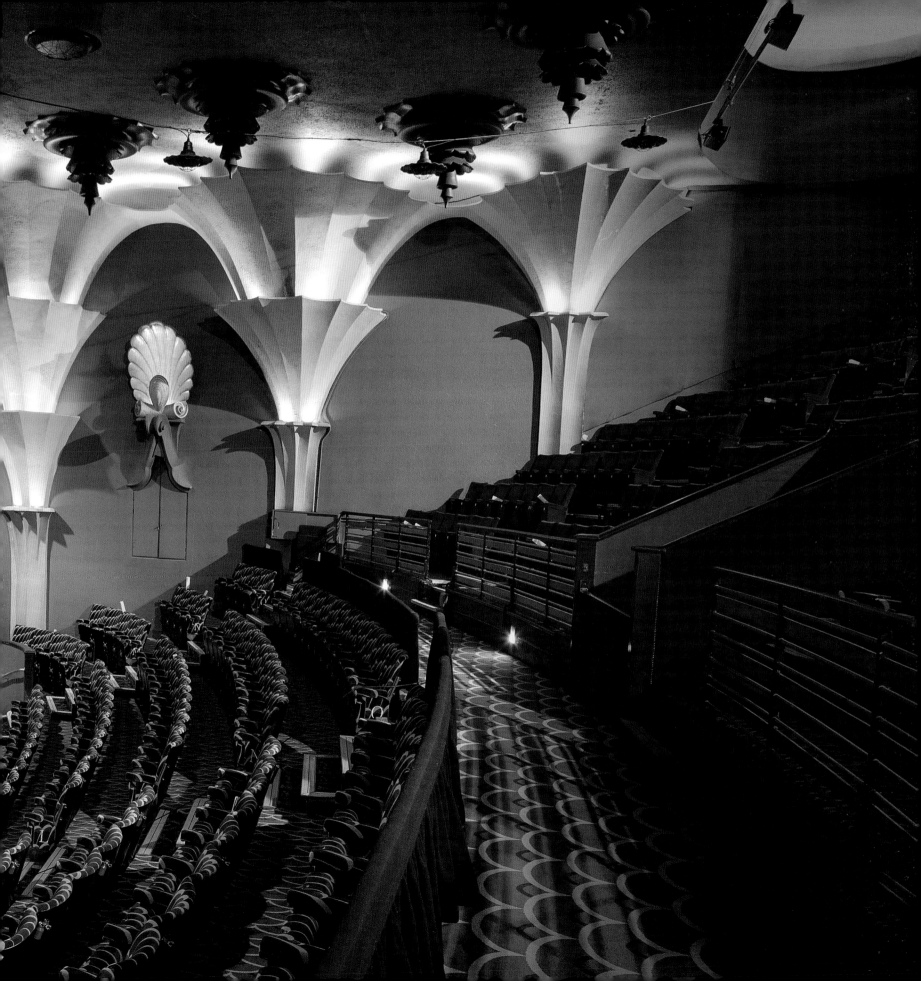

TWENTY-FIRST CENTURY

JILL RITBLAT'S POOL & PARTY ROOM
LONDON

A Postscript to our Story

I<small>F ANY ROOM IN THIS BOOK SPEAKS</small> for itself, it is this pool room built under a house in one of the Regency terraces designed by John Nash on the edge of Regent's Park, London. When the pool is emptied, the base is raised level to the surround to become the floor of a party room. This room was designed by Ken Shuttleworth and took five years to plan and four years to build, approximately the same time that went into creating Spencer House (pages 131–39). It is deceptively simple in appearance but, of course, was very complicated to achieve.

The design and execution of the work are both to a very high standard. This room is on just one level of a three-storey basement, but the transition from Regency to contemporary architecture is carefully and successfully handled. The staircase on all levels is modern; the living rooms from the ground floor upwards are period and beautifully decorated. In many cases where there is a modern insertion in a historic building, there is an uncomfortable jump or, as some art historians have said, 'a bumpy ride'; here, the contrast is smoothly achieved.

The new interior is as great a contrast as one could have to the English cluttered interior or *le désordre anglais*, as the French call it, sometimes with secret envy. One cannot take minimalism further, so it will be interesting to see what happens next.

Jill Ritblat's Pool & Party Room is a brave and fine example of contemporary minimalism. The base of the pool can be raised to become a dance floor, and the lighting can change its colour scheme in many different combinations.

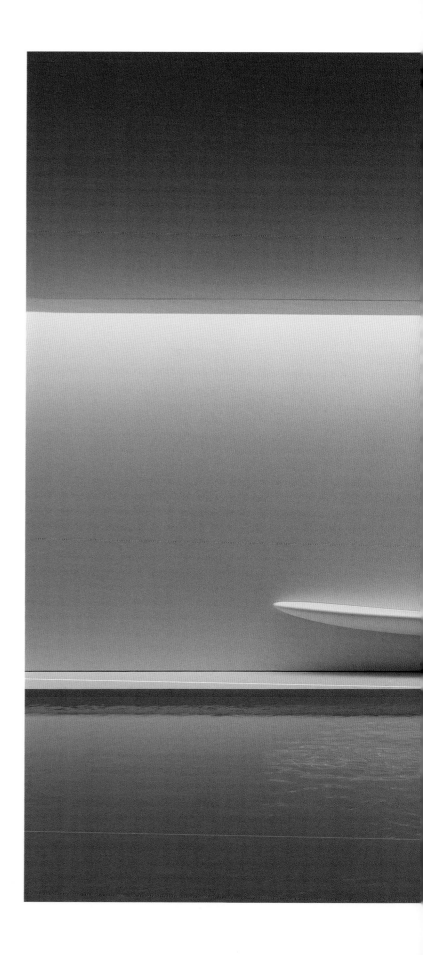

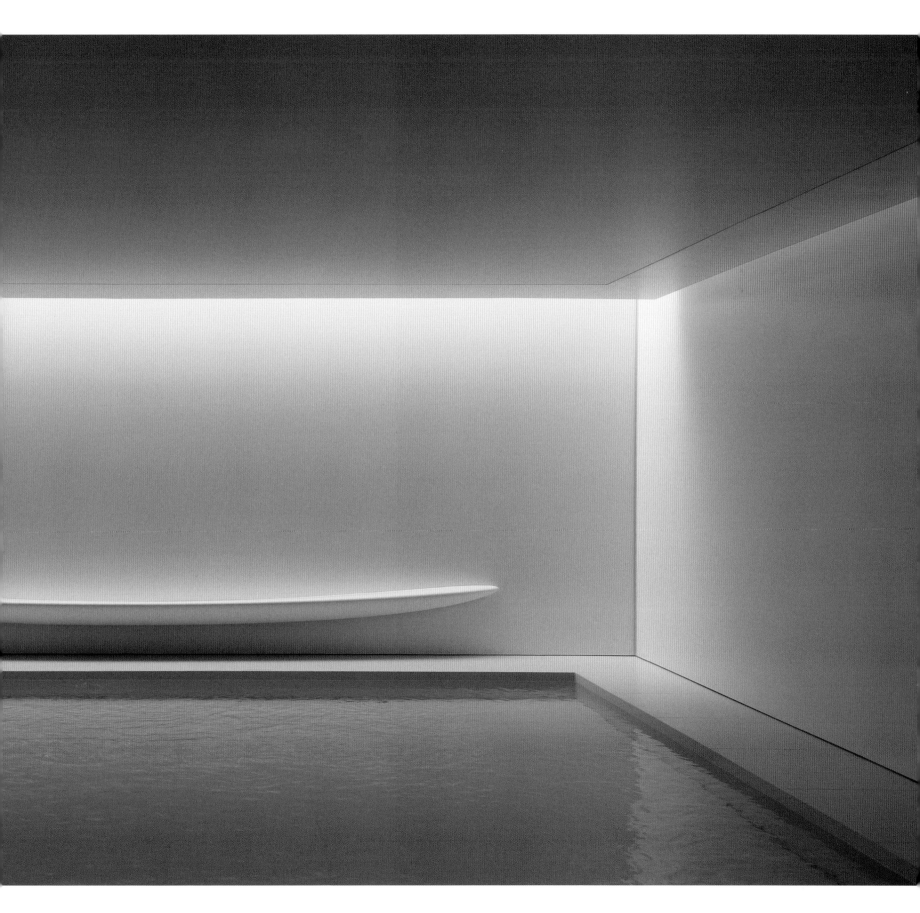

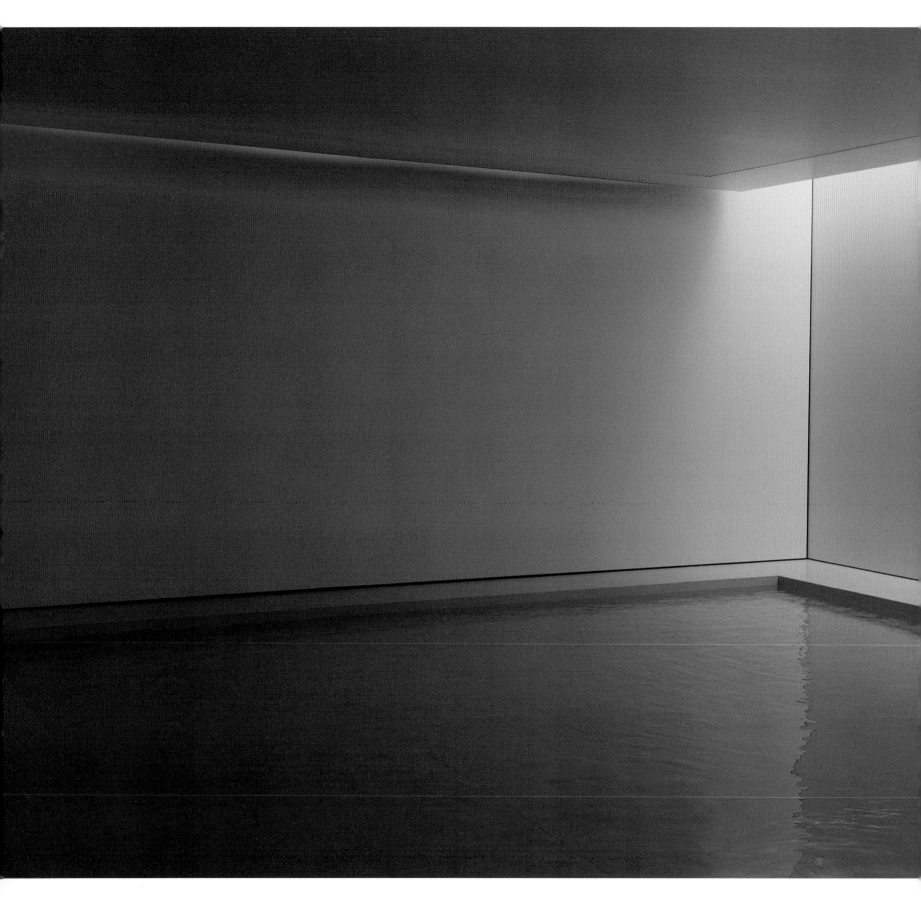

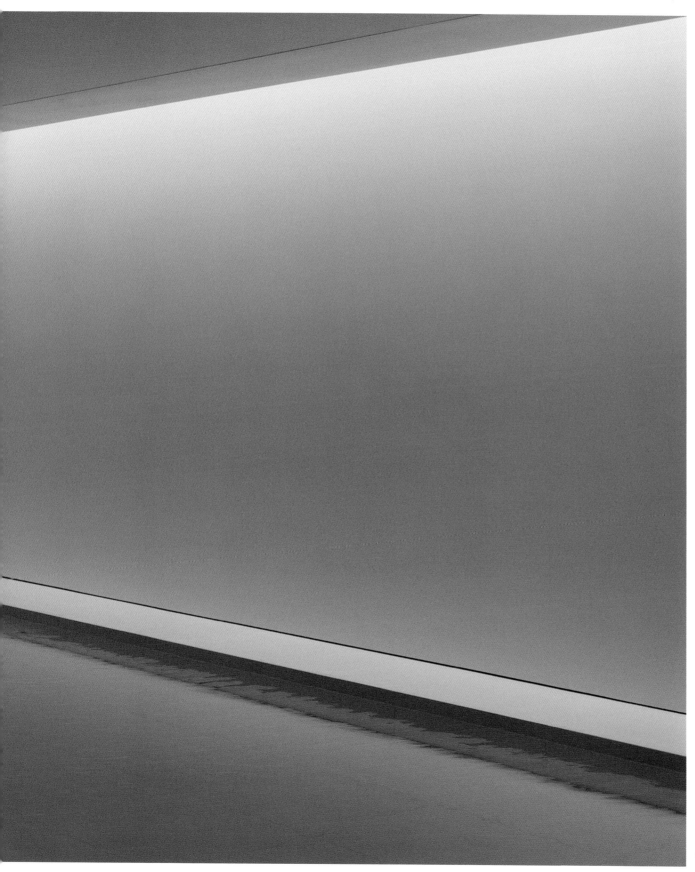

The pool and its surround are both faced in pale cream stone so that the colour of the water is pale blue.

221

INDEX

THE AUTHORS WOULD LIKE TO THANK

Christina Alfonsin

Nigel Bailey

Howard Barclay

Jake Barrett

Diane Bellis

Hatta Byng

Pippa Campbell

The Marquess of Cholmondeley

Katy Conover

Jasper Conran

The Duke and Duchess of Devonshire

Jane Finch

Leslie Fiore

Jon and Lois Hunt

Peter Inskip

Sir Simon Jenkins

Jackie McDevitt

Lord Edward Manners

Thomas Marriott

Martha Mlinaric

Marina Moore

Wendy Nichols

The Duke and Duchess of Northumberland

Josephine Oxley

Sarah Payne

The Earl and Countess of Pembroke

Vicky Perry

Jane Rick

Sir John and Lady Ritblat

Orlando Rock

Chris Rolfe

Lord Rothschild

The Marquis and Marchioness of Salisbury

Rafael Serrano

Pippa Shirley

Emily Tobin

Brent Wallace

The Duke and Duchess of Wellington

Martin Wood

Editorial direction: Lincoln Dexter / Sabine Schmid
Copy-editing: Rosanna Fairhead
Design: Lisa Limber/eye.media
Index: Vicki Robinson
Production management: Luisa Klose
Separations: Ludwig Media, Zell am See
Printing and binding: DZS, d.o.o., Ljubljana
Paper: Primasilk

Printed in Slovenia